31ST PUBLICATION DESIGN ANNUAL

THE SOCIETY OF PUBLICATION DESIGNERS

ROCKPORT PUBLISHERS INC.
ROCKPORT, MASSACHUSETTS
DISTRIBUTED BY NORTH LIGHT BOOKS, CINCINNATI, OHIO

09348497

The Gala

The Society wishes to thank The New York Times
Company Foundation for its generosity to
the New York Public Library, which has enabled
the Society of Publication Designers to hold
its annual awards Gala in this very special place.

The Sponsors

The Society thanks its corporate sponsors
for their continuing support:

Adobe Systems, Inc.
American Express Publishing
Apple Computers, Inc.
Applied Graphics Technologies
Champion Paper Co.
Condé Nast Publications, Inc.
Dow Jones & Company, Inc.
Hachette Filipacchi Magazines, Inc.
Hearst Magazines
IBM
Meredith Corporation
Newsweek
The New York Times
Wenner Media
Time Inc.
U.S. News & World Report
Westvaco Corporation

Special Thanks

Frederica Gamble of Condé Nast Publications
Applied Graphics Technologies for engraving & printing
 of Call for Entry, Gala program
 and Student Competition Call for Entry
Chris Callahan, Chris Hamilton and Diane Romano
 of Applied Graphics Technologies

Robert Altemus, Call for Entry design & illustration
Steven Freeman, photographer
Susan Isaak, photography assistant
Alvaro Cuellar, photography assistant
Rio Hyde, make-up artist
Color Edge Film Processing

Officers

President
Tom Bentkowski, LIFE

Vice President
Sue Llewellyn

Vice President
Robert Altemus, Altemus Creative Servicenter

Secretary
Rhonda Rubinstein, R Company

Treasurer
Karen Bloom, Westvaco Corporation

Executive Director
Bride M. Whelan

Board of Directors

David Barnett, Barnett Design Group
Caroline Bowyer, American Lawyer
Traci Churchill, Money
Gigi Fava, Fava Design
Malcolm Frouman, BusinessWeek
Michael Grossman, Meigher Communications
Diana LaGuardia, Esquire
Greg Leeds, The Wall Street Journal
Janet Waegel, Time
Scott Yardley, Good Housekeeping
Lloyd Ziff, Lloyd Ziff Design

Ex Officio
Walter Bernard , WBMG
Phyllis Richmond Cox, Bride's

The Society of Publication Designers, Inc.
60 East 42nd Street, Suite 721
New York, NY 10165
Telephone: (212) 983-8585
Fax: (212) 983-6042
Email: SPDnyc@aol.com
Web site: HTTP://www.SPD.ORG

The SPD 31st Design Annual

Jacket and book designed by Mimi Park.

Copyright ©1996
The Society of Publication Designers, Inc.

All rights reserved. No part of this book may be
reproduced in any form without written permission
of the copyright owners. All images in this book have
been reproduced with the knowledge and prior
consent of the artists concerned and no responsibility
is accepted by producer, publisher, or printer
for any infringement of copyright or otherwise,
arising from the contents of this publication.
Every effort has been made to ensure that credits
accurately comply with information supplied.

First published in the United States of America by:
Rockport Publishers,Inc.
146 Granite Street
Rockport, Massachusetts 01966-1299
Telephone: (508) 546-9590
Fax: (508) 546-7141

Distributed to the book trade and art trade
in the U.S. and Canada by:
North Light, an imprint of F & W Publications
1507 Dana Avenue
Cincinnati, OH 45207
Telephone: (800) 289-0963

Other Distribution by:
Rockport Publishers, Inc.
Rockport, Massachusetts 01966-1299

ISBN 1-56496-296-2

10 9 8 7 6 5 4 3 2 1

Printed in China

ACKNOWLEDGEMENTS

CONTENTS

▼ ● THE COMPETITION

The Society of Publication Designers Annual Competition draws several thousand entries from the United States and abroad. A distinguished jury, representing various design and editorial disciplines, judges the works submitted in twenty-one categories.

Once the most outstanding has been selected for the exhibition and publication design annual, the jury awards, Gold and Silver medals, the highest awards for editorial design, and Merit awards for distinction. The result, is a body of work representing the best in design, photography, and illustration.

This year, the Society inaugurated two new categories: *Overall Design*, honoring outstanding and consistent design achievement throughout the year, and *Online Design*, recognizing exceptional design on the world wide web.

■ COMPETITION & GALA CHAIRPERSONS ■ STUDENT COMPETITION CHAIRPERSONS

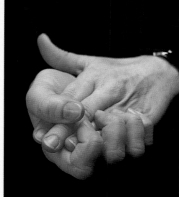
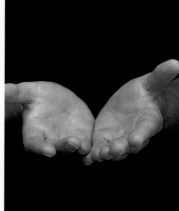
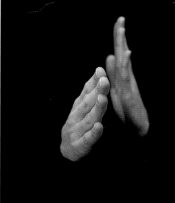

ROBERT ALTEMUS
ALTEMUS CREATIVE SERVICENTER

TRACI CHURCHILL
MONEY

MALCOLM FROUMAN
BUSINESSWEEK

RHONDA RUBINSTEIN
R COMPANY

PHOTOGRAPHS BY **STEVEN FREEMAN**

■ THE JUDGES

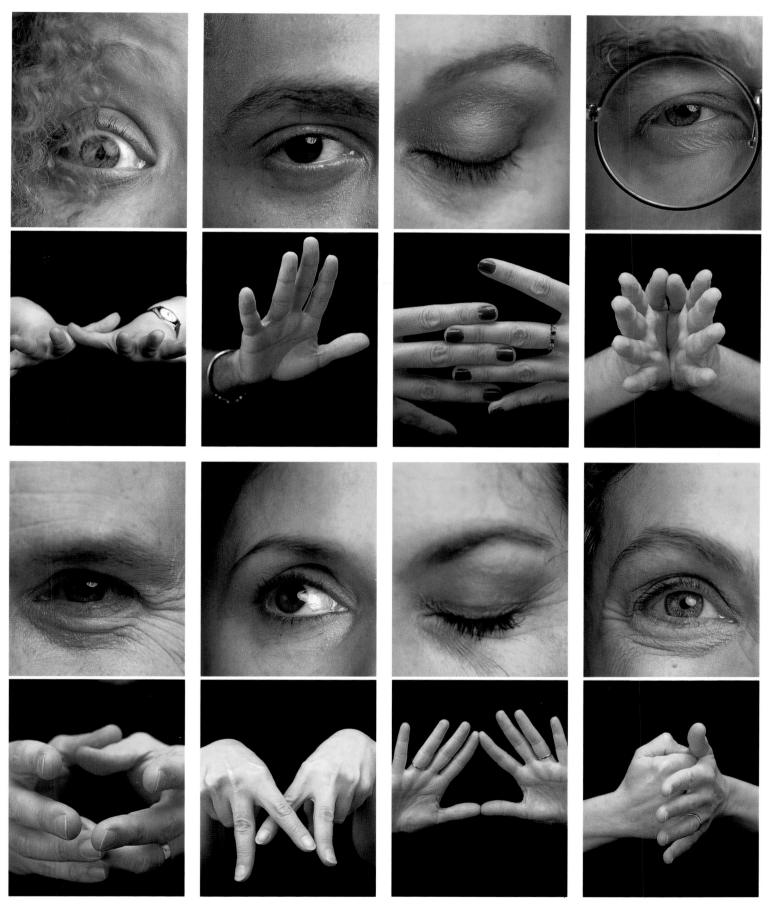

GAIL ANDERSON
ROLLING STONE

ROB COVEY
US NEWS & WORLD REPORT

RICHARD BAKER
US

GIGI FAVA
FAVA DESIGN

DORIS BRAUTIGAN
ENTERTAINMENT WEEKLY

LOUISE FILI
LOUISE FILI DESIGN

BOB CIANO
ENCYCLOPEDIA BRITTANICA

JANET FROELICH
THE NEW YORK TIMES MAGAZINE

5

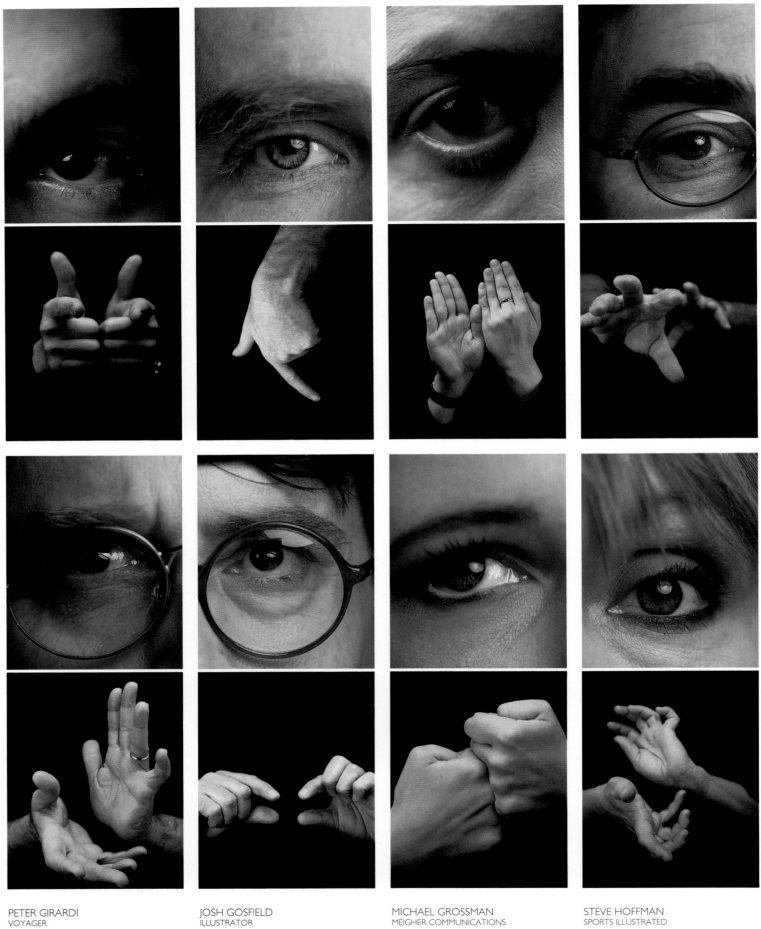

PETER GIRARDI
VOYAGER

RUDY HOGLUND
MONEY

JOSH GOSFIELD
ILLUSTRATOR

NIGEL HOLMES
NIGEL HOLMES GRAPHICS

MICHAEL GROSSMAN
MEIGHER COMMUNICATIONS

GALIE JEAN-LOUIS
ANCHORAGE DAILY NEWS

STEVE HOFFMAN
SPORTS ILLUSTRATED

ANITA KUNZ
ILLUSTRATOR

6

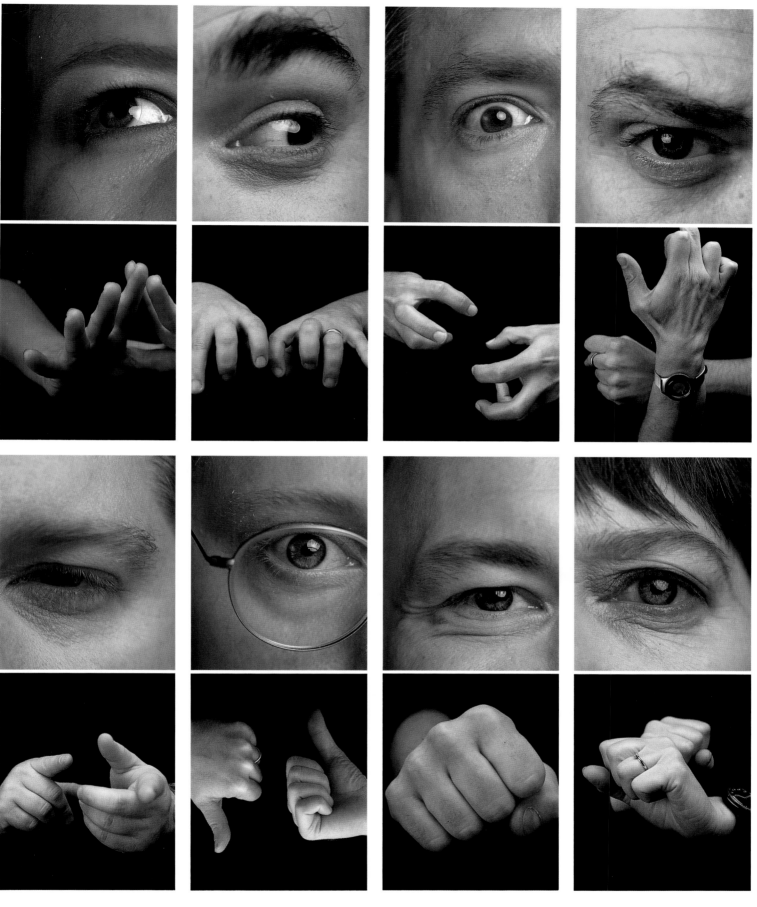

PATRICIA MARROQUIN
AMERICAN PHOTO

PATRICK MITCHELL
FAST COMPANY

RON MECKLER
RE:DESIGN

DON MORRIS
DON MORRIS DESIGN

SCOTT MENCHIN
ILLUSTRATOR

BOB NEWMAN
NEW YORK

MARK MICHAELSON
CONDÉ NAST NEW MEDIA

MARGARET RICHARDSON
U&lc

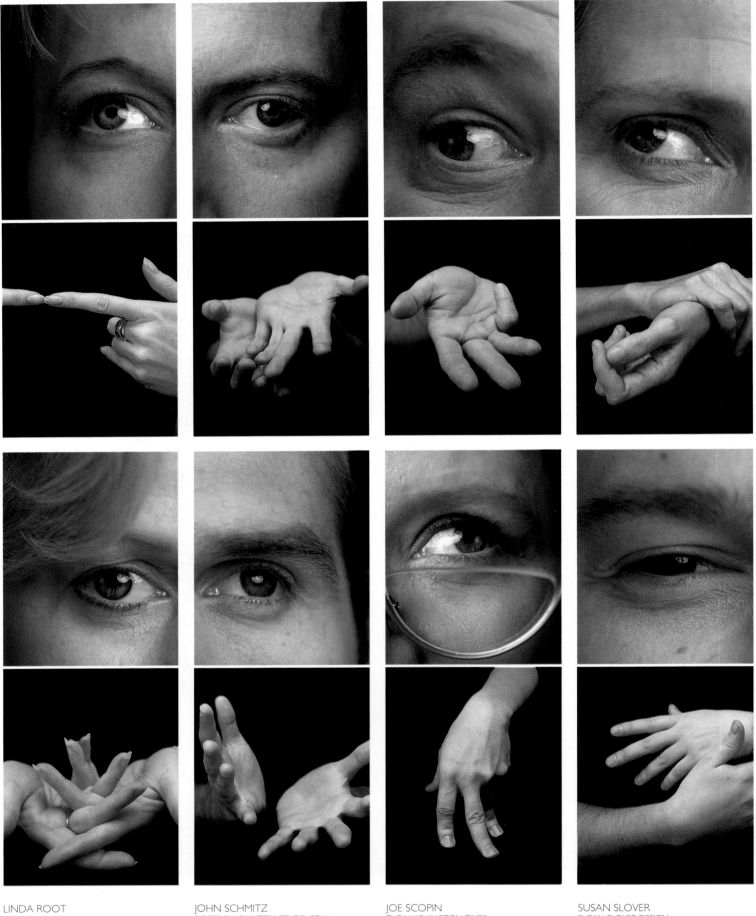

LINDA ROOT
SELLING

LYNN STALEY
NEWSWEEK

JOHN SCHMITZ
ROGER BLACK INTERACTIVE BUREAU

D. J. STOUT
TEXAS MONTHLY

JOE SCOPIN
THE WASHINGTON TIMES

MELISSA TARDIFF
INDIGO INFORMATION SYSTEMS

SUSAN SLOVER
SUSAN SLOVER DESIGN

SCOTT YARDLEY
GOOD HOUSEKEEPING

DESIGN

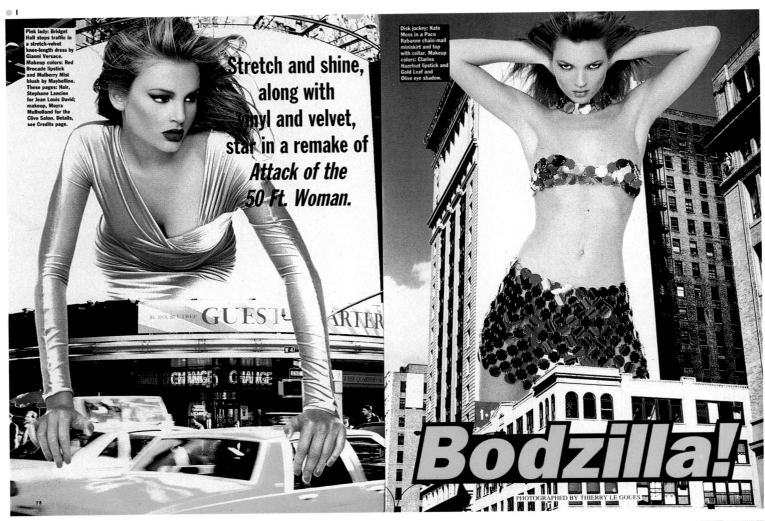

Pink lady: Bridget Hall stops traffic in a stretch-velvet knee-length dress by Gianni Versace. Makeup colors: Red Brocade lipstick and Mulberry Mist blush by Maybelline. These pages: Hair, Stephane Lancien for Jean Louis David; makeup, Moyra Mulholland for the Clive Salon. Details, see Credits page.

Stretch and shine, along with vinyl and velvet, star in a remake of *Attack of the 50 Ft. Woman.*

Disk jockey: Kate Moss in a Paco Rabanne chain-mail miniskirt and top with collar. Makeup colors: Clarins Hazelnut lipstick and Gold Leaf and Olive eye shadow.

Bodzilla!

PHOTOGRAPHED BY THIERRY LE GOUES

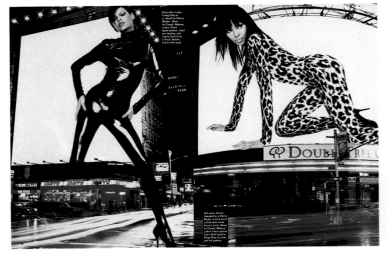

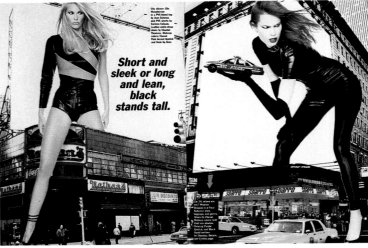

Short and sleek or long and lean, black stands tall.

Publication Allure
Design Director Shawn Young
Designer Shawn Young
Photo Editor Claudia Lebenthal
Photographer Thierry Le Gowes
Publisher Condé Nast Publications Inc.
Issue July 1995
Category Story/Feature

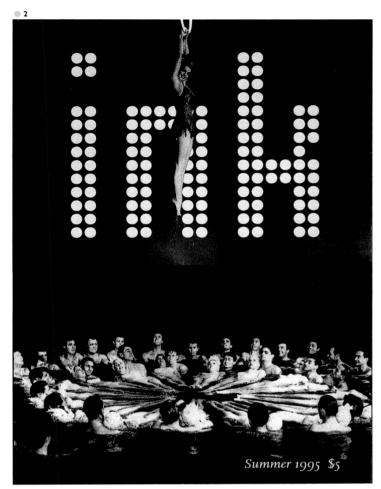

Summer 1995 $5

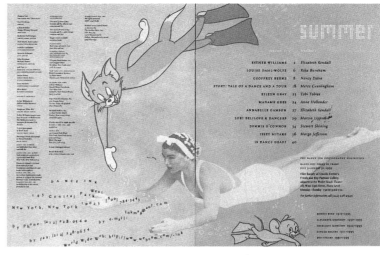

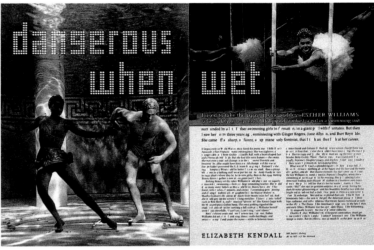

Publication Dance Ink
Art Director J. Abbott Miller
Designers J. Abbott Miller, Paul Carlos, Luke Hayman
Photographers Josef Astor, Marcia Lippman, David Michalek, Stewart Shining
Photo Editor Katherine Schlesinger
Studio Design/Writing/Research, New York
Publisher Dance Ink, Inc.
Issue June 1995
Category Entire Issue

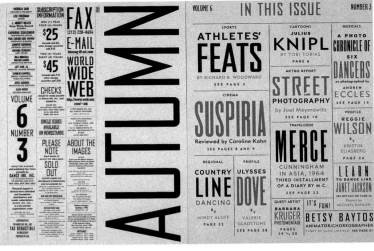

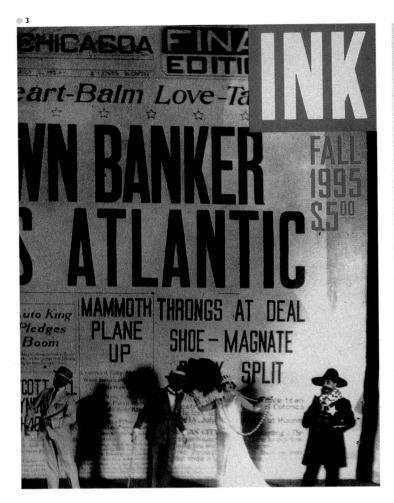

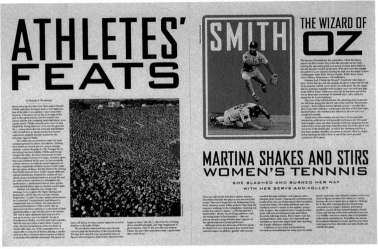

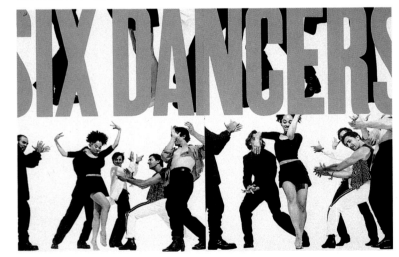

●3
Publication Dance Ink
Art Director J. Abbott Miller
Designers J. Abbott Miller, Paul Carlos, Luke Hayman
Photographers K.C. Bailey, Andrew Eccles,
Jeff Jacobson, Anthony Saint James, Joel Meyerowitz
Photo Editor Katherine Schlesinger
Publisher Dance Ink, Inc.
Issue September 1995
Category Entire Issue

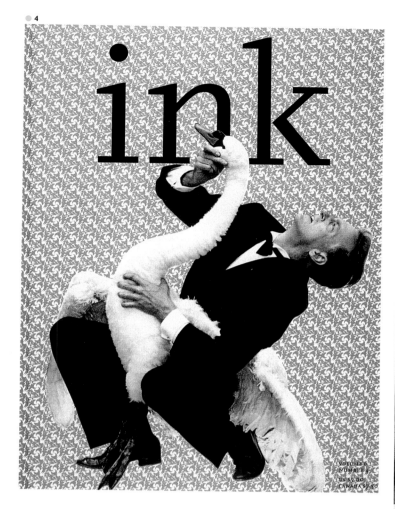

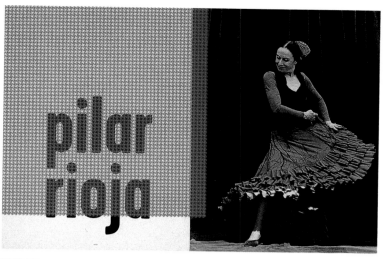

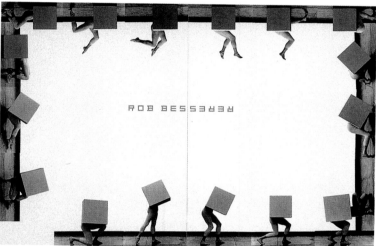

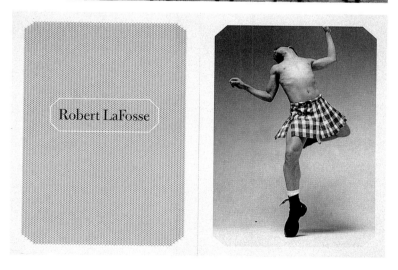

Publication Dance Ink
Art Director J. Abbott Miller
Designers J. Abbott Miller, Paul Carlos, Luke Hayman
Photographers Josef Astor, K.C. Bailey, Andrew Eccles,
Timothy Greenfield Sanders, Duane Michals
Photo Editor Katherine Schlesinger
Studio Design/Writing/Research, New York
Publisher Dance Ink, Inc.
Issue December 1995
Category Entire Issue

When I close my eyes, I can still see the tree that once stood at the center of the universe.

My universe, the world as I saw it through the eyes of a child. Hideaway, lookout, and clubhouse all

HOW TO

in one, that trunk and those branches

towered over the secret garden of my

imagination. My actual tree was cut down years ago, but it's a place I return to in my mind when-

ever I contemplate changing the real-world garden I have now—or when other people ask me how

DREAM

to start designing a "dream garden" all their own. ▪ The best way to start, I've learned, is to put

aside all books and magazines—and to stop worrying about everybody else's ideas. Think back to

the childhood haunts where

you went to daydream.

A GARDEN

Maybe your favorite spot for reveries wasn't a tree. Was it the boulder you climbed for a view that

stretched to the brink of outer space, or was it that overgrown bush you turned into a jungle hut?

BY JULIE MOIR MESSERVY Did you kneel on the bank of a creek to watch the

dragonflies skitter, or did you flop down in a meadow to stare at the clouds? Or did a cozy attic or

a twisty alleyway seem much more magical than the sandbox or jungle gym you were supposed

to play in? For many ILLUSTRATIONS BY ROSS MACDONALD

of us, a genuine secret garden could only be found outside the tame terrain our parents

fenced in and mowed. ▪ Jot down a list of these special places—even if they weren't literally

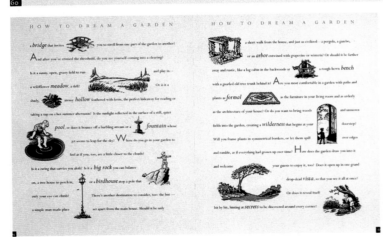

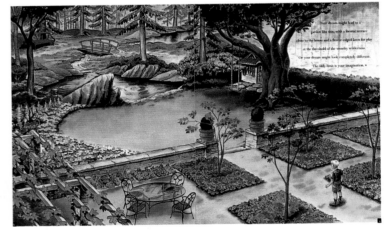

●5
Publication Garden Design
Creative Director Michael Grossman
Art Director Paul Roelofs
Illustrator Ross MacDonald
Photo Editor Susan Goldberger
Publisher Meigher Communications
Issue February/March 1995
Category Story/Feature

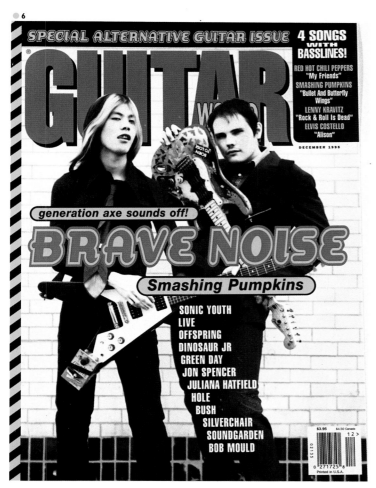

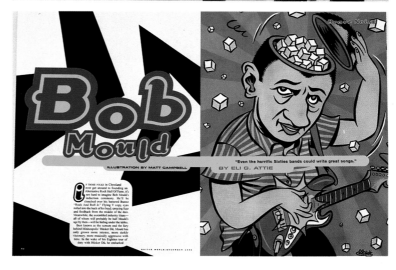

●6
Publication Guitar World
Design Director Peter Yates
Designers Sandra Monteparo, Peter Yates
Illustrators Matt Cambell, Jay Lincoln, Mark Marek
Photographers Danny Clinch, Sue Schaffner, Charles Peterson,
Catherine McGann, Marty Temme, Lorinda Sullivan, Kwaku Alston
Publisher Harris Publications
Issue December 1995
Category Entire Issue

02/09/95

Independent
Magazine

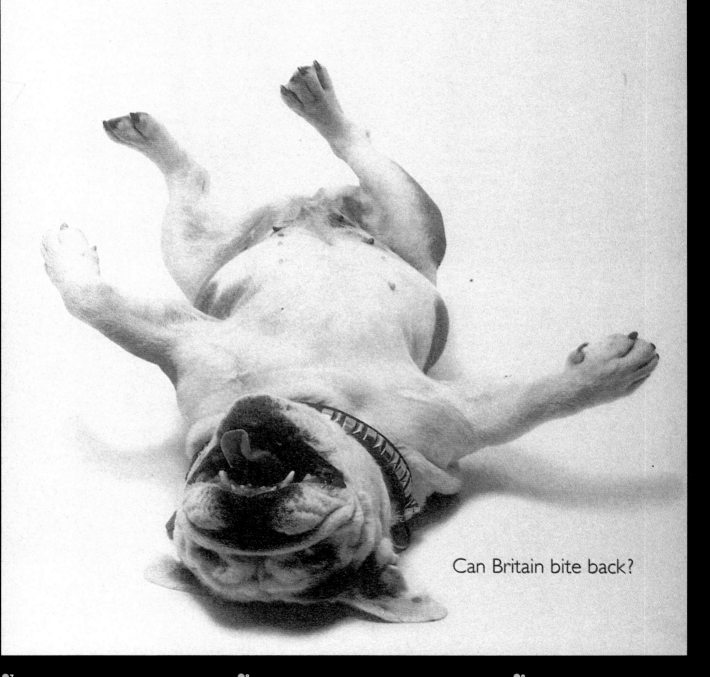

Can Britain bite back?

● 7
Publication Independent Magazine
Creative Director Vince Frost
Designer Vince Frost
Photographer Giles Revell
Studio Frost Design
Publisher Mirror Group
Category Cover

● 8
Publication New York
Design Director Robert Best
Art Director Syndi Becker
Designer Robert Best
Photo Editor Margery Goldberg
Photographers Chris Bobin, Paul Manangan
Publisher K-III Publications
Issue February 20, 1995
Category Spread/Feature

● 9
Publication Texas Monthly
Creative Director D. J. Stout
Designers D. J. Stout, Nancy McMillen
Illustrator David Cowles
Photo Editor D. J. Stout
Publisher Texas Monthly
Issue February 1995
Category Spread/Feature

8

Has AIDS Won?

By Craig Horowitz

9

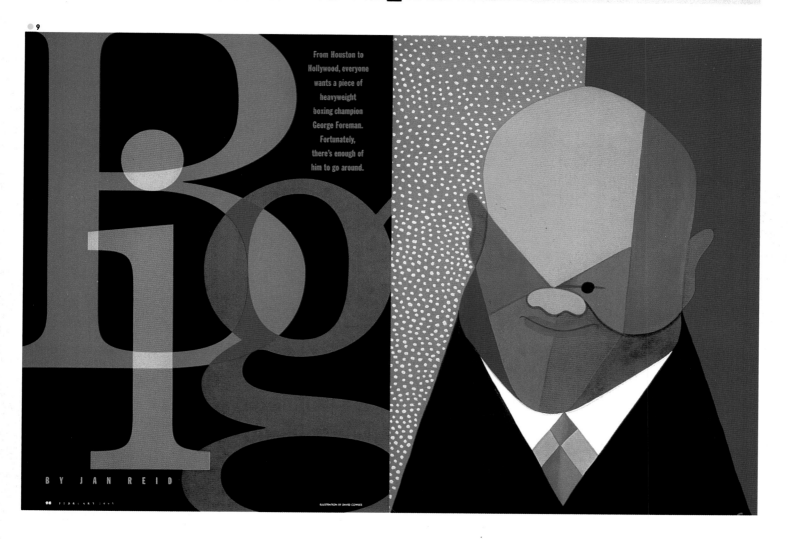

From Houston to Hollywood, everyone wants a piece of heavyweight boxing champion George Foreman. Fortunately, there's enough of him to go around.

BY JAN REID

ILLUSTRATION BY DAVID COWLES

The SWEET SONG of JUSTICE

It took the jury less than three hours to find Yolanda Saldivar guilty of murdering Selena. But for two weeks in October, all of Texas followed the most sensational trial in years. A behind-the-scenes look at what happened inside the courtroom.
by Joe Nick Patoski

TEXAS MONTHLY 102 December 1995 ILLUSTRATION BY OWEN SMITH

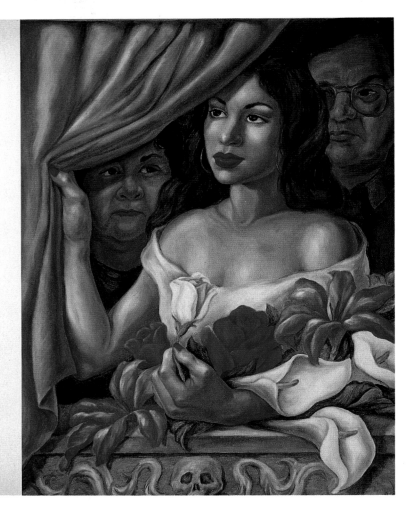

● 10
Publication Texas Monthly
Creative Director D. J. Stout
Designers D. J. Stout, Nancy McMillen
Illustrator Owen Smith
Publisher Texas Monthly
Issue December 1995
Category Spread/Feature

● 11
Publication The New York Times Magazine
Art Director Janet Froelich
Designer Lisa Naftolin
Photo Editor Kathy Ryan
Photographer Richard Burbridge
Publisher The New York Times
Issue June 25, 1995
Category Cover

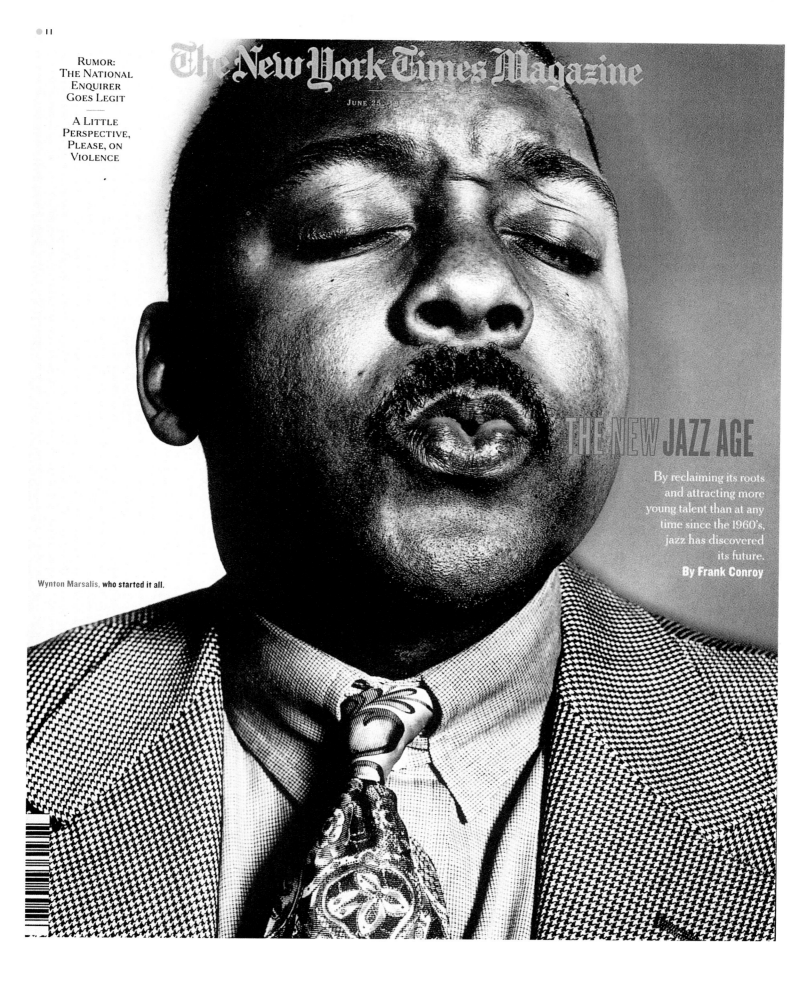

The New York Times Magazine

JUNE 25

RUMOR:
THE NATIONAL
ENQUIRER
GOES LEGIT

A LITTLE
PERSPECTIVE,
PLEASE, ON
VIOLENCE

THE NEW JAZZ AGE

By reclaiming its roots
and attracting more
young talent than at any
time since the 1960's,
jazz has discovered
its future.
By Frank Conroy

Wynton Marsalis, **who started it all.**

12

IMPULSE

In the snapshot, they looked like a family picture in 1950s America — three blond children, clean-shaved dad and mother in a plaid shirtdress.

By MELINDA SACKS-Knight-Ridder Newspapers

AMERICAN

GOTHIC

HORROR

They stood together, backs to the camera, gazing up at the Lincoln Memorial.

Filmmaker's family portrait

darker than TV's Waltons

But appearances, as the saying goes, can be so misleading.

Just three years later, in 1968, Pam Walton's mother was dead of lung cancer, her father had remarried — Please see Page E-4, WALTONS

Illustration by Amy Guip

GAYS CAN ROCK 4

Pansy Division plays queercore/homocore

OLD ART FORM 4

Native dancers star in museum series

JUST DON'T ASSUME 4

Stallone says 'Dredd' isn't just a bloodfest

20

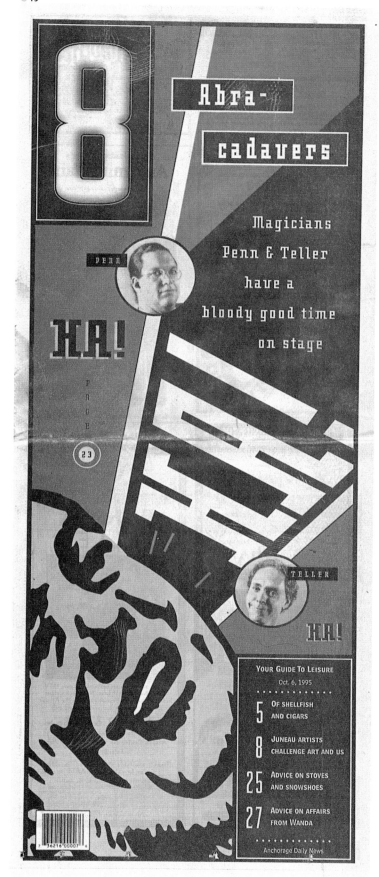

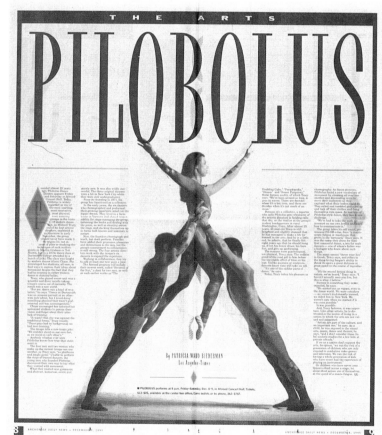

● 12
Publication Anchorage Daily News/Impulse
Creative Director Galie Jean-Louis
Designer Galie Jean-Louis
Illustrator Amy Guip
Photo Editor Galie Jean-Louis
Publisher Anchorage Daily News
Issue July 17, 1995
Category Front Page
　　　　　 Merit Spread/Feature

● 13
Publication Anchorage Daily News/Impulse
Creative Director Galie Jean-Louis
Designers Kevin Ellis, Lance Lekander, Mike Bain
Illustrators Lance Lekander, Kevin Ellis
Photo Editor Galie Jean-Louis
Publisher Anchorage Daily News
Issue October 6, 1995
Category Redesign

LIFE BEGINS IN THE GARDEN: *Carly Simon's Island* · *Great Gazebos* · *Bulbs to Bank on*

GARDEN
DESIGN

$5.00 · OCT./NOV.,1995

Turning Over a New Leaf
HOW TO MAKE FALL A SECOND SPRING

marzipan

MARZIPAN IN ITS PURE FORM IS LIKE RUPAUL WITHOUT THE MAKEUP: A BLANK SLATE WAITING TO BE TRANSFORMED INTO SOMETHING ABSOLUTELY FABULOUS. THIS SOFT CANDY, A MIXTURE OF FINELY GROUND ALMONDS, CONFECTIONERS' SUGAR, AND EITHER CORN SYRUP OR EGG WHITES, STARTS OUT AS A NEUTRAL-COLORED PASTE. BUT MARZIPAN ISN'T MARZIPAN UNTIL IT'S ALL DRESSED UP TO PLAY A PART, USUALLY IN TINY HOMAGE TO OBJECTS IN NATURE'S REPERTOIRE.

IN MARZIPAN'S MINIATURE WORLD, LIFE IS ALWAYS SWEET. PERHAPS THIS EXPLAINS THE CANDY'S POPULARITY NOT JUST OVER THE YEARS, BUT THE CENTURIES. MARZIPAN IS THOUGHT TO HAVE MADE ITS CALORIC TREK FROM THE MIDDLE EAST TO ITALY BY ABOUT 1300. THERE IT GOT ITS NAME, *MARZAPANE*, MEANING "SWEET BOX," AND ATTAINED THE STATUS OF EDIBLE ART FORM. THE NINETEENTH-CENTURY NOVELIST HONORÉ DE BALZAC WAS SO TAKEN BY THE MARZIPAN BONBONS CRAFTED BY URSULINE NUNS IN THE PROVENÇAL VILLAGE OF ISSOUDUN THAT IN *THE BLACK SHEEP* HE DEEMED THEM "ONE OF THE GREATEST CREATIONS OF FRENCH CONFECTIONERY." BALZAC THEN PUT HIS MONEY WHERE HIS MOUTH WAS, BANKROLLING A MARZIPAN SHOP ON PARIS'S RUE DE VIVIENNE TO IMPORT THE ISSOUDUN *MASSEPAINS*.

WHILE THE BALZACIAN SWEETS REMAIN LEGEND, PASTRY CHEF KIM JURADO, WHO MADE THE MARZIPAN CONFECTIONS ON THESE PAGES, HAS TAKEN THIS CRAFT TO NEW HEIGHTS OF REALISM. MARZIPAN IS A HOLIDAY TRADITION IN JURADO'S FAMILY. HER SWEDISH MOTHER MADE THE CUSTOMARY SHAPES, SUCH AS CHICKS AT EASTER, AND PIGS AND APPLES FOR CHRISTMAS STOCKINGS. JURADO STARTS BY BLENDING A POUND OF ALMOND PASTE WITH A POUND OF CONFECTIONERS' SUGAR, THEN ADDS THREE FLUID OUNCES OF CORN SYRUP OR EGG WHITES. IN SHAPING HER MARZIPAN CREATIONS, SHE TAKES HER INSPIRATION FROM THE SEASONS: IN AUTUMN, SHE MIGHT CRAFT A SQUASH OR FALLEN LEAF. IN SUMMER, A TROPICAL PAPAYA. "EVERYBODY HAS A MEDIUM," SAYS JURADO, "AND MINE IS MARZIPAN."

TEXT BY INGRID ABRAMOVITCH PHOTOGRAPHS BY CARLTON DAVIS

▼14
Publication Garden Design
Creative Director Michael Grossman
Art Director Paul Roelofs
Photo Editor Susan Goldberger
Photographer André Baranowski
Publisher Meigher Communications
Issue October/November 1995
Category Cover

▼15
Publication Martha Stewart Living
Creative Director Gael Towey
Art Director Eric A. Pike
Designer Claudia Bruno
Photo Editor Heidi Posner
Photographer Carlton Davis
Publisher Time Inc.
Issue October 1995
Category Spread/Feature

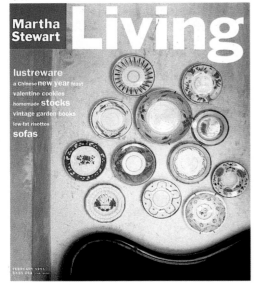
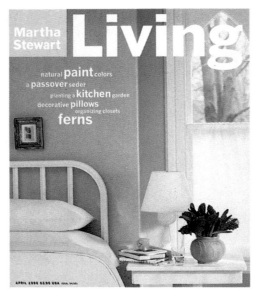
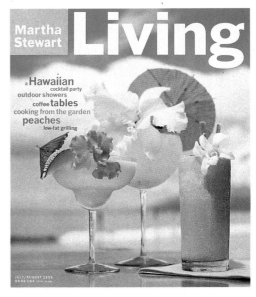

Martha Stewart Living

lustreware
a Chinese new year feast
valentine cookies
homemade stocks
vintage garden books
low-fat risottos
sofas

FEBRUARY 1995
$3.95 USA

natural paint colors
a passover seder
planting a kitchen garden
decorative pillows
organizing closets
ferns

APRIL 1995 $3.95 USA

a Hawaiian cocktail party
outdoor showers
coffee tables
cooking from the garden
peaches
low-fat grilling

JULY/AUGUST 1995
$3.95 USA

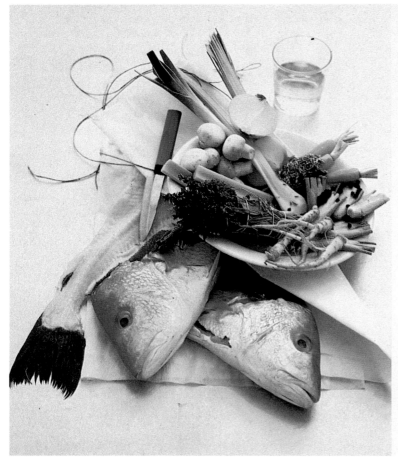

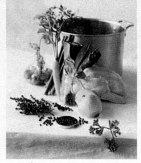

stocks
The secret of fine cooking is in these simple-to-make broths

Italian arborio rice may be the heart of an authentic risotto, but the soul of the dish is its stock. From paella to bouillabaisse, good stock is the foundation of flavor. And the best-quality stock isn't a problem to produce. With a modicum of planning, the cheapest possible ingredients, and common kitchen equipment, you can make it easily at home. The time it takes is a fraction of the time it saves, once made, in creating quick high-caliber meals.

Stocks—broths based on meat, fish, or vegetables—are fundamental to all kinds of cooking. They are the brilliance behind haute cuisine. Called *fonds* or foundations, the pyramid of the classic French sauce system is built upon them. But they are also the beauty of home cooking. There is no substitute for the fragrance of freshness that good stocks infuse into even the heartiest soups or stews.

Stocks represent an incredible economy in the kitchen. Though they're a powerful enrichment to food, stocks themselves are constructed from the most common, least expensive ingredients: bones, tough cuts, root vegetables, and ubiquitous market herbs. And properly defatted, stocks as enrichments are gold without guilt, unlike butter or cream.

Stocks are no rural mystery, nor are they a three-star-restaurant trick of the trade. Like all basic cooking, they are made with recipes that stipulate ingredients, techniques, and cooking times. The recipes are simplicity itself: The solid ingredients are simmered in liquid, whether water, wine, or another stock, for a prescribed period. A bouquet garni—an aromatic packet of herbs or spices—helps flavor the stock by steeping in it as the liquid cooks.

Though stocks are simple to make, they are a project. The good news is that once stocks are made, life instantly becomes easier, as stocks lend their excitement to the most basic pastas, rices and soups and the most modest braises, roasts, pan-fries, and gratins. Even the bad news is not so bad: Simple planning eases most of the inconvenience.

To make stock, take stock. Give your butcher or fishmonger at least one day's advance notice. They can begin piling up bones for you; fishmongers especially may need

Whether for a fish fumet (opposite) or a chicken stock (above), ingredients for stocks are inexpensive and readily available.

TEXT BY WILLIAM L. HAMILTON
PHOTOGRAPHS BY CHRISTOPHER BAKER

67

▼16
Publication Martha Stewart Living
Creative Director Gael Towey
Art Director Eric A. Pike
Designers Gael Towey, Eric A. Pike, Agnethe Glatved, Constance Old, Claudia Bruno, Scot Schy, Anne-Marie Midy
Photographers John Dugdale, Dana Gallagher, Stephen Lewis
Publisher Time Inc.
Issues February 1995, April 1995, July 1995
Category Overall

LUSTREWARE

Whether it's silver, pink, or gold, everyone who sees this pottery takes a shine to it

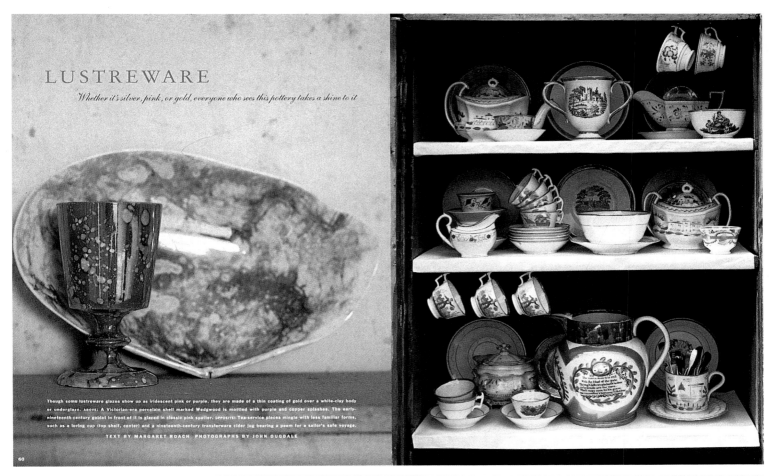

Though some lustreware glazes show up as iridescent pink or purple, they are made of a thin coating of gold over a white-clay body or underglaze. ABOVE: A Victorian-era porcelain shell marked Wedgwood is mottled with purple and copper splashes. The early-nineteenth-century goblet in front of it is glazed in classic pink spatter. OPPOSITE: Tea-service pieces mingle with less familiar forms, such as a loving cup (top shelf, center) and a nineteenth-century transferware cider jug bearing a poem for a sailor's safe voyage.

TEXT BY MARGARET ROACH · PHOTOGRAPHS BY JOHN DUGDALE

60

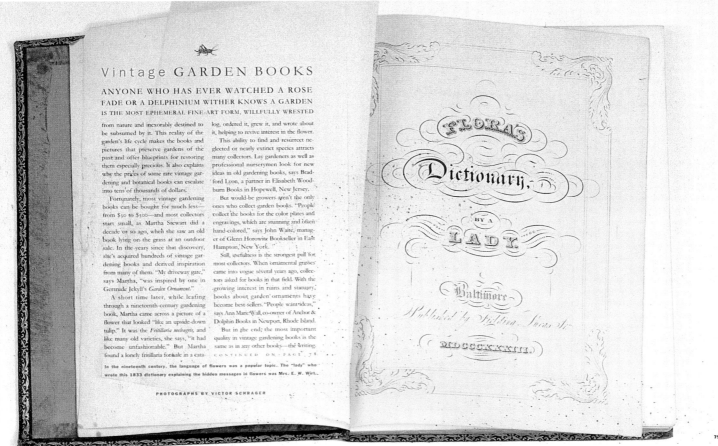

Vintage GARDEN BOOKS

ANYONE WHO HAS EVER WATCHED A ROSE FADE OR A DELPHINIUM WITHER KNOWS A GARDEN IS THE MOST EPHEMERAL FINE-ART FORM, WILLFULLY WRESTED

from nature and inexorably destined to be subsumed by it. This reality of the garden's life cycle makes the books and pictures that preserve gardens of the past and offer blueprints for restoring them especially precious. It also explains why the prices of some rare vintage gardening and botanical books can escalate into tens of thousands of dollars.

Fortunately, most vintage gardening books can be bought for much less—from $50 to $100—and most collectors start small, as Martha Stewart did a decade or so ago, when she saw an old book lying on the grass at an outdoor sale. In the years since that discovery, she's acquired hundreds of vintage gardening books and derived inspiration from many of them. "My driveway gate," says Martha, "was inspired by one in Gertrude Jekyll's *Garden Ornament*."

A short time later, while leafing through a nineteenth-century gardening book, Martha came across a picture of a flower that looked "like an upside-down tulip." It was the *Fritillaria meleagris*, and like many old varieties, she says, "it had become unfashionable." But Martha found a lonely fritillaria for sale in a cata-

log, ordered it, grew it, and wrote about it, helping to revive interest in the flower.

This ability to find and resurrect neglected or nearly extinct species attracts many collectors. Lay gardeners as well as professional nurserymen look for new ideas in old gardening books, says Bradford Lyon, a partner in Elisabeth Woodburn Books in Hopewell, New Jersey.

But would-be growers aren't the only ones who collect garden books. "People collect the books for the color plates and engravings, which are stunning and often hand-colored," says John Waite, manager of Glenn Horowitz Bookseller in East Hampton, New York.

Still, usefulness is the strongest pull for most collectors. When ornamental grasses came into vogue several years ago, collectors asked for books in that field. With the growing interest in ruins and statuary, books about garden ornaments have become best-sellers. "People want ideas," says Ann Marie Wall, co-owner of Anchor & Dolphin Books in Newport, Rhode Island.

But in the end, the most important quality in vintage gardening books is the same as in any other books—the writing.

CONTINUED ON PAGE 78

In the nineteenth century, the language of flowers was a popular topic. The "lady" who wrote this 1833 dictionary explaining the hidden messages in flowers was Mrs. E. W. Wirt.

PHOTOGRAPHS BY VICTOR SCHRAGER

74

75

25

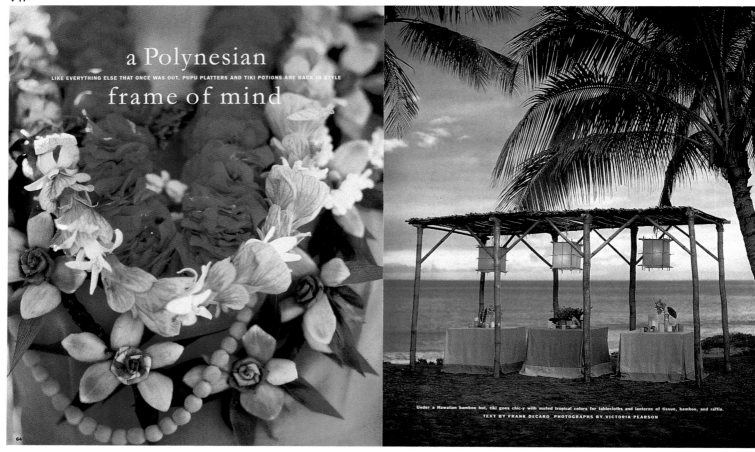

a Polynesian

LIKE EVERYTHING ELSE THAT ONCE WAS OUT, PUPU PLATTERS AND TIKI POTIONS ARE BACK IN STYLE

frame of mind

Under a Hawaiian bamboo hut, tiki goes chic-y with muted tropical colors for tablecloths and lanterns of tissue, bamboo, and raffia.

TEXT BY FRANK DECARO PHOTOGRAPHS BY VICTORIA PEARSON

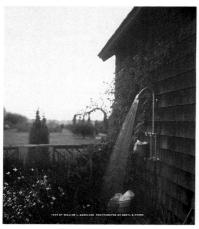

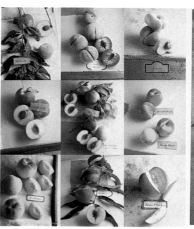

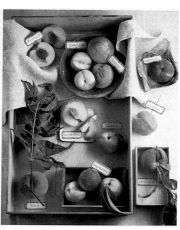

▼ 17
Publication Martha Stewart Living
Creative Director Gael Towey
Art Director Eric A. Pike
Designers Gael Towey, Eric A. Pike, Agnethe Glatved, Constance Old, Claudia Bruno, Scot Schy, Anne-Marie Midy
Photographers Victoria Pearson, Reed Davis, Stephen Lewis
Publisher Time Inc.
Issue July/August 1995
Category Entire Issue

26

▼ 18

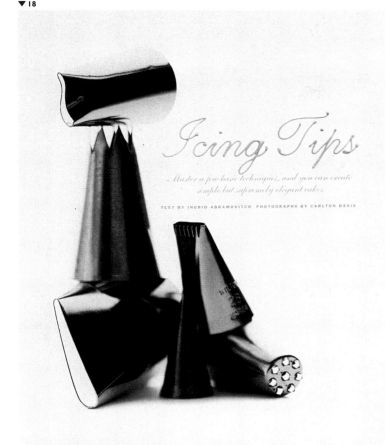

Icing Tips

Master a few basic techniques, and you can create
simple but supremely elegant cakes

TEXT BY INGRID ABRAMOVITCH PHOTOGRAPHS BY CARLTON DAVIS

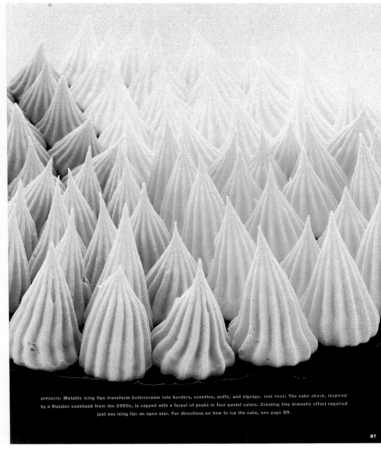

OPPOSITE: Metallic icing tips transform buttercream into borders, rosettes, puffs, and zigzags. THIS PAGE: The cake above, inspired by a Russian cookbook from the 1950s, is capped with a forest of peaks in four pastel colors. Creating this dramatic effect required just one icing tip: an open star. For directions on how to ice the cake, see page 89.

87

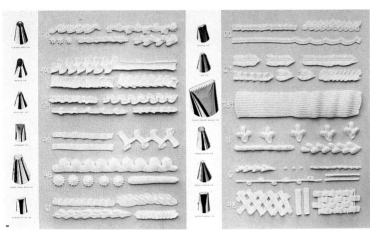

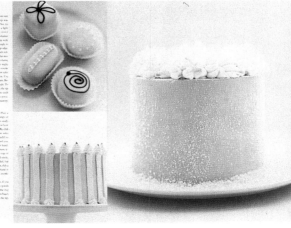

▼ 18
Publication Martha Stewart Living
Creative Director Gael Towey
Art Director Anne Johnson
Designer Anne Johnson
Photographer Carlton Davis
Publisher Time Inc.
Issue May 1995
Category Story/Feature

27

contents

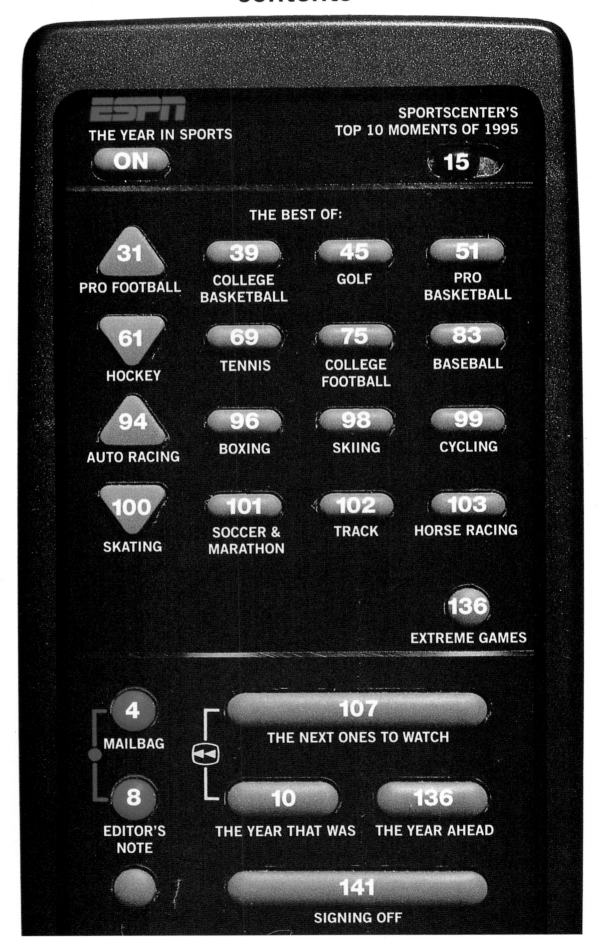

REMOTE CONTROL: BILL STEELE. COVER PHOTO CREDITS (FROM T TO S): APWIDE WORLD PHOTOS; LOS ANGELES TIMES PHOTO; TOM DIPACE; GERARDO SOMOZA/OUTLINE; BOB ROSATO; NATHANIEL S. BUTLER/NBA PHOTOS; RICK STEWART/ALLSPORT; WILL HART; AL BELLO/ALLSPORT; AL BELLO/ALLSPORT; NYT PICTURES; DOUG PENSINGER/ALLSPORT; P. MAROVICH/GOLF STOCK; STEVEN E. SUTTON/DUOMO.

$2.95 • DECEMBER 11, 1995

NEW YORK

Earthquake

NOT ONLY CAN IT
HAPPEN HERE—IT *WILL*

By Fred Graver and
Charlie Rubin

▼19
Publication ESPN The Year In Sports
Art Director Nancy Kruger Cohen
Designers Robin L. Helman, Nicole Salzano
Photo Editors Maisie Todd, Deborah Gottesfeld
Photographer Bill Steele
Publisher The Hearst Corporation-Magazines Division
Issue December 1995
Category Contents

▼20
Publication New York
Design Director Robert Best
Art Director Syndi Becker
Designer Robert Best
Photo Editors Margery Goldberg, Yvonne Stender
Publisher K-III Publications
Issue December 11, 1995
Category Cover

TALL PEOPLE, SHORT PEOPLE, GOOD-LOOKING PEOPLE,

BEING

UGLY PEOPLE, NICE PEOPLE, SCARY PEOPLE—

HUMAN

PEOPLE REMAIN THE CITY'S BUMPER CROP

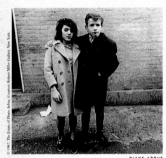

DIANE ARBUS
'Teenage Couple, Hudson Street, N.Y.C., 1963.'

New York has always run a bull market in personalities—people are more unabashedly, variously human here than they are almost anywhere else in America. For photographers, this has offered unprecedented opportunities; a wholesale gallery of human typologies careening down the avenues at a rate of 3,000 an hour. The best New York school artists were not all street practitioners, but they were urban curators (cf. Diane Arbus, Lisette Model, and Leon Levinstein's anti-sentimental portraits; Sid Grossman, Weegee, and Bruce Davidson's youth salads). At the very least, their images tell us that the city attracts a disproportionate share of the world's most interesting people; that ours is a culture tolerant of difference, as it's now called; and that this remains a very weird place.

PHOTOGRAPHED BY
CHRISTIAN WITKIN

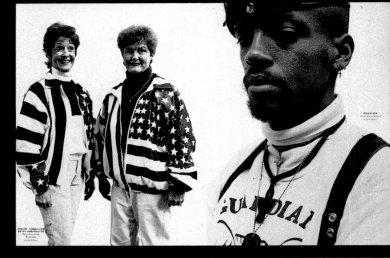

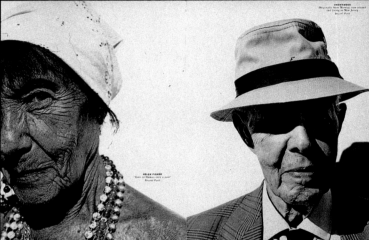

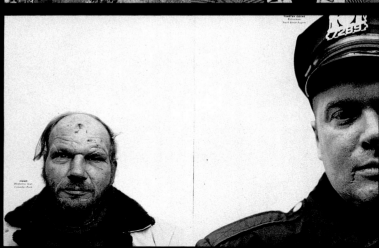

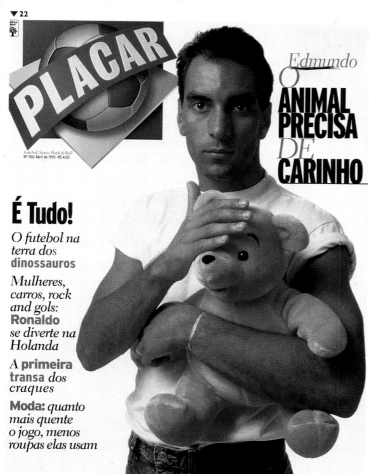

▼ 22
Publication Placar
Creative Director Roger Black
Design Director Stephen Gullo
Designers Ariel Cepeda, Stephen Gullo
Studio Roger Black Incorporated
Client Editora Abril
Publisher Editora Abril
Issue April 1995
Category Redesign

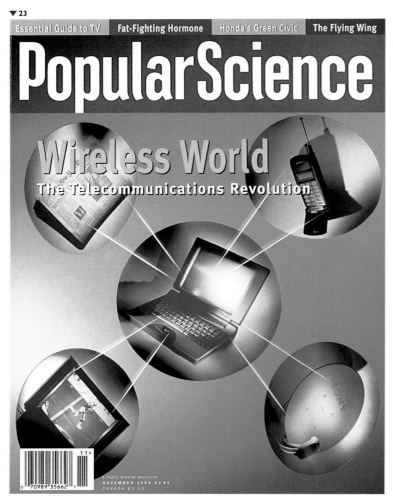

▼ 23
Publication Popular Science
Creative Director Don Morris
Design Directors Teresa Fernandes, W. David Houser
Designers Don Morris, James Reyman, Lea Ann Hutter
Photo Editor John B. Carnett
Studio Don Morris Design
Publisher Times Mirror Magazines
Issue October 1995
Category Redesign

▼ 24
Publication Premiere
Art Director John Korpics
Designer John Korpics
Photo Editor Chris Dougherty
Photographer Firooz Zahedi
Publisher Hachette Filipacchi Magazines, Inc.
Issue January 1995
Category Spread/Feature

▼ 25
Publication US
Art Director Richard Baker
Photo Editors Jennifer Crandall, Rachel Knepfer
Photographer Mark Seliger
Publisher US Magazine Co., L.P.
Issue February 1995
Category Spread/Feature

▼ 24

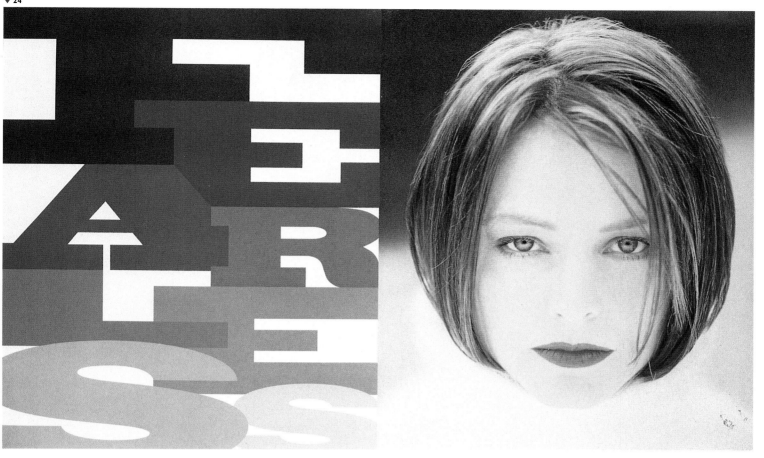

▼ 25

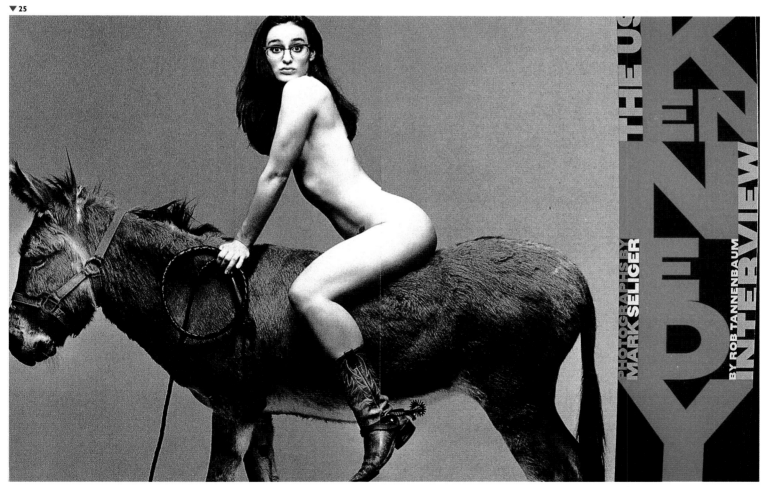

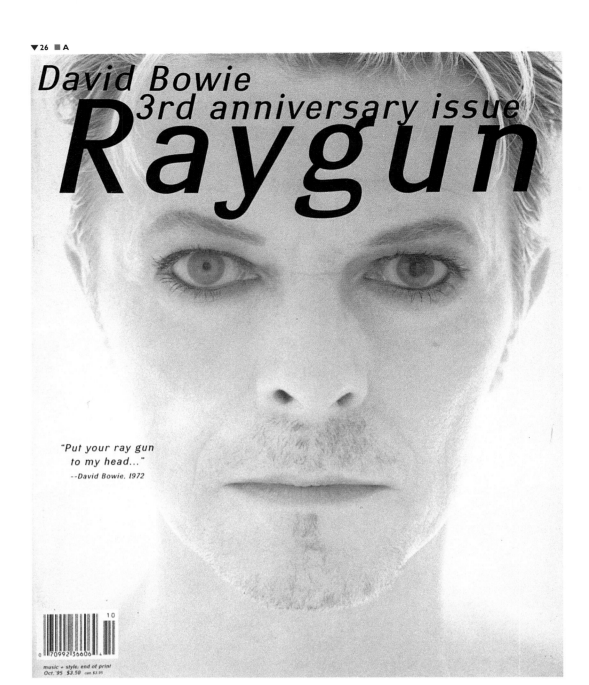

David Bowie
3rd anniversary issue
Raygun

"Put your ray gun
to my head..."
--David Bowie, 1972

music + style, end of print
Oct. '95 $3.50 can.$3.95

0 70992 36606

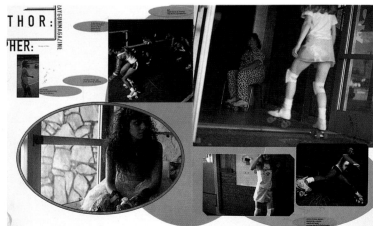

▼26
Publication Ray Gun
Design Director David Carson
Designer David Carson
Issue October 1995
Category Entire Issue
■A Merit Cover

34

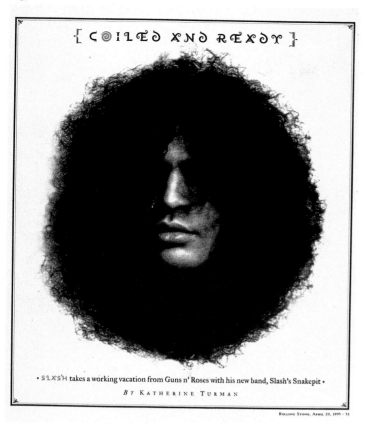

{ COILED AND READY }

• SLASH takes a working vacation from Guns n' Roses with his new band, Slash's Snakepit •

BY KATHERINE TURMAN

Rolling Stone, April 20, 1995 · 53

VEN UNDER THE BEST of circumstances, the Hamburger Hamlet that anchors the west end of L.A.'s Sunset Strip is lacking in serious ambience. At 3 in the afternoon on a rainy Saturday, though, the venerable if unremarkable restaurant is surprisingly crowded, the day's watery light lending a strangely cozy, slightly surreal air. ⊕HE EATERY'S PROXIMITY to the Atlantic and the Geffen record-company offices makes it a humming power-lunch destination during the week. Weekends, however, find plastic-surgerized Beverly Hills matrons quaffing diet sodas and kibitzing in the restaurant's brighter front rooms while the serious drinkers huddle in the welcoming banquette booths or at the bar in the slightly more dissolute atmosphere of the taproom. ⊕ERCHED ON A BARSTOOL is one Saul Hudson, colloquially known as Slash, Guns n' Roses' guitar guru. Save for the hefty diamond studs glittering in both ears, Slash — sporting facial scruff, a backward baseball cap, a hoop in his nose and a cigarette dangling from his lips — might be any other wanna-be rock star enjoying a midafternoon cocktail. ⊕LASH ACCIDENTALLY ARRIVED an hour early for his scheduled interview, but unperturbed by the time mix-up, he waves to the waitress — clearly an old acquaintance — grabs his vodka and cranberry from the bar and slides into a booth, leaning forward conspiratorially. "Mr. T is sitting two tables away," he says sotto voce, excitement in his eyes. ⊕HOUGH JET-LAGGED AND UNSHAVEN, the guitarist proves loquacious, candid and relaxed. While he's got the slacker-musician vibe in spades, his conversation moves between topics — from piercing {"The next time you see me, I'll have my navel pierced"{ to Les Paul {"He wiped the stage with me once"{ — with frightening rapidity and surprising clarity, never straying far from his current raison d'etre, a down-and-dirty little rock & roll lineup known as Slash's Snakepit. Featured on the band's 14-song debut, *It's Five O'Clock Somewhere*, are ex-Gunner guitarist Gilby Clarke, present Gunner drummer Matt Sorum, Alice in Chains bassist Mike Inez and former Jellyfish background singer and guitarist Eric Dover on lead vocals. ⊕LASH WAVES at the maitre d', who,

XXL said, 'That's not the music I want to do.' I said, 'OK,' and took it all back. That's happened too many times." -SLASH

kindly, has not asked the guitarist to extinguish his cigarette despite stringent new anti-smoking laws in L.A. "That's Don," Slash says. "He's from the Sherman Oaks Hamburger Hamlet that was destroyed in the earthquake." ⊕LASH DRAGS on his cigarette and downs a shot of Jägermeister. "This is the whole scheme," he says, shifting gears. "Initially I was just writing what I thought was cool. I was a kid in a toy store. I had a studio in my house. Get up in the morning. Literally. Press ON. Plug in your guitar and go. I don't look at stuff from the concept of writing the quintessential hit record. Just guitar riffs. ⊕UNS GOT OFF THE ROAD," Slash continues. "I had the studio built right next to my snake cage, a walk-in with all these 20-foot snakes in it. It's *Slash's* Snakepit at this point, because all of a sudden there's an all-girl band in San Diego called Snake Pit." He laughs. "Don't ask."

MR. T'S VOICE RISES above the din, and Slash peers at him over the heads of the other diners and grins, his eyes crinkling. "If Dean Martin were here, that would be classic," says the 29-year-old guitarist. He settles back into the booth and easily picks up his train of thought. "It's like I'm owned by Guns n' Roses in a way," Slash continues in his intimate, stoner-ish timbre. "It's our band. So if I write something, my first and foremost priority would be to dedicate it to Guns." He draws heavily on his cigarette as the maitre d' hovers. "At the time, no one seemed to be interested in the material. Axl {Rose{ said, 'That's not the kind of music I want to do.' I said, 'OK,' and took it all back. We've had that happen too many times in Guns, when certain songs just didn't make it, and they would have been killer. I didn't want to lose any more material." ⊕LASH WASN'T PLANNING on a solo record — "side project," the much-preferred term. "It's not a solo project," he says, "because everybody in the band got to play whatever the fuck he wanted." The third original member of Guns n' Roses to release a solo album {following bassist Duff McKagan and ex-guitarist Izzy Stradlin{, Slash wrote all the music to the songs that appear on *It's Five O'Clock Somewhere* in his home studio, completing the initial concepts and tracks in early '94. The LP title was taken from a generous bartender at LAX airport, who gave Slash an early morning drink with the dictum "Hey, it's 5 o'clock somewhere, pal." ⊕HE COOLEST OMEN," says Slash, "was the night I recorded three songs and {Cont. on 96{

• *Photographs by* MATT MAHURIN •

54 · Rolling Stone, April 20, 1995

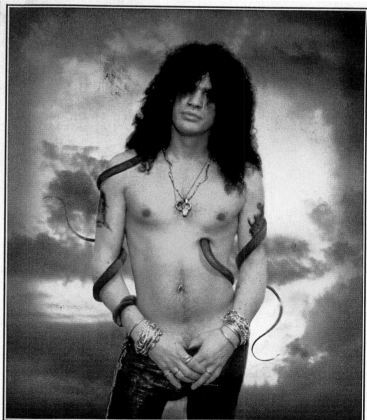

Rolling Stone, April 20, 1995 · 55

▼27
Publication Rolling Stone
Creative Director Fred Woodward
Designers Fred Woodward, Gail Anderson
Photo Editor Jodi Peckman
Photographer Matt Mahurin
Publisher Wenner Media
Issue April 20, 1995
Category Story/Feature

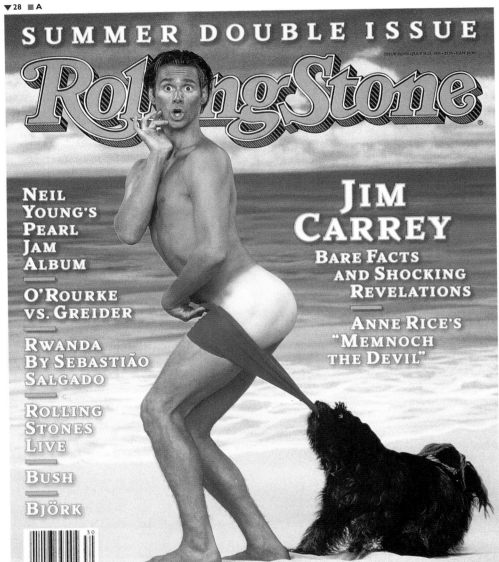

SUMMER DOUBLE ISSUE

RollingStone

NEIL
YOUNG'S
PEARL
JAM
ALBUM

O'ROURKE
VS. GREIDER

RWANDA
BY SEBASTIÃO
SALGADO

ROLLING
STONES
LIVE

BUSH

BJÖRK

JIM
CARREY

BARE FACTS
AND SHOCKING
REVELATIONS

ANNE RICE'S
"MEMNOCH
THE DEVIL"

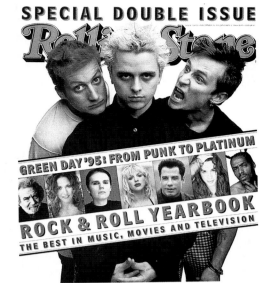

SPECIAL DOUBLE ISSUE

RollingStone

GREEN DAY '95: FROM PUNK TO PLATINUM

ROCK & ROLL YEARBOOK

THE BEST IN MUSIC, MOVIES AND TELEVISION

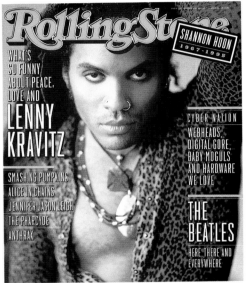

RollingStone

SHANNON HOON
1967-1995

WHAT'S
SO FUNNY
ABOUT PEACE,
LOVE AND
LENNY
KRAVITZ

SMASHING PUMPKINS
ALICE IN CHAINS
JENNIFER JASON LEIGH
THE PHARCYDE
ANTHRAX

CYBER NATION
WEBHEADS,
DIGITAL GORE,
BABY MOGULS
AND HARDWARE
WE LOVE

THE
BEATLES
HERE, THERE AND
EVERYWHERE

■ B

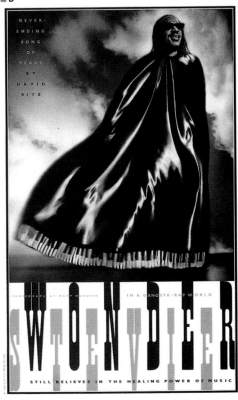

NEVER-
ENDING
SONG
OF
PEACE
BY
DAVID
RITZ

STILL BELIEVES IN THE HEALING POWER OF MUSIC

▼ 28
Publication Rolling Stone
Creative Director Fred Woodward
Designers Fred Woodward, Gail Anderson,
Geraldine Hessler, Lee Bearson, Eric Siry
Photo Editors Jodi Peckman, Denise Sfraga, Fiona McDonagh
Publisher Wenner Media
Issues July 13, 1995, November 30, 1995, December 28, 1995
Category Overall
 ■A Merit Cover
 ■B Merit Spread
 ■C Merit Spread

36

■ c

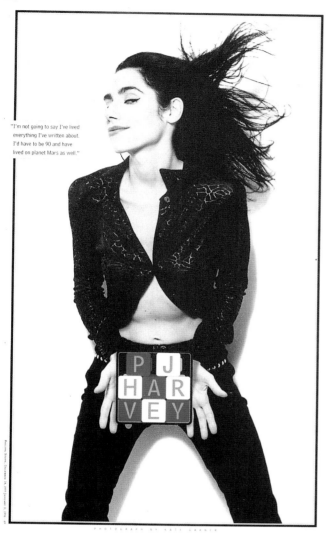

"I'm not going to say I've lived everything I've written about. I'd have to be 90 and have lived on planet Mars as well."

P J
H A R
V E Y

In Rwanda a year after the massacres, there is still no justice, no peace

A F T E R M A T H

PHOTOGRAPHS BY SEBASTIÃO SALGADO

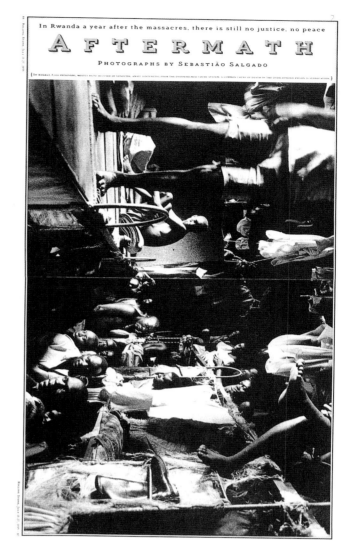

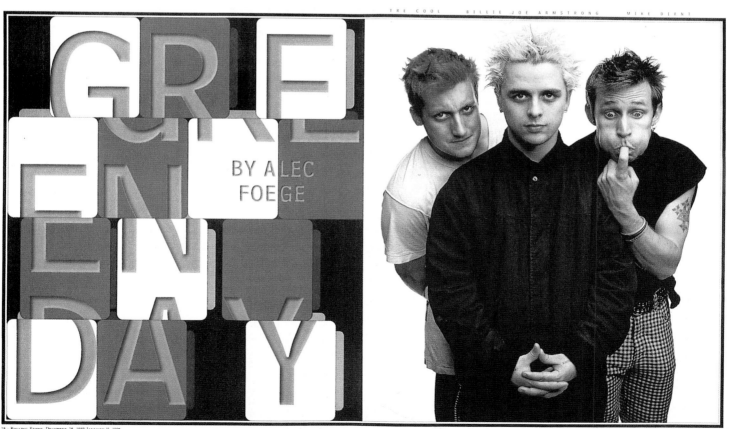

GRE
EN
EN
DAY

BY ALEC
FOEGE

PHOTOGRAPHS BY MARK SELIGER

BALANCING ACT
EDDIE VANHALEN

THE
ROLLING STONE
INTERVIEW BY DAVID WILD
PHOTOGRAPHS BY MARK SELIGER

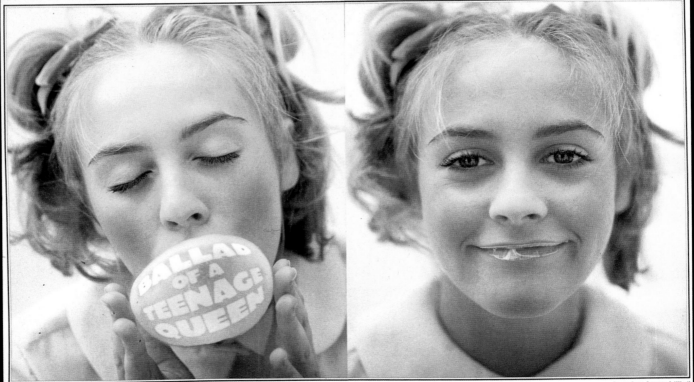

44 · ROLLING STONE, SEPTEMBER 7, 1995

ROLLING STONE, SEPTEMBER 7, 1995 · 45

29
Publication Rolling Stone
Creative Director Fred Woodward
Designer Geraldine Hessler
Photo Editor Jodi Peckman
Photographer Mark Seliger
Publisher Wenner Media
Issue April 6, 1995
Category Spread/Feature

30
Publication Rolling Stone
Creative Director Fred Woodward
Designers Fred Woodward, Geraldine Hessler
Photo Editor Jodi Peckman
Photographer Peggy Sirota
Publisher Wenner Media
Issue September 7, 1995
Category Spread/Feature

▼ 31 ■ A

■ B

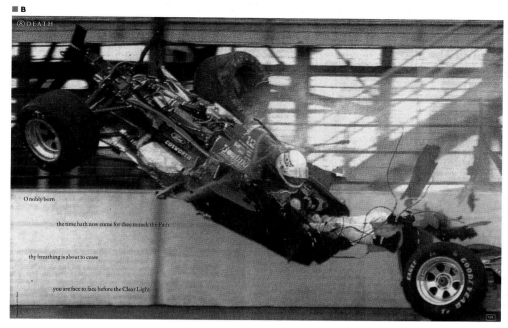

▼ 31
Publication Soho Journal
Creative Director Gary Koepke
Designers Gary Koepke, Joe Polevy
Studio Koepke International, Ltd.
Issue September 20, 1995
Category Entire Issue
 ■ A Merit Spread/Feature
 ■ B Merit Cover
 ▼ C Silver Spread/Feature

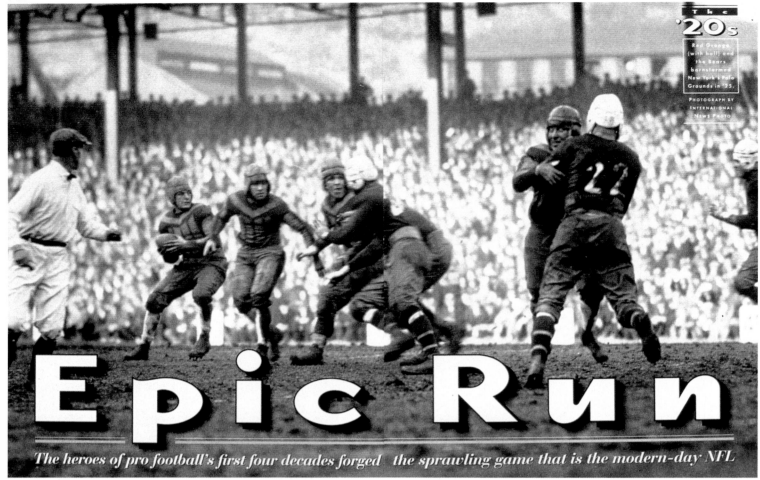

The '20s

Red Grange (with ball) and the Bears barnstormed New York's Polo Grounds in '25.

PHOTOGRAPH BY INTERNATIONAL NEWS PHOTO

Epic Run

The heroes of pro football's first four decades forged the sprawling game that is the modern-day NFL

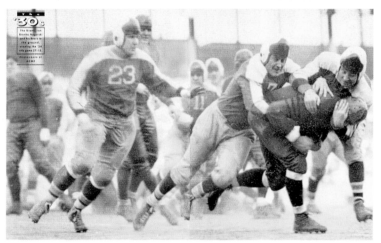

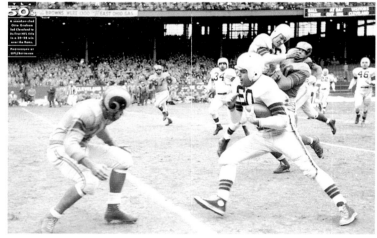

The '30s

The Giants cut Bronko Nagurski and his Bears to the ground, winning the '34 title game 27–13.

PHOTOGRAPH BY ACME

The '50s

A sneaker-clad Otto Graham led Cleveland to its first NFL title in a 30–28 win over the Rams.

PHOTOGRAPH BY UPI/Bettmann

▼ 32
Publication Sports Illustrated Classic
Design Director Steven Hoffman
Art Director Craig Gartner
Designer Craig Gartner
Publisher Time Inc.
Issue Fall 1995
Category Story/Feature

CREW

Spring 1995

the Crew Flak Jacket. Practical? Oh, yes. It can fend off winter winds or hot 9mm slugs.

For casual drive-bys. Nights on the town. Zip out the bulletproof liner for a lightweight getaway. Zip it in for a serious shoot-out. Kevlar sleeves clip on for added protection, leaving one cozy and rumble-ready.

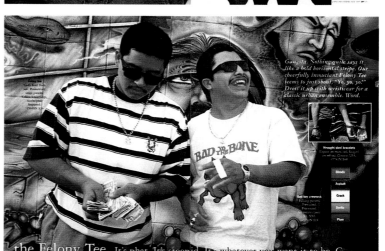

Gangsta. Nothing quite says it like a bold horizontal stripe. Our cheerfully insouciant Felony Tee seems to just shout, "Yo, yo, yo!" Dress it up with wristwear for a classic urban ensemble. Word.

the Felony Tee. It's phat. It's stoopid. It's whatever you want it to be, G.

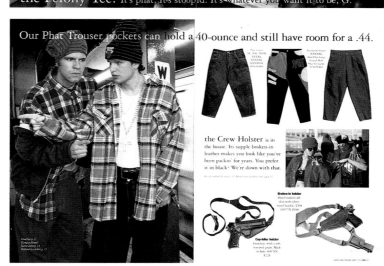

Our Phat Trouser pockets can hold a 40-ounce and still have room for a .44.

the Crew Holster is in the house. Its supple broken-in leather makes you look like you've been packin' for years. You prefer it in black? We're down with that.

▼ 33
Publication SPY
Design Director Robert J. George
Photo Editor Elisabeth Sinsabaugh
Photographer Greg Miller
Studio RJG Design
Issue January/February 1995
Category Story/Feature

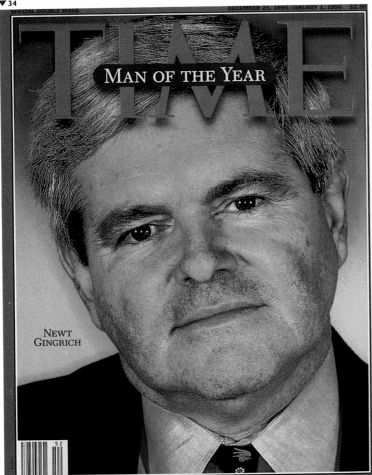

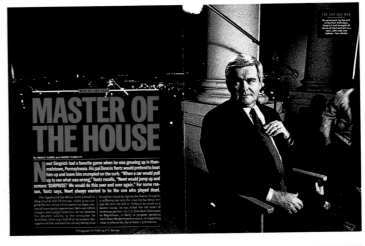

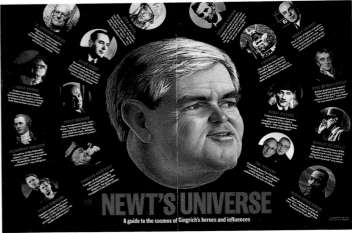

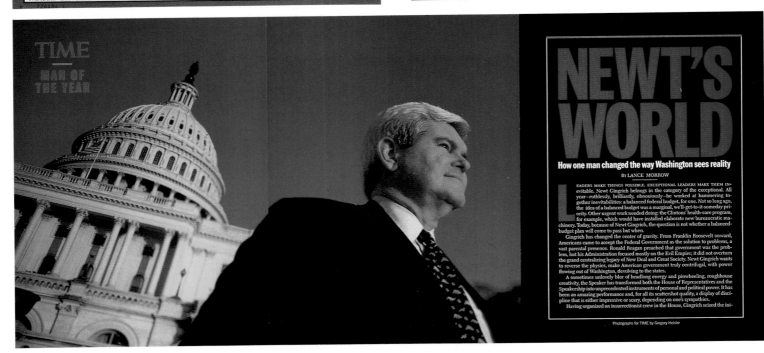

34
Publication TIME
Art Director Arthur Hochstein
Designer Sharon Okamoto
Photo Editors Michele Stephenson, Richard Boeth
Photographers Gregory Heisler, P. F. Bentley
Publisher Time Inc.
Issue December 25, 1995
Category Story/Feature

35
Publication Anchorage Daily News/Impulse
Creative Director Galie Jean-Louis
Designer Galie Jean-Louis
Illustrator Galie Jean-Louis
Photo Editor Galie Jean-Louis
Publisher Anchorage Daily News
Issue November 4, 1995
Category Front Page
 Merit Spread/Feature

■ **COMICS:** Puzzles, L.M. Boyd / D-4,5　　　　　　　　　　■ **TELEVISION:** Today's highlights / D-6

IMPULSE

SATURDAY, November 4, 1995　　　　　ANCHORAGE DAILY NEWS　　　　　SECTION D

Food' for thought

Gangsta rappers push the

Dogg Food

envelope on free speech

By JON PARELES
The New York Times

After all their skirmishes with those who want them silenced, rappers have learned at least one thing: how to make notoriety pay off. The politicians and public figures who pressed the Warner Music Group to dissolve its ties with Interscope Records have been, in essence, the warm-up act for "Dogg Food" by Tha Dogg Pound, which was released Tuesday. Stores ordered 1.7 million copies in advance.

Some of those ended up in Anchorage. Van Green, manager at Sound Warehouse on Mountain View, says sales at his store have been brisk, but most outlets in Anchorage have had slow to moderate responses to the album that has been in the news.

Please see Page D-2, RAP

To hear samples of Tha Dogg Pound's debut album, dial the Newsline at 277-1500, then enter 1037 and 1058.

LOCAL COLD SPELL	**3**	LIFE ON STAGE	**3**	NEWS IN BRIEF	**6**
Fugazi guys not much for crowd interaction		*Rhodessa Jones stuns with 'Blue Stories'*		*Hall of Fame, Oasis and Ranch Romance*	

The New York Times
Book Review

July 30, 1995
Section 7 Copyright © 1995 The New York Times

Hiroshima's Legacy

The Second Generation
'Dark Sun,' by Richard Rhodes, tells the story of the race for 'the Super' – the H-bomb/**9**

A State Of Denial
Does America still feel guilty about the bomb? Michael Sherry looks at the evidence/**11**

Why We Dropped It
Not to avoid a costly invasion, a new study by Gar Alperovitz says, but to impress the Soviets/**10**

Survivors and Witnesses
Accounts and pictures, old and new: how the bomb came to be, its effects, its aftermath/**13**

MIRKO ILIC

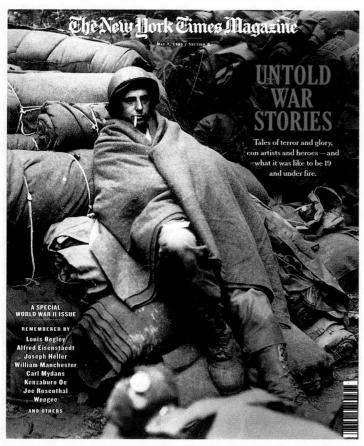

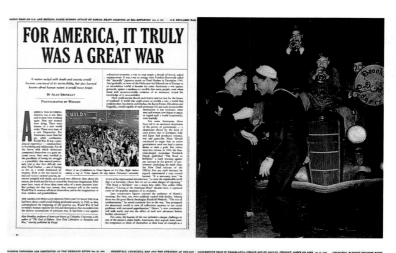

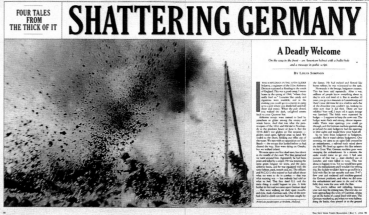

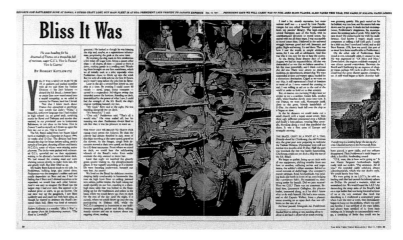

▼37
Publication The New York Times Magazine
Art Directors Janet Froelich, Catherine Gilmore-Barnes
Designers Joel Cuyler, Nancy Harris, Lisa Naftolin
Photo Editor Kathy Ryan
Publisher The New York Times
Issue May 7, 1995
Category Entire Issue

PERFORMANCE PLUMBING
Make the Profit Connection

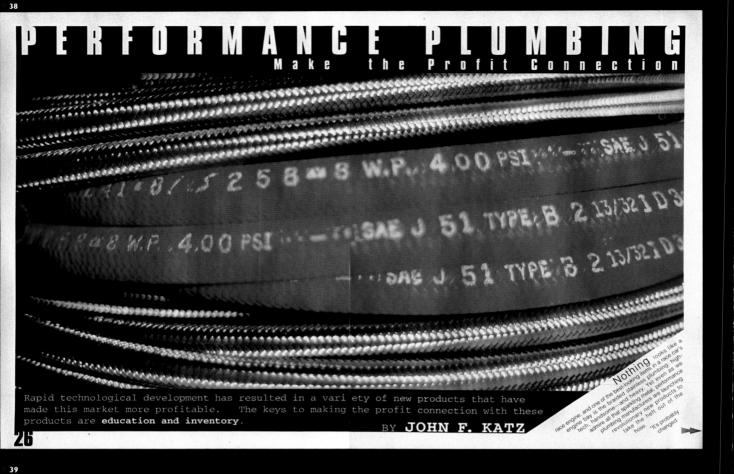

Rapid technological development has resulted in a variety of new products that have made this market more profitable. The keys to making the profit connection with these products are **education and inventory**.

BY **JOHN F. KATZ**

Nothing looks like a race engine, and one of the best-looking items in a race car's engine bay is the braided stainless plumbing: high-tech, handsome—and heavy. Yet even as we admire all that sparkling metal, performance plumbing manufacturers are launching revolutionary new products to take the heft out of the hose. "It's probably changed

GOING

Having a good

It's a story of undeniable appeal. In 1983, 25-year-old Bob Levine and 29-year-old Craig Benson begin cutting computer cables for customers of Bob's father's business. Six years later, the enterprise they founded, Cabletron, goes public, raising $26.1 million for the company and over $20 million apiece for its two founders. By 1994, the Rochester, New Hampshire company is a leading maker of "smart" hubs for controlling computer networks, bringing in $600 million in revenues and employing four thousand five hundred worldwide. A romance, a tale of transformation — two people begin with little more than an idea, and build something that becomes part of the fabric of public life. ¶ A critical stage in this metamorphosis, the initial public offering is the company's debut into public equity markets. At its heart, going public is about valuation. The price of a new issue must be set without any guidance from a prior market. In the case of a young company, this can be especially tricky because what is being valued is promise — a growth opportunity — not assets in place. The IPO process itself is a complex and sometimes contentious three-way negotiation between shareholders, underwriters, and potential investors. Risks and uncertainty pervade all sides. And timing is crucial, as investor sentiment can mysteriously wax or wane. ¶ The outcome alters the life of the company and its stockholders, bringing both money and public scrutiny. It also has significant economic consequences. From 1960 to 1993, over ten thousand U.S. operating companies went public, far more than the number of publicly traded firms that disappeared through bankruptcy, mergers, and takeovers. Some were spinoffs like Fisher Scientific, or reverse lever-

By Jane Katz

company matters when selling a new issue, but so do luck and timing.

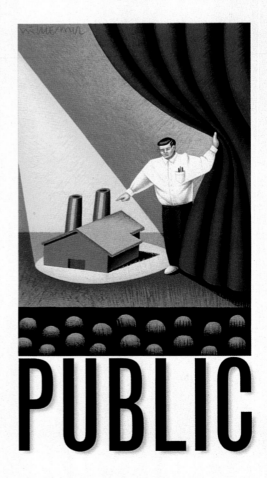

PUBLIC

▼ 40

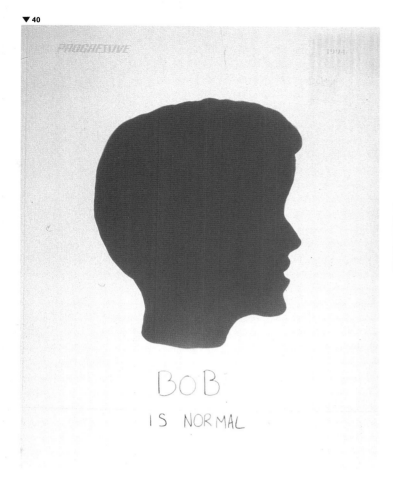

BOB
IS NORMAL

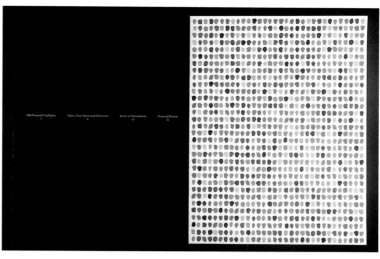

HORACIO
IF ITS WORTH HAVING ITS WORTH
FIGHTING FOR

WARREN
IS NOT RELIGIOUS BUT LOVES
CHRISTMAS BONUSES

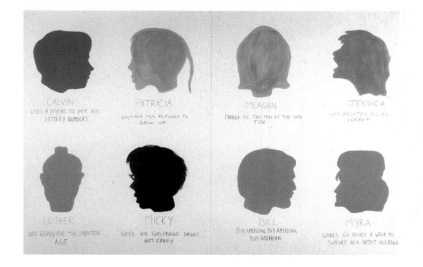

CALVIN
USES A PSYCHIC TO PICK HIS
LOTTERY NUMBERS

PATRICIA
SAYS HER MOM REFUSES TO
GROW UP

MEAGAN
MARRIED TO TWO MEN AT THE SAME
TIME

JESSICA
WAS ADOPTED AS AN
INFANT

LOTHER
NOT READY FOR THE COMPUTER
AGE

MICKY
SAYS HIS GIRLFRIEND DRIVES
HIM CRAZY

BILL
BUY AMERICAN, BUY AMERICAN,
BUY AMERICAN

MYRA
WORKS 60 HOURS A WEEK TO
SUPPORT HER ARTIST HUSBAND

▼ 38

Publication Performance Racing Industry
Art Director Alex Melli
Designer Steve Lewis
Photo Editor Alex Melli
Photographer Caryn Golden
Publisher Laguna Coast Publishing, Inc.
Issue November 1995
Category Spread/Feature

▼ 39

Publication Regional Review
Design Director Ronn Campisi
Illustrator Adam Niklewicz
Studio Ronn Campisi Design
Client The Federal Reserve Bank of Boston
Publisher The Federal Reserve Bank of Boston
Issue Winter 1995
Category Spread/Feature

▼ 40

Publication The Progressive Corporation 1994 Annual Report
Creative Directors Mark Schwartz, Joyce Nesnadny
Designers Joyce Nesnadny, Michelle Moehler, Mark Schwartz
Illustrator Carter Kustera
Studio Nesnadny & Schwartz
Issue March 1995
Category Entire Issue

▼41

AZURE

Design Architecture & Art

MAR
APR 1995
DISPLAY UNTIL MAY 15
$4.25

10

CANADIAN PUBLICATIONS MAIL PRODUCT SALES AGREEMENT NO. 175306

How to celebrate Azure's tenth anniversary: first a toast is in order (for the rest of the kitchen see page 15), then a fabulous dinner in a divinely-designed restaurant (page 22). Pick up an anonymous object (page 26) and before you get Virtuous (page 32) splash on some Cologne (page 30). Finally head for the back page for true confessions on why 10 years ago we called it Azure.

▼41
Publication Azure
Design Directors Diti Katona, John Pylypczak
Designer Susan McIntee
Photographer Roman Pylypczak
Studio Concrete Design Communications Inc.
Publisher Sergio Sgaramella
Issue March/April 1995
Category Cover

■ 42
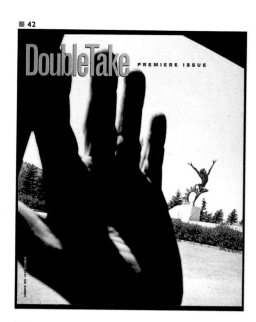

■ 43
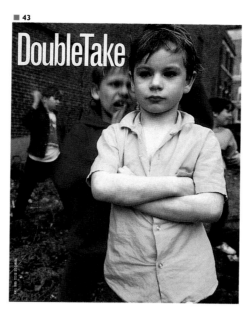

■ 44
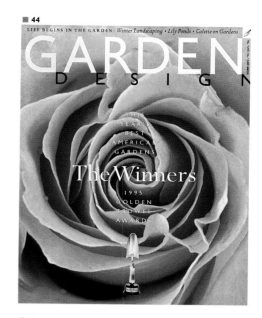

■ 45
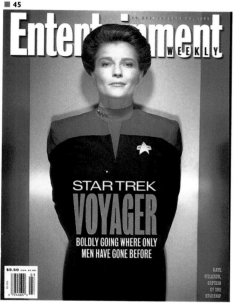

■ 46

■ 47

■ 42
Publication
DoubleTake
Design Director
Molly Renda
Photo Editor
Alex Harris
Photographer
Jerry Berndt
Publisher
DoubleTake/Center for
Documentary Studies
Issue Summer 1995
Category Cover

■ 43
Publication
DoubleTake
Design Director
Molly Renda
Photo Editor
Alex Harris
Photographer
Paul D'Amato
Publisher
DoubleTake/Center for
Documentary Studies
Issue Fall 1995
Category Cover

■ 44
Publication
Garden Design
Creative Director
Michael Grossman
Art Director
Paul Roelofs
Photo Editor
Susan Goldberger
Photographer
Randall Friesen
Publisher
Meigher Communications
Issue December 1995/
January 1996
Category Cover

■ 45
Publication
Entertainment Weekly
Design Director
Robert Newman
Photo Editors
Mary Dunn,
Alice Babcock
Photographer
Andrew Brusso
Publisher Time Inc.
Issue January 20, 1995
Category Cover

■ 46
Publication
Entertainment Weekly
Design Director
Robert Newman
Photo Editors
Doris Brautigan,
Mary Dunn
Photographer
Ruven Afanador
Publisher Time Inc.
Issue February 10, 1995
Category Cover

■ 47
Publication
Entertainment Weekly
Design Director
Robert Newman
Photo Editors
Doris Brautigan,
Mary Dunn
Photographer
George Holz
Publisher Time Inc.
Issue May 19, 1995
Category Cover

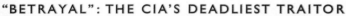

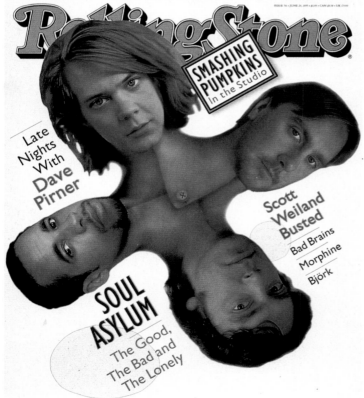

■ 48
Publication Rolling Stone
Creative Director Fred Woodward
Designer Fred Woodward
Photo Editor Jodi Peckman
Photographer Peggy Sirota
Publisher Wenner Media
Issue September 7, 1995
Category Cover

■ 49
Publication Rolling Stone
Creative Director Fred Woodward
Designer Fred Woodward
Photo Editor Jodi Peckman
Photographer Mark Seliger
Publisher Wenner Media
Issue May 18, 1995
Category Cover

■ 50
Publication Rolling Stone
Creative Director Fred Woodward
Designer Fred Woodward
Photo Editor Jodi Peckman
Photographer Matt Mahurin
Publisher Wenner Media
Issue June 29, 1995
Category Cover

■ 51
Publication Rolling Stone
Creative Director Fred Woodward
Designer Fred Woodward
Photo Editor Jodi Peckman
Photographer Mark Seliger
Publisher Wenner Media
Issue November 16, 1995
Category Cover

■ 52

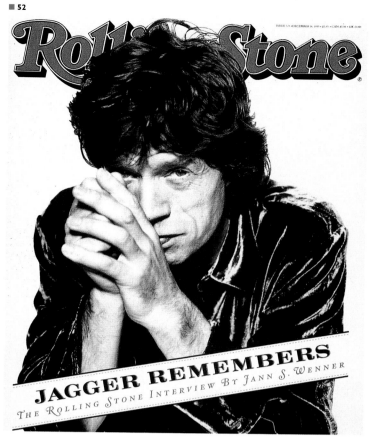

■ 53

■ 54

29/07/95

Independent
Magazine

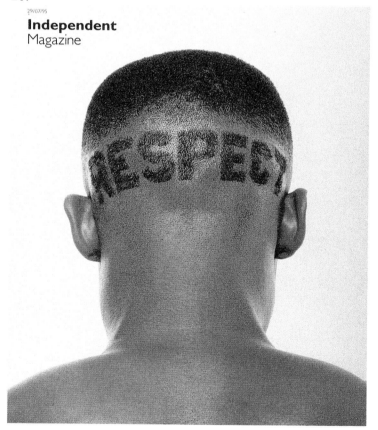

■ 55

04/11/95

Independent
Magazine

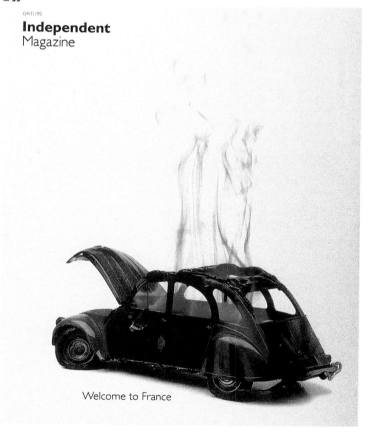

Welcome to France

■ 52
Publication Rolling Stone
Creative Director Fred Woodward
Designer Fred Woodward
Photo Editor Jodi Peckman
Photographer Peter Lindbergh
Publisher Wenner Media
Issue December 17, 1995
Category Cover

■ 53
Publication Vibe
Art Director Diddo Ramm
Designers Diddo Ramm, Ellen Fanning
Photo Editor George Pitts
Photographer Reisig & Taylor
Publisher Time Inc.
Issue April 1995
Category Cover

■ 54
Publication Independent Magazine
Creative Director Vince Frost
Designer Vince Frost
Photographer James Cant
Studio Frost Design
Publisher Mirror Group
Issue July 29, 1995
Category Cover

■ 55
Publication Independent Magazine
Creative Director Vince Frost
Designer Vince Frost
Photographer Mathew Donaldson
Studio Frost Design
Publisher Mirror Group
Issue November 4, 1995
Category Cover

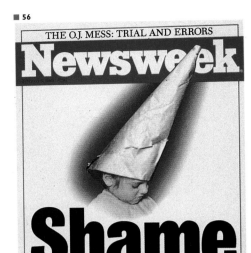

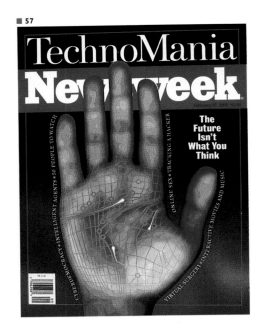

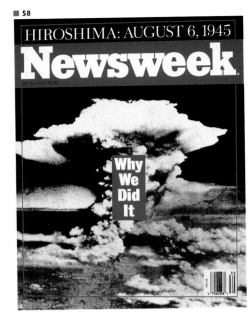

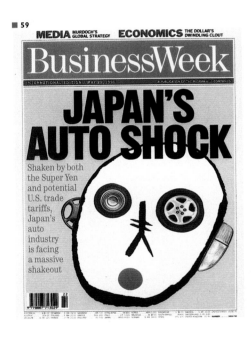

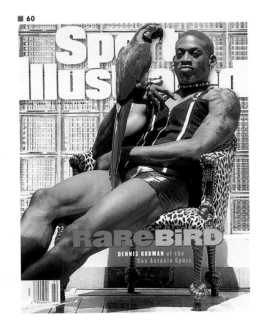

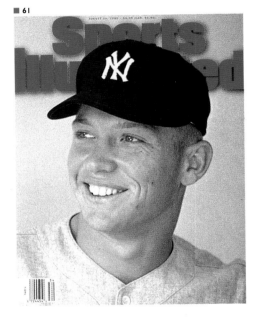

■ 56
Publication Newsweek
Design Director
Lynn Staley
Art Director
Kandy Littrell
Publisher Newsweek Inc.
Issue February 6, 1995
Category Cover

■ 57
Publication Newsweek
Design Director
Lynn Staley
Art Director
Kandy Littrell
Illustrator
Cha Jiempreecha
Publisher Newsweek Inc.
Issue February 27, 1995
Category Cover

■ 58
Publication Newsweek
Design Director
Lynn Staley
Art Director
Kandy Littrell
Publisher Newsweek Inc.
Issue July 24, 1995
Category Cover

■ 59
Publication
Business Week
Art Director
Jay Petrow
Illustrator
Scott Menchin
Publisher Business Week
Issue May 29, 1995
Category Cover

■ 60
Publication
Sports Illustrated
Design Director
Steven Hoffman
Designer Ed Truscio
Photographer
John W. McDonough
Publisher Time Inc.
Issue May 29, 1995
Category Cover

■ 61
Publication
Sports Illustrated
Design Director
Steven Hoffman
Designer Ed Truscio
Photographer
George Silk
Publisher Time Inc.
Issue August 21, 1995
Category Cover

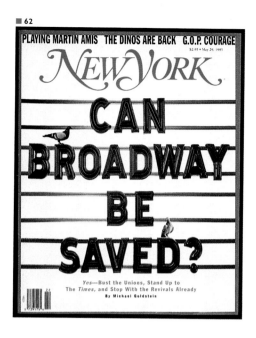

62

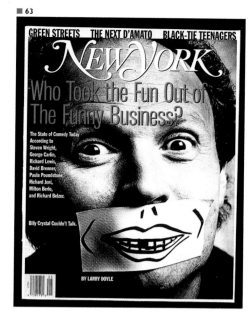

63

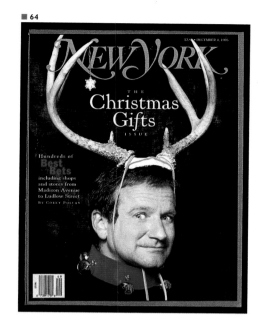

64

65

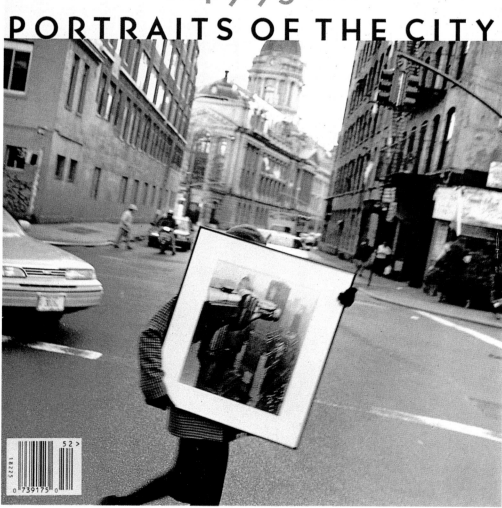

■ 62
Publication New York
Design Director Robert Best
Art Director Syndi Becker
Designer Robert Best
Photo Editor Margery Goldberg
Photographer Steve Wisbauer
Publisher K-III Publications
Issue May 29,1995
Category Cover

■ 63
Publication New York
Design Director Robert Best
Art Director Syndi Becker
Designer Robert Best
Photo Editor Margery Goldberg
Photographer Nigel Parry
Publisher K-III Publications
Issue June 19, 1995
Category Cover

■ 64
Publication New York
Design Director Robert Best
Art Director Syndi Becker
Designer Robert Best
Photo Editors Margery Goldberg,
Jordan Schaps
Photographer Nigel Parry
Publisher K-III Publications
Issue December 4, 1995
Category Cover

■ 65
Publication New York
Design Director Robert Best
Art Director Syndi Becker
Designer Robert Best
Photo Editor Margery Goldberg
Photographer Danny Clinch
Publisher K-III Publications
Issue December 25, 1995/
January 1, 1996
Category Cover

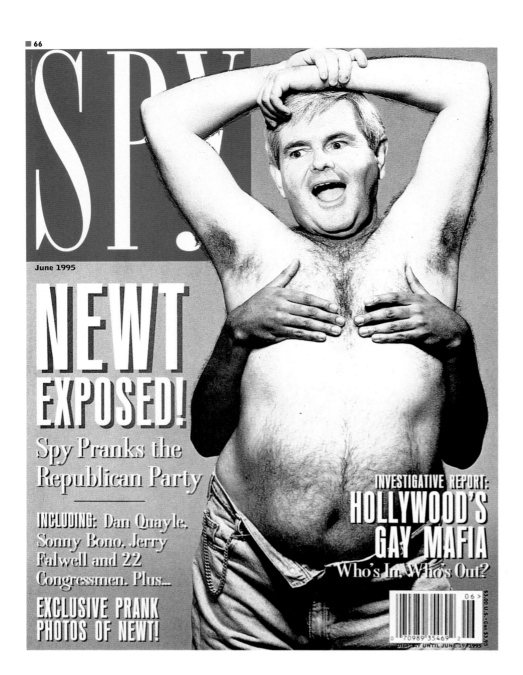

■ 66

SP Y

June 1995

NEWT EXPOSED!

Spy Pranks the Republican Party

INCLUDING: Dan Quayle, Sonny Bono, Jerry Falwell and 22 Congressmen. Plus...

EXCLUSIVE PRANK PHOTOS OF NEWT!

INVESTIGATIVE REPORT: HOLLYWOOD'S GAY MAFIA

Who's In, Who's Out?

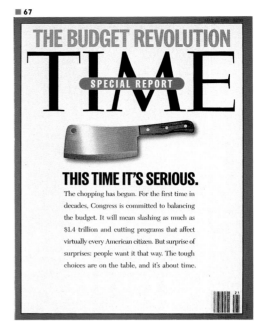

■ 67

THE BUDGET REVOLUTION

TIME

SPECIAL REPORT

THIS TIME IT'S SERIOUS.

The chopping has begun. For the first time in decades, Congress is committed to balancing the budget. It will mean slashing as much as $1.4 trillion and cutting programs that affect virtually every American citizen. But surprise of surprises: people want it that way. The tough choices are on the table, and it's about time.

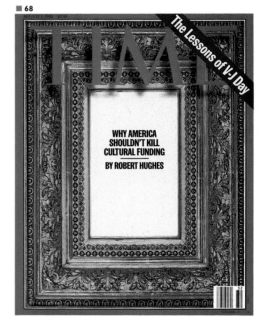

■ 68

The Lessons of V-J Day

TIME

WHY AMERICA SHOULDN'T KILL CULTURAL FUNDING

BY ROBERT HUGHES

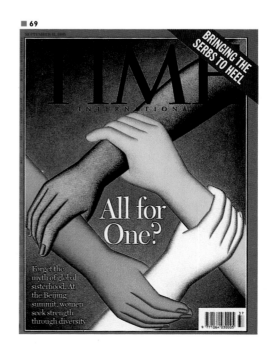

■ 69

BRINGING THE SERBS TO HEEL

TIME

INTERNATIONAL

All for One?

Forget the myth of global sisterhood. At the Beijing summit, women seek strength through diversity

■ 66
Publication SPY
Design Director
Robert J. George
Illustrator
Digital Facelifts, Inc.
Photo Editor
Elisabeth Sinsabaugh
Issue June 1995
Category Cover

■ 67
Publication TIME
Art Director
Arthur Hochstein
Photo Editor
Michele Stephenson
Photographer Ted Thai
Publisher Time Inc.
Issue May 22, 1995
Category Cover

■ 68
Publication TIME
Art Director
Arthur Hochstein
Photo Editor
Michele Stephenson
Publisher Time Inc.
Issue August 7, 1995
Category Cover

■ 69
Publication TIME
Art Director
Arthur Hochstein
Designer Jane Frey
Illustrator
Sandra Dionisi
Publisher Time Inc.
Issue September 11, 1995
Category Cover

54

■ 70
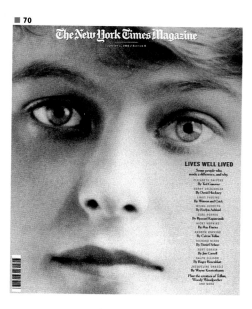

■ 71
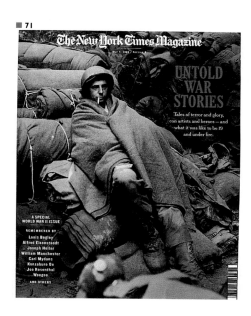

■ 72
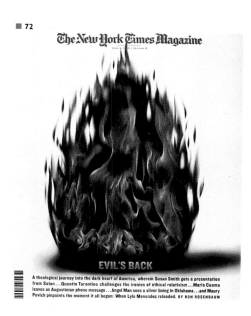

■ 73
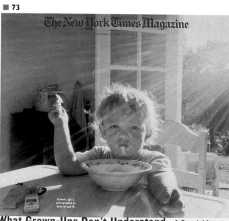

■ 74

■ 75

■ 70
Publication The New York Times Magazine
Art Director Janet Froelich
Designer Catherine Gilmore-Barnes
Photo Editor Kathy Ryan
Publisher The New York Times
Issue January 1, 1995
Category Cover

■ 71
Publication The New York Times Magazine
Art Directors Janet Froelich, Catherine Gilmore-Barnes
Designer Joel Cuyler
Photo Editor Kathy Ryan
Publisher The New York Times
Issue May 7, 1995
Category Cover

■ 72
Publication The New York Times Magazine
Art Director Janet Froelich
Designer Joel Cuyler
Photographer Matt Mahurin
Publisher The New York Times
Issue June 4, 1995
Category Cover

■ 73
Publication The New York Times Magazine
Art Director Janet Froelich
Designer Catherine Gilmore-Barnes
Photo Editor Sarah Harbutt
Publisher The New York Times
Issue October 8, 1995
Category Cover

■ 74
Publication The New York Times Magazine
Art Director Janet Froelich
Designer Catherine Gilmore-Barnes
Publisher The New York Times
Issue December 24, 1995
Category Cover

■ 75
Publication The New York Times Book Review
Art Director Steven Heller
Illustrator Mark Summers
Publisher The New York Times
Issue November 12, 1995
Category Cover

■ 76
Publication Adobe Magazine
Art Directors Nancy O'Connell, Jenna Ashley
Designer Jenna Ashley
Publisher Adobe Systems Inc.
Issue December 1995
Category Cover

■ 77
Publication Forbes FYI
Creative Director Mark Grischke
Design Director Alexander Isley
Art Director Penny Blatt
Designer Julia Wargaski
Photographer J. Michael Myers
Publisher Forbes Inc.
Issue May 8, 1995
Category Cover

■ 78
Publication The Village Voice
Design Director Audrey Shachnow
Art Director Ted Keller
Illustrator Alan E. Cober
Publisher Village Voice Publishing Corporation
Issue December 1995
Category Front Page

■ 79

Martha Stewart Living

farmstead **cheese**
a **doctor** in the house
a great lakes **picnic**
sunflowers
planting a tree
county fairs

SEPTEMBER 1995
$3.95 USA [CAN. $4.95]

■ 80

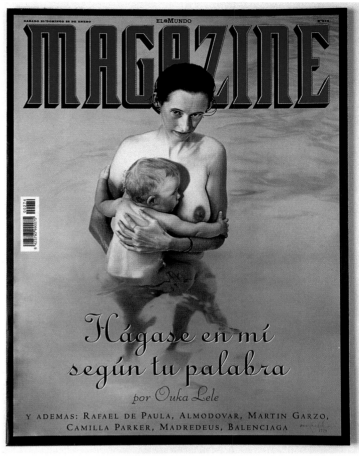

EL MUNDO

MAGAZINE

Hágase en mí
según tu palabra
por Ouka Lele

Y ADEMAS: RAFAEL DE PAULA, ALMODOVAR, MARTIN GARZO,
CAMILLA PARKER, MADREDEUS, BALENCIAGA

■ 81

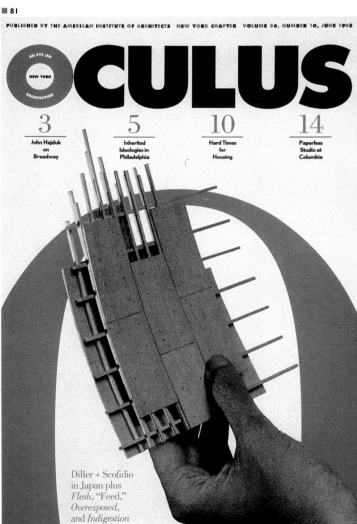

PUBLISHED BY THE AMERICAN INSTITUTE OF ARCHITECTS NEW YORK CHAPTER VOLUME 56, NUMBER 10, JUNE 1995

OCULUS

AN EYE ON NEW YORK ARCHITECTURE

3	5	10	14
John Hejduk on Broadway	Inherited Ideologies in Philadelphia	Hard Times for Housing	Paperless Studio at Columbia

Diller + Scofidio
in Japan plus
Flesh, "Feed,"
Overexposed,
and *Indigestion*

■ 79
Publication Martha Stewart Living
Creative Director Gael Towey
Art Director Eric A. Pike
Designer Agnethe Glatved
Photo Editor Heidi Posner
Photographer Christopher Baker
Publisher Time Inc.
Issue September 1995
Category Cover

■ 80
Publication El Mundo
Design Director Carmelo Caderot
Art Director Rodrigo Sanchez
Designers Rodrigo Sanchez, Miguel Buckenmeyer, Amparo Redondo
Photographer Ouka Lele
Publisher Unidad Editorial S.A.
Issue January 15, 1995
Category Cover

■ 81
Publication Oculus
Creative Director Michael Gericke
Designer Edward Chiquitucto
Photographer Dorothy Alexander
Studio Pentagram Design, Inc.
Publisher American Institute of Architects/New York
Issue June 1995
Category Cover

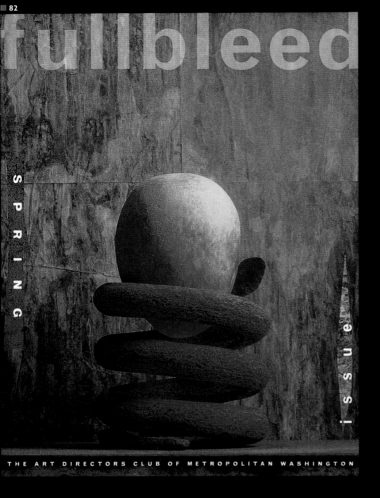

fullbleed

S
P
R
I
N
G

i
s
s
u
e

THE ART DIRECTORS CLUB OF METROPOLITAN WASHINGTON

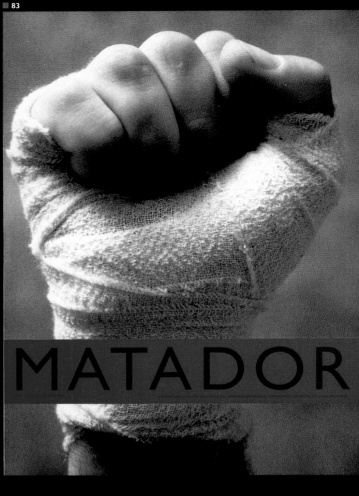

MATADOR

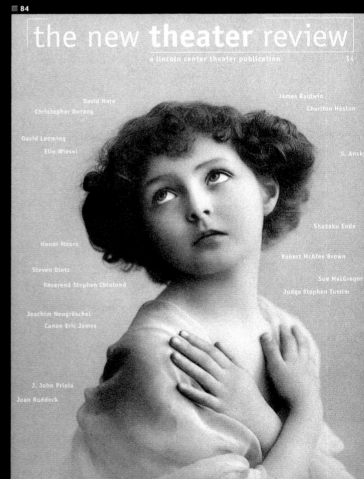

the new **theater** review

a lincoln center theater publication $4

David Hare
Christopher Durang

James Baldwin
Charlton Heston

David Leeming
Elie Wiesel

S. Ansky

Shusaku Endo

Honor Moore

Robert McAfee Brown

Steven Dietz

Sue MacGregor

Reverend Stephen Chinlund

Judge Stephen Tumim

Joachim Neugröschel
Canon Eric James

J. John Priola
Joan Ruddock

82

Publication Fullbleed
Art Director Glenn Pierce
Illustrator Glenn Pierce
Photographer Clara Griffin
Studio The Magazine Group
Publisher Art Directors Club of Metropolitan Washington
Issue Spring 1995
Category Cover

83

Publication Matador
Art Director Fernando Gutierrez
Photo Editor Luis De Las Alas
Photographer James A. Fox
Publisher La Fabrica
Issue Vol. A, 1995
Category Cover

84

Publication The New Theater Review
Creative Directors Tamar Cohen, David Slatoff
Designers Tamar Cohen, David Slatoff
Studio Slatoff + Cohen Partners Inc.
Client Lincoln Center Theater
Issue Fall 1995
Category Cover

■ 85

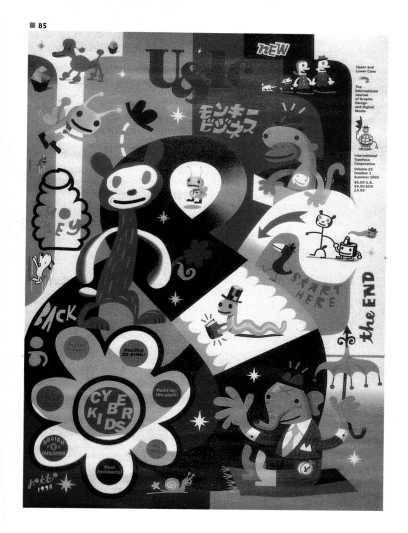

■ 86

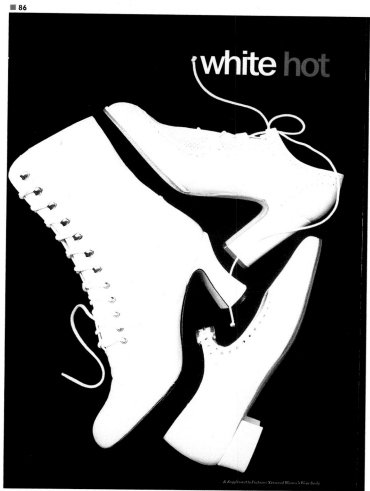

■ 87

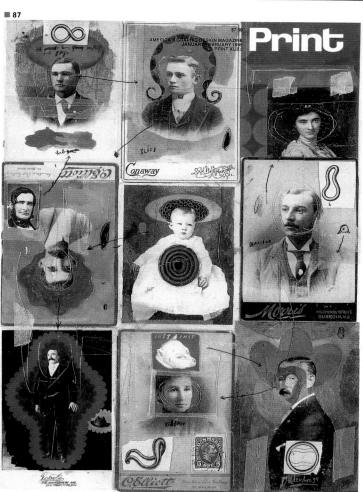

■ 85
Publication Upper & Lower Case
Art Director Rhonda Rubinstein
Designer J. Otto Seibold
Studio R Company
Client International Typeface Corporation
Publisher International Typeface Corp.
Issue Summer 1995
Category Cover

■ 86
Publication Footwear News
Art Director Elizabeth Slott
Designer Elizabeth Slott
Photographer Andreas Bleckman
Publisher Fairchild Publications
Issue March 1995
Category Cover

■ 87
Publication Print
Creative Director Andrew Kner
Designer Andrew Kner
Illustrator Henrik Drescher
Publisher RC Publications
Issue January/February 1995
Category Cover

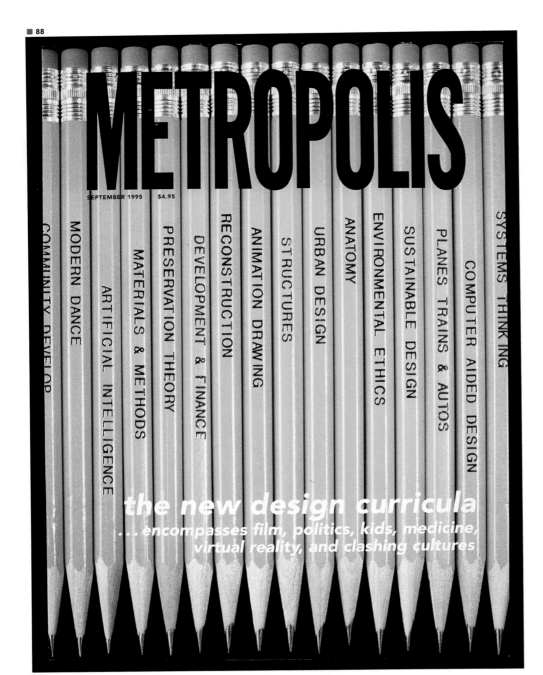

METROPOLIS

SEPTEMBER 1995 $4.95

COMMUNITY DEVELOP
MODERN DANCE
ARTIFICIAL INTELLIGENCE
MATERIALS & METHODS
PRESERVATION THEORY
DEVELOPMENT & FINANCE
RECONSTRUCTION
ANIMATION DRAWING
STRUCTURES
URBAN DESIGN
ANATOMY
ENVIRONMENTAL ETHICS
SUSTAINABLE DESIGN
PLANES TRAINS & AUTOS
COMPUTER AIDED DESIGN
SYSTEMS THINKING

the new design curricula
...encompasses film, politics, kids, medicine,
virtual reality, and clashing cultures

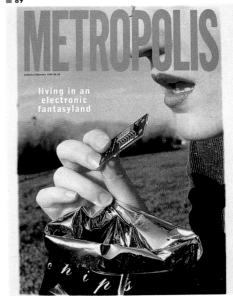

METROPOLIS

living in an
electronic
fantasyland

chips

METROPOLIS

AAAAA BBBB CCCC
the new typography
DDD EEEE FFFF
GGGG HHHH IIIIII
and its new technology
JJJ KKK LLLL MM
MM NNN OOOOOP
carrot pieces
PPP QQ O RRRR S
soup stains
SS TTTT UUUUU
served piping hot
VVVV WW XXYYZ

■ 88
Publication Metropolis
Art Directors Carl Lehmann-Haupt,
William van Roden
Publisher Havemeyer-Bellerophon
Publications Inc.
Issue September 1995
Category Cover

■ 89
Publication Metropolis
Art Directors Carl Lehmann-Haupt,
Nancy Kruger Cohen
Photographer Kristine Larsen
Publisher Havemeyer-Bellerophon
Publications Inc.
Issue January/February 1995
Category Cover

■ 90
Publication Metropolis
Art Directors Carl Lehmann-Haupt,
Nancy Kruger Cohen, Kevin Slavin
Publisher Havemeyer-Bellerophon
Publications Inc.
Issue March 1995
Category Cover

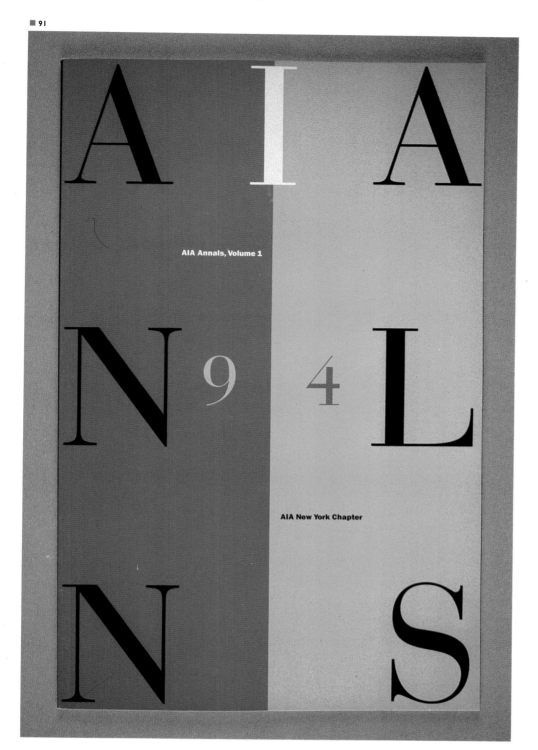

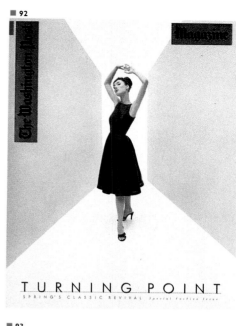

■ 91

Publication AIA Annals
Creative Director Michael Gericke
Designer Michael Gericke
Studio Pentagram Design, Inc.
Publisher American Institute of Architects/New York
Issue Vol. 1, 1995
Category Cover

■ 92

Publication The Washington Post Magazine
Art Director Kelly Doe
Designer Kelly Doe
Photographer Christian Witkin
Issue March 5, 1995
Category Cover

■ 93

Publication ARTFORUM
Design Director Kristin Johnson
Photographer Anders Edström
Publisher ARTFORUM
Issue March 1995
Category Cover

■ 94

The New York Times

Summer Arts

Sunday, May 14, 1995

Arts & Leisure

A GUIDE
TO FESTIVALS,
COAST
TO COAST

■ 95

IMPULSE
ANCHORAGE DAILY NEWS

it was murder

| NOT OVER HERE | 4 | NOT A DRAG | 4 | TUNES AND TOURS | 4 |

■ 96

75¢

8

B
I
N
G
O
!

Whatever
your [skills,]
local parlors
have your
[number]

YOUR GUIDE TO LEISURE
April 14, 1995

8 CONTROVERSIAL TLINGIT AGONIZES AT UAA

11 KILT 'EM ALL, LET FILM SORT 'EM OUT

23 WINTER GOLFERS DRIVEN INSIDE

25 POET RITA DOVE SAYS GOODBYE

Anchorage Daily News

■ 94
Publication The New York Times
Art Director Linda Brewer
Illustrator Benoit
Publisher The New York Times
Issue May 14, 1995
Category Front Page

■ 95
Publication Anchorage Daily News/Impulse
Creative Director Galie Jean-Louis
Designer Dee Boyles
Illustrator Eric Dinyer
Photo Editor Galie Jean-Louis
Publisher Anchorage Daily News
Issue July 10, 1995
Category Front Page

■ 96
Publication Anchorage Daily News/Impulse
Creative Director Galie Jean-Louis
Designer Kevin Ellis
Illustrators Kevin Ellis, Evan Steinhauser
Photo Editor Galie Jean-Louis
Publisher Anchorage Daily News
Issue April 14, 1995
Category Front Page

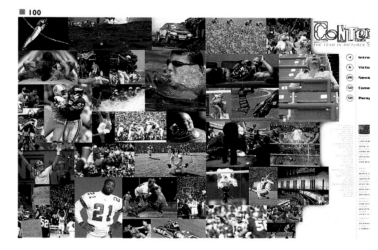

■97
Contents
Issue 690 • September 19, 1995

Advocate

fall preview

cover story
26 Emma Thompson talks about *Carrington* and being raised by, loving, and working with gay men. Then there are her lesbian films.

music
37 Linda Perry is well over 4 Non Blondes and happily on her way to a tough new solo album and her own rock record label.

books
41 Andrew Sullivan's book *Virtually Normal* is bound to lift the controversy he's stirred up at *The New Republic* to new heights.

television
45 Jenifer Lewis laughs and frets about taking on the role of a black lesbian judge in the new TV drama series *Courthouse*.

cinema
49 Paul Verhoeven braces himself for another storm over his upcoming *Showgirls*. Those who freaked over *Basic Instinct*, beware.

theater
53 George C. Wolfe carries his black and gay heritage proudly as he directs *The Tempest* and preps a new Tony Kushner play.

Letters ... 8
Agenda ... 11
Viewpoint: Maria Maggenti 18
Your Health: Katherine A. O'Hanlan, MD 21
Breaking Silence: Janis Ian 61
Reviews .. 63
The Buzz ... 71
Last Word: Bruce Bawer 80

ON THE COVER: Emma Thompson photographed by Andrew MacPherson

SEPTEMBER 19, 1995 — THE ADVOCATE 5

■98
AZURE
March/April 1995

22 dining out by design
How has the design of Toronto restaurants evolved to accommodate changing social realities?
ALEX NEWMAN

26 né de père inconnu
D'après la croyance populaire, les Design Victims seraient tous des obsédés de la signature, incapables d'apprécier l'esthétique formelle, l'intelligence, la performance d'un objet s'il est d'origine inconnue. Archifaux! Du moins c'est ce qui ressort de la mini-enquête menée auprès de quelques uns d'entre eux.
MARIAM GARNON

30 trading places
A selection of new furniture from the 1995 Cologne Furniture Fair.
NICOLA HO PATT

32 in virtu veritas
Powered by the indefatigable spirit of Esther Shipman, the Virtu competitions/exhibitions, lectures, shop and other initiatives have made a significant contribution to the culture of design in Canada.
ANNY TOMLIN

10 Forms and Functions
Virtu 9... design on air... Ecologe... Elaine Lustig Cohen... Philips by Alessi... Health and your computer keyboard...

41 Free Advertiser Information

42 News in Design
New products with great design, good conscience or lots of style.

44 Calendar
Exhibitions, conferences, trade fairs, workshops and competitions.

50 Azure Directory

54 Last Words
Why 10 years ago we called it Azure.

Cover photograph by Roman Pylypczak.
Design by Concrete Design Communications Inc.

Canada Post Canadian Publications Mail Sales Product Agreement # 175366. ISSN No. 0829-982X. Address notices, undeliverable copies and subscription orders should be sent to Azure Magazine, 2 Silver Avenue, Toronto, Ontario, Canada M6R 3A2 Telephone (416) 588-2588 Fax (416) 588-2357. Return Postage Guaranteed.

MARCH/APRIL 95 • AZURE 5

■97
Publication The Advocate
Creative Director Ron Goins
Photographer Andrew Macpherson
Issue September 19, 1995
Category Contents

■98
Publication Azure
Design Directors Diti Katona, John Pylypczak
Designer Susan McIntee
Studio Concrete Design Communications Inc.
Publisher Sergio Sgaramella
Issue March/April 1995
Category Contents

■99
Publication Sports Illustrated Classic
Design Director Steven Hoffman
Art Director Craig Gartner
Photographer Hy Peskin
Publisher Time Inc.
Issue Fall 1995
Category Contents

■100
Publication Sports Illustrated Presents
Art Director F. Darrin Perry
Designer Michael D. Schinnerer
Photo Editor Jeffrey Weig
Publisher Time Inc.
Issue Fall 1995
Category Contents

Actual Letters
Small Print
Dolemite
Andy Ricard
it Bytes
Engine 88
Apples In Stereo
Extra Fancy
Zap
Chavez
Skylab
Schizchaft
Ass Ghosnoff
Sparalaperna
Dambuilders
Garbage
Luna
David Bowie
The Fewgitives
Sound in Print
Ben Harper
Music by Design
Roller Derby Queen
In Error
Korea
Reviews
last page

photo: kate garner
(cover+contents)

25

song: onward christian soldiers group: mormon tabernacle choir artist: lane twitchell, s.v.a.

new order. actual letters small print rabelaisian without a clue

railroad jerk kitchens of distinction it bytes our town with mercury

rev the 6ths elastica juliana hatfield morphine spiritualized pave-

ment opening frights marianne faithfull sound in print bootlegs

claw hammer +wayne kramer music by design fashion grant

mclennan reviews. cover: pavement by guy aroch

26

actual letters

small print

rabelaisian

towa tei

laiko

new bomb turks and gaunt

h.p. zinker

kirsty maccoll

it bytes

pizzicato five

henry rollins and isa

beastie boys + fascious pac

moby+the orb

sound in print

kendra smith

peter murphy

music by design

fashion

roger corman

reviews

last page

cover: beastles + fascious by art marmarosky
this page: henry + isa? by natalie oscheger

ray gun #27 on the road again

actual letters

small print

rabelaisian

flying saucer attack st. johnny

steel pole bathtub

sweet+low orchestra

pooh sticks

pusherman

it bytes

music by design

victoria williams' art

aphex twin

bjork

road worriers

ass ponys

archers of loaf

the drivers

matthew sweet

male groupies

sound in print

goths on acid

reviews

last page

cover: bjork by dave stewart
this page: illustration by blair thornley

Publication Ray Gun
Design Director David Carson
Designer David Carson
Category Contents

Publication Ray Gun
Design Director David Carson
Designer David Carson
Category Contents

Publication Ray Gun
Design Director David Carson
Designer David Carson
Category Contents

Publication Ray Gun
Design Director David Carson
Designer David Carson
Category Contents

Entertainment

FRIDAY, JUNE 30, 1995

NEWS & NOTES

6/Jam Session Pearl Jam finally kicks off its tour...*Congo* drums up box office...*20 more* questions for Michael Jackson...Jon Stewart's next step...HOT SHEET...MONITOR...and more.

14/Behind the Scenes How *Smoke* sparked an improvised film featuring Harvey Keitel, Roseanne, and Madonna.

SPECIAL ISSUE

16/Summer Cool For the fourth year running, a guide to people and things so refreshing, they beat the heat. ◆ **18/Cool Star Picks** Hot celebs weigh in on what's cool and uncool. ◆ **24/Cool Movies** Val Kilmer, Lauren Holly, Robert Thurman, Nicolas Cage and Patricia Arquette, a film set crawling with cockroaches, blaxploitation, Tim Roth, Natasha Henstridge, and Sid 6.7. ◆ **42/Cool TV** Urkel, *Hercules, Squirt TV*, Brian Lamb, Lisa Kudrow, the daughters on *Cybill*, and Peter MacNicol. ◆ **50/Cool Books** Jim Carroll, the supercomic *Gen 13*, Oliver Sacks, Martha Stewart's calendar, Chang-rae Lee, and Philip Weiss. ◆ **60/Cool Music** Bjork, Compulsion, Joan Osborne, the Roots, and George Jones and Tammy Wynette. ◆ **66/Cool Multimedia** The MIT Media Lab, CD-ROM magazines, and MUDs. ◆ **68/Cool Style** Retro, kitsch, and other neat stuff. ◆ **74/The Cold Page** Making the call on all that's a bit past cool.

REVIEWS

78/MOVIES OWEN GLEIBERMAN on *Apollo 13*; also *Safe* and *Belle de Jour*. **PLUS:** Former spaceman Jim Lovell looks back; *As the World Turns* churns out film stars.

88/TELEVISION KEN TUCKER on the *Welcome Back, Kotter* comeback. **PLUS:** *Grace Under Fire* goes Russian.

92/BOOKS MARK HARRIS on *Beach Music*, Pat Conroy's follow-up to *The Prince of Tides*; also the Ted Turner bio, *Citizen Turner*. **PLUS:** Reading lists of the rich and famous.

96/MUSIC DAVID BROWNE on Neil Young's *Mirror Ball*; also Pink Floyd's *Pulse* and Phish's *A Live One*. **PLUS:** Catching up with Blessid Union of Souls and All-4-One.

102/MULTIMEDIA JACQUELINE SAVAIANO on a school where videogame programming is the curriculum.

106/VIDEO GLENN KENNY on *The Last Seduction* and other films featuring Linda Fiorentino. **PLUS:** Killer women.

DEPARTMENTS

4/Mail Nicoles Kidman and Eggert, Comedy Central.
112/Encore July 2, 1955: Lawrence Welk bubbles over.

Cover VAL KILMER PHOTOGRAPHED FOR *EW* BY RUVEN AFANADOR, STYLING MAUI VISION; GROOMING, JEAN BOURSE STREETER; ARTS SWIMETH SILVER

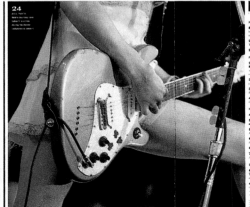

Publication Entertainment Weekly
Design Director Robert Newman
Designer Joe Kimberling
Illustrator Paul Corio
Publisher Time Inc.
Issue June 30, 1995
Category Contents

Publication Entertainment Weekly
Design Director Robert Newman
Art Director Helene Silverman
Designers Joe Kimberling, Helene Silverman
Illustrator Paul Corio
Publisher Time Inc.
Issue Fall 1995
Category Contents

Publication Entertainment Weekly
Design Director Robert Newman
Designer Florian Bachleda
Illustrator Matt Groening
Issue May 12, 1995
Publisher Time Inc.
Category Contents

Publication Entertainment Weekly
Design Director Robert Newman
Designer Elizabeth Betts
Photo Editor Michele Romero
Photographer Frank Micelotta
Publisher Time Inc.
Issue July 21, 1995
Category Contents

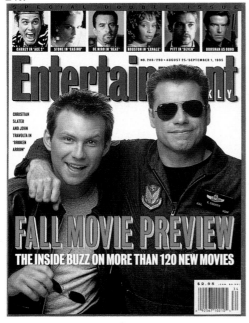

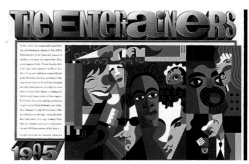

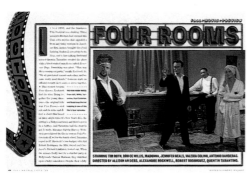
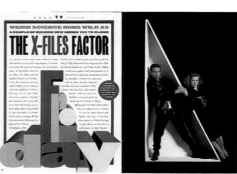
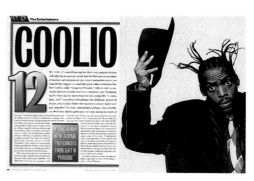

■ 109

Publication Entertainment Weekly
Design Director Robert Newman
Art Directors Elizabeth Betts, Michael Picon
Designers Florian Bachleda, Keith Campbell, Susan Conley,
George Karabotsos, Joe Kimberling, Bobby B. Lawhorn Jr.,
Karmen Lizzul, Stacie Reistetter, Julie Schrader, Michael Picon
Photo Editors Doris Brautigan, Mary Dunn, Alice Babcock, Michael Kochman
Publisher Time Inc.
Issues August 25, 1995, September 15, 1995, December 29, 1995
Category Overall

■ 110

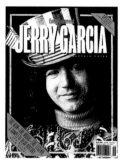
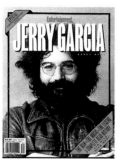
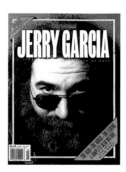

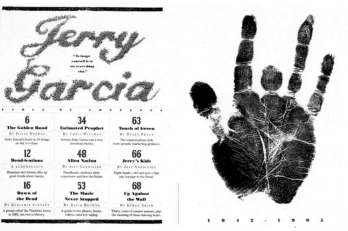

■ 111 A

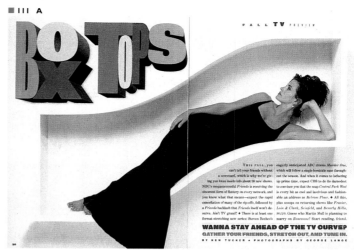

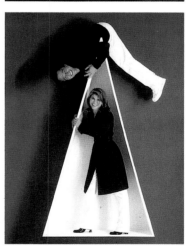

■ 110
Publication Entertainment Weekly
Design Director Robert Newman
Art Director Mark Michaelson
Designers Susan Conley, Keith Campbell,
Joe Kimberling, Mark Michaelson,
Karmen Lizzul, Jesse Reyes, Julie Schrader
Photo Editor Michele Romero
Publisher Time Inc.
Issue September 11, 1995
Category Entire Issue

■ 111
Publication Entertainment Weekly
Design Director Robert Newman
Art Director George Karabotsos
Designers Florian Bachleda, George Karabotsos
Photo Editors Alice Babcock, Mary Dunn
Photographer George Lange
Issue September 15, 1995
Publisher Time Inc.
Category Story/Feature
 ■ A Spread/Feature

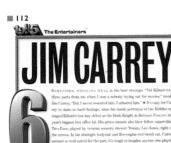

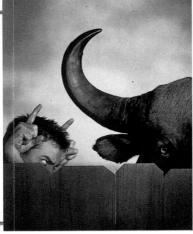

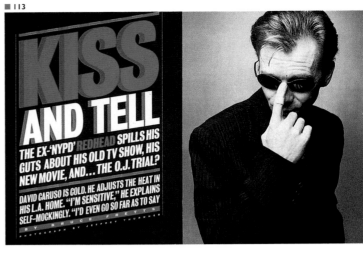

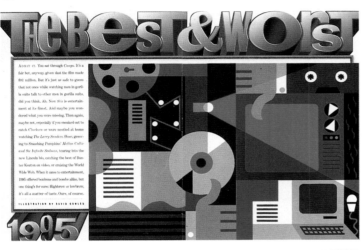

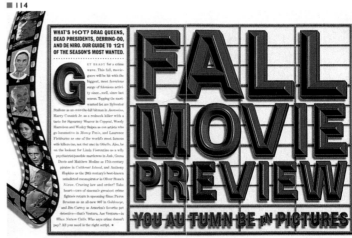

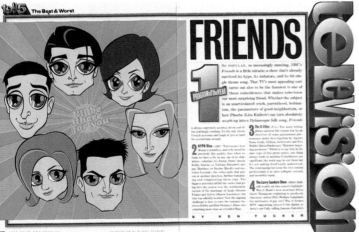

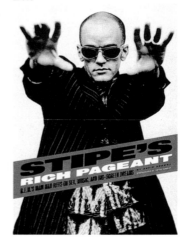

■ 112
Publication Entertainment Weekly
Design Director Robert Newman
Art Directors George Karabotsos, Elizabeth Betts
Designers George Karabotsos, Susan Conley, Florian Bachleda, Joe Kimberling
Photo Editors Doris Brautigan, Mary Dunn
Publisher Time Inc.
Issue December 29, 1995
Category Entire Issue

■ 113
Publication Entertainment Weekly
Design Director Robert Newman
Designer Michael Picon
Photo Editor Doris Brautigan
Photographer Jeffrey Thumher
Publisher Time Inc.
Issue April 28, 1995
Category Spread/Feature

■ 114
Publication Entertainment Weekly
Design Director Robert Newman
Designer Michael Picon
Photo Editor Doris Brautigan
Publisher Time Inc.
Issue August 25, 1995
Category Spread/Feature

■ 115
Publication Entertainment Weekly
Design Director Robert Newman
Designer Florian Bachleda
Photo Editor Michele Romero
Photographer Anton Corbijn
Publisher Time Inc.
Issue July 14, 1995
Category Single/Feature

■ 116

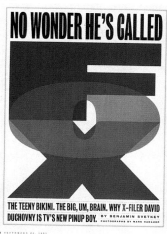

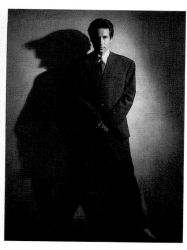

NO WONDER HE'S CALLED X

THE TEENY BIKINI. THE BIG, UM, BRAIN. WHY X-FILER DAVID DUCHOVNY IS TV'S NEW PINUP BOY. BY BENJAMIN SVETKEY PHOTOGRAPHS BY MARK HANAUER

■ 119

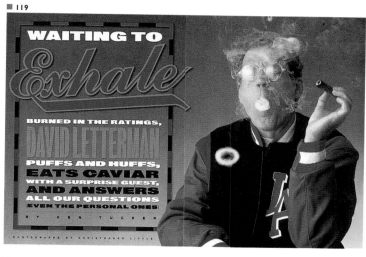

WAITING TO Exhale

BURNED IN THE RATINGS, DAVID LETTERMAN PUFFS AND HUFFS, EATS CAVIAR WITH A SURPRISE GUEST, AND ANSWERS ALL OUR QUESTIONS (EVEN THE PERSONAL ONES) BY KEN TUCKER

PHOTOGRAPHS BY CHRISTOPHER LITTLE

■ 117

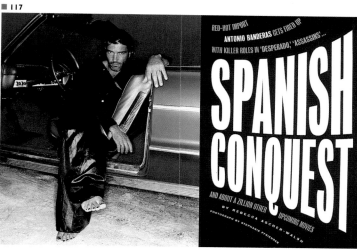

RED-HOT IMPORT ANTONIO BANDERAS GETS FIRED UP WITH KILLER ROLES IN 'DESPERADO', 'ASSASSINS'...

SPANISH CONQUEST

AND ABOUT A ZILLION OTHER UPCOMING MOVIES

BY REBECCA ASCHER-WALSH

PHOTOGRAPH BY STEPHANIE PFRIENDER

■ 120

TELEVISION

The Two Faces of Dave

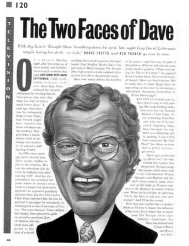

Letterman still makes the grade

■ 118

BY DANA KENNEDY

King OF THE JUNGLE

A NEW ACE VENTURA, ANOTHER $40 MILLION IN THE BANK, AND RAW ANIMAL MAGNETISM MAKE JIM CARREY MORE THAN A LAUGHING MATTER

PHOTOGRAPHS BY DAN WINTERS

■ 121

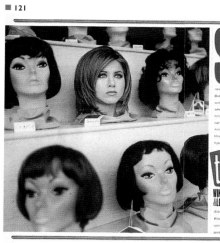

PLAY WITH ME, says Jennifer Aniston...

tv WINNERS & LOSERS

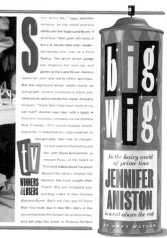

big Wig

In the hairy world of prime time JENNIFER ANISTON is a cut above the rest

BY BRET WATSON

■ 116
Publication
Entertainment Weekly
Design Director
Robert Newman
Designer
Florian Bachleda
Photo Editors
Alice Babcock, Mary Dunn
Photographer
Mark Hanauer
Publisher Time Inc.
Issue September 29, 1995
Category Spread/Feature

■ 117
Publication
Entertainment Weekly
Design Director
Robert Newman
Designer Michael Picon
Photo Editor
Doris Brautigan
Photographer
Stephanie Pfriender
Publisher Time Inc.
Issue October 6, 1995
Category Spread/Feature

■ 118
Publication
Entertainment Weekly
Design Director
Robert Newman
Designer
George Karabotsos
Photo Editor
Doris Brautigan
Photographer
Dan Winters
Publisher Time Inc.
Issue November 10, 1995
Category Spread/Feature

■ 119
Publication
Entertainment Weekly
Design Director
Robert Newman
Designer Michael Picon
Photo Editor
Mary Dunn
Photographer
Christopher Little
Publisher Time Inc.
Issue December 1, 1995
Category Spread/Feature

■ 120
Publication
Entertainment Weekly
Design Director
Robert Newman
Art Director
Elizabeth Betts
Designer Julie Schrader
Illustrator
S.B. Whitehead
Publisher Time Inc.
Issue August 11, 1995
Category Department

■ 121
Publication
Entertainment Weekly
Design Director
Robert Newman
Designer Michael Picon
Photo Editors
Mary Dunn,
Michael Kochman
Photographer
Robert Trachtenberg
Issue December 15, 1995
Category Spread/Feature

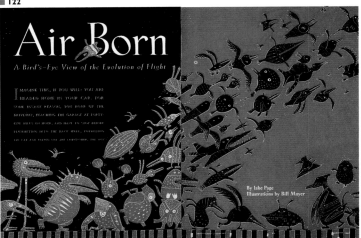

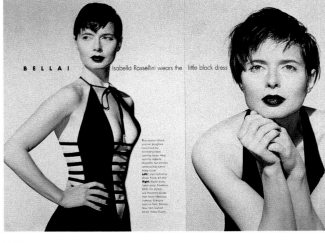

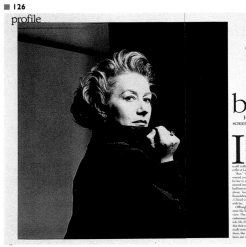

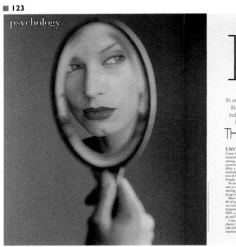

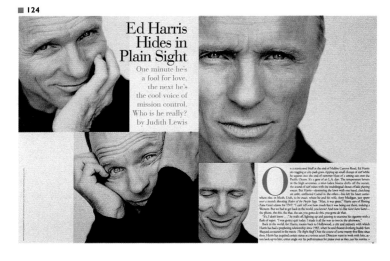

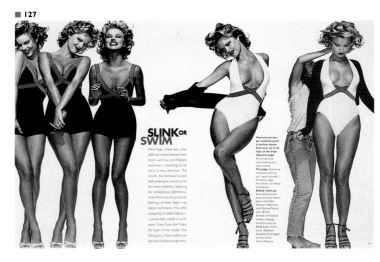

■ 122
Publication
Destination Discovery
Design Director
John Lyle Sanford
Art Director
David Whitmore
Designer
David Whitmore
Illustrator Bill Mayer
Publisher Discovery
Channel Publishing
Issue October 1995
Category Spread/Feature

■ 123
Publication Elle
Art Director
Nora Sheehan
Designer
Nora Sheehan
Photo Editor
Alison Morley
Photographer
Andrew Eccles
Publisher Hachette
Filipacchi Magazines, Inc.
Category Spread/Feature

■ 124
Publication Elle
Art Director
Nora Sheehan
Designer
Nora Sheehan
Photo Editor
Alison Morley
Photographer
Mark Hanauer
Publisher Hachette
Filipacchi Magazines, Inc.
Category Spread/Feature

■ 125
Publication Elle
Art Director
Nora Sheehan
Designers
Nora Sheehan,
Regis Pagniez
Photo Editor
Alison Morley
Photographer
Gilles Bensimon
Publisher Hachette
Filipacchi Magazines, Inc.
Category Spread/Feature

■ 126
Publication Elle
Art Director
Nora Sheehan
Designer
Nora Sheehan
Photo Editor
Alison Morley
Photographer
Jeffrey Thumher
Publisher Hachette
Filipacchi Magazines, Inc.
Category Spread/Feature

■ 127
Publication Elle
Art Director
Nora Sheehan
Designer
Nora Sheehan
Photo Editor
Alison Morley
Photographer
Isabel Snyder
Publisher Hachette
Filipacchi Magazines, Inc.
Category Spread/Feature

Di Rosa
Devilishly

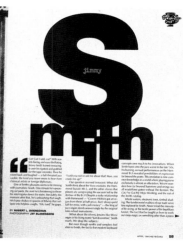

S
m-ith
Jimmy

INSIDE THE AMBIENT TECHNO ULTRAWORLD

If music is a response to the temper of our times, then the Orb is exactly what America needs. Things are getting a little too cut-and-dried here: Complex problems beget weirdly simple solutions — kicking people out of the country, putting them in institutions, shutting down institutions, or just saying no.

As the guiding force of the group known as the Orb, Alex Paterson sees things differently. His music is all blur and fuzz. Scraps of sound fade in and out, drifting over fields unbound by the barbed wire of verse and chorus. There's rhythm, and it's as regular as anything on the prosaic dance charts. But so are heartbeats regular, though life swirls through and around them with beguiling imprecision.

Shapes are hard to identify in Paterson's world. Voices fly about, sometimes as sharp and intrusive as a mosquito's whine, more often muffled and unintelligible; someone is talking, but we can't quite make it out. Occasionally the aural clouds lift and we hear something more clearly — something ugly or scary, a snake-handler's snarl, or fragile, a child's tale. We hold our breaths and listen, afraid of losing this picture of innocence as it sinks

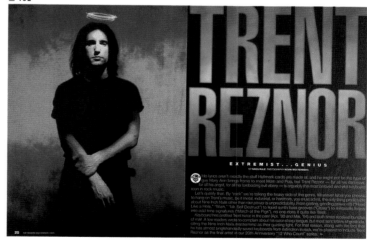

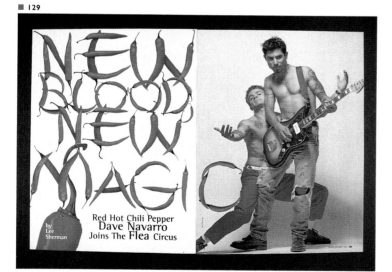

NEW BLOOD NEW MAGIC

Red Hot Chili Pepper
Dave Navarro
Joins The Flea Circus
by Lee Sherman

TRENT REZNOR
EXTREMIST...GENIUS

■ 128
Publication France
Creative Director Kelly Doe
Art Director Susan Langholz
Designer Kelly Doe
Publisher French Embassy
Issue Winter 1995
Category Spread/Feature

■ 129
Publication Guitar
Art Director
Stephanie Warzecha
Designers Stan Stanski,
Phil Yarnall
Photographer Neil Zlozower
Studio SMAY Vision
Publisher
Cherry Lane Magazines
Issue October 1995
Category Spread/Feature

■ 130
Publication Keyboard
Art Director Paul Martinez
Photographer Jay Blakesberg
Publisher Miller Freeman, Inc.
Issue April 1995
Category Spread/Feature

■ 131
Publication Keyboard
Art Director Paul Martinez
Photographer Mitch Tobias
Publisher Miller Freeman, Inc.
Issue June 1995
Category Spread/Feature

■ 132
Publication Keyboard
Art Director Paul Martinez
Photographer
Kevin Westenberg
Publisher Miller Freeman, Inc.
Issue December 1995
Category Spread/Feature

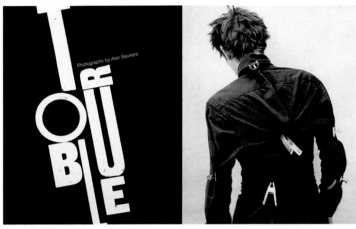

When Lebanese hostage **Frank Reed** returned to Malden in the spring of 1990, America welcomed him as a hero. Five years later, he found himself locked up in a mental hospital, broke, scared, and all but forgotten.

the

by LOUISE PALMER

lost

hostage

MALIK UNDER COVER

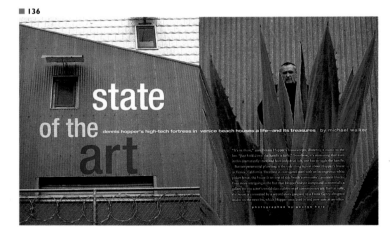

state
of the
art

dennis hopper's high-tech fortress in venice beach houses a life—and its treasures by michael walker

photographed by george holz

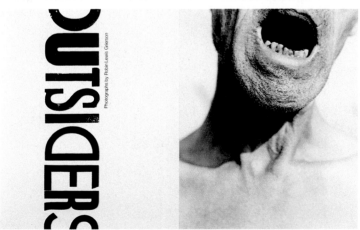

■ 133
Publication Big
Creative Director Vince Frost
Designer Vince Frost
Photo Editor Vince Frost
Photographers Gino Sprio,
Robin Grierson, Alan Beukers, Giles Revell
Studio Frost Design
Client Big Location
Publisher Marcelo Jüneman
Issue March 3, 1995
Category Entire Issue

■ 134
Publication Boston
Art Director Gregory Klee
Designer Gregory Klee
Photographer William Huber
Publisher Boston Magazine
Issue July 1995
Category Spread/Feature

■ 135
Publication Build
Creative Director Diddo Ramm
Designer Diddo Ramm
Studio Diddo.NY
Issue December 15, 1995
Category Spread/Feature

■ 136
Publication InStyle
Art Director Richard Ferretti
Designer Richard Ferretti
Photo Editor Laurie Kratochvil
Photographer George Holz
Publisher Time Inc.
Issue August 1995
Category Spread/Feature

■ 137

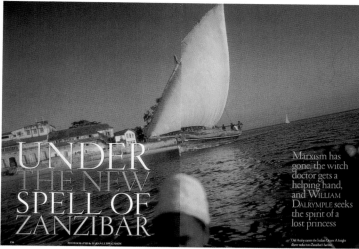

UNDER THE NEW SPELL OF ZANZIBAR

Marxism has gone, the witch doctor gets a helping hand, and WILLIAM DALRYMPLE seeks the spirit of a lost princess

PHOTOGRAPHS by HAKAN LUDWIGSSON

Old Araby meets the Indian Ocean: A bright dhow tacks into Zanzibar's harbor.

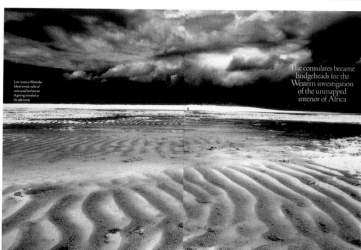

The consulates became bridgeheads for the Western investigation of the unmapped interior of Africa

Low water at Matemba Island reveals miles of coral sand, but beware of getting stranded as the tide turns.

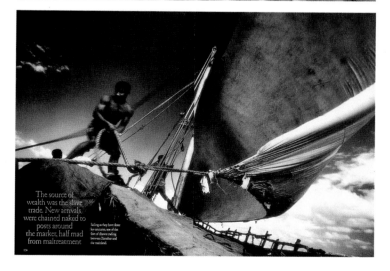

The source of wealth was the slave trade. New arrivals were chained naked to posts around the market, half mad from maltreatment

Sailing as they have done for centuries, one of the fleet of dhows trading between Zanzibar and the mainland.

■ 138

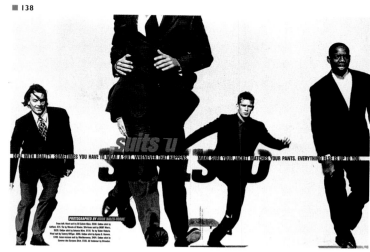

suits u

PHOTOGRAPHED BY HUGH HALES-TOOKE

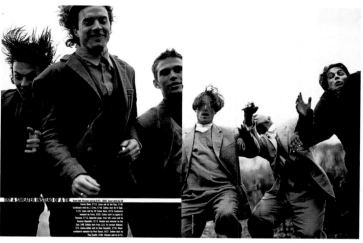

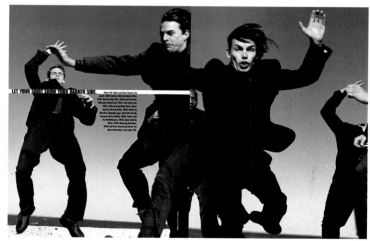

■ 137
Publication Condé Nast Traveler
Design Director Diana LaGuardia
Art Director Christin Gangi
Designer Christin Gangi
Photographer Hakan Ludwigsson
Publisher Condé Nast Publications Inc.
Issue April 1995
Category Story/Feature

■ 138
Publication Details
Creative Director William Mullen
Art Director Markus Kiersztan
Designer Markus Kiersztan
Photo Editor Greg Pond
Photographer Hugh Hales-Tooke
Publisher Condé Nast Publications Inc.
Issue February 1995
Category Spread/Feature

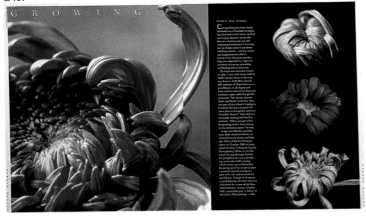

LIFE BEGINS IN THE GARDEN: *World's Best Flower Show* • *Plans That Work* • *Daylilies*

GARDEN DESIGN

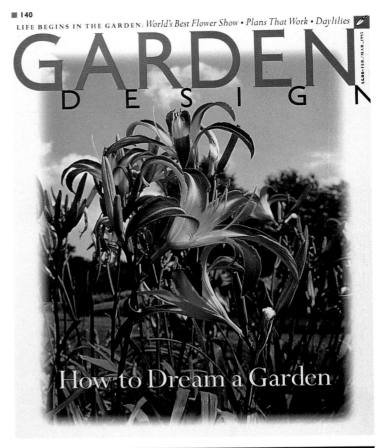

How to Dream a Garden

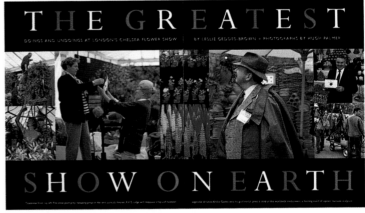

THE GREATEST SHOW ON EARTH

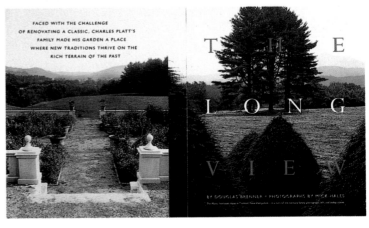

FACED WITH THE CHALLENGE
OF RENOVATING A CLASSIC, CHARLES PLATT'S
FAMILY MADE HIS GARDEN A PLACE
WHERE NEW TRADITIONS THRIVE ON THE
RICH TERRAIN OF THE PAST

THE LONG VIEW

■ 139
Publication Garden Design
Creative Director Michael Grossman
Art Director Paul Roelofs
Photo Editor Susan Goldberger
Publisher Meigher Communications
Issue October/November 1995
Category Entire Issue

■ 140
Publication Garden Design
Creative Director Michael Grossman
Art Director Paul Roelofs
Photographers Hugh Palmer, Mick Hales
Photo Editor Susan Goldberger
Publisher Meigher Communications
Issues February/March 1995, October/November 1995, June/July 1995
Category Overall

■ 141

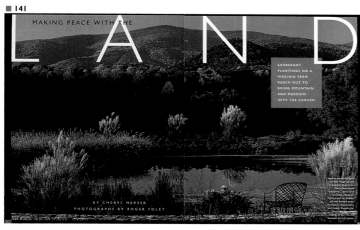

MAKING PEACE WITH THE

L A N D

EXUBERANT PLANTINGS ON A VIRGINIA FARM REACH OUT TO BRING MOUNTAIN AND MEADOW INTO THE GARDEN

BY CHERYL MERSER
PHOTOGRAPHS BY ROGER FOLEY

■ 142

The 1995 Golden Trowel Awards

MEET THE GARDENERS WHO'VE WON THE LAURELS IN OUR SECOND ANNUAL CONTEST

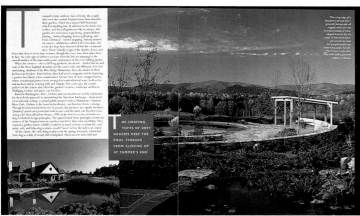

THE SWAYING TUFTS OF SOFT GRASSES KEEP THE POOL TERRACE FROM CLOSING UP AT SUMMER'S END

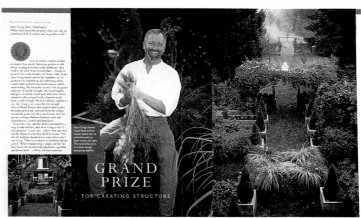

GRAND PRIZE

FOR CREATING STRUCTURE

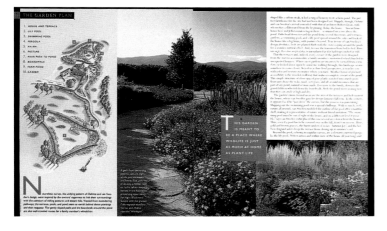

THE GARDEN PLAN

1. HOUSE AND TERRACE
2. LILY POOL
3. SWIMMING POOL
4. PERGOLA
5. HA-HA
6. PASTURE
7. MAIN PATH TO POND
8. BOARDWALK
9. FARM POND
10. GAZEBO

THIS GARDEN IS MEANT TO BE A PLACE WHERE WILDLIFE IS JUST AS MUCH AT HOME AS PLANT LIFE

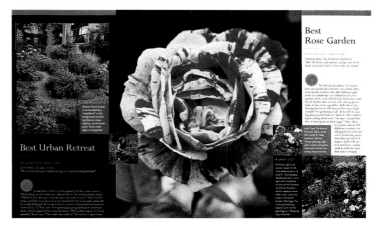

Best Urban Retreat

Best Rose Garden

■ 141
Publication Garden Design
Creative Director Michael Grossman
Art Director Paul Roelofs
Designer Paul Roelofs
Photo Editor Susan Goldberger
Photographer Roger Foley
Publisher Meigher Communications
Issue October/November 1995
Category Story/Feature

■ 142
Publication Garden Design
Creative Director Michael Grossman
Art Director Paul Roelofs
Designers Paul Roelofs, Carla Frank
Photo Editor Susan Goldberger
Publisher Meigher Communications
Issue December 1995/January 1996
Category Story/Feature

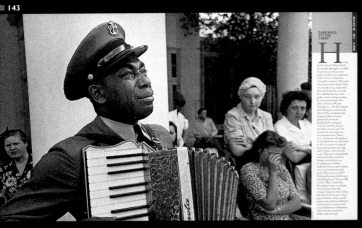

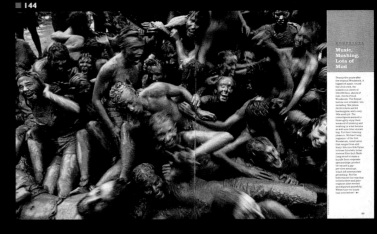

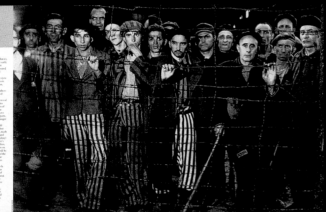

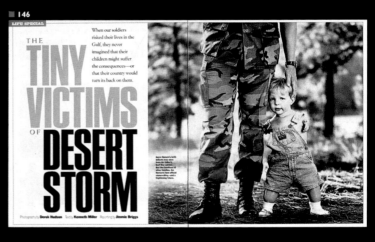

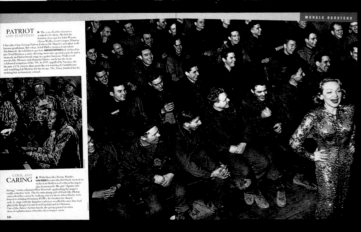

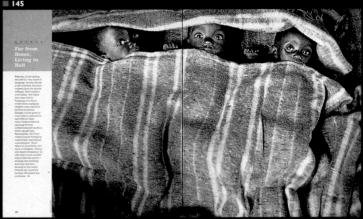

■ 143
Publication LIFE
Design Director Tom Bentkowski
Art Director Marti Golon
Designer Marti Golon
Photo Editors Adrienne Aurichio,
Pamela Sztybel Winningham
Photographers Margaret Bourke-White,
George Silk, Ralph Crane, Ed Clark
Publisher Time Inc.
Issue Special
Category Entire Issue

■ 144
Publication LIFE
Design Director Tom Bentkowski
Designer Marti Golon
Photo Editor Barbara Baker Burrows
Photographer Paul Fusco
Publisher Time Inc.
Issue January 1995
Category Spread/Feature

■ 145
Publication LIFE
Design Director Tom Bentkowski
Designer Marti Golon
Photo Editor Barbara Baker Burrows
Photographer Sebastiao Salgado
Publisher Time Inc.
Issue January 1995
Category Spread/Feature

■ 146
Publication LIFE
Design Director Tom Bentkowski
Designer Marti Golon
Photo Editor David Friend
Photographer Derek Hudson
Publisher Time Inc.
Issue November 1995
Category Spread/Feature

■147

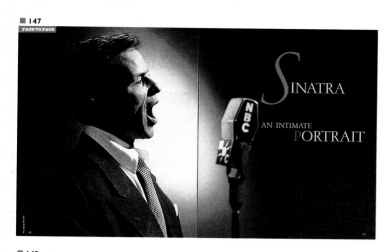

SINATRA

AN INTIMATE PORTRAIT

■150

CHAIN GANGS

Photography by
JAMES NACHTWEY
Text by
BRAD DARRACH

■148

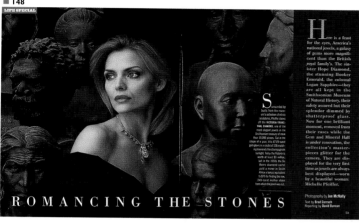

ROMANCING THE STONES

■151

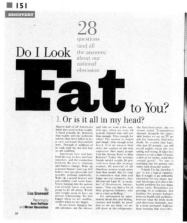
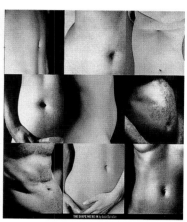

28 questions (and all the answers) about our national obsession

Do I Look Fat to You?

1. Or is it all in my head?

■149

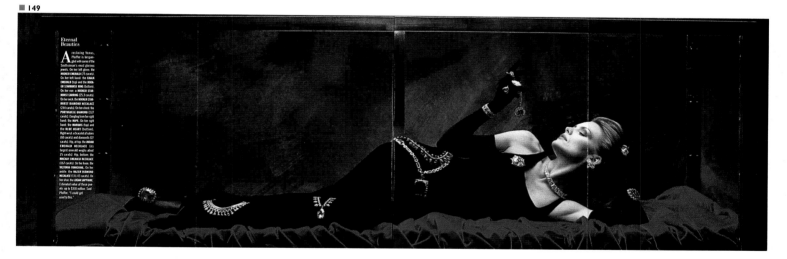

■147
Publication LIFE
Design Director
Tom Bentkowski
Designer Marti Golon
Photo Editor Marie Schumann
Publisher Time Inc.
Issue October 1995
Category Spread/Feature

■148
Publication LIFE
Design Director
Tom Bentkowski
Designer Mimi Park
Photo Editor
Barbara Baker Burrows
Photographer Joe McNally
Publisher Time Inc.
Issue March 1995
Category Spread/Feature

■149
Publication LIFE
Design Director
Tom Bentkowski
Designer Mimi Park
Photo Editor David Friend
Photographer Joe McNally
Publisher Time Inc.
Issue March 1995
Category Spread/Feature

■150
Publication LIFE
Design Director
Tom Bentkowski
Designer Mimi Park
Photo Editors
Barbara Baker Burrows,
Marie Schumann
Photographer James Nachtwey
Publisher Time Inc.
Issue October 1995
Category Spread/Feature

■151
Publication LIFE
Design Director
Tom Bentkowski
Designer Mimi Park
Photo Editor Vivette Porges
Photographer Lisa Spindler
Publisher Time Inc.
Issue February 1995
Category Spread/Feature

77

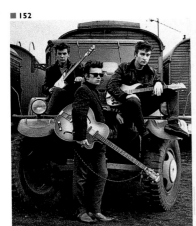

1 9 6 0

8/17 The Beatles begin performing at Bruno Koschmider's Indra club on this, the night of their arrival in Hamburg. They play for seven weeks, despite tiny, hostile audiences, complaints from neighbors and subhuman living conditions in the Bambi Kino, a movie theater across the street. Finally, Koschmider orders them to his more popular Kaiserkeller, where design student Klaus Voormann catches their act. He loves them and returns with his girlfriend, Astrid Kirchherr. She's even more smitten, particularly with Stu ◄ (at center), to whom she becomes engaged. (Stu will leave the band to live blissfully with Astrid but will die of a brain hemorrhage in 1962.) Astrid gives the Beatles a makeover—leather clothes, *those* haircuts—and takes these classic portraits. The Beatles heat up and land a lucrative offer from a rival club, the Top Ten. Koschmider is furious, and suddenly Paul and Pete are arrested for arson, and George is deported for being underage. The lads regroup in England and return triumphantly to the Top Ten the following April. In Hamburg they record their first single, backing fellow Brit Tony Sheridan on a rock treatment of "My Bonnie."

1 9 6 4

2/7 "I Want to Hold Your Hand" rockets to No. 1 on the U.S. charts, and, on this day, Pan Am Flight 101 rockets across the Atlantic bearing four rather insecure moptops. "They've got everything over there," says George. "What do they want us for?" At Kennedy Airport, ▼ 3,000 hysterical Beatlemaniacs greet them. When the lads first glimpse the crowd, they figure the President must be landing. Two days later, a record 73 million people watch them on *The Ed Sullivan Show* (including a lucky few in the studio audience ►). The first name of each Beatle is superimposed on the screen. John's caption has a P.S.: "Sorry, Girls, He's Married."

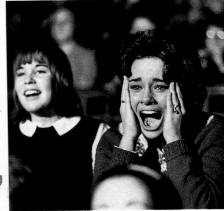

" I remember hearing 'I Want to Hold Your Hand,' and all of a sudden, for the first time in my life, I started dancing. It seemed that the years of wartime repression were really over, or something had begun. People were returning back into their bodies unafraid and were celebrating their physical existence—the dance, which is an old, human ritual. Everybody was moved to dance.
ALLEN GINSBERG, *Rolling Stone* "

Imagine

Imagine the places of your life—your childhood home, your teenage haunts, the city where you first fell in love—made public, a connect-the-dots of tourism. If you were a Beatle, this would be your strange reality. But in the midnight of memory, there are no hordes of fans: Liverpool has no Beatle tours; the Ed Sullivan Theater has no Letterman show; Abbey Road has no out-of-towners replicating the famous walk. LIFE sent photographer Shimon Attie to four cities that defined the Beatles. Some sites he found unchanged, others transformed by time. Using his signature technique of capturing, in a single frame, old images projected on modern streetscapes, Attie created haunting portraits of homecoming and loss. He took the Beatles back.

photography by **Shimon Attie** ■ text by **Allison Adato**

The Cavern Club where the pre-Ringo Beatles reigned is gone. But a replica was built under the slope-roofed building behind this barren lot, and the neighborhood is still a center of nightlife. If Liverpool reminds the world of the Beatles, it has always reminded the Beatles of childhood: Paul of Penny Lane, John of Strawberry Field, George of his home at 12 Arnold Grove. "It was O.K., that house, very pleasant for being little. The worst was going to the big grammar school. That was when the darkness began, and I realized it was raining and clouding with old streets and backward teachers." But still: "Good place to wash your hair, Liverpool. Nice soft water."

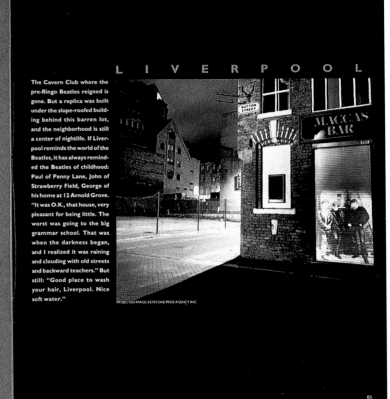

PROJECTED IMAGE: KEYSTONE PRESS AGENCY INC.

■ 152
Publication LIFE
Design Director Tom Bentkowski
Art Director Mimi Park
Designers Mimi Park, Tom Bentkowski
Photo Editors David Friend, Pamela Sztybel Winningham
Photographer Astrid Kirchherr
Publisher Time Inc.
Issue December 1995
Category Spread/Feature

■ 153
Publication LIFE
Design Director Tom Bentkowski
Art Director Mimi Park
Designers Mimi Park, Tom Bentkowski
Photo Editors David Friend, Pamela Sztybel Winningham
Photographers Robert Freeman, Harry Grossman
Publisher Time Inc.
Issue December 1995
Category Spread/Feature

■ 154
Publication LIFE
Design Director Tom Bentkowski
Art Director Mimi Park
Designers Mimi Park, Tom Bentkowski
Photo Editors David Friend, Pamela Sztybel Winningham
Photographer Shimon Attie
Publisher Time Inc.
Issue December 1995
Category Spread/Feature

■ 155

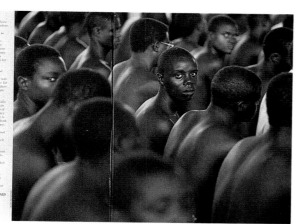

The BIG Picture

■ 156

The Big Picture

Why?

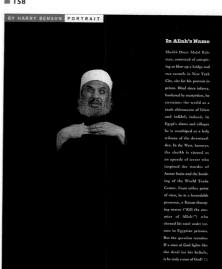

Photographed over the Remarkable Mountains, New Zealand

■ 157

CAMERA AT WORK

Shimon Attie

Documenting a community that no longer exists

Prior to World War II, Berlin had a Jewish community: Jewish homes, businesses and pastry shops, talk of the weather, Talmudic debate, children at play. When Shimon Attie left his native Los Angeles in 1991 to live in Berlin's Scheunenviertel, the former Jewish quarter, what he saw was expected but nonetheless shocking. Not so much as a Hebrew sign bore witness to the culture that was once at home there. Evidence could be found only in archives. By physically superimposing photographic proof on contemporary Berlin, Attie has made pictures that document a lost way of life and ask: What of these people, these ghosts of a city's past?

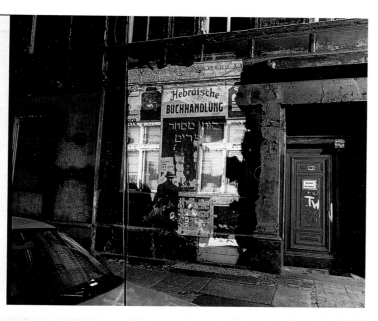

Before becoming a photographer, Attie (left, in Berlin was a psychologist. Right: Almstadtstrasse 43 (formerly Grenadierstrasse 7), Hebrew Bookstore, 1930 (taken in 1992).

■ 158

BY HARRY BENSON PORTRAIT

In Allah's Name

Sheikh Omar Abdel Rahman, convicted of conspiring to blow up a bridge and two tunnels in New York City, sits for his portrait in prison. Blind since infancy, hardened by martyrdom, he envisions the world as a stark chiaroscuro of Islam and infidel; indeed, in Egypt's slums and villages he is worshiped as a holy tribune of the downtrodden. In the West, however, the sheikh is viewed as an apostle of terror who inspired the murder of Anwar Sadat and the bombing of the World Trade Center. From either point of view, he is a formidable presence, a Koran-thumping orator ("Kill the enemies of Allah!") who showed his steel under torture in Egyptian prisons. But the question remains: If a man of God fights like the devil for his beliefs, is he truly a man of God?

Linienstrasse 137, Police Raid on Jewish Residents, 1920 (taken in 1992)

Scouring local archives, Attie found images that had been salvaged from family albums and newspapers of the 1920s and '30s. To locate the places where the pictures were taken, he used a prewar map. (East Germany had renamed many streets.) Once he tracked down a location—or a nearby building of the same era if the original structure was gone—he projected a slide of the historical picture onto its former site and photographed the scene in color. What he creates is an eerie contrast between old and new, sacred and secular. The people in his photographs are unknown to him, but the work is personal. "I didn't lose anyone in a concentration camp," says Attie, whose maternal grandfather left Germany for America before the war. "But like most Jews, I have a strong connection to what happened. From an early age, my parents talked to me about the Holocaust."

"My work deals with memory, history and loss, not just the Holocaust."

"Toward the end of the project, the situation in East Berlin had worsened to where I was harassed and threatened almost every evening."

Berlin today has a small Jewish population. "With their history, German Jews are more restrained," observes Attie. "In America, Jews are more comfortably public about being Jewish." Imagine then the reaction of Berliners to haunting images of a Jewish past beaming through the night sky as Attie was working. "A man in his fifties responded quite emotionally and told me his grandfather had been deported to Auschwitz. A teenager from a German-Israeli friendship group offered to help me." To others, Attie was an unwelcome presence. One man called the police, protesting that his neighbors would think he was Jewish. While projecting a former Hebrew bookstore on its site, Attie recalls, "a man rushed out shouting, 'My father purchased this building fair and square from Mr. Jacob in 1938.' I asked him what happened to Mr. Jacob. He said, 'He was a multimillionaire and moved to New York.'" Someone else doused the photographer and his equipment with water. He remains undeterred. Attie's Acts of Remembrance project moves to Copenhagen's canals, where he will photograph images of Jews rescued by shipping boats during the war. Then on to Cologne, Krakow and Amsterdam. The Berlin pictures appear in his book, The Writing on the Wall. In it, he thanks his father, "who taught me the importance of not looking away from what has gone before." —ALLISON ADATO

Joachimstrasse 11a, Jewish Café with Patrons, 1933 (taken in 1992)

From the book The Writing on the Wall, published by Edition Braus

■ 155
Publication LIFE
Design Director Tom Bentkowski
Designer Jean Andreuzzi
Photo Editor Azurea Lee Dudley
Photographer Jacques Langevin
Publisher Time Inc.
Issue April 1995
Category Department

■ 156
Publication LIFE
Design Director Tom Bentkowski
Designer Jean Andreuzzi
Photo Editor Barbara Baker Burrows
Photographer Stephen Wilkes
Publisher Time Inc.
Issue August 1995
Category Department

■ 157
Publication LIFE
Design Director Tom Bentkowski
Designer Jean Andreuzzi
Photo Editor Vivette Porges
Photographer Shimon Attie
Publisher Time Inc.
Issue November 1995
Category Department

■ 158
Publication LIFE
Design Director Tom Bentkowski
Designer Jean Andreuzzi
Photo Editor David Friend
Photographer Harry Benson
Publisher Time Inc.
Issue November 1995
Category Department

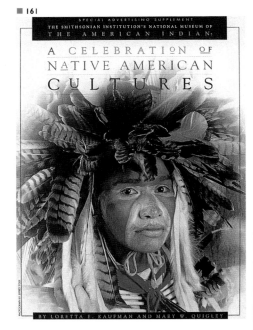

BY TOM WILKINSON

It has the makings of a very bad evening.

You're traveling on business, after dark, in a city that's not really familiar to you. Suddenly, you feel a bump in the road, followed a few seconds later by the sickening *flop-flop-flop* of a flat tire.

As you look for a place to pull over, you see only darkened industrial buildings. There are few cars on the road. There isn't a gas station or convenience store in sight.

What to do? You reach up and push a button on the car's overhead console. A few seconds later, a friendly voice responds over the cellular phone. You may not know where you are, but the operator on the line does.

AUTOMOTIVE INNOVATION

■159
Publication Forbes
Art Director
Susanne Iocca-Fritzlo
Designer Susanne Iocca-Fritzlo
Photographers
Peter Poulides, Tony Stone
Publisher Forbes Inc.
Issue August 28, 1995
Category Department

■160
Publication Forbes
Art Director
Susanne Iocca-Fritzlo
Designer Susanne Iocca-Fritzlo
Illustrator Kayley Le Faiver
Publisher Forbes Inc.
Issue October 16, 1995
Category Department

■161
Publication Forbes
Art Director
Susanne Iocca-Fritzlo
Designer Susanne Iocca-Fritzlo
Photographer Jeffrey Foxx
Publisher Forbes Inc.
Issue October 16, 1995
Category Department

■162
Publication Forbes
Art Director
Susanne Iocca-Fritzlo
Designer Susanne Iocca-Fritzlo
Photographer
General Motors, Inc.
Publisher Forbes Inc.
Issue October 23, 1995
Category Department

■ 163

Take those Pounds and DROP THem.

LOSE WEIGHT NOW

Here's a meal plan you can live with.

By Mindy Hermann, R.D.

■ 164

ARTICLE BY CAROL KAHN · PHOTOGRAPH BY VICTOR SKREBNESKI

living on the edge

■ 165

WORKS VS WORKS

Claris or Microsoft? We pick a VICTOR in the race for best integrated-software program.

by david pogue

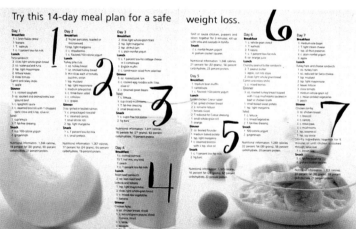

Try this 14-day meal plan for a safe weight loss.

■ 166

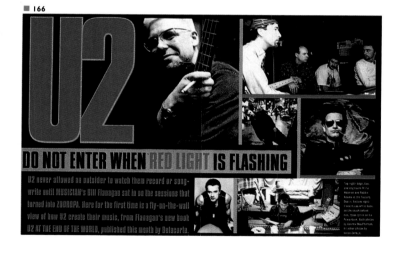

U2

DO NOT ENTER WHEN RED LIGHT IS FLASHING

U2 never allowed an outsider to watch them record or song-write until MUSICIAN's Bill Flanagan sat in on the sessions that turned into ZOOROPA. Here for the first time is a fly-on-the-wall view of how U2 create their music, from Flanagan's new book U2 AT THE END OF THE WORLD, published this month by Delacorte.

■ 163
Publication Living Fit
Creative Director Kathy Nenneker
Art Director John Miller
Designer John Miller
Illustrator Donna Ingemanson
Photo Editor Beth Katz
Photographer Karl Petzke
Publisher Weider Publications
Issue Fall 1995
Category Story/Feature

■ 164
Publication Longevity
Creative Director Frank DeVino
Art Director Cathryn Mezzo
Photographer Victor Skrebneski
Category Spread/Feature

■ 165
Publication Macworld
Design Director Dennis McLeod
Art Director Kent Tayenaka
Designer Tim Johnson
Illustrator Glenn Mitsui
Publisher Macworld Communications
Issue November 1995
Category Spread/Feature

■ 166
Publication Musician
Art Director Robin Lee Malik
Designer Robin Lee Malik
Photographers
Andrew Macpherson, Anton Corbijn
Publisher BPI Publications
Category Spread/Feature

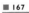

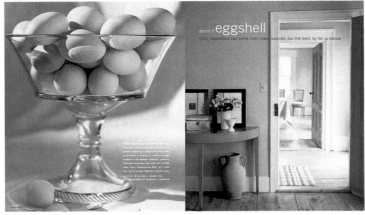

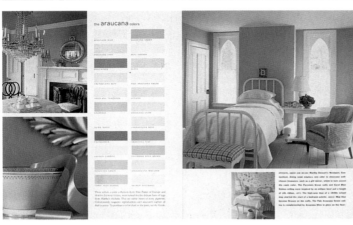

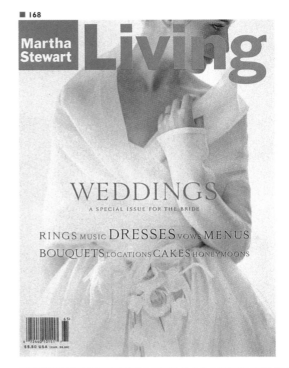

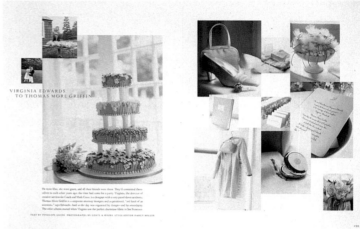

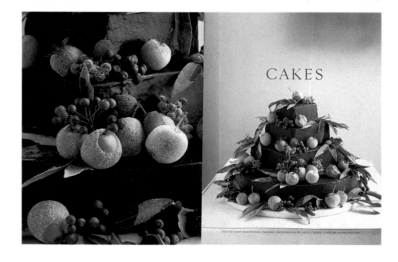

■ 167
Publication Martha Stewart Living
Creative Director Gael Towey
Art Director Eric A. Pike
Designers Gael Towey, Eric A. Pike, Agnethe Glatved,
Constance Old, Claudia Bruno, Scot Schy, Anne-Marie Midy
Photo Editor Heidi Posner
Photographers Thibault Jeansen, Dana Gallagher, Maria Robledo
Publisher Time Inc.
Issue April 1995
Category Entire Issue

■ 168
Publication Martha Stewart Living
Creative Director Gael Towey
Art Directors Eric A. Pike, Claudia Bruno
Designers Claudia Bruno, Gael Towey, Eric A. Pike,
Agnethe Glatved, Scot Schy, Britta Steinbrecht, Anne-Marie Midy
Photo Editor Heidi Posner
Photographers Victoria Pearson, Victor Schrager, Stewart Ferebee
Publisher Time Inc.
Issue December 1995
Category Entire Issue

■ 169

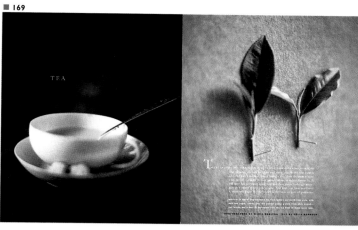

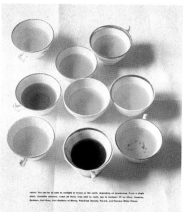

■ 170

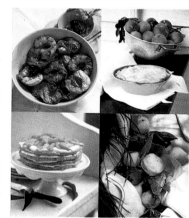

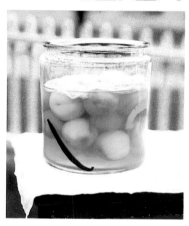

■ 169
Publication Martha Stewart Living
Creative Director Gael Towey
Art Director Eric A. Pike
Designer Claudia Bruno
Photo Editor Heidi Posner
Photographer Maria Robledo
Publisher Time Inc.
Issue March 1995
Category Story/Feature

■ 170
Publication Martha Stewart Living
Creative Director Gael Towey
Designer Gael Towey
Photo Editor Heidi Posner
Photographer Christopher Baker
Publisher Time Inc.
Issue July 1995
Category Story/Feature

marzipan

It is to scrubbing behind your ears what fresh corn is to eating your vegetables. An outdoor shower is more morning swim than daily bath. No Puritan notion of cleanliness interferes. But godliness it is. And though it removes dirt, you may forget to wash. Anyone ever caught in a summer rainstorm has some idea of what showering outdoors is like. Unlike the heavens, it's a change in the weather you can engineer.

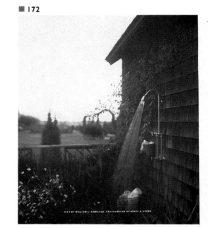

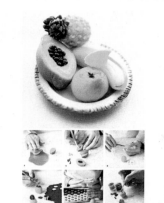

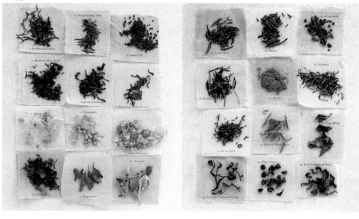

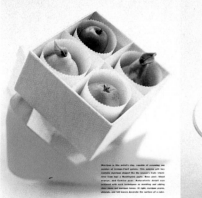

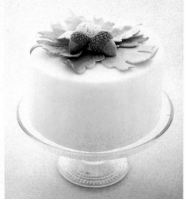

transfer WARE

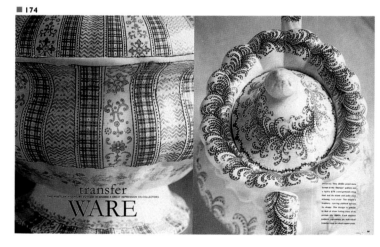

■ 171

Publication Martha Stewart Living
Creative Director Gael Towey
Art Director Eric A. Pike
Designer Claudia Bruno
Photo Editor Heidi Posner
Photographer Carlton Davis
Publisher Time Inc.
Issue October 1995
Category Story/Feature

■ 172

Publication Martha Stewart Living
Creative Director Gael Towey
Art Director Eric A. Pike
Designer Agnethe Glatved
Photo Editor Heidi Posner
Photographer Gentl & Hyers
Publisher Time Inc.
Issue July 1995
Category Spread/Feature

■ 173

Publication Martha Stewart Living
Creative Director Gael Towey
Designer Gael Towey
Photo Editor Heidi Posner
Photographer Christopher Baker
Publisher Time Inc.
Issue July 1995
Category Spread/Feature

■ 174

Publication Martha Stewart Living
Creative Director Gael Towey
Art Director Eric A. Pike
Designer Claudia Bruno
Photo Editor Heidi Posner
Photographer Maria Robledo
Publisher Time Inc.
Issue November 1995
Category Spread/Feature

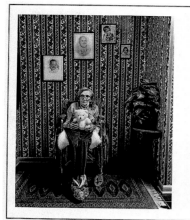

CONSUMER SCAMS

by Marlys J. Harris

ELDER FRAUD

Con artists STEAL BILLIONS from SENIORS each year—or worse. Here's how to protect LOVED ONES.

Photographs by Mary Ellen Mark

RATING THE BROKERS

WHICH BROKERAGE FIRMS TREAT YOU RIGHT, WHICH DON'T

AND WHAT YOU CAN DO ABOUT IT TODAY

Our exclusive undercover test shows you don't always get top service from full-service firms.

by Ruth Simon

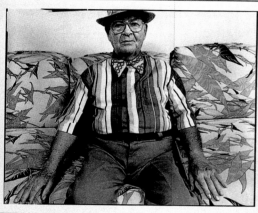

CONSUMER SCAMS

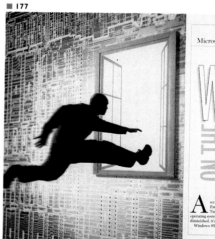

systems

Microsoft's new operating software is much improved.
But don't write off Macs just yet.

WINDOWS ON THE WORLD

BY KATIE HAFNER

The STAKES can be HUGE. "It's not unusual to see losses of $10,000, $50,000, $100,000 or more," says a legal official.

choices

SHOP RIGHT

Buying entertainment software can be exasperating and expensive. Here's how to avoid the pitfalls.

BY BRONWYN FRYER

■ 175
Publication Money
Art Director Rudy Hoglund
Designer Scott A. Davis
Photo Editors Deborah Pierce, Leslie Yoo
Photographer Mary Ellen Mark
Publisher Time Inc.
Issue November 1995
Category Story/Feature

■ 176
Publication Money
Art Director Rudy Hoglund
Designer Scott A. Davis
Illustrator Gary Baseman
Publisher Time Inc.
Issue April 1995
Category Spread/Feature

■ 177
Publication Newsweek: Computers & the Family
Art Director Miriam Campiz
Designer Miriam Campiz
Photographer William Duke
Publisher Newsweek Inc.
Issue October 1995
Category Spread/Feature

■ 178
Publication Newsweek: Computers & the Family
Art Director Miriam Campiz
Designer Miriam Campiz
Illustrator Matt Groening
Publisher Newsweek Inc.
Issue October 1995
Category Spread/Feature

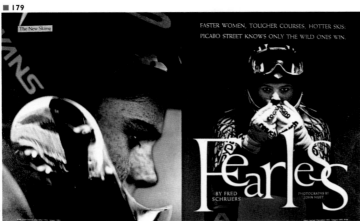
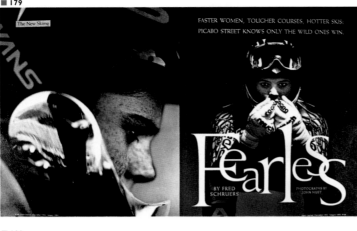

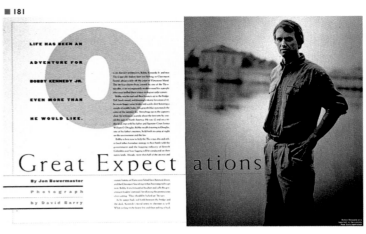
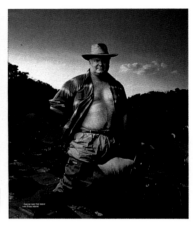

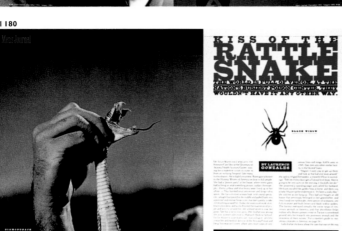

■ 184

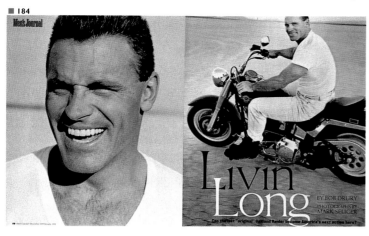

■ 187

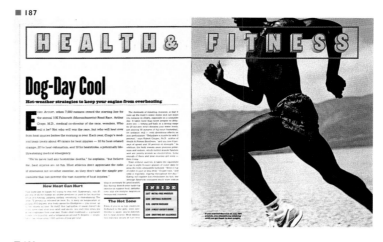

■ 185

■ 186

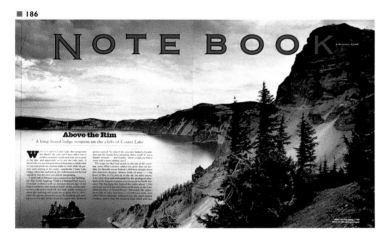

■ 188

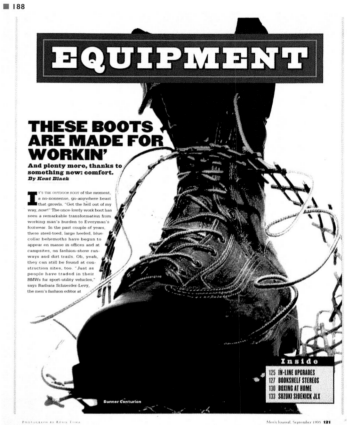

■ 184
Publication Men's Journal
Art Director Mark Danzig
Designer Mark Danzig
Photo Editor Deborah Needleman
Photographer Mark Seliger
Publisher Wenner Media
Issue December 1995
Category Spread/Feature

■ 185
Publication Men's Journal
Art Director Mark Danzig
Designer Susan Dazzo
Photo Editor Kim Gougenheim
Photographer Mark Hanauer
Publisher Wenner Media
Issue February 1995
Category Department

■ 186
Publication Men's Journal
Art Director Mark Danzig
Designer Susan Dazzo
Photo Editor Kim Gougenheim
Photographer Len Jenshel
Publisher Wenner Media
Issue March 1995
Category Department

■ 187
Publication Men's Journal
Art Director Mark Danzig
Designer Susan Dazzo
Photo Editor Deborah Needleman
Photographer John Huet
Publisher Wenner Media
Issue June 1995
Category Department

■ 188
Publication Men's Journal
Art Director Mark Danzig
Designer Dirk Barnett
Photo Editor Deborah Needleman
Photographer Kenji Toma
Publisher Wenner Media
Issue September 1995
Category Department

PHIL JACKS N

THE MEN'S JOURNAL INTERVIEW

THE Zen HOOPSTER

BY BILL BRASHLER

PHOTOGRAPHS BY TOM WOLFF

Does Buddhist philosophy have relevance in the rough-and-tumble NBA? Of course, Grasshopper.

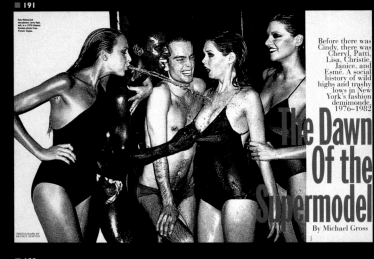

Before there was Cindy, there was Cheryl, Patti, Lisa, Christie, Janice, and Esmé. A social history of wild highs and trashy lows in New York's fashion demimonde, 1976–1982

The Dawn Of the Supermodel

By Michael Gross

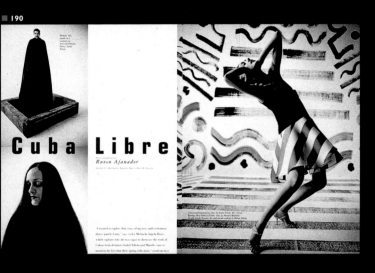

Cuba Libre

Presented by Raven Ajanador

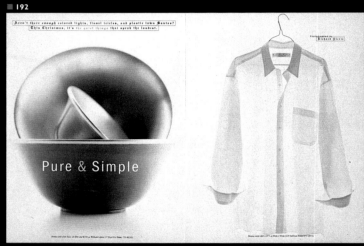

Aren't there enough colored lights, tinsel icicles, and plastic lawn Santas? This Christmas, it's the quiet things that speak the loudest.

Pure & Simple

More than 80 people were interviewed for this piece. They came from many different disciplines. They had wildly competitive agendas. But there was one thing they all agreed on: It's coming.

They disagreed on how big, how devastating, how soon. But this, no one denies—we're going to see an earthquake. In New York City. And we're not ready for it. Columbia University seismologist Klaus Jacob knows why.

WAITING FOR THE BIG ONE

MAYBE NOT TODAY, MAYBE NOT TOMORROW. BUT MANY SCIENTISTS AGREE: A QUAKE IS COMING. AND NEW YORK ISN'T READY FOR IT.

By Fred Graver and Charlie Rubin

■ 189
Publication Men's Journal
Art Director Mark Danzig
Designer Mark Danzig
Photo Editor Deborah Needleman
Photographer Tom Wolff
Publisher Wenner Media
Issue November 1995
Category Spread/Feature

■ 190
Publication New York
Design Director Robert Best
Art Director Syndi Becker
Designer Robert Best
Photo Editors Margery Goldberg, Jordan Schaps
Publisher K-III Publications
Issue February 27, 1995
Category Spread/Feature

■ 191
Publication New York
Design Director Robert Best
Art Director Syndi Becker
Designer Robert Best
Photo Editors Margery Goldberg, Sabine Meyer
Photographer Helmut Newton
Publisher K-III Publications
Issue April 3, 1995
Category Spread/Feature

■ 192
Publication New York
Design Director Robert Best
Art Director Syndi Becker
Designers Robert Best, Syndi Becker, Deanna Lowe
Photo Editors Margery Goldberg, Jordan Schaps
Photographer Richard Pierce
Publisher K-III Publications
Issue December 4, 1995
Category Spread/Feature

■ 193
Publication New York
Design Director Robert Best
Art Director Syndi Becker
Designer Deanna Lowe
Photo Editors Margery Goldberg, Nakyung Han
Photographer Paul Thompson
Publisher K-III Publications
Issue December 11, 1995
Category Spread/Feature

■194

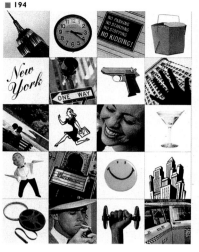

BY MARK J. PENN AND DOUGLAS E. SCHOEN

A
TALE OF
FOUR
CITIES

THE 1995 NEW YORK
NEW YORK POLL

PHOTOGRAPHED BY
JOANNE DUGAN

The question isn't What is a typical New Yorker? but Which typical New Yorker?
A citywide poll reveals that New York is home to four different typical New
Yorkers, all living very different lives in, for all practical purposes, different cities.

■195

The
Whole
Enchi-
lada

Finally: Mexican food gets real. From
midtown to the barrios, from taco trucks
to haute outposts, Gael Greene's
Baedeker to the current boom

■196

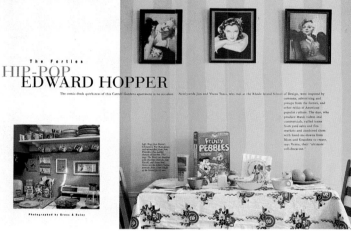

The Forties
HIP-POP
EDWARD HOPPER

The comic-book quirkiness of this Carroll Gardens apartment is no accident.

Photographed by Gross & Daley

■197

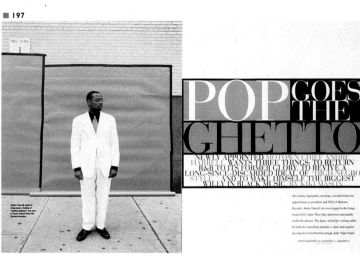

POP GOES
THE
GHETTO

NEWLY APPOINTED MOTOWN CHIEF ANDRE
HARRELL WANTS THREE THINGS TO RETURN
R&B TO ITS FORMER GLORY, TO REVIVE A
LONG-SINCE-DISCARDED IMAGE OF THE NEGRO
A WAY IN BLACK MUSIC HE THE BIGGEST

PHOTOGRAPHED BY GEOFFROY de BOISMENU

■194

Publication New York
Design Director Robert Best
Art Director Syndi Becker
Designer Syndi Becker
Photo Editors Margery Goldberg,
Sabine Meyer
Photographer Joanne Dugan
Publisher K-III Publications
Issue August 21, 1995
Category Story/Feature

■195

Publication New York
Design Director Robert Best
Art Director Syndi Becker
Designer Deanna Lowe
Photo Editor Margery Goldberg
Photographer Karen Capucilli
Publisher K-III Publications
Issue January 23, 1995
Category Spread/Feature

■196

Publication New York
Design Director Robert Best
Art Director Syndi Becker
Designer Syndi Becker
Photo Editors Margery Goldberg,
Jordan Schaps
Photographer Gross + Daley
Publisher K-III Publications
Issue March 27, 1995
Category Spread/Feature

■197

Publication New York
Design Director Robert Best
Art Director Syndi Becker
Designer Deanna Lowe
Photo Editors Margery Goldberg,
Sabine Meyer
Photographer Geoffroy de Boismenu
Publisher K-III Publications
Issue October 23, 1995
Category Spread/Feature

PHOTOGRAPHERS HAVE PLAYED A CENTRAL ROLE IN

PORTRAITS

SHAPING THE WAY WE THINK AND FEEL ABOUT THIS CITY

OF THE CITY

AND IN TELLING TRUTHS WE'D RATHER LEAVE UNSAID

BY LUC SANTE

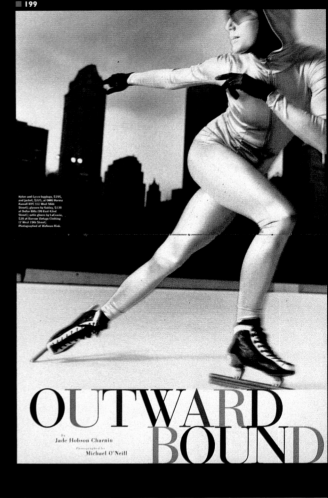

Nylon and Lycra leggings, $195, and jacket, $225, at OMO Norma Kamali NYC (11 West 56th Street); glasses by Oakley, $130 at Dollar Bills (99 East 42nd Street); satin gloves by LaCrasia, $20 at Barrow Vintage Clothing (9 West 19th Street). Photographed at Wollman Rink.

THE NEW YORK 400 MAY BE A RELIC, BUT THE NEW NEW YORK 600 HAS NO TROUBLE DISPORTING ITSELF IN SUITABLY REGAL STYLE. NOW, OF COURSE, IT'S ALL DONE FOR CHARITY.

OUTWARD BOUND

By Jade Hobson Charnin

Photographed by Michael O'Neill

■ 198
Publication New York
Design Director Robert Best
Art Director Syndi Becker
Designers Robert Best, Syndi Becker, Deanna Lowe, Vita Parrino
Photo Editors Margery Goldberg, Sabine Meyer, Nakyung Han, Yvonne Stender
Publisher K-III Publications

■ 199
Publication New York
Design Director Robert Best
Art Director Syndi Becker
Designer Robert Best
Photo Editor Margery Goldberg
Photographer Michael O'Neill
Publisher K-III Publications

■ 200

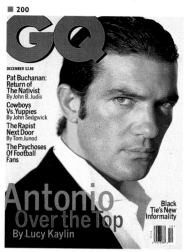

■ 201

Getting Borked

By JOSEPH NOCERA

■ 202

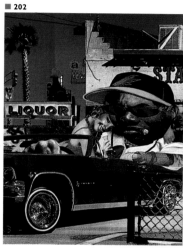

Requiem FOR A gangsta

BY MIKE SAGER

ILLUSTRATION BY EDMUND GUY

valentino's

■ 358

FICTION
The Long Voyage Home

Dietrich and the Duke? A-yup

BY DAN BARDEN

■ 204

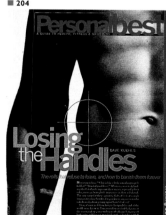

Personal best

Losing the Handles

■ 200

Publication GQ
Art Director John Korpics
Designers Susan Dazzo, Rina Migliaccio
Photo Editor Karen Frank
Photographers Michael O'Neill, Mathew Rolston
Publisher Condé Nast Publications Inc.
Issue December 1995
Category Redesign

■ 201

Publication GQ
Art Director John Korpics
Designer John Korpics
Illustrator Anita Kunz
Issue September 1995
Publisher Condé Nast Publications Inc.
Category Spread/Feature

■ 202

Publication GQ
Art Director John Korpics
Designer John Korpics
Illustrator Edmund Guy
Publisher Condé Nast Publications Inc.
Issue November 1995
Category Spread/Feature

■ 203

Publication GQ
Art Director John Korpics
Designer Rina Migliaccio
Illustrator C. F. Payne
Publisher Condé Nast Publications Inc.
Issue October 1995
Category Department

■ 204

Publication GQ
Art Director John Korpics
Designer Rina Migliaccio
Photographer John Huet
Publisher Condé Nast Publications Inc.
Issue December 1995
Category Department

SPEED

THEY ARE HUMAN BULLETS.
Their world is defined by 100-meter lengths of track.
Their goal? To run as fast as a body can. Then faster.

BY DANIEL COYLE Photographs by MICHAEL LLEWELLYN

COMPRESSED AS A DIAMOND, THE 100 METERS IS ABSTRACT EXPRESSIONISM, A VIOLENT ACT OF CREATION.

THEY CAN'T REVEAL A CRACK IN THE BRITTLE CUTICLE WRAPPING THE SELF. AS THE SAYING GOES, THE RACE IS 100 METERS LONG AND ONE LANE WIDE.

LOVING THEM TO
DEATH

It's the "wilderness experience" at its most extreme—rehabilitation of wayward teenagers delivered with the in-your-face discipline of a boot camp. But in the past five years at least four young people have died, the victims of alleged beatings, starvation, and emotional abuse, and the so-called therapy is looking more like murder.

BY JON KRAKAUER

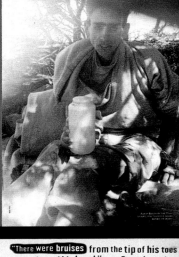

"There were bruises from the tip of his toes to the top of his head," says Bacon's mother.

CAVEAT EMPTORIUM

A user's guide to a very iffy marketplace

■ 205
Publication Outside
Creative Director Susan Casey
Designer Susan Casey
Photo Editor Susan B. Smith
Photographer Michael Llewellyn
Publisher Mariah Media
Issue June 1995
Category Story/Feature

■ 206
Publication Outside
Creative Director Susan Casey
Designer David Allen
Photo Editor Susan B. Smith
Photographers Mike Hill,
Joe Morgenstern, Jon Krakauer
Publisher Mariah Media
Issue October 1995
Category Story/Feature

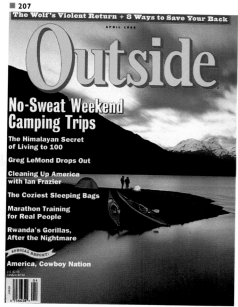

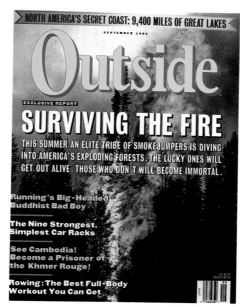

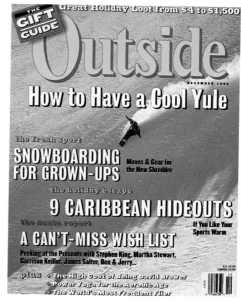

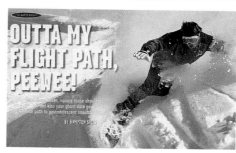

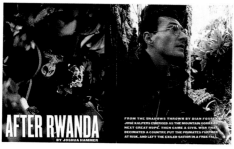

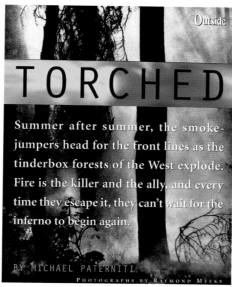

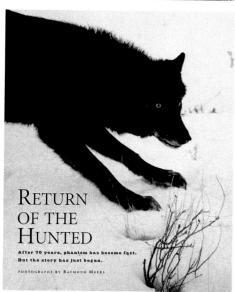

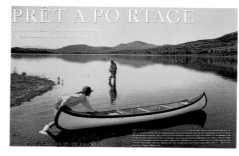

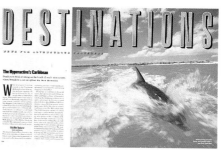

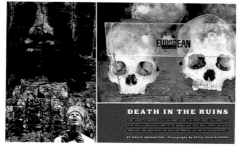

■ 207
Publication Outside
Creative Director Susan Casey
Art Directors David Allen, David Cox
Designers Susan Casey, David Allen, David Cox
Photo Editor Susan B. Smith
Publisher Mariah Media
Issues April 1995, September 1995, December 1995
Category Overall

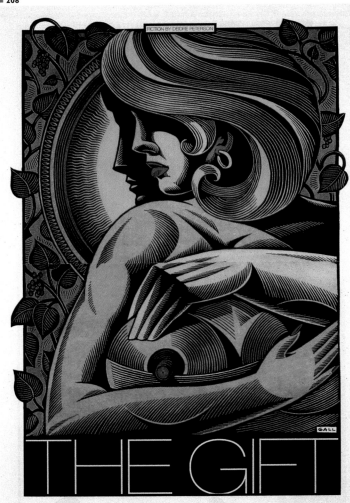

FICTION BY DEIDRE PETERSON

GALL

THE GIFT

THE **LANDLADY** AND

Fiction by Mary Bringle
Illustrations by Janet Woolley

The room was clean, airy and it offered a nice view. The rent was cheap, and the "kitchen privileges" were wide open

THE **BLINDMAN**

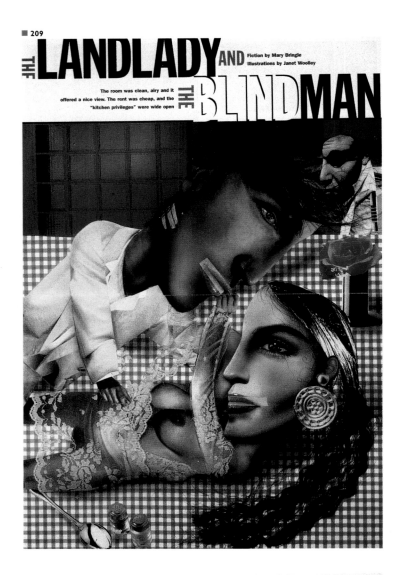

TRACY AND TODD WERE LOVERS

BY CARMEN FICARRA
Like a lot of girls who've been told they're pretty as a princess one too many times, Tracy Lippard dreamed of being a queen. A beauty queen, headed straight for the top as Miss America. When she's NEWS LETTER finally behind bars, she'll probably still fantasize about walking down that runway in Atlantic City in her gown, tiara and high heel shoes, carrying the trademark bouquet of red roses bestowed each year upon the woman crowned America's number-one sweetheart. Instead, she ultimately became famous for carrying not a bouquet of roses,

Brooks

■ 208
Publication Penthouse Letters
Creative Director Frank DeVino
Art Directors Tim Baldwin, Michael F. Di Ioia
Designers Rommel Alama, Michael F. Di Ioia
Illustrator Chris Gall
Publisher General Media Inc.
Issue September 5, 1995
Category Single/Feature

■ 209
Publication Penthouse Letters
Creative Director Frank DeVino
Art Director Michael F. Di Ioia
Designers Michael F. Di Ioia, Tim Baldwin, Rommel Alama
Illustrator Janet Woolley
Publisher General Media Inc.
Issue October 5, 1995
Category Single/Feature

■ 210
Publication Penthouse Letters
Creative Director Frank DeVino
Art Director Michael F. Di Ioia
Designers Kervin Ligasan, Tim Baldwin, Michael F. Di Ioia
Publisher General Media Inc.
Illustrator Lou Brooks
Category Spread/Feature

■ 211

Article by Joseph Bosco

NOTES FROM CAMP O.J.

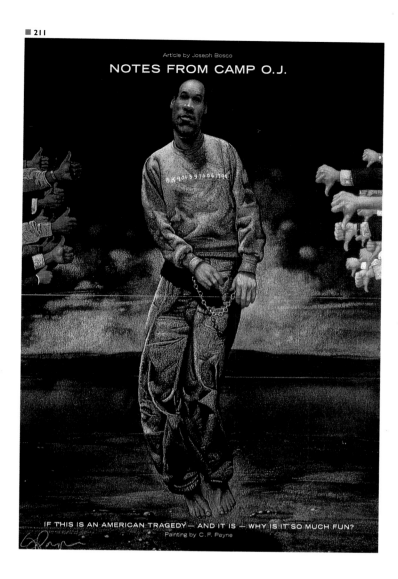

IF THIS IS AN AMERICAN TRAGEDY — AND IT IS — WHY IS IT SO MUCH FUN?
Painting by C. F. Payne

■ 212

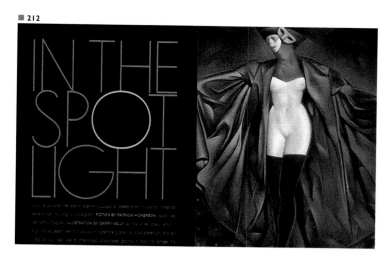

IN THE
SPOT
LIGHT

■ 213

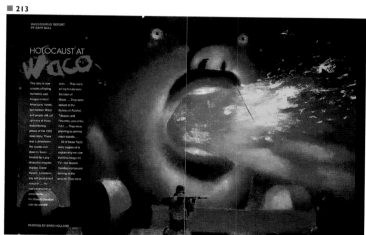

INVESTIGATIVE REPORT
BY GARY NULL

HOLOCAUST AT
WACO

PAINTING BY BRAD HOLLAND

■ 211
Publication Penthouse
Creative Director Frank DeVino
Art Director David Curcurito
Designers Allison Brown, Mike McClellan
Illustrator C. F. Payne
Publisher General Media Inc.
Issue October 1995
Category Single/Feature

■ 212
Publication Penthouse Letters
Creative Director Frank DeVino
Art Directors Michael F. Di Ioia, Tim Baldwin
Designers Michael F. Di Ioia,
Tim Baldwin, Gary Kelley
Illustrator Garry Kelly
Publisher General Media Inc.
Issue October 1995
Category Spread/Feature

■ 213
Publication Penthouse
Creative Director Frank DeVino
Art Director David Curcurito
Designers Mike McClellan, Allison Brown
Illustrator Brad Holland
Publisher General Media Inc.
Category Spread/Feature

■ 214

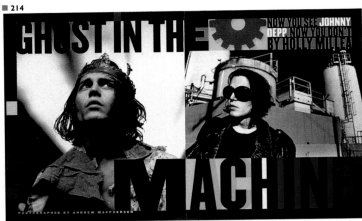

GHOST IN THE

NOW YOU SEE JOHNNY DEPP. NOW YOU DON'T
BY HOLLY MILLEA

MACHINE

PHOTOGRAPHED BY ANDREW MACPHERSON

■ 217

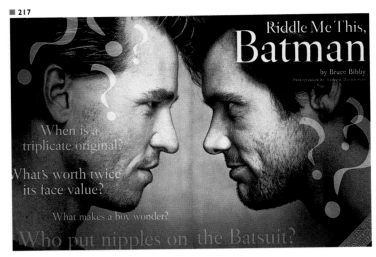

Riddle Me This,
Batman
by Bruce Bibby
Photographed by Andrew Macpherson

When is a triplicate original?

What's worth twice its face value?

What makes a boy wonder?

Who put nipples on the Batsuit?

■ 215

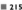

by Peter Biskind

Viv La Litte

Miranda Richardson adds 'Tom & Viv' to her growing list of scene-stealers

T.S. Eliot's wife is

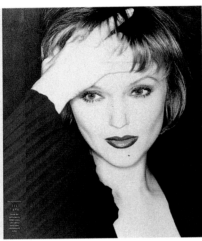

■ 218

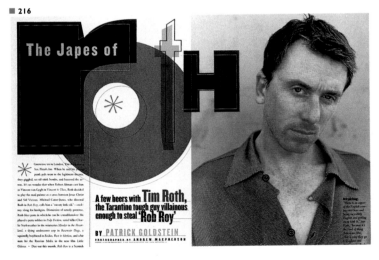

SAM

SUMMER PREVIEW '95

I

AM

He may have lost the Oscar, but the star of 'Die Hard With a Vengeance' is winning the war

BY CLAUDIA DREIFUS

■ 216

The Japes of ROTH

A few beers with Tim Roth, the Tarantino tough guy villainous enough to steal 'Rob Roy'

BY PATRICK GOLDSTEIN

PHOTOGRAPHED BY ANDREW MACPHERSON

■ 219

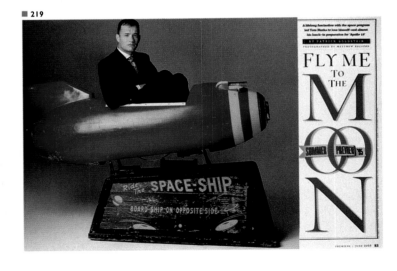

A lifelong fascination with the space program led Tom Hanks to lose himself—and almost his lunch—in preparation for 'Apollo 13'

BY PATRICK GOLDSTEIN

PHOTOGRAPHED BY MATTHEW ROLSTON

FLY ME TO THE MOON

SUMMER PREVIEW '95

Ride The SPACE-SHIP
BOARD SHIP ON OPPOSITE SIDE

■ 214
Publication Premiere
Art Director John Korpics
Designer John Korpics
Photo Editor Chris Dougherty
Photographer Andrew Macpherson
Publisher Hachette Filipacchi Magazines, Inc.
Issue February 1995
Category Spread/Feature

■ 215
Publication Premiere
Art Director John Korpics
Designer David Matt
Photo Editor Chris Dougherty
Photographer Bob Frame
Publisher Hachette Filipacchi Magazines, Inc.
Issue March 1995
Category Spread/Feature

■ 216
Publication Premiere
Art Director John Korpics
Designer John Korpics
Photo Editor Chris Dougherty
Photographer Andrew Macpherson
Publisher Hachette Filipacchi Magazines, Inc.
Issue April 1995
Category Spread/Feature

■ 217
Publication Premiere
Art Director John Korpics
Designer John Korpics
Photo Editor Chris Dougherty
Photographer Andrew Macpherson
Publisher Hachette Filipacchi Magazines, Inc.
Issue May 1995
Category Spread/Feature

■ 218
Publication Premiere
Art Director John Korpics
Designer John Korpics
Photo Editor Chris Dougherty
Photographer Firooz Zahedi
Publisher Hachette Filipacchi Magazines, Inc.
Issue May 1995
Category Spread/Feature

■ 219
Publication Premiere
Art Director John Korpics
Designer John Korpics
Photo Editor Chris Dougherty
Photographer Matthew Rolston
Publisher Hachette Filipacchi Magazines, Inc.
Issue June 1995
Category Spread/Feature

■ 220

REVENGE OF THE KILLER TOMATO

■ 222

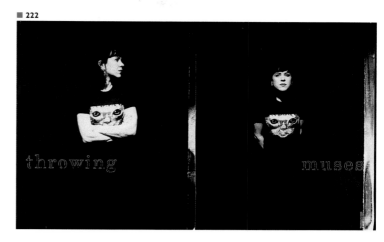

throwing *muses*

■ 221

RUSHES
EARVIN RENEWAL

With his new chain of high-tech theaters, **Magic Johnson** gives the inner city a home-court advantage

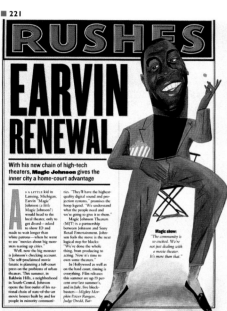

■ 223

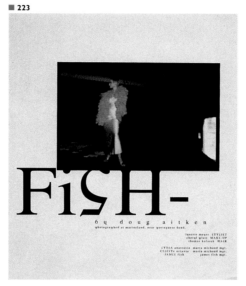

FiSH-
by doug aitken

■ 224

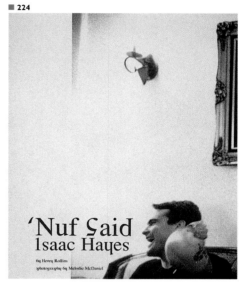

'Nuf Said
Isaac Hayes

by Henry Rollins
photography by Melodie McDaniel

■ 225

■220
Publication Premiere
Art Director David Matt
Designer David Matt
Photo Editor
Chris Dougherty
Photographer
Andrew Macpherson
Publisher Hachette
Filipacchi Magazines, Inc.
Issue December 1995
Category Spread/Feature

■221
Publication Premiere
Art Director
John Korpics
Designer David Matt
Illustrator Mark Ulriksen
Photo Editor
Chris Dougherty
Publisher Hachette
Filipacchi Magazines, Inc.
Issue July 1995
Category Department

■222
Publication Ray Gun
Design Director
David Carson
Designer David Carson
Category Spread/Feature

■223
Publication Ray Gun
Design Director
David Carson
Designer David Carson
Category Single/Feature

■224
Publication Ray Gun
Design Director
David Carson
Designer David Carson
Category Spread/Feature

■225
Publication Ray Gun
Design Director
David Carson
Designer David Carson
Category Single/Feature

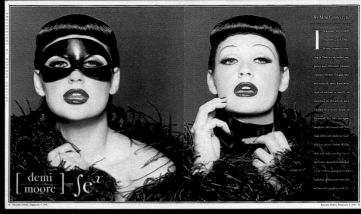

226
Publication Ray Gun
Design Director
David Carson
Designer David Carson
Category Spread/Feature

227
Publication Ray Gun
Design Director
David Carson
Designer David Carson
Category Spread/Feature

228
Publication Ray Gun
Design Director
David Carson
Designer David Carson
Category Spread/Feature

229
Publication
Rolling Stone
Creative Director
Fred Woodward
Designers
Fred Woodward,
Gail Anderson
Photo Editor
Jodi Peckman
Photographer
Matthew Rolston
Publisher Wenner Media
Issue February 9, 1995
Category Spread/Feature

230
Publication
Rolling Stone
Creative Director
Fred Woodward
Designer Lee Bearson
Publisher Wenner Media
Issue April 6, 1995
Category Spread/Feature

231
Publication
Rolling Stone
Creative Director
Fred Woodward
Designer Gail Anderson
Illustrator
Gary Baseman
Publisher Wenner Media
Issue April 20, 1995
Category Spread/Feature

■ 232

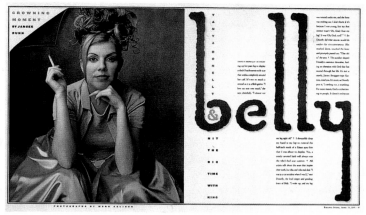

■ 235

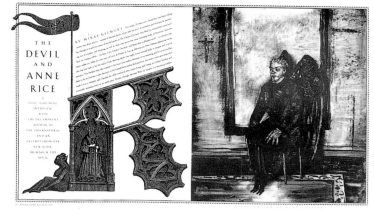

■ 233

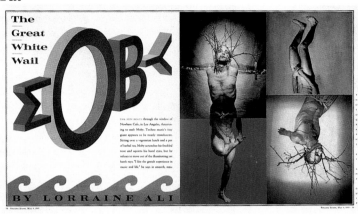

■ 236

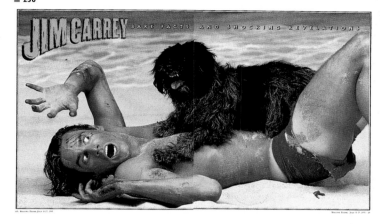

■ 234

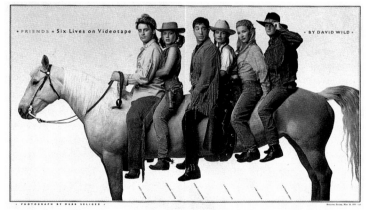

■ 237

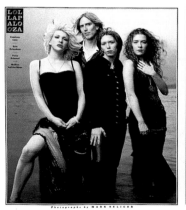

■ 232	■ 233	■ 234	■ 235	■ 236	■ 237
Publication Rolling Stone	**Publication** Rolling Stone	**Publication** Rolling Stone	**Publication** Rolling Stone	**Publication** Rolling Stone	**Publication** Rolling Stone
Creative Director Fred Woodward	**Creative Director** Fred Woodward	**Creative Director** Fred Woodward	**Creative Director** Fred Woodward	**Creative Director** Fred Woodward	**Creative Director** Fred Woodward
Designers Fred Woodward, Geraldine Hessler	**Designers** Fred Woodward, Lee Bearson	**Designers** Fred Woodward,	**Designer** Geraldine Hessler	**Designers** Fred Woodward, Gail Anderson	**Designers** Fred Woodward, Geraldine Hessler
Photo Editor Jodi Peckman	**Photo Editor** Denise Sfraga	**Photo Editor** Jodi Peckman	**Illustrator** John Collier	**Photo Editor** Jodi Peckman	**Photo Editor** Jodi Peckman
Photographer Mark Seliger	**Photographer** Amy Guip	**Photographer** Mark Seliger	**Publisher** Wenner Media	**Photographer** Herb Ritts	**Photographer** Mark Seliger
Publisher Wenner Media	**Publisher** Wenner Media	**Publisher** Wenner Media	**Issue** July 13-27, 1995	**Publisher** Wenner Media	**Publisher** Wenner Media
Issue April 20, 1995	**Issue** May 4, 1995	**Issue** May 18, 1995	**Category** Spread/Feature	**Issue** July 13-27, 1995	**Issue** August 24, 1995
Category Spread/Feature	**Category** Spread/Feature	**Category** Spread/Feature		**Category** Spread/Feature	**Category** Spread/Feature

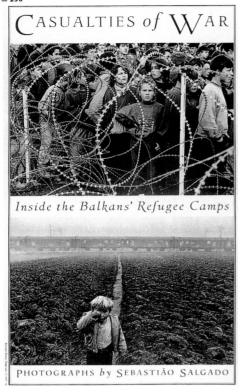

CASUALTIES of WAR

Inside the Balkans' Refugee Camps

PHOTOGRAPHS *by* SEBASTIÃO SALGADO

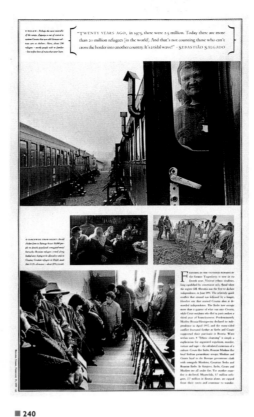

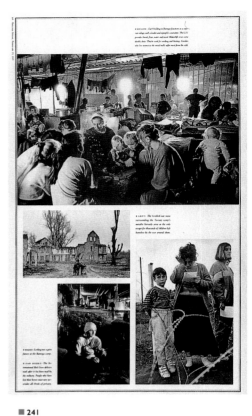

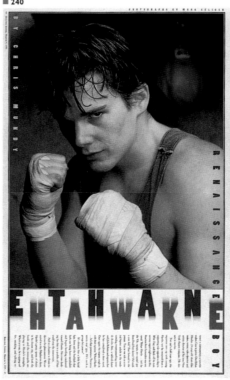

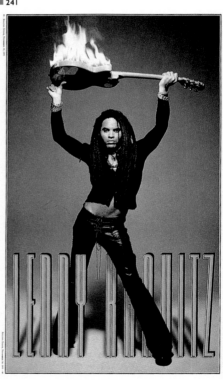

■238
Publication Rolling Stone
Creative Director Fred Woodward
Designers Fred Woodward,
Gail Anderson
Photo Editor Jodi Peckman
Photographer Sebastião Salgado
Publisher Wenner Media
Issue February 23, 1995
Category Story/Feature

■239
Publication Rolling Stone
Creative Director Fred Woodward
Designers Fred Woodward,
Gail Anderson, Geraldine Hessler,
Lee Bearson, Eric Siry
Illustrator James Pendergrast
Photo Editor Jodi Peckman
Photographer Kate Garner
Publisher Wenner Media
Issue December 28, 1995
Category Department

■240
Publication Rolling Stone
Creative Director Fred Woodward
Designers Fred Woodward,
Geraldine Hessler
Photo Editor Jodi Peckman
Photographer Mark Seliger
Publisher Wenner Media
Issue March 9, 1995
Category Spread/Feature

■241
Publication Rolling Stone
Creative Director Fred Woodward
Designers Fred Woodward,
Geraldine Hessler
Photo Editor Jodi Peckman
Photographer Matthew Rolston
Publisher Wenner Media
Issue November 30, 1995
Category Spread/Feature

■ 242

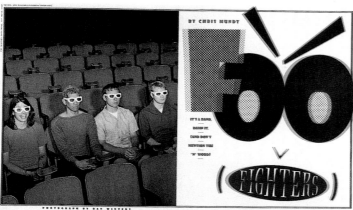

■ 245

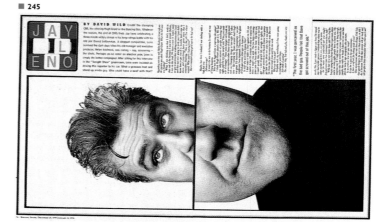

■ 243

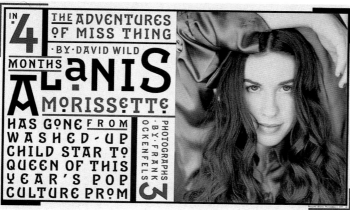

■ 246

■ 244

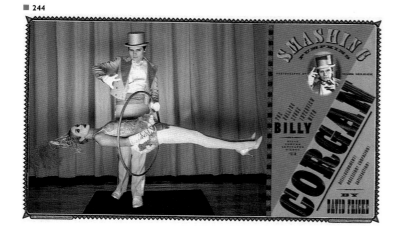

■ 242
Publication Rolling Stone
Creative Director
Fred Woodward
Designer Gail Anderson
Photo Editor Jodi Peckman
Photographer Dan Winters
Publisher Wenner Media
Issue October 5, 1995
Category Spread/Feature

■ 243
Publication Rolling Stone
Creative Director
Fred Woodward
Designers Fred Woodward,
Geraldine Hessler
Photo Editor Jodi Peckman
Photographer
Frank Ockenfels 3
Publisher Wenner Media
Issue October 5, 1995
Category Spread/Feature

■ 244
Publication Rolling Stone
Creative Director
Fred Woodward
Designers Fred Woodward,
Geraldine Hessler
Photo Editor Jodi Peckman
Photographer Mark Seliger
Publisher Wenner Media
Issue November 16, 1995
Category Spread/Feature

■ 245
Publication Rolling Stone
Creative Director
Fred Woodward
Designers Fred Woodward,
Gail Anderson
Photo Editor Jodi Peckman
Photographer Mark Seliger
Publisher Wenner Media
Issue December 28, 1995
Category Spread/Feature

■ 246
Publication Rolling Stone
Creative Director
Fred Woodward
Designers Fred Woodward,
Geraldine Hessler
Publisher Wenner Media
Issue August 24, 1995
Category Department

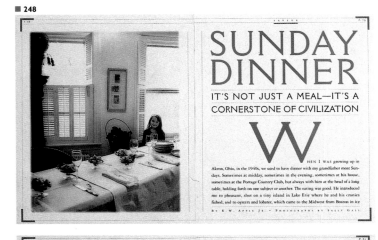

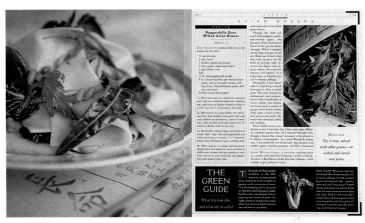

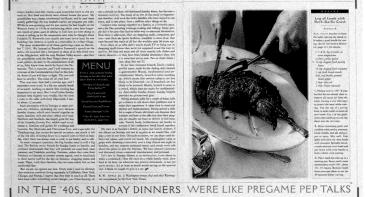

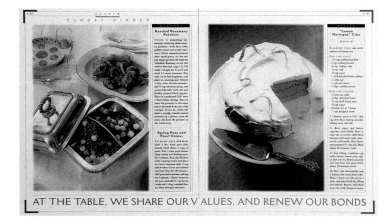

■ 247
Publication Saveur
Creative Director Michael Grossman
Art Director Jill Armus
Designer Jill Armus
Photo Editor Susan Goldberger
Photographer Christopher Hirsheimer
Publisher Meigher Communications
Issue March/April 1995
Category Story/Feature

■ 248
Publication Saveur
Creative Director Michael Grossman
Art Director Jill Armus
Designer Jill Armus
Photo Editor Susan Goldberger
Photographer Sally Gall
Publisher Meigher Communications
Issue March/April 1995
Category Story/Feature

■ 249

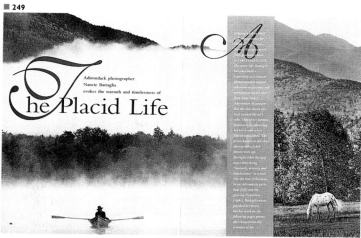

The Placid Life

Adirondack photographer
Nancie Battaglia
evokes the warmth and timelessness of

■ 250

Martha, Inc.

■ 251

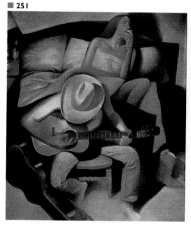

NASHVILLE

Screenplay by JOAN TEWKESBURY

Illustrated by GARY KELLEY

■ 252

PROSTITUTES

Screenplay by STACY COCHRAN

Illustrated by SCOTT MENCHIN

■ 249
Publication Snow Country
Art Director Julie Curtis
Photographer Nancie Battaglia
Publisher The New York Times
Issue September 1995
Category Story/Feature

■ 250
Publication Working Woman
Art Director Gina Davis
Designers Jamie Lipps, Gina Davis
Photo Editor María Millán
Photographer Ruven Afanador
Publisher Lang Communications
Issue June 6, 1995
Category Spread/Feature

■ 251
Publication Scenario
Creative Director Andrew Kner
Designer Andrew Kner
Illustrator Gary Kelley
Publisher RC Publications
Issue February 15, 1995
Category Spread/Feature

■ 252
Publication Scenario
Creative Director Andrew Kner
Designers Scott Menchin,
Andrew Kner
Illustrator Scott Menchin
Publisher RC Publications
Issue July 1995
Category Spread/Feature

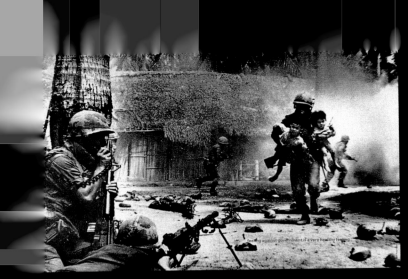

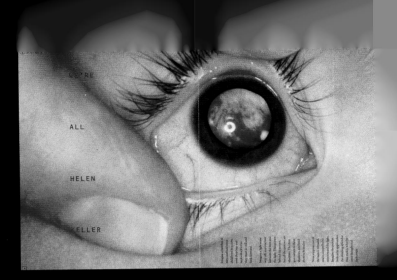

The aggressive stylization of this mass-produced cockpit, the exaggerated mouldings of the instrument binnacles emphasized my growing sense of a new junction between my own body and the automobile, closer than my feelings for Renata's broad hips and strong legs stowed out of sight beneath her red plastic raincoat. I leaned forward, feeling the rim of the steering wheel against the scars on my chest, pressing my knees against the ignition switch and handbrake

Publication Soho Journal
Creative Director
Gary Koepke
Designers Gary Koepke,
Joe Polevy
Studio Koepke
International, Ltd.
Issue September 20, 1995
Category Spread/Feature

Publication Soho Journal
Creative Director
Gary Koepke
Designers Gary Koepke,
Joe Polevy
Studio Koepke
International, Ltd.
Issue September 20, 1995
Category Spread/Feature

Publication Soho Journal
Creative Director
Gary Koepke
Designers Gary Koepke,
Joe Polevy
Studio Koepke
International, Ltd.
Issue September 20, 1995
Category Spread/Feature

Publication Soho Journal
Creative Director
Gary Koepke
Designers Gary Koepke,
Joe Polevy
Studio Koepke
International, Ltd.
Issue September 20, 1995
Category Spread/Feature

Publication Soho Journal
Creative Director
Gary Koepke
Designers Gary Koepke,
Joe Polevy
Studio Koepke
International, Ltd.
Issue September 20, 1995
Category Spread/Feature

■ 258

music

art

take out

books

film

around town

■ 259

music

take out

books

kids.

film.

■ 260

TIME IN
SURF CITY A selective guide to what's on

Wednesday 18

■ 261

EAT OUT
SERVING UP THE CITY

Not shaken but stirred
A palatable guide to the city's best dry martini

By Jesse Sheidlower Photographed by Bernd Auers

■ 262

CHECK OUT
A BUYER'S MARKET

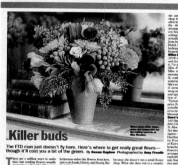

Killer buds
The FTD man just doesn't fly here. Here's where to get really great fleurs—though it'll cost you a bit of the green. By Susan Kaplow Photographed by Amy Freeth

■ 263

VIDEO

BYTE ME
ONLINE, MULTIMEDIA, GAMES
Siliconvention
The Multimedia and Design Conference offers creative types an introduction to new media
by Tom Samiljan

■ 258

Publication
Time Out New York
Art Director
Ron De La Peña
Photo Editor
Holly Spink
Photographer
David Byrne
Publisher Time Out
New York
Issue September 27, 1995
Category Department

■ 259

Publication
Time Out New York
Art Director
Ron De La Peña
Photo Editor
Holly Spink
Photographers
F. Scott Schafer, Ken Miller,
J. Terry Fisk, Keith Yagaloff,
Arthur Strange
Publisher Time Out
New York
Issue November 22, 1995
Category Department

■ 260

Publication
Time Out New York
Art Director
Ron De La Peña
Designer
Rommel Alama
Photo Editor
Holly Spink
Publisher Time Out
New York
Issue September 27, 1995
Category Department

■ 261

Publication
Time Out New York
Art Director
Ron De La Peña
Designer Emily Woller
Photo Editor
Holly Spink
Photographer
Bernd Auers
Publisher Time Out
New York
Issue November 22, 1995
Category Department

■ 262

Publication
Time Out New York
Art Director
Ron De La Peña
Designer
Rommel Alama
Photo Editor
Holly Spink
Photographers
Amy Freeth, Carlos Emilio
Publisher Time Out
New York
Issue November 29, 1995
Category Department

■ 263

Publication
Time Out New York
Art Director
Ron De La Peña
Designer
Rommel Alama
Photo Editor
Holly Spink
Photographers
Rodney Greenblat,
David Teich
Publisher Time Out
New York
Issue November 1, 1995
Category Department

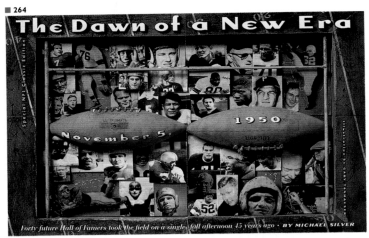

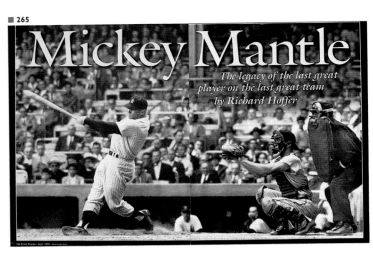

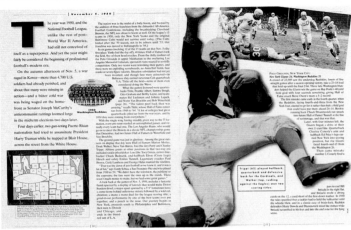

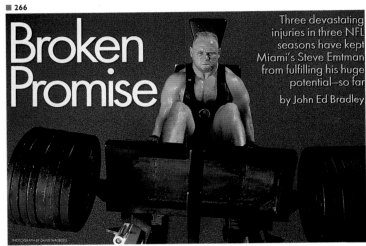

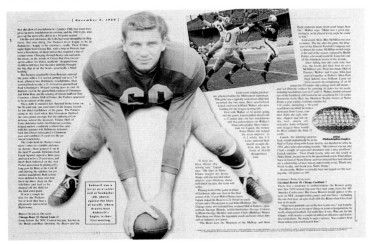

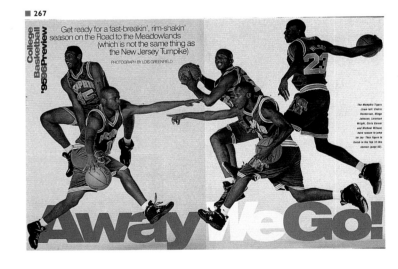

■ 264
Publication Sports Illustrated Classic
Design Director Steven Hoffman
Art Director Craig Gartner
Publisher Time Inc.
Issue Fall 1995
Category Story/Feature

■ 265
Publication Sports Illustrated
Design Director Steven Hoffman
Designer Ed Truscio
Photographer Grey Villet
Publisher Time Inc.
Issue August 21, 1995
Category Spread/Feature

■ 266
Publication Sports Illustrated
Design Director Steven Hoffman
Art Director Craig Gartner
Photographer David Walberg
Publisher Time Inc.
Issue September 25, 1995
Category Spread/Feature

■ 267
Publication Sports Illustrated
Design Director Steven Hoffman
Art Director Craig Gartner
Photographer Lois Greenfield
Publisher Time Inc.
Issue November 27, 1995
Category Spread/Feature

■ 268

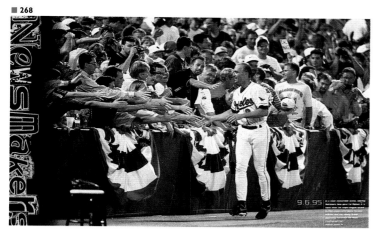

■ 269

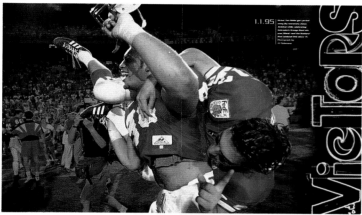

■ 270

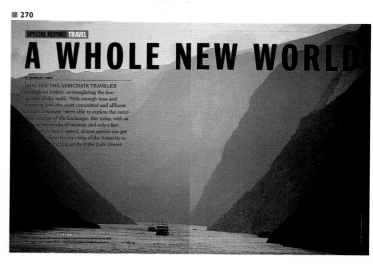

A WHOLE NEW WORLD

■ 271

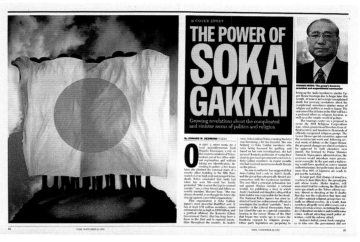

THE POWER OF SOKA GAKKAI

■ 272

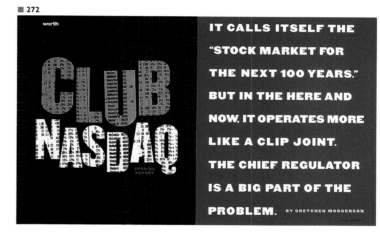

IT CALLS ITSELF THE "STOCK MARKET FOR THE NEXT 100 YEARS." BUT IN THE HERE AND NOW, IT OPERATES MORE LIKE A CLIP JOINT. THE CHIEF REGULATOR IS A BIG PART OF THE PROBLEM. BY GRETCHEN MORGENSON

■ 268
Publication
Sports Illustrated Presents
Art Director F. Darrin Perry
Designer Michael D. Schinnerer
Photo Editor Jeffrey Weig
Photographer Walter Iooss Jr.
Publisher Time Inc.
Issue Fall 1995
Category Department

■ 269
Publication
Sports Illustrated Presents
Art Director F. Darrin Perry
Designer Michael D. Schinnerer
Photo Editor Jeffrey Weig
Photographer Al Tielemans
Publisher Time Inc.
Issue Fall 1995
Category Department

■ 270
Publication TIME
Art Director Arthur Hochstein
Designer Jane Frey
Photo Editors
Michele Stephenson, Linda Ferrer
Photographer
Jeffrey Aaronson
Publisher Time Inc.
Issue June 12, 1995
Category Spread/Feature

■ 271
Publication TIME
Art Director Arthur Hochstein
Designer Jane Frey
Illustrator Matt Mahurin
Photo Editor
Michele Stephenson
Publisher Time Inc.
Issue November 20, 1995
Category Spread/Feature

■ 272
Publication Worth
Art Director Ina Saltz
Designer Philip Bratter
Publisher Capital Publishing
Issue June 1995
Category Spread/Feature

CHEAP THRILLS ONCE THEIR LURID TALL TALES WERE DEVOURED BY READERS: NOW VINTAGE WESTERN MAGAZINES ARE HOTLY COLLECTED. HERE ARE 16 COLORFUL COVERS THAT RECALL THE DAYS WHEN SIX-GUNS ROARED AND TIN STARS GLEAMED. BY ANNE DINGUS

NOW A PASSION FOR COMETS LED A TEXAS ASTRONOMER TO REDEFINE THE SOLAR SYSTEM—AND TURNED HER INTO A BIG STAR. BY HELEN THORPE

BRUSH WITH FAME

A NEW BIOGRAPHY OF JERRY BYWATERS REVEALS THE RICH, ARTISTIC, AND INTELLECTUAL LIFE OF TEXAS' BELOVED REGIONALIST PAINTER. BY ANNE DINGUS

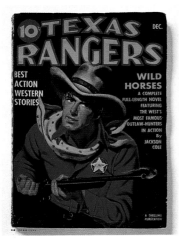

Mrs. & Mrs.

BRIDGE

Mildred Breed and Tobi Sokolow can barely stand to talk to one another. But at the card table . . .

. . . they are invincible, and they're gone to China in a bid to be world champions. by Paul Burka

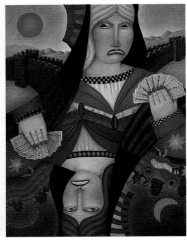

■ 273
Publication Texas Monthly
Creative Director D. J. Stout
Designers D. J. Stout, Nancy McMillen
Photo Editor D. J. Stout
Photographer Wyatt McSpadden
Publisher Texas Monthly
Issue June 1995
Category Story/Feature

■ 274
Publication Texas Monthly
Creative Director D. J. Stout
Designers D. J. Stout, Nancy McMillen
Photo Editor D. J. Stout
Photographer David Mackenzie
Publisher Texas Monthly
Issue August 1995
Category Spread/Feature

■ 275
Publication Texas Monthly
Creative Director D. J. Stout
Designers D. J. Stout, Nancy McMillen
Illustrator Jerry Bywater
Photo Editor D. J. Stout
Publisher Texas Monthly
Issue January 1995
Category Spread/Feature

■ 276
Publication Texas Monthly
Creative Director D. J. Stout
Designers D. J. Stout, Nancy McMillen
Illustrator Keith Graves
Photo Editor D. J. Stout
Publisher Texas Monthly
Issue November 1995
Category Spread/Feature

■ 277

Copenhagen

CAN A CITY BE TOO NICE? THIS MOST CIVILIZED OF EUROPEAN CAPITALS ONLY LOOKS THAT WAY
Photographed by Denis Bednes
BY JOHN RUSSELL

■ 280

VIETNAM
FACE to FACE

A VERY PERSONAL JOURNEY THROUGH THE
MEKONG DELTA
AT THIS TURNING POINT IN ITS HISTORY
WHO KNOWS HOW LONG THIS MOMENT WILL LAST?

BY GINI ALHADEFF
PHOTOGRAPHED BY KURT MARKUS

■ 278

THE FINE
ROMANCE
OF
SICILY

ON THE ISLAND WHERE
APHRODITE WAS BORN,
LIFE IS STILL LIVED WITH
A SPECIAL INTENSITY

BY VICTOR HAZAN · PHOTOGRAPHS BY MANUELA PAVESI

■ 281

The Best of the
Caribbean

TRAVEL & LEISURE'S SPECIAL
TWO-PART WINTER '96 REPORT STARTS AT THE TOP
WITH REVIEWS OF THE LONGEST-RUNNING,
MOST LUXURIOUS RESORTS IN THE ISLANDS.
LET THE SEASON BEGIN...
BY RICHARD ALLEMAN

PHOTOGRAPHED BY STEWART FEREBEE

■ 279

THE NEW L.A.
IS THE OLD L.A.
THE BEST OF THE CITY
THAT INVENTED
GLAMOUR
(IT'S THE FORTIES
ALL OVER AGAIN)
BY JILL ROBINSON

PHOTOGRAPHED BY MELODIE McDANIEL
FASHION EDITOR · PAUL SINCLAIRE

■ 277
Publication Travel & Leisure
Art Director Giovanni Russo
Designers Gaemer Gutierrez, Giovanni Russo
Photo Editor James Franco
Photographer Henry Bouvre
Publisher American Express Publishing
Issue March 1995
Category Spread/Feature

■ 278
Publication Travel & Leisure
Art Director Giovanni Russo
Designer Gaemer Gutierrez
Photo Editor James Franco
Photographer Manuela Pavesi
Publisher American Express Publishing
Issue April 1995
Category Spread/Feature

■ 279
Publication Travel & Leisure
Art Director Giovanni Russo
Designers Gaemer Gutierrez, Giovanni Russo
Photo Editor James Franco
Photographer Melodie McDaniel
Publisher American Express Publishing
Issue April 1995
Category Spread/Feature

■ 280
Publication Travel & Leisure
Art Director Giovanni Russo
Designer Giovanni Russo
Photo Editor James Franco
Photographer Kurt Markus
Publisher American Express Publishing
Issue October 1995
Category Spread/Feature

■ 281
Publication Travel & Leisure
Art Director Giovanni Russo
Designers Giovanni Russo, Gaemer Gutierrez
Photo Editor James Franco
Photographer Stewart Ferebee
Publisher American Express Publishing
Issue October 1995
Category Spread/Feature

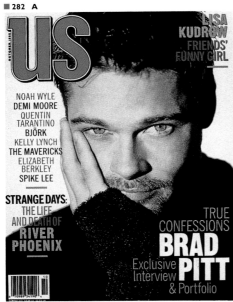

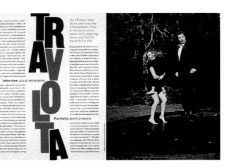

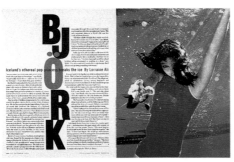
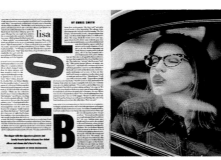
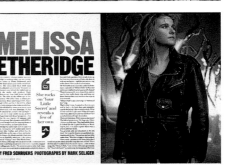

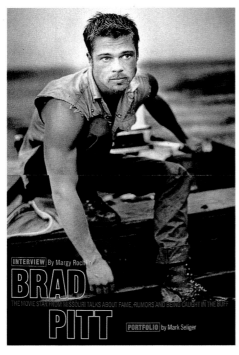

■ 282
Publication US
Art Director Richard Baker
Designers Richard Baker, Daniel Stark, Megan Kingsbury
Photo Editors Jennifer Crandall, Rachel Knepfer
Photographers Mark Seliger, Davis Factor, Kate Garner, Andrew Southam, Lance Staedler, Kevin Westenberg, Sante D'Orazio
Publisher US Magazine Co., L.P.
Issues October 1995, November 1995, December 1995
Category Overall
　■ A Entire Issue

■ 283

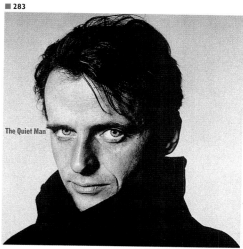

The Quiet Man

BY TRISH DEITCH ROHRER • PHOTOGRAPH BY DAVID BAILEY

■ 286 A

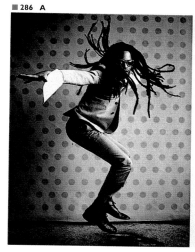

Let Lenny Rule

PHOTOGRAPH BY RUVEN AFANADOR

On his new album, 'Circus,' Lenny Kravitz finds his religion and gets some respect. Now all that's missing is true love

By Chris Smith

■ 284

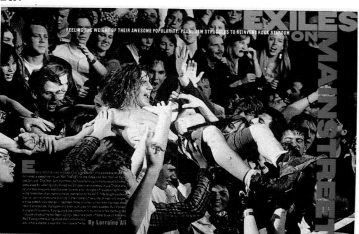

FEELING THE WEIGHT OF THEIR AWESOME POPULARITY, PEARL JAM STRUGGLES TO REINVENT ROCK STARDOM

EXILES ON MAINSTREET

By Lorraine Ali

VeNUS

By Katherine Dieckmann

Gwyneth Paltrow romances Hollywood — and Brad Pitt

RisIng

PHOTOGRAPH BY KATE GARNER

■ 285

JON BON JOVI

The high-haired king of arena rock & roll gets ready for his big-screen close-up

The US Interview

By David Hochman
Photographs by Dana Lixenberg

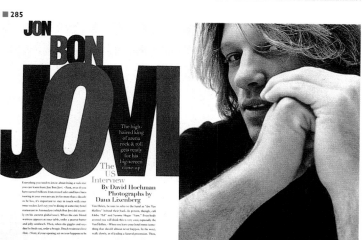

SENSE & SensiTivity

By Jancee Dunn

PHOTOGRAPH BY MARK SELIGER

Reluctant sex symbol David Schwimmer makes 'Friends'

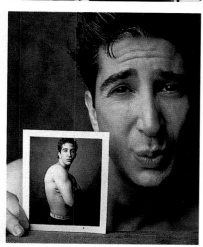

■283
Publication US
Art Director Richard Baker
Designer Lisa Wagner
Photo Editor Jennifer Crandall
Photographer David Bailey
Publisher US Magazine Co., L.P.
Issue February 1995
Category Spread/Feature

■284
Publication US
Art Director Richard Baker
Designer Daniel Stark
Photo Editors Jennifer Crandall, Rachel Knepfer
Photographer Lance Mercer
Publisher US Magazine Co., L.P.
Issue April 1995
Category Spread/Feature

■285
Publication US
Art Director Richard Baker
Designer Daniel Stark
Photo Editors Jennifer Crandall, Rachel Knepfer
Photographer Dana Lixenberg
Publisher US Magazine Co., L.P.
Issue August 1995
Category Spread/Feature

■286
Publication US
Art Director Richard Baker
Designers Richard Baker, Daniel Stark, Mimi Dutta
Photo Editor Jennifer Crandall
Photographers Ruven Afanador, Kate Garner, Mark Seliger
Publisher US Magazine Co., L.P.
Issue September 1995
Category Story/Feature
　■A Spread

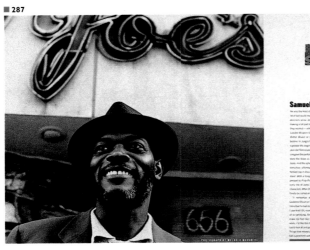

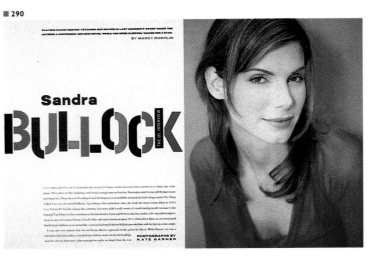

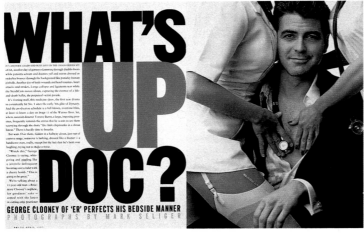

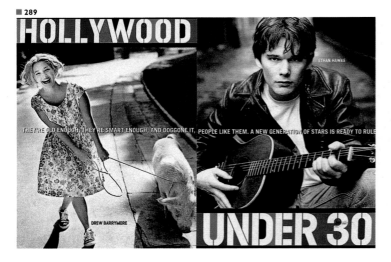

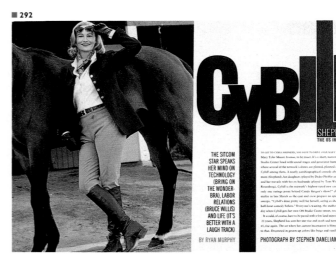

■287	■288	■289	■290	■291	■292
Publication US	**Publication** US	**Publication** US	**Publication** US	**Publication** US	**Publication** US
Art Director Richard Baker	**Art Director** Richard Baker	**Art Director** Richard Baker	**Art Director** Richard Baker	**Art Director** Richard Baker	**Art Director** Richard Baker
Photo Editors Jennifer Crandall, Rachel Knepfer	**Designer** Daniel Stark	**Designers** Richard Baker, Daniel Stark	**Photo Editor** Jennifer Crandall	**Photo Editors** Jennifer Crandall, Rachel Knepfer	**Designer** Daniel Stark
Photographer Melodie McDaniel	**Photo Editor** Jennifer Crandall	**Photo Editors** Jennifer Crandall, Rachel Knepfer	**Photographer** Kate Garner	**Photographer** Peggy Sirota	**Photo Editor** Jennifer Crandall
Publisher US Magazine Co., L.P.	**Photographer** Mark Seliger	**Photographer** Mark Seliger	**Publisher** US Magazine Co., L.P.	**Publisher** US Magazine Co., L.P.	**Photographer** Stephen Danelian
Issue April 1995	**Publisher** US Magazine Co., L.P.	**Publisher** US Magazine Co., L.P.	**Issue** May 1995	**Issue** June 1995	**Publisher** US Magazine Co., L.P.
Category Spread/Feature	**Issue** April 1995	**Issue** May 1995	**Category** Spread/Feature	**Category** Spread/Feature	**Issue** June 1995
	Category Spread/Feature	**Category** Spread/Feature			**Category** Spread/Feature

■ 293

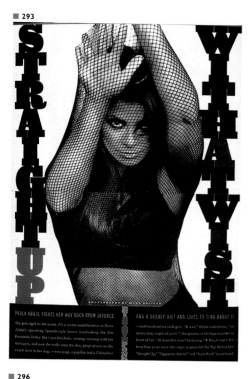

■ 294

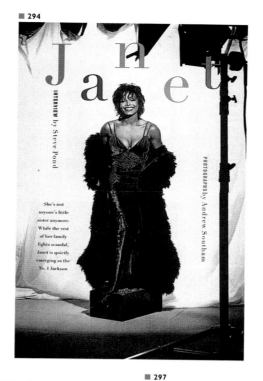

■ 295

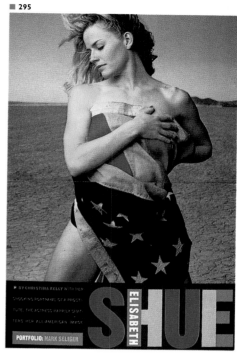

■ 296

■ 297

■ 293
Publication US
Art Director Richard Baker
Photo Editors
Jennifer Crandall, Rachel Knepfer
Photographer Mark Seliger
Publisher US Magazine Co., L.P.
Issue July 1995
Category Spread/Feature

■ 294
Publication US
Art Director Richard Baker
Photo Editors
Jennifer Crandall, Rachel Knepfer
Photographer
Andrew Southam
Publisher US Magazine Co., L.P.
Issue November 1995
Category Spread/Feature

■ 295
Publication US
Art Director Richard Baker
Photo Editor Jennifer Crandall
Photographer Mark Seliger
Publisher US Magazine Co., L.P.
Issue December 1995
Category Spread/Feature

■ 296
Publication US
Art Director Richard Baker
Photo Editors
Jennifer Crandall, Rachel Knepfer
Publisher US Magazine Co., L.P.
Photographer Mary Ellen Mark
Issue November 1995
Category Spread/Feature

■ 297
Publication US
Art Director Richard Baker
Photo Editor Jennifer Crandall
Photographer Mary Ellen Mark
Publisher US Magazine Co., L.P.
Issue September 1995
Category Spread/Feature

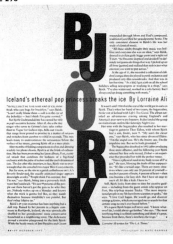
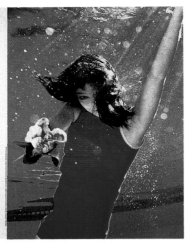

BJORK

Iceland's ethereal pop princess breaks the ice By Lorraine Ali

loose talk
COMPILED BY CAROL DITTBRENNER

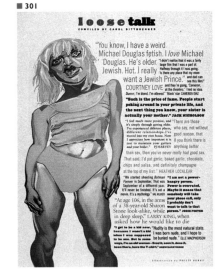

BY CHRIS SMITH

lisa LOEB

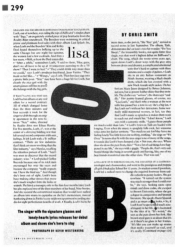

The singer with the signature glasses and lonely-hearts lyrics releases her debut album and shows she's here to stay

PHOTOGRAPH BY KEVIN WESTENBERG

SPECIAL 2ND ANNIVERSARY ISSUE

VIBE

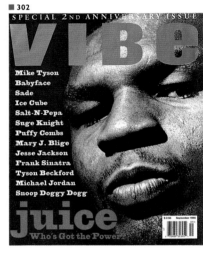

Mike Tyson
Babyface
Sade
Ice Cube
Salt-N-Pepa
Suge Knight
Puffy Combs
Mary J. Blige
Jesse Jackson
Frank Sinatra
Tyson Beckford
Michael Jordan
Snoop Doggy Dogg

juice
Who's Got the Power?

He's cooler than Bond and lives like a Rockefeller. Now America's comeback kid is enjoying fame and fatherhood in his 40s

TRAVOLTA

Interview LESLIE VAN BUSKIRK

Portfolio SANTE D'ORAZIO

SUPER FREAK

■298	■299	■300	■301	■302	■303
Publication US	**Publication** US	**Publication** US	**Publication** US	**Publication** Vibe	**Publication** Vibe
Art Director Richard Baker	**Art Director** Richard Baker	**Art Director** Richard Baker	**Art Director** Richard Baker	**Art Director** Diddo Ramm	**Art Director** Diddo Ramm
Designer Daniel Stark	**Photo Editors** Jennifer Crandall, Rachel Knepfer	**Photo Editors** Jennifer Crandall, Rachel Knepfer	**Illustrator** Philip Burke	**Designers** Ellen Fanning, David Harley, Diddo Ramm	**Designer** Diddo Ramm
Photo Editors Jennifer Crandall, Rachel Knepfer	**Photographer** Kevin Westenberg	**Photographer** Sante D'Orazio	**Photo Editor** Jennifer Crandall	**Photo Editor** George Pitts	**Photo Editor** George Pitts
Photographer Kate Garner	**Publisher** US Magazine Co., L.P.	**Publisher** US Magazine Co., L.P.	**Publisher** US Magazine Co., L.P.	**Publisher** Time Inc.	**Photographer** Dana Lixenberg
Publisher US Magazine Co., L.P.	**Issue** November 1995	**Issue** December 1995	**Issue** July 1995	**Issue** September 1995	**Publisher** Time Inc.
Issue October 1995	**Category** Spread/Feature	**Category** Spread/Feature	**Category** Single/Feature	**Category** Entire Issue	**Issue** January 1995
Category Spread/Feature					**Category** Spread/Feature

■ 304

DEATH

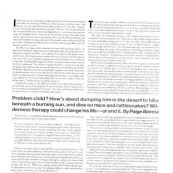

Aaron Bacon
1977–1994

TRIP

Problem child? How's about dumping him in the desert to hike beneath a burning sun, and dine on mice and rattlesnakes? Wilderness therapy could change his life—or end it. By Paige Bierma

■ 305

THE VIBE Q READY TO LIVE

2
PAC
SHAKUR

■ 306

The VIBE Q: bullheads

UN
CUT
FUNK

A cutting-edge cultural satirist drops bombs on racism, sexism, O.J. Simpson, Rush Limbaugh, Oprah, Camille Paglia, Louis Farrakhan—and saves some for gangsta rap and its critics. Photographs by Barron Claiborne

By Kevin Powell

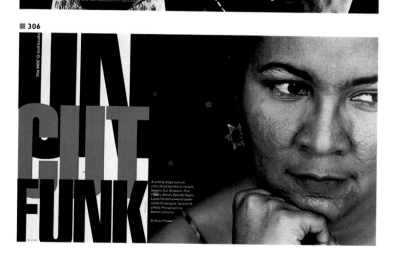

■ 307

THE
MC
ST
O
RY

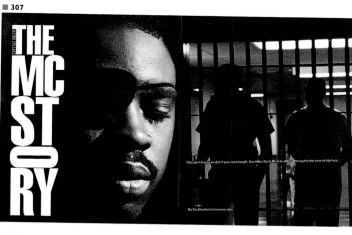
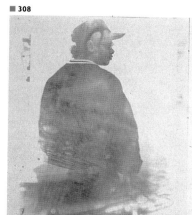

This ain't funny so don't you dare laugh. Our hero Sick Rick is still suffering for the sins of hip hop

By Da Ghetto Communicator

■ 308

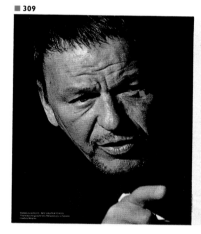

Over 18,000 people died of AIDS in the City of Angels before gangsta rap kingpin Eric "Eazy-E" Wright, but his death is the first that speaks

EAZY LIVING

directly to the hip hop nation. Is anybody listening? *Carter Harris* **reports on Eazy's last days.** *Photograph by Everard Williams Jr.*

■ 309

O.G.

■304
Publication Vibe
Art Director Diddo Ramm
Designer Ellen Fanning
Photo Editor George Pitts
Publisher Time Inc.
Issue March 1995
Category Spread/Feature

■305
Publication Vibe
Art Director Diddo Ramm
Designer Diddo Ramm
Photo Editor George Pitts
Photographer Reisig & Taylor
Publisher Time Inc.
Issue March 1995
Category Spread/Feature

■306
Publication Vibe
Art Director Diddo Ramm
Designer Diddo Ramm
Photo Editor George Pitts
Photographer Barron Claiborne
Publisher Time Inc.
Issue May 1995
Category Spread/Feature

■307
Publication Vibe
Art Director Diddo Ramm
Designer Ellen Fanning
Photo Editor George Pitts
Publisher Time Inc.
Issue May 1995
Category Spread/Feature

■308
Publication Vibe
Art Director Diddo Ramm
Designer Diddo Ramm
Photo Editor George Pitts
Photographer Everard Williams Jr.
Issue June 1995
Category Spread/Feature

■309
Publication Vibe
Art Director Diddo Ramm
Designer Diddo Ramm
Photo Editor George Pitts
Photographer Everard Williams, Jr.
Issue September 1995
Category Spread/Feature

KRS
ACT LIKE YA KNOW
ONE

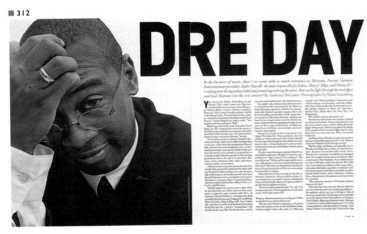

DRE DAY

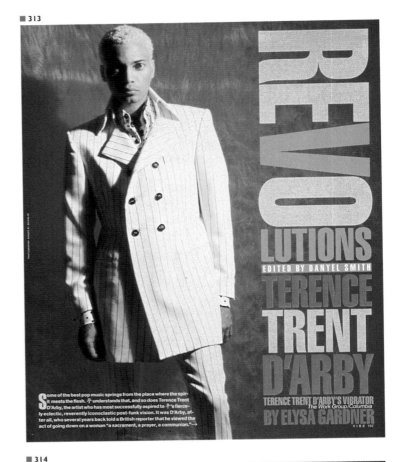

■310
Publication Vibe
Art Director Diddo Ramm
Designer Diddo Ramm
Photo Editor George Pitts
Photographer George Lange
Publisher Time Inc.
Issue November 1995
Category Spread/Feature

■311
Publication Vibe
Art Director Diddo Ramm
Designers Diddo Ramm, Ellen Fanning
Photo Editor George Pitts
Photographer Josef Astor
Publisher Time Inc.
Issue November 1995
Category Spread/Feature

■312
Publication Vibe
Art Director Diddo Ramm
Designer Diddo Ramm
Photo Editor George Pitts
Photographer Dana Lixenberg
Publisher Time Inc.
Issue December 1995
Category Spread/Feature

■313
Publication Vibe
Art Director Diddo Ramm
Designer David Harley
Photo Editor George Pitts
Publisher Time Inc.
Issue June 1995
Category Department

■314
Publication Vibe
Art Director Diddo Ramm
Designer David Harley
Photo Editor George Pitts
Publisher Time Inc.
Issue September 1995
Category Department

■ 315

W

Fresh Fashion

Mia Farrow's New Life

Hollywood's Power Grill

Who's Got Great Hair?

Hillary Clinton's Big Problem

Men's Gifts

Suzy at the Miller Wedding

Best of Paris & Milan

Mr. MTV

MTV chairman Tom Freston straddles the zone between The Kids and The Suits to keep the channel in the groove and in the black. By Merle Ginsberg

PHOTO BY NIGEL PARRY

RALPH'S TEEPEE

When Mr. Lauren wants a real pouwwow, he gets it—inside his new buffalo-hide hideout

PHOTO BY MICHAEL MUNDY

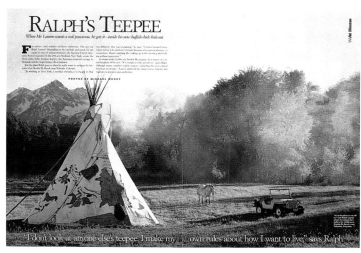

"I don't look at anyone else's teepee. I make my own rules about how I want to live," says Ralph.

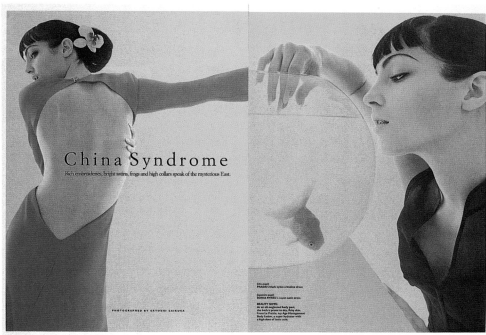

China Syndrome

Rich embroideries, bright satins, frogs and high collars speak of the mysterious East.

PHOTOGRAPHED BY SATOSHI SAIKUSA

■ 315

Publication W
Creative Director Dennis Freedman
Design Director Edward Leida
Art Director Kirby Rodriguez
Designers Edward Leida, Kirby Rodriguez,
Rosalba Sierra, Myla Sorensen
Publisher Fairchild Publications
Issues April 1995, May 1995, December 1995
Category Overall

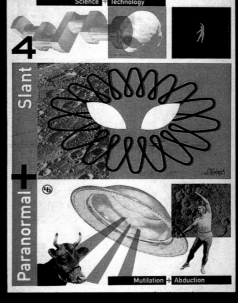

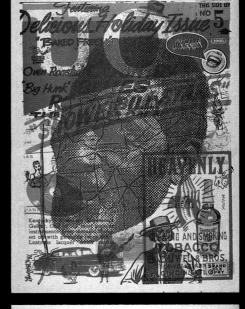

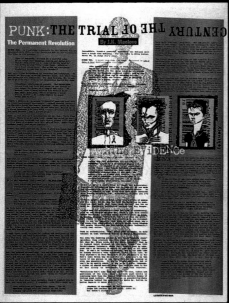

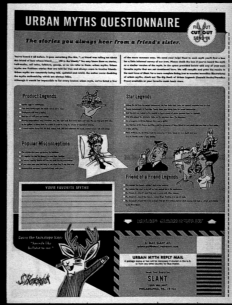

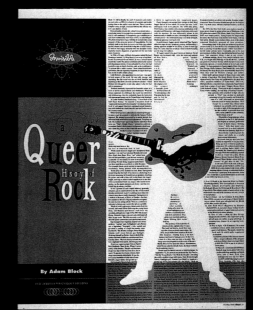

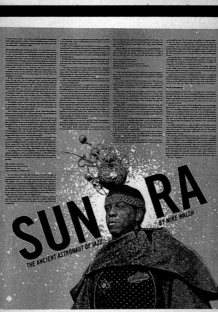

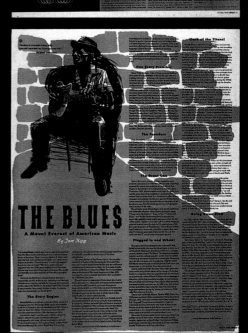

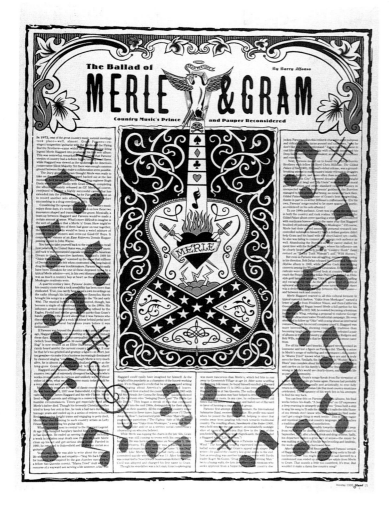

Publication Slant
Design Director Howard Brown
Art Directors Mike Calkins,
Designers Howard Brown,
Mike Calkins, Art Chantry,
Ed Fotheringham, Gary Panter,
Jesse Reyes, Anthony Arnold,
C.S.A. Design, Todd Piper-Hauswirth,
Michael Mabry, Ashleigh Talbot
Illustrators Mike Calkins,
Ed Fotheringham, Stephen Kroninger,
Gary Panter, Glen Barr, Mike Calkins,
Angela Dundee, Mitch O'Connell,
Andy Ruso, Joe Ciardello,
Michael Mabry, Asheigh Talbot
Studio Urban Outfitters Inc.
Client In-house
Publisher Urban Outfitters Inc.
Issues Spring 1995,
Fall 1995, Holiday 1995
Category Overall

Publication Slant
Design Director Howard Brown
Art Director Mike Calkins
Studio Urban Outfitters Inc.
Publisher Urban Outfitters Inc.
Issue Fall 1995
Category Spread/Feature

Publication Wired
Creative Director
Thomas Schneider
Art Directors Noreen Morioka,
Sean Adams
Designers Noreen Morioka,
Sean Adams
Photo Editors Sean Adams,
Noreen Morioka
Studio Adams Morioka, Inc.
Issue October 1995
Category Entire Issue

Publication Texas Medicine
Creative Director Herman Ellis Dyal
Designer Kevin Goodbar
Studio Fuller Dyal & Stamper
Issue September 1995
Category Spread/Feature

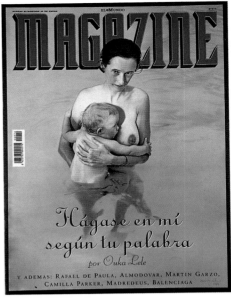

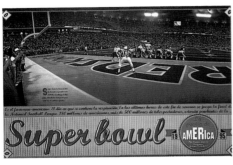

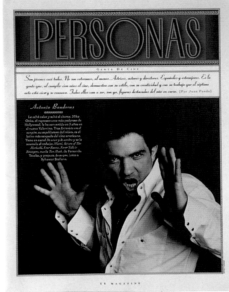

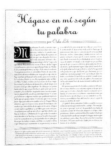

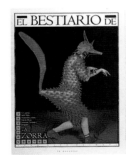

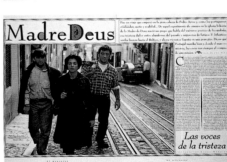

320
Publication El Mundo
Design Director Carmelo Caderot
Art Director Rodrigo Sanchez
Designers Rodrigo Sanchez,
Miguel Buckenmeyer, Amparo Redondo
Publisher Unidad Editorial S.A.
Issues January 28, 1995,
March 25, 1995, February 21, 1995
Category Overall

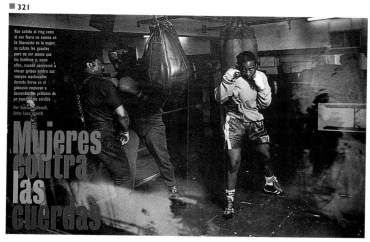

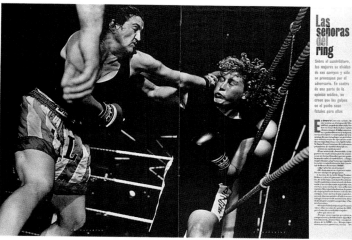

RUSSIAN SECRETS

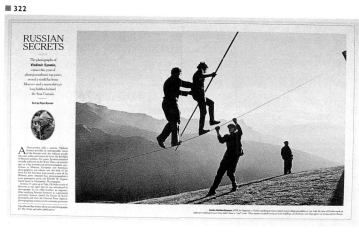

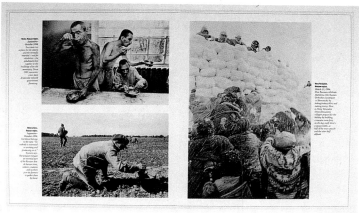

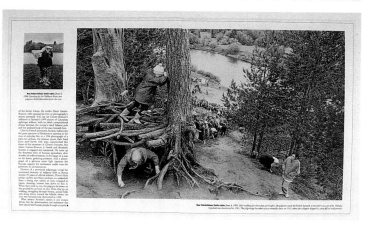

■ 321
Publication El Mundo
Design Director Carmelo Caderot
Art Director Rodrigo Sanchez
Designers Rodrigo Sanchez, Miguel Buckenmeyer, Amparo Redondo
Photographer Luca Zanetti
Publisher Unidad Editorial S.A.
Issue September 23, 1995
Category Story/Feature

■ 322
Publication The New York Times Magazine
Art Director Janet Froelich
Designer Catherine Gilmore-Barnes
Photo Editor Kathy Ryan
Photographer Vladimir Syomin
Publisher The New York Times
Issue November 26, 1995
Category Story/Feature

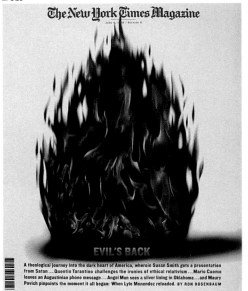
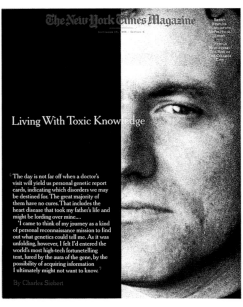
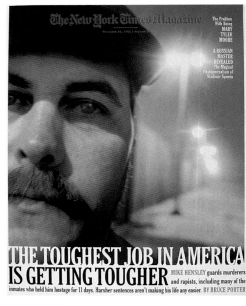

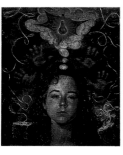

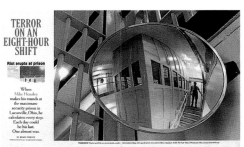

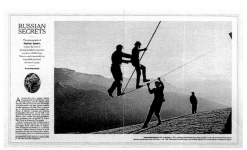

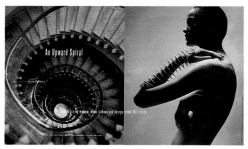

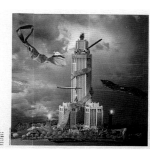

■323
Publication The New York Times Magazine
Art Director Janet Froelich, Catherine Gilmore-Barnes
Designers Catherine Gilmore-Barnes,
Nancy Harris, Lisa Naftolin, Joel Cuyler
Photo Editor Kathy Ryan
Publisher The New York Times
Issues June 4, 1995, September 17, 1995,
November 26, 1995
Category Overall

■ 324

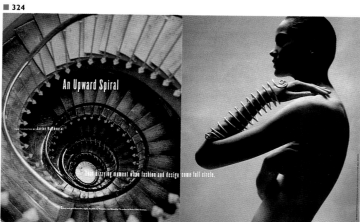

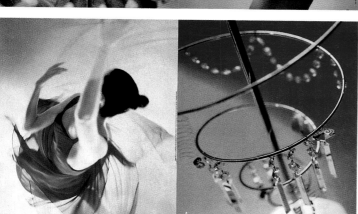

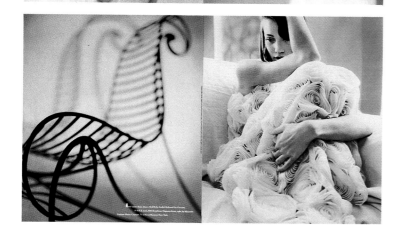

■ 325

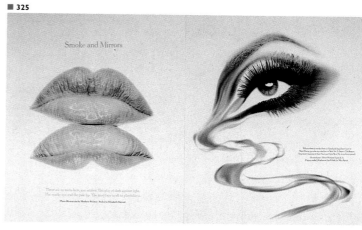

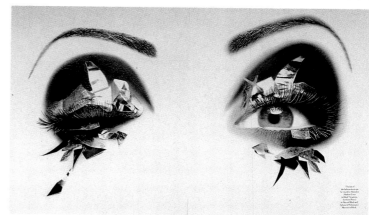

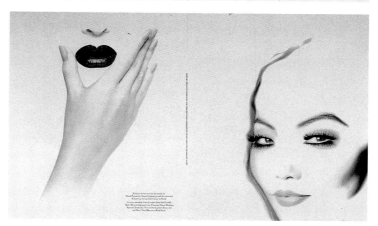

■ 324
Publication The New York Times Magazine
Art Director Janet Froelich
Designer Catherine Gilmore-Barnes
Photographers Javier Vallhonrat,
Franciscus Ankoné
Publisher The New York Times
Issue June 4, 1995
Category Story/Feature

■ 325
Publication The New York Times Magazine
Art Director Janet Froelich
Designer Lisa Naftolin
Photographers Matthew Rolston,
Elizabeth Stewart
Publisher The New York Times
Issue September 10, 1995
Category Story/Feature

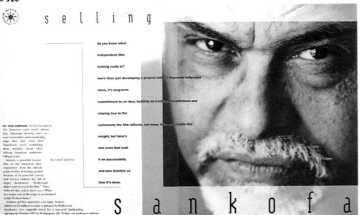

selling

sankofa

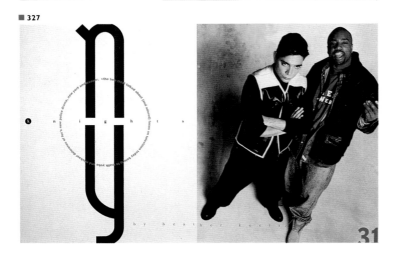

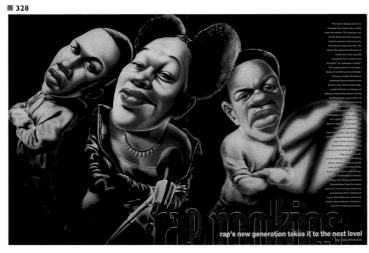

rap's new generation takes it to the next level

anatomy of a

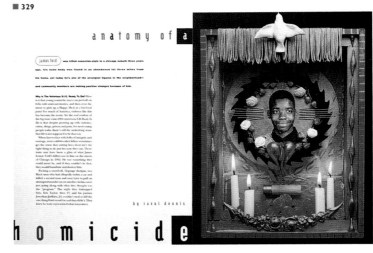

homicide

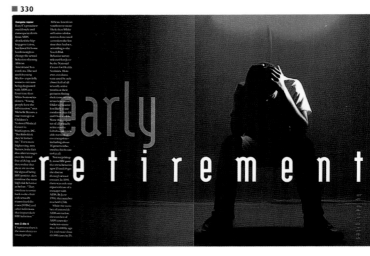

early **retirement**

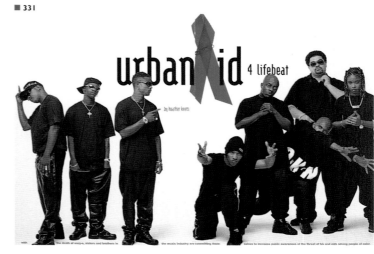

urban aid 4 lifebeat

Publication
YSB Magazine
Creative Director
Lance Pettiford
Art Director
Gregory Atkins
Designer Steve Jones
Photo Editor
Stephen Chin
Photographer
Mypheduh Productions
Publisher
Paige Publications
Issue February 1995
Category Spread/Feature

Publication
YSB Magazine
Creative Director
Lance Pettiford
Art Director
Gregory Atkins
Designer Lance Pettiford
Photo Editor
Stephen Chin
Photographer
Dennis Dichiaro
Publisher
Paige Publications
Issue March 1995
Category Spread/Feature

Publication
YSB Magazine
Creative Director
Lance Pettiford
Art Director
Gregory Atkins
Designer Gregory Atkins
Illustrator Carlos Torres
Publisher
Paige Publications
Issue May 1995
Category Spread/Feature

Publication
YSB Magazine
Creative Director
Lance Pettiford
Art Director
Gregory Atkins
Designer Lance Pettiford
Illustrator Jennifer Jessee
Photo Editor
Stephen Chin
Publisher
Paige Publications
Issue May 1995
Category Spread/Feature

Publication
YSB Magazine
Creative Director
Lance Pettiford
Art Director
Gregory Atkins
Designer Steve Jones
Photo Editor
Stephen Chin
Photographer
Jana Birchum
Publisher
Paige Publications
Issue October 1995
Category Spread/Feature

Publication
YSB Magazine
Creative Director
Lance Pettiford
Art Director
Gregory Atkins
Designer Gregory Atkins
Photo Editor
Stephen Chin
Photographer
Jeffrey Henson Scales
Publisher
Paige Publications
Issue October 1995
Category Spread/Feature

■ 332

■ 333

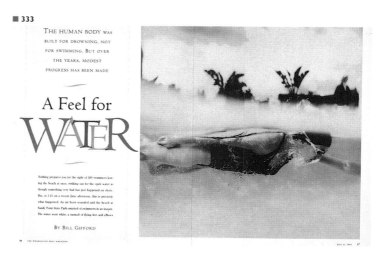

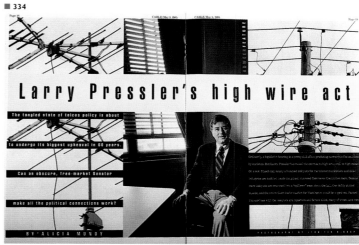

■ 334

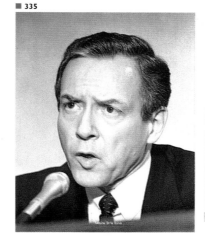

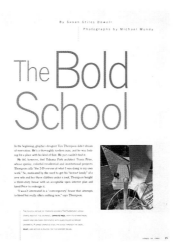

■ 335

■ 332
Publication
The Washington Post Magazine
Art Director Kelly Doe
Designers Kelly Doe,
Sandra Schneider
Illustrators David Goldin,
Philippe Weisbecker
Photo Editors
Karen Tanaka, Lauren Hicks
Photographers Dana Gallagher,
Michael Mundy, David Sharpe
Publisher The Washington Post Co.
Issue April 30, 1995
Category Entire Issue

■ 333
Publication
The Washington Post Magazine
Art Director Kelly Doe
Designer Sandra Schneider
Photo Editors
Karen Tanaka, Lauren Hicks
Photographer Mark Hanauer
Publisher The Washington Post Co.
Issue July 23, 1995
Category Spread/Feature

■ 334
Publication Adweek
Design Director Blake Taylor
Designer Blake Taylor
Photo Editor Lisa Moore
Photographer Jennifer Bishop
Publisher BPI Publications
Issue May 8, 1995
Category Spread/Feature

■ 335
Publication American Lawyer
Design Director Caroline Bowyer
Art Director Linda Rubes
Designer Caroline Bowyer
Photo Editor Tracy Litt
Photographer Susan Muniak
Publisher American Lawyer Media LP
Issue March 1995
Category Spread/Feature

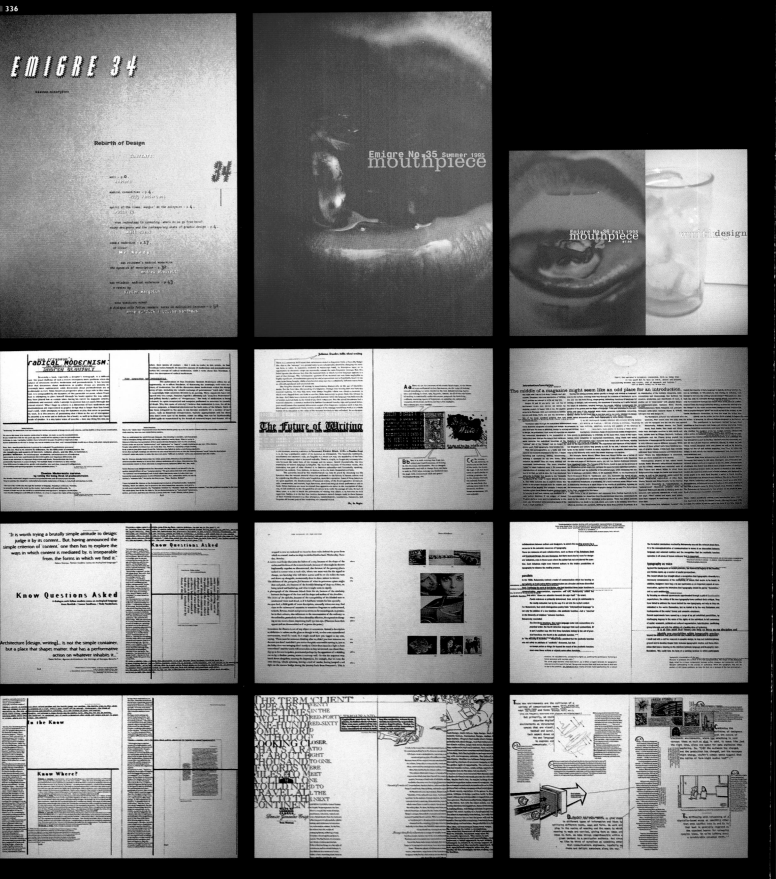

336
Publication Emigre
Art Director Anne Burdick, Rudy VanderLans
Designer Anne Burdick
Photographers Anne Burdick, Susan Burdick
Publisher Emigre
Issues Spring 1995, Summer 1995, Fall 1995
Category Overall

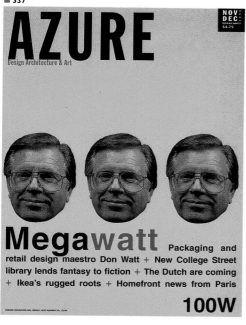

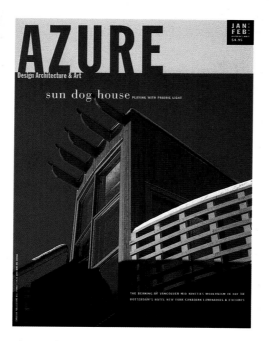

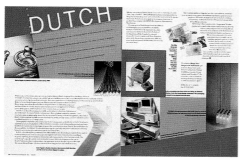

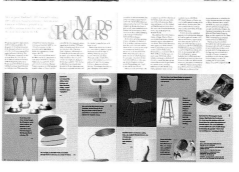

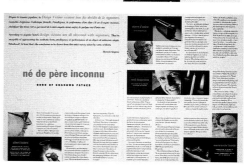

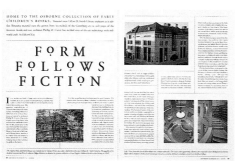

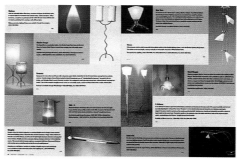

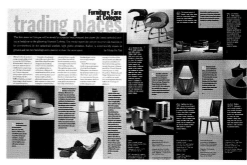

■ 337
Publication Azure
Design Directors Diti Katona, John Pylypczak
Designer Susan McIntee
Studio Concrete Design Communications Inc.
Publisher Sergio Sgaramella
Issues March/April 1995, November/December 1995, January/February 1996
Category Overall

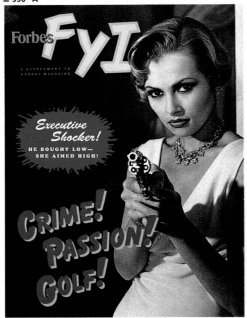

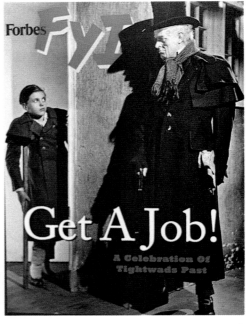

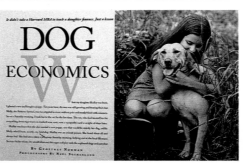
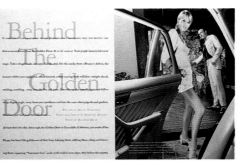

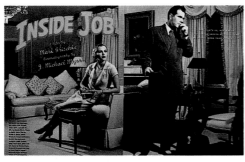
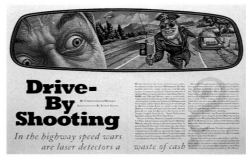
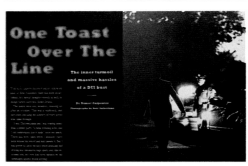

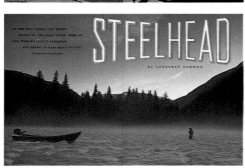

■ 338
Publication Forbes FYI
Design Director Alexander Isley
Art Director Paul Donald, Penny Blatt
Publisher Forbes Inc.
Issues March 13, 1995, September 25, 1995,
November 20, 1995
Category Overall
 ■ A Entire Issue

16/09/95

Independent
Magazine

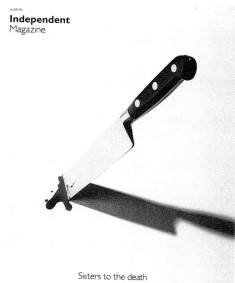

Sisters to the death

02/12/95

Independent
Magazine

Burning with seasonal desires

29/07/95

Independent
Magazine

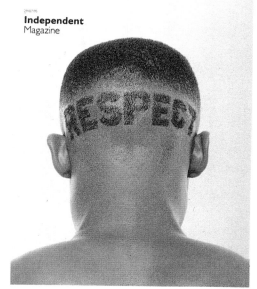

DIVO
ORCE

All I want for Christmas

GQ man

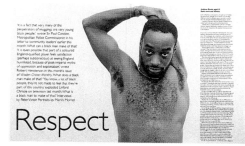

Respect

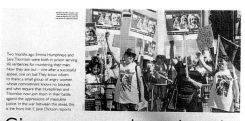

Two months ago Emma Humphreys and Sara Thornton were both in prison serving life sentences for murdering their men. Now they are out — one after a successful appeal, one on bail. They know whom to thank; a small group of angry women whose commitment knows no bounds and who require that Humphreys and Thornton now join them in their battle against the oppressions of masculine justice. In the war between the sexes, this is the front line. E. Jane Dickson reports

Sisters to the death

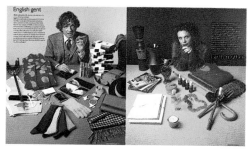

English gent

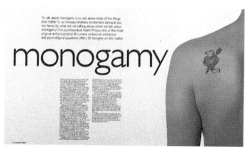

monogamy

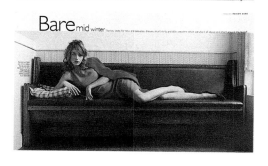

Bare mid winter

Seventies man

Minimalist

Linford

■ 339
Publication Independent Magazine
Creative Director Vince Frost
Designer Vince Frost
Illustrator Irene Treskow
Photo Editor Caroline Metcalf
Photographers Matthew Donaldson,
Sandro Sodano, James Cant, Martin Morrell
Studio Frost Design
Publisher Mirror Group
Category Overall

Council of Fashion
Designers of America

1994

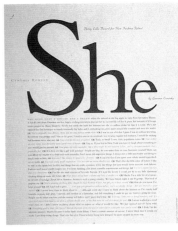

Jackie

■341

A SPIKE LEE RETROSPECTIVE

Nearly ten years ago, Spike Lee burst onto the American film scene with the low-budget *She's Gotta Have It*. A surprise critical and commercial success, the film sparked a resurgence in African-American filmmaking and inspired a generation of independent filmmakers.

With the inventive and socially conscious *School Daze* and *Do The Right Thing*, Lee made his move into mainstream commercial filmmaking while maintaining an uncompromisingly independent artistic voice. An assured director, outspoken advocate for African-Americans, self-described provocateur, and marketing genius, Lee has emerged as a social and cultural phenomenon.

His subject is contemporary black urban life. His films, which fuse melodramatic and comedic tones, deftly explore complex relationships within families and communities. The richness of his style and his eagerness for experimentation are reflected in the vivid colors, fluid camera movements, and jarring off-kilter compositions which characterize his films.

In addition to his talent as director, writer, actor, and producer, Lee has proven himself a canny businessman with a flair for controversy and self-promotion. While critics and audiences have received his "joints" with a mixture of enthusiasm, animosity, encouragement, and disbelief, Lee remains one of America's most accomplished and respected filmmakers. Few directors have so thoroughly explored race relations, urban tensions, class divisions, and African-American sexuality and culture.

Special thanks to Forty Acres and a Mule, Universal Pictures, Warner Bros., Island Pictures, HBO, and Boondocks Video. Organized by Erika Muhammad, Assistant Curator of Film & Video.

SEPTEMBER 16 - OCTOBER 1, 1995

ORSON

Orson Welles, who read Shakespeare at age three and was a famous theater director by his twenties, arrived in Hollywood in 1939 during the apex of the classical studio system. Movies of this period were meant to be seamless entertainments—the story was everything, and the means of storytelling, as well as the voice of the teller, remained invisible.

Until *Citizen Kane*. Granted an astonishing degree of creative control by the financially troubled yet progressive RKO studio, Welles developed an exciting new model for narrative film. Fusing the pictorial richness of silent cinema, the technical mastery of Hollywood studios, and a dynamic approach to sound and ensemble acting drawn from his own radio and theater work, Welles made *Citizen Kane* a pivotal film that drew from the best of cinema's past and foreshadowed the rise of the director as star. He foregrounded artistry and technique, imbuing each frame of the film with his vibrant personality.

"I want to use the motion picture camera as an instrument of poetry," said Welles, an unmistakable maverick who was writer, director and star of virtually all of his films. (Anderson was the lone feature he directed in which he did not appear.)

The cinema of Orson Welles deserves to be called Shakespearean; his movies are thematically grand in their fascination with death, power, and the mysteries of human behavior, and they are endlessly inventive in their playful command of the medium. Yet Hollywood rejected Welles, who spent most of his career toiling in his own (and Kane's) shadow. "I drag my myth around with me," he once lamented. What is astonishing is how much great cinema he did manage to produce during these years, whether working on the fringe of Hollywood or in Europe.

Special thanks to Richard Gordon, Gary Graver, Jillian Kesner, Jimmy Quinoll, The British Film Institute, Cecile Hill Films, Columbia Repertory, The Museum of Modern Art, Paramount Pictures, Turner Entertainment, UCLA Film and Television Archives, The Voyage Company.

JULY 8-30, 1995

Orson Welles and Rita Hayworth in THE LADY FROM SHANGHAI. On the cover: Orson Welles in CITIZEN KANE.

The task of photographing AMMI's collection has been given to photographer David Sundberg. Since July, Sundberg has been photographing highlights of the Museum's moving image apparatus and popular culture holdings.

Photographing the Collection

Photography is one of the most

Erich von Stroheim
and the Road to Sunset Boulevard

There were three young directors who showed promise in those days... Erich von Stroheim tells us as Max von Mayerling in the 1950 film *Sunset Boulevard*. "D.W. Griffith, Cecil B. De Mille, and Max von Mayerling." Von Stroheim was being atypically modest here by including Griffith, his beloved mentor, and De Mille, along with himself.

Von Stroheim claimed to have hated "that goddamned butler role," the alter ego Billy Wilder had created expressly for him, but the part of Max in *Sunset Boulevard* would prove a remarkable climax to one of Hollywood's most extravagant, blighted, and misunderstood careers.

In 1950, movies over twenty years old seemed ancient, and the men and women whose careers had stopped when talkies arrived were Hollywood's back numbers. Until

Kevin Brownlow began interviewing the survivors a decade later for *The Parade's Gone By*, even most historians had forgotten the era, its films, and nearly all of the people who made them.

How was it that von Stroheim, for a time one of Hollywood's most honored and highly paid directors, found himself a generation later in a string of meretricious B-movies? Was Hollywood at fault? Or was it the jaded Depression-era audience? Or was "the man you love to hate" ultimately responsible for his own critical and commercial demise?

Special thanks to the Library of Congress, George Eastman House, Kino International, Turner Entertainment Co., Paramount Pictures, Films Inc., and William K. Everson. Organized by Richard Koszarski, Head of Collections & Exhibitions.

IN THE RIKLIS THEATER *all films are screened in 35mm unless otherwise noted*

SCHEDULE

SILENT MOVIES WITH LIVE MUSIC BY JON SPURNEY
2:00 p.m. **Blind Husbands** Universal, 1919, c. 80 mins., 16mm. *Directed by von Stroheim. With von Stroheim, Francelia Billington.*

SILENT MOVIES WITH LIVE MUSIC BY JON SPURNEY
2:00 p.m. **Merry-Go-Round** Universal, 1923, c. 110 mins., 16mm. *Directed by von Stroheim and Rupert Julian. With Mary Philbin, Norman Kerry.*

GREED Goldwyn, 1924, c. 125 mins. *Directed by von Stroheim. With Gibson Gowland, Zasu Pitts.*

2:00 p.m. SILENT MOVIE WITH LIVE MUSIC BY JON SPURNEY
The Merry Widow MGM, 1925, c. 120 mins. *Directed by von Stroheim. With Mae Murray, John Gilbert.*

4:30 p.m. **The Wedding March** Paramount, 1928, 113 mins., 16mm. *Directed by von Stroheim. With Fay Wray.*

■341

Publication American Museum of the Moving Images
Design Director Alexander Isley
Designers David Albertson, Gabrielle Dubois Pellerin
Studio Alexander Isley Design
Issues April/May/June 1995, July/August 1995, September/October 1995
Category Overall

■340

Publication CFDA 1994 Awards Gala Program
Designers Michael Bierut, Esther Bridavsky
Studio Pentagram Design, Inc.
Client Council of Fashion Designers of America
Publisher Council of Fashion Designers of America
Issue February 1995
Category Entire Issue

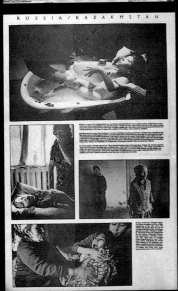

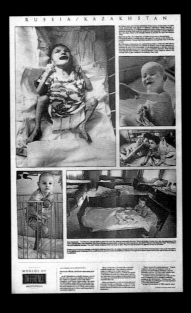

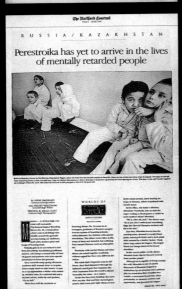

■ 342
Publication The Hartford Courant
Art Director Christian Potter Drury
Designer Christian Potter Drury
Photo Editors Thom McGuire, John Scanlan
Publisher The Hartford Courant
Issue June 18, 1995
Category Story/Feature

■ 343
Publication Boy Scouts Annual Report
Creative Director John Brady
Art Director Paula Madden
Designers John Brady, Paula Madden
Photo Editor Paula Madden
Photographer Tom Gigliotti
Studio John Brady Design Consultants
Client Greater Pittsburgh Council
Issue June 7, 1995
Category Entire Issue

■ 344 A

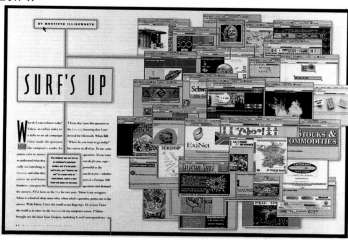

■ 345

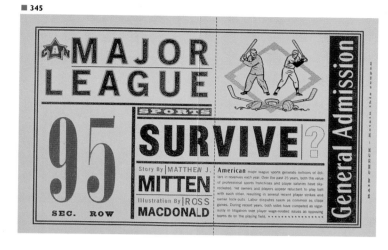

■ 346

■ 344
Publication Hemispheres
Art Director Jaimey Easler
Designer Jaimey Easler
Photo Editor J. Kirby Heard
Client United Airlines
Publisher Pace Communications
Issue October 1995
Category Story/Feature
■ A Spread/Feature

■ 345
Publication Quarterly
Art Director Mark Geer
Designer Mark Geer
Illustrator Ross MacDonald
Studio Geer Design
Publisher Pace Communications
Issue March 31, 1995
Category Spread/Feature

■ 346
Publication Quarterly
Art Director Mark Geer
Designer Mark Geer
Illustrator Linda Bleck
Studio Geer Design
Publisher Pace Communications
Issue August 15, 1995
Category Spread/Feature

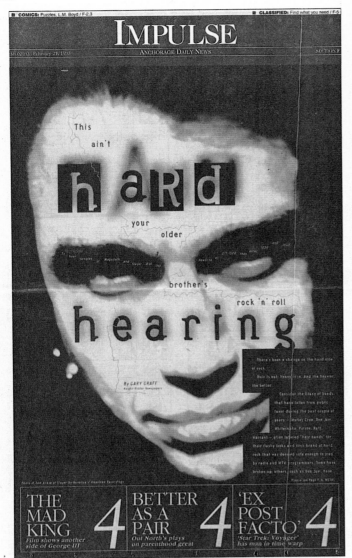

Polese Clancy

Redefining Marketing Communications

Click anywhere to enter Polese Clancy's Web site.

Last updated: 4/1/96

■347
Publication Anchorage Daily News/Impulse
Creative Director Galie Jean-Louis
Designer Dee Boyles
Photo Editor Galie Jean-Louis
Photographer Anna Lisa
Publisher Anchorage Daily News
Issue February 27, 1995
Category Spread/Feature

■348
Publication
Macmillan Digital USA
Art Directors
Janet Tingey, Lisa Powers
Designer Lisa Powers
Studio Lisa Powers
Online Address
http:/www.mcp.com/macdigital
Publisher Simon & Schuster
Issue August 1995
Category Home Page

■349
Publication PC Homepage
Creative Director Ellen Clancy
Designers Ellen Clancy, Mark Field
Illustrator Mark Field
Studio Polese Clancy
Online Address
http:www.PoleseClancy.com.pc/
Issue September 10, 1995
Category Home Page

■350
Publication LIFE
Design Director Tom Bentkowski
Designers Steve Walkowiak,
Tom Bentkowski
Photo Editor David Friend
Publisher Time Inc.
Online Address
http://pathfinder.com/Life/lifehome.html
Category Home Page

LIFE
ROCK & ROLL
GALLERY
CELEBRATING
The ROCK & ROLL Hall of Fame

The Best on **GUITAR**

The **Beatles**

Rock & Roll **ARTIFACTS**

Best Rock **RECORDINGS**

LIFE Classic Essay **ROCK PARENTS**

Rock & Roll **LEGENDS**

ELVIS THE KING

Rock **TRIVIA**

LIFE Covers **Rock & Roll**

THE BEST ON **GUITAR** Photos by HARRY BENSON

B.B. KING "B"

When B.B. King, 70, was growing up in Indianola, Miss., he picked cotton for $7 a ton. Today he picks "Lucille," a custom-made Gibson ES 335, named after a woman who caused the biggest bar fight he ever saw.

Eddie **VAN HALEN** Bonnie **RAITT** B.B. **KING** Carlos **SANTANA** Buddy **GUY**
Robbie **ROBERTSON** Chuck **BERRY** Les **PAUL** Jerry **GARCIA** Eric **CLAPTON**

Return to Essay

Rock & Roll Gallery Home Page

Click on a square below to go to those subjects

LIFE with **The Beatles '64-'95**

LIFE

Beatle Covers

other

Beatles Websites

an essay: exclusive

On and On

Linda McCartney Photos

The Beatles were reborn this fall with a LIFE commemorative issue (on newsstands October 31, 1995), an ABC-TV prime-time special *"The Beatles Anthology"* and a "reunion" song, *Free As A Bird*, appearing on a new Beatle CD.

Presented here are highlights from LIFE's issue, including exclusive photos (by Harry Benson and Linda McCartney) of Paul, George, Ringo--and Yoko--today.

■ 351
Publication LIFE
Design Director Tom Bentkowski
Designer Steve Walkowiak
Photo Editor David Friend
Publisher Time Inc.
Online Address
http://pathfinder.com/Life/rocknroll/rocknroll.html
Category Entire Issue
■ **A** Home Page

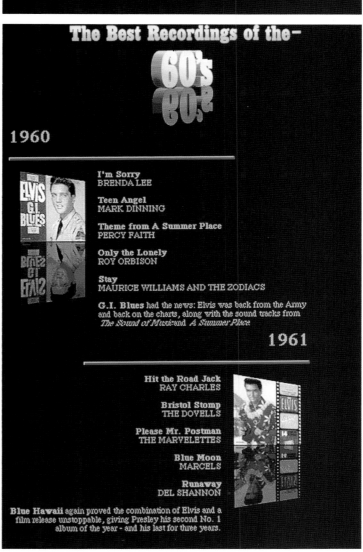

The Best Recordings of the—

60's

1960

I'm Sorry
BRENDA LEE

Teen Angel
MARK DINNING

Theme from A Summer Place
PERCY FAITH

Only the Lonely
ROY ORBISON

Stay
MAURICE WILLIAMS AND THE ZODIACS

G.I. Blues had the news: Elvis was back from the Army and back on the charts, along with the sound tracks from *The Sound of Music* and *A Summer Place.*

1961

Hit the Road Jack
RAY CHARLES

Bristol Stomp
THE DOVELLS

Please Mr. Postman
THE MARVELETTES

Blue Moon
MARCELS

Runaway
DEL SHANNON

Blue Hawaii again proved the combination of Elvis and a film release unstoppable, giving Presley his second No. 1 album of the year – and his last for three years.

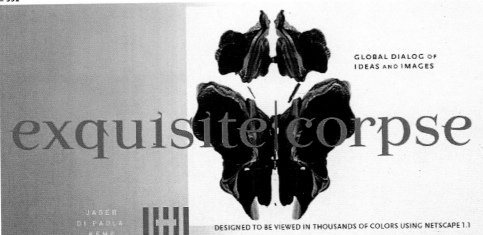

GLOBAL DIALOG OF
IDEAS AND IMAGES

exquisite corpse

JAGER
DI PAOLA
KEMP

DESIGNED TO BE VIEWED IN THOUSANDS OF COLORS USING NETSCAPE 1.1

CARIBBEAN

Click on the name of the island or island chain you would like to visit

Great escapes

Click the name of the country or region you would like to visit

Publication Exquisite Corpse
Creative Director Michael Jager
Design Director David Covell
Designers Chris Bradley
Studio Jager Di Paola Kemp Design
Online Address http://www.jdk.com
Issue July 1995
Category Home Page

Publication
Condé Nast Traveler Online
Art Director Stephen Orr
Illustrator Alex Reardon
Publisher Condé Nast Publications Inc.
Online Address http://cntraveler.com
Category Home Page

Publication
Condé Nast Traveler Online
Art Director Stephen Orr
Illustrator Alex Reardon
Publisher Condé Nast Publications Inc.
Online Address http://cntraveler.com
Category Home Page

Publication Epicurious
Creative Director Mark Michaelson
Design Director Kayvan Sotoodeh
Art Directors
Kevin Slavin, Paul Tedesco
Photo Editor Anastasia Pleasant
Publisher Condé Nast Publications Inc.
Online Address
http://www.Epicurious.com
Category Home Page

ILLUSTRATION

ILLUSTRATION GOLD

RECORDINGS HEARTBREAK KIDS
BY DAINA DARZIN

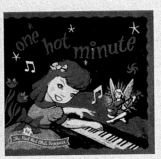

★ ★ ★ 1/2
ONE HOT MINUTE
The Red Hot Chili Peppers
Warner Bros.

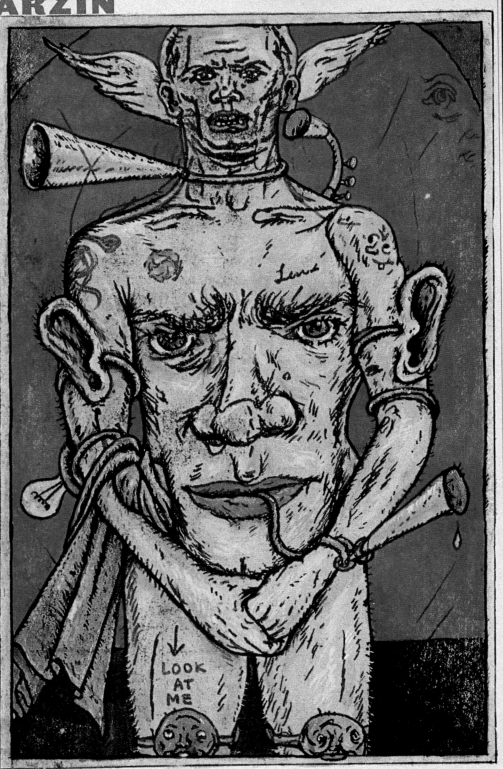

FAKE HEARTBREAK IS A TOP 40 STA-ple; it's usually carried by Michael Boltonesque histrionics. On the other hand, real heartbreak (think Joy Division) tends to be quiet; it kinda sneaks up on you and grabs you and then sticks with you for the rest of the day. On *One Hot Minute*, "Tran-scending" has that quality: gorgeously trancey, anguished, undulating rhythm loops and crescendos wrap around lyrics about death that are both weirdly spiritual ("Never know when the gods will come and/Take you/To a loving stream") and raging ("Fuck the maga-zines/Fuck the green machine").

All this from the Red Hot Chili Peppers, the sloppy punk-funk troupe that rose to fame wearing tube socks on its dicks.

One Hot Minute dives into the emotionally deep end of drug addiction and loss, themes the Chili Peppers first touched on in their biggest hit to date, "Under the Bridge," from their 1991 megaplatinum wonder, *Blood Sugar Sex Magik*. For these guys, seriousness turns out to be a lot more liberating than any mis-adventure. Before their original guitarist Hillel Slovak's 1988 accidental-overdose death, the Peppers' gleeful insanity often masked their broad and fluent musical vocabulary, including bassist Flea's interest in jazz and classical music. Now their belief in the power of jamming, innovation and spontaneity is fully unleashed. *One Hot Minute* is a ferociously eclectic and imaginative disc that also presents the band members as more thoughtful, spiritual — even

ILLUSTRATION BY JONATHON ROSEN

356
Publication Rolling Stone
Creative Director Fred Woodward
Art Director Richard Baker
Illustrator Jonathon Rosen
Publisher Wenner Media
Issue October 5, 1995
Category Single Page

RECORDINGS HIS BACKPAGES
BY SUSAN RICHARDSON

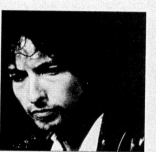

★★★★
MTV UNPLUGGED
Bob Dylan
Columbia

★★★
GREATEST HITS, VOL. III
Bob Dylan
Columbia

THIRTY YEARS AFTER THE acoustic Bob Dylan gave the rock world its definitive "plug in," he has joined the ranks of the unplugged. Of course, this doesn't mean the same thing for him that it does for other artists who have played the MTV forum: Dylan has been remaking his songs for three decades anyway. Yet this album still comes across as a statement. Appearing on the heels of a successful tour and the release of *Greatest Hits, Vol. III,* Dylan's *Unplugged* is less about stylistic experimentation than about his reconnection with his audience and his past.

Even the *Greatest Hits* is, predictably, atypical. While for most artists, putting together a greatest hits is tantamount to lining up the No. 1's, Dylan's body of work is far more complex. In documenting his best since 1971, the inclusion of "Tangled Up in Blue" and "Forever Young" makes perfect sense, but why "Changing of the Guards" instead of "Every Grain of Sand," "Hurricane" instead of "Blind Willie McTell"? If the collection is debatable as a hits package, though, it's nonetheless classic Dylan.

For the *Unplugged* session, however, Dylan wanders unabashedly into his indisputable greatest. Backed by a tight acoustic ensemble, he opens with "Tombstone Blues" — a cut, ironically, from *Highway 61 Revisited,* his first fully electric album. "All Along the Watchtower" broadens out into a stately end-

ILLUSTRATION BY HANOCH PIVEN

ILLUSTRATION SILVER ▶

▼357
Publication Rolling Stone
Creative Director Fred Woodward
Illustrator Hanoch Piven
Publisher Wenner Media
Issue May 4, 1995
Category Single Page

139

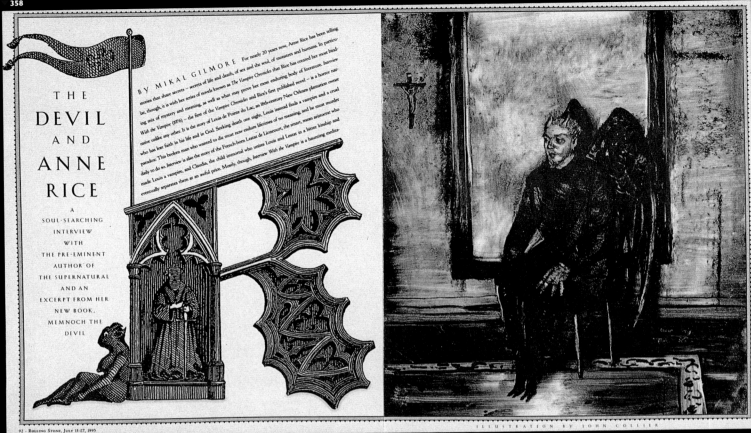

THE
DEVIL
AND
ANNE
RICE

A
SOUL-SEARCHING
INTERVIEW
WITH
THE PRE-EMINENT
AUTHOR OF
THE SUPERNATURAL
AND AN
EXCERPT FROM HER
NEW BOOK,
MEMNOCH THE
DEVIL

BY MIKAL GILMORE For nearly 20 years now, Anne Rice has been telling stories that share secrets — secrets of life and death, of sex and the soul, of monsters and humans. In particular, though, it is with her series of novels known as *The Vampire Chronicles* that Rice has created her most binding mix of mystery and meaning, as well as what may prove her most enduring body of literature. *Interview With the Vampire* (1976) — the first of the *Vampire Chronicles* and Rice's first published novel — is a horror narrative unlike any other. It is the story of Louis de Pointe du Lac, an 18th-century New Orleans plantation owner who has lost faith in his life and in God. Seeking death one night, Louis instead finds a vampire and a cruel paradox: This broken man who wanted to die must now endure lifetimes of no meaning, and he must murder daily to do so. *Interview* is also the story of the French-born Lestat de Lioncourt, the smart, mean aristocrat who made Louis a vampire, and Claudia, the child immortal who unites Louis and Lestat in a bitter kinship and eventually separates them at an awful price. Mostly, though, *Interview With the Vampire* is a haunting medita-

92 · ROLLING STONE, JULY 13-27, 1995

ILLUSTRATION BY JOHN COLLIER

358
Publication Rolling Stone
Creative Director Fred Woodward
Designer Geraldine Hessler
Illustrator John Collier
Publisher Wenner Media
Issue July 13, 1995
Category Spread

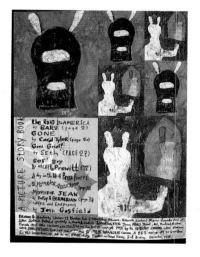
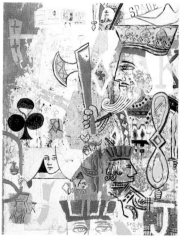
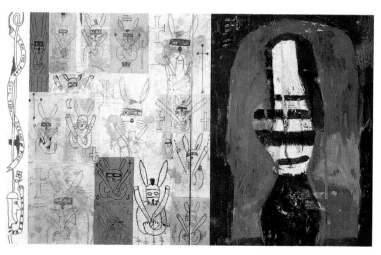

▼359
Publication Drawn and Quarterly
Design Director Chris Oliveros
Art Director Josh Gosfield
Illustrator Josh Gosfield
Studio Joshua Simon Gosfield's Mighty House of Pictures
Publisher Drawn and Quarterly Publishing
Issue December 1995
Category Story

POWER 101

USED TO BE, if you wanted more power, you just went out and conquered. Alexander the Great plowed through Persia, the Romans gobbled up the known world, Attila plundered the Romans. No lawyers, no accountants, no dog and pony show for the nightly news. Back then, they called it war. ◆ These days they call it a "merger," but the underlying philosophy is much the same: the bigger, the better. And over the past year, showbiz has witnessed enough mergers (proposed or otherwise) to make the Huns look laid-back. In April, Seagram bought MCA. In July, Disney bought ABC. Next day, Westinghouse bought CBS. A month later, Time Warner merged with Turner Broadcasting to create an $18.7 billion media empire, the biggest in the world. ◆ In short, Hollywood has never seen such a quick succession of power grabs. For those perplexed by this brave new world of "global synergy" and "vertical integration," take heart: ENTERTAINMENT WEEKLY's sixth annual Power Is-

sue will help you keep track of who's up and who's down—and what it all means. Yes, you'll see big changes. (A year ago, who'd have guessed that Ted Turner or Michael Ovitz would play second fiddle to anyone?) You'll also see no change at all. (White guys still run almost everything.) ◆ And if you're nervous about the Orwellian implications—wondering, perhaps, about a world in which a handful of mammoth corporations control all channels of communication, including the magazine you're holding—relax. No one knows if these mergers will wind up making companies richer and more powerful or just give them more headaches. Besides, history teaches us a lesson about empires: There's always a pack of barbarians at the gate eager to do a little downsizing.

WRITTEN AND REPORTED BY:

Erica K. Cardozo, Steve Daly, Jeff Gordinier, Dana Kennedy, Gregg Kilday, Albert Kim, Curt Feldman, Nisid Hajari, Tiarra Mukherjee, Chris Nashawaty, Tim Purtell, Laura C. Smith, Dan Snierson, Daneet Steffens, Anne Thompson, Louis Vogel, Bret Watson, and Chris Willman

ILLUSTRATION AND ICONS BY SCOTT MENCHIN

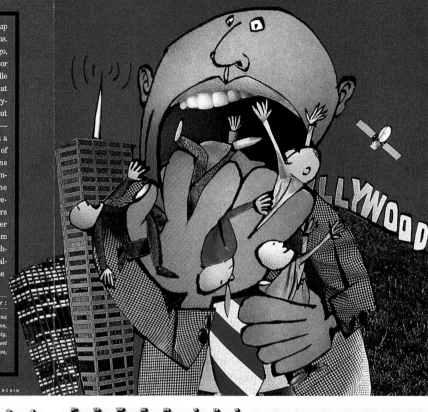

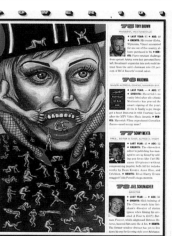

Publication Entertainment Weekly
Design Director Robert Newman
Art Director Florian Bachleda
Designers Florian Bachleda, Bobby B. Lawhorn Jr.
Illustrators Kyle Baker, Barry Blitt, Steve Brodner, Calef Brown, Sue Coe, David Cowles, Drew Friedman, Matt Groening, John Kascht, Scott Menchin, Tim O'Brien, Gary Panter, C. F. Payne, Hanoch Piven
Publisher Time Inc.
Issue October 27, 1995
Category Story

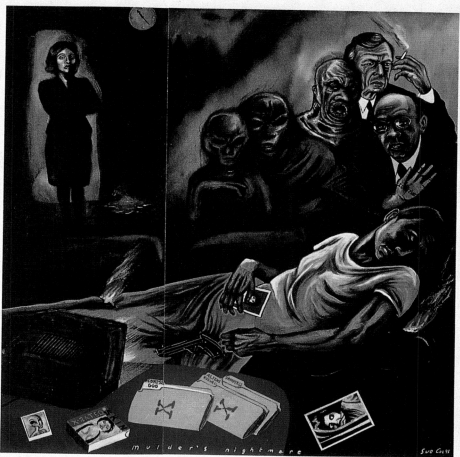

Entertainment
FRIDAY, SEPTEMBER 29, 1995

NEWS & NOTES

8/What *The Brady Bunch* Begot A new wave of old sitcoms heads for the big screen...Pope mania...Party pics from all over...HOT SHEET...FLASHES...MONITOR...and more.

14/The Biz The first four films of Michael Douglas' megadeal.

16/Being There O.J. trial watchers cruise the high seas.

19/Behind the Scenes Unusual buzz boosts *Usual Suspects*.

FEATURES

20/COVER No Wonder He's Called Fox BY BENJAMIN SVETKEY Smart, sexy David Duchovny is handling his *X-Files* stardom just swimmingly—right down to his Speedos.

28/Girls! Girls! Girls! BY BENJAMIN SVETKEY *Showgirls* leads off a pack of stripper movies, testing the audience for both the genre and the NC-17 rating. **PLUS:** A history of strip flicks.

32/Fiddler Through the Roof BY DANA KENNEDY Bluegrass singer-fiddler Alison Krauss wins fans, three Grammys, and four '95 Country Music Association nods with her "newgrass" sound.

REVIEWS

36/MOVIES OWEN GLEIBERMAN on *Seven*; also *Devil in a Blue Dress*. **PLUS:** *Seven*'s scribe; how *To Wong Foo* plays in Peoria.

44/TELEVISION KEN TUCKER on the onslaught of new talk shows; also *The Bonnie Hunt Show*, *The Pursuit of Happiness*, and *Can't Hurry Love*. **PLUS:** Life after *The Facts of Life*.

53/BOOKS GENE LYONS on Colin Powell's *My American Journey*; also Leonard Nimoy's *I Am Spock* and Ann Beattie's *Another You*. **PLUS:** Three sources for the last word on style.

58/MUSIC DAVID BROWNE on the *Friends* soundtrack; also Emmylou Harris, the Mavericks, Lisa Loeb, and Sonic Youth.

65/MULTIMEDIA CHRIS NASHAWATY on celebrity worship on the World Wide Web. **PLUS:** Videogames hit the print button.

68/VIDEO GLENN KENNY on *The Monkees: The Collector's Edition*; also two creepy hits from the '30s. **PLUS:** Ami Dolenz.

DEPARTMENTS

6/Mail "The Gay '90s," Judge Ito on the *Melrose Place* issue.
74/Encore Oct. 2, 1985: Rock Hudson succumbs to AIDS.

Cover DAVID DUCHOVNY PHOTOGRAPHED FOR *EW* BY MARK HANAUER; STYLING GEORGE BLODWELL-CLOUTIER; GROOMING: LUCIENNE ZAMMIT; CLOUTIER; CLOTHING: THIERRY MUGLER.

ENTERTAINMENT WEEKLY (ISSN 1049-0434) is published weekly except two weeks the last issues of February, June, August, and December, by Entertainment Weekly Inc., a wholly owned subsidiary of The Time Inc. Magazine Company. Principal office: 1675 Broadway, New York. New York. NY 10019. Michael J. Klingensmith, President; George H. Valentine, Treasurer; Harry M. Johnston, Secretary. Second-class postage paid at New York, NY and additional mailing offices. U.S. subscriptions $51.48 for 52 issues. Canada Post International Publications Mail Canadian Distribution Sales Agreement No. 549431. GST #R126856657. POSTMASTER: Send address changes to ENTERTAINMENT WEEKLY, Post Office Box 30608, Tampa, FL 33630-0608. ©1995 ENTERTAINMENT WEEKLY INC. ALL RIGHTS RESERVED. REPRODUCTION IN WHOLE OR IN PART WITHOUT PERMISSION IS PROHIBITED. ENTERTAINMENT WEEKLY IS A REGISTERED TRADEMARK OF ENTERTAINMENT WEEKLY INC.

ILLUSTRATION BY SUE COE

EW ONLINE
Entertainment Weekly is available on AMERICA ONLINE (keyword: EW) and on PATHFINDER on the World Wide Web (http://pathfinder.com/ew/).

◆ **Missed our online** chat with *Star Trek's* Leonard Nimoy? Download the transcript from EW Interactive on America Online—and check out the event schedule for future guests.

20
X-TREME DREAM: Assorted eerie aliens and other bad memories come back to haunt FBI special agent Mulder (David Duchovny)

ILLUSTRATION SILVER ▼

loose talk
COMPILED BY CAROL DITTBRENNER

"You know, I have a weird Michael Douglas fetish. I *love* Michael Douglas. He's older. Jewish. Hot. I really want a Jewish Prince." COURTNEY LOVE

"I didn't realize that it was a fairly large film that I was a part of. Halfway through it I was going, 'Is there any place that my mom and dad can see this film?' and they're going, 'Cameron, at the *theaters*.' I had no idea. *Durrrrr*, I'm blond. I'm allowed." 'Mask' star CAMERON DIAZ

"Such is the price of fame. People start poking around in your private life, and the next thing you know, your sister is actually your mother." JACK NICHOLSON

"I feel much more positive, and it's simply through getting older. I've experienced different places, different relationships. I've moved into my own house. Now I appreciate how important it is just to maintain your gutters and your boiler." PJ HARVEY

"There are those who say, not without good reason, that if you think there is anything better than sex, then you've never really had good sex. That said, I'd put garlic, baked garlic, chocolate, chips and salsa, and definitely champagne at the top of my list." HEATHER LOCKLEAR

"We started shooting *Batman Forever* in September. That was September of a different year. It'll never be finished. It's not a movie. It's a mythology." VAL KILMER

"I am not a power-hungry person. Power is overrated. Maybe it means that somebody will take your phone call, only I probably don't want to talk to that person." JODIE FOSTER

"At age 106, in the arms of a 38-year-old Sharon Stone look-alike, while in deep sleep." LARRY KING, when asked how he would like to die

"I get to be a kid now, because I wasn't a kid when I was supposed to be one. But in some ways, I'm an old woman – lived it, seen it, done it, been there, have the T-shirt." DREW BARRYMORE

"Nudity is the most natural state. I was born nude, and I hope to be buried nude." ELLE MACPHERSON

Illustration by PHILIP BURKE

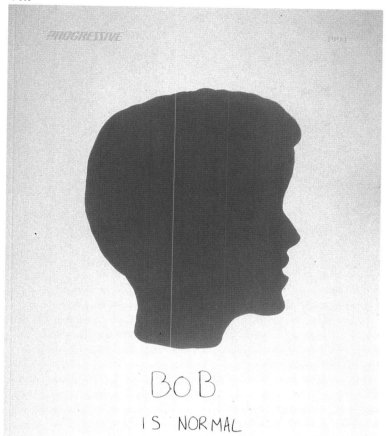

BOB

IS NORMAL

Diversity
reminds me
of the art
of pointillism:
perfect
individual dots
up close;
blurred images
from five
paces back;
remarkable
clarity
of each point's
purpose
and
value from the
intended
perspective.

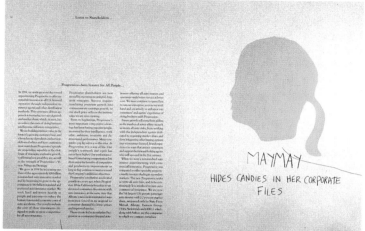

MAYMAY

HIDES CANDIES IN HER CORPORATE
FILES

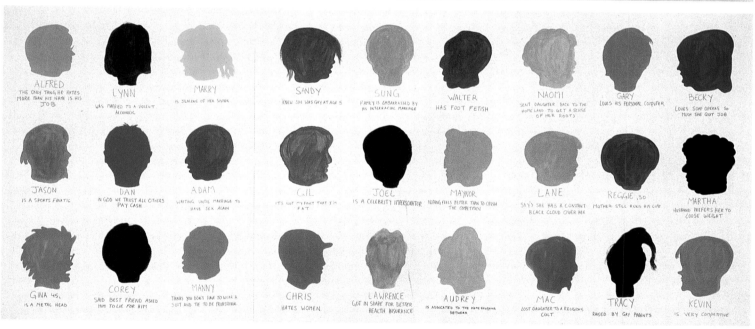

▼ 362
Publication US
Art Director Richard Baker
Illustrator Philip Burke
Publisher US Magazine Co., L.P.
Issue July 1995
Category Single Page

▼ 363
Publication The Progressive Corporation 1994 Annual Report
Creative Directors Mark Schwartz, Joyce Nesnadny
Designers Joyce Nesnadny, Michelle Moehler, Mark Schwartz
Illustrator Carter Kustera
Studio Nesnadny & Schwartz
Issue March 1995
Category Story

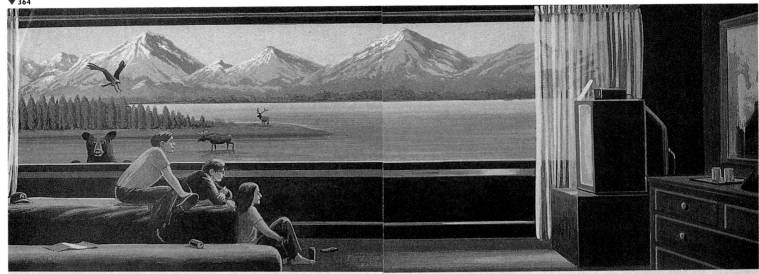

OH BEAUTIFUL, FOR, LIKE, WOW, SPACIOUS SKIES

EVERY FAMILY DREAMS OF TOURING THE GREAT AMERICAN NATIO NAL PARKS ONE IDYLLIC SUMMER. HERE'S WHAT REALLY HAPPENS

BY REBECCA OKRENT

ILLUSTRATED BY BRUCE McCALL

We were an unlikely band to be trekking across Utah. Confirmed city people, we view vacations as occasions for self-indulgence and coddling. Hand us plane tickets to Europe and we will happily be seduced by the honey-colored light glinting off a zinc bar in a Paris bistro.

Utah was our children's fault. To visit Europe with them and their peanut butter palates would be like traveling blindfolded. And so last summer we bowed to the kids, joining the caravan of other American families exploring our national parks.

Ours is a story of survival. We survived 2,600 miles of driving and sharing rooms, the rapids of the Colorado River, reliably dull food, a scorpion, Siegfried & Roy, and other challenges of the trail.

▼ 364
Publication Travel & Leisure
Art Director Giovanni Russo
Designers Gaemer Gutierrez, Giovanni Russo
Illustrator Bruce McCall
Publisher American Express Publishing
Issue May 1995
Category Story

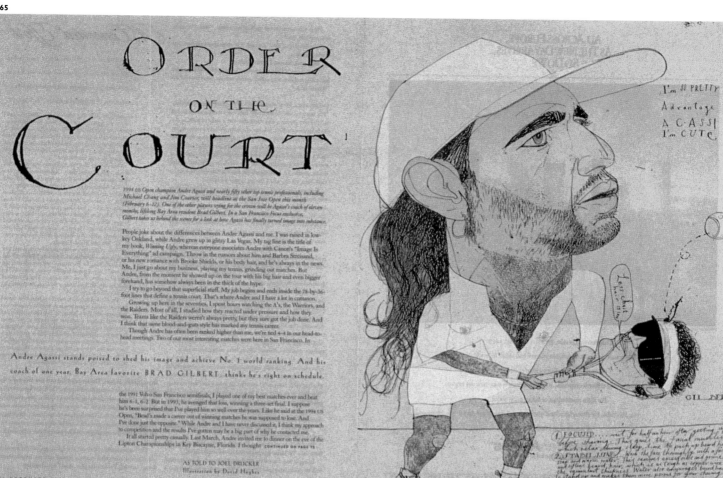

ORDER ON THE COURT

▼ 365
Publication San Francisco Focus
Art Director David Armario
Designers David Armario, John Walker
Illustrator David Hughes
Publisher KQED, Inc.
Issue February 1995
Category Spread

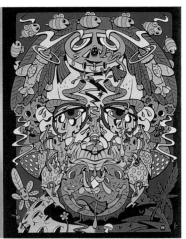

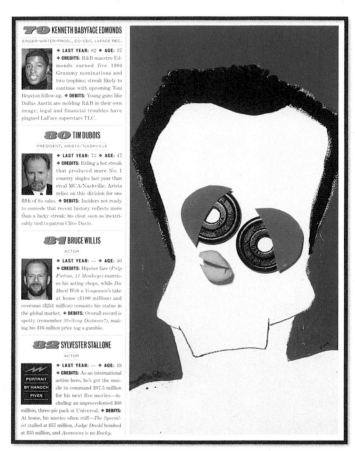

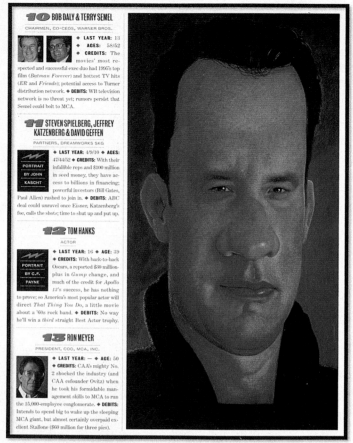

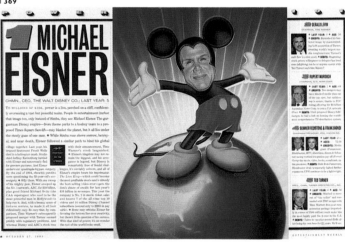

■ 366
Publication Entertainment Weekly
Design Director Robert Newman
Art Director Mark Michaelson
Designer Susan Conley
Illustrator Steven Cerio
Publisher Time Inc.
Issue September 11, 1995
Category Spread

■ 367
Publication Entertainment Weekly
Design Director Robert Newman
Designer Florian Bachleda
Illustrator Hanoch Piven
Publisher Time Inc.
Issue October 27, 1995
Category Single Page

■ 368
Publication Entertainment Weekly
Design Director Robert Newman
Designer Florian Bachleda
Illustrator C. F. Payne
Publisher Time Inc.
Issue October 27, 1995
Category Single Page

■ 369
Publication Entertainment Weekly
Design Director Robert Newman
Designer Florian Bachleda
Illustrator Tim O'Brien
Publisher Time Inc.
Issue October 27, 1995
Category Spread

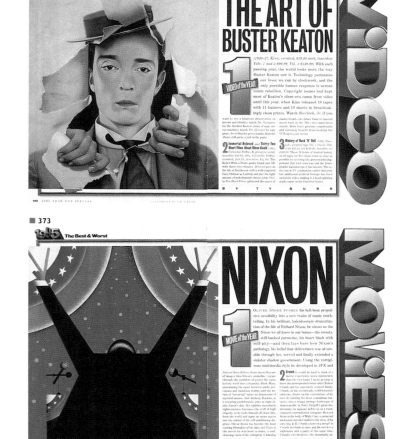

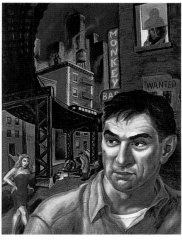

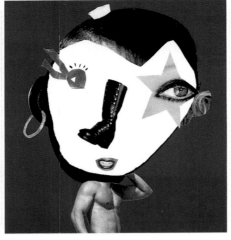

AMERICA SEES SHADES OF GAY

A ONCE-INVISIBLE GROUP FINDS THE SPOTLIGHT

BY JESS CAGLE

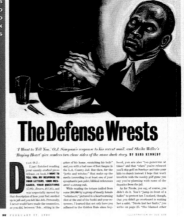
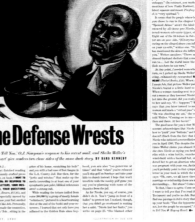

Book Ends

JONATHAN KELLERMAN

The Defense Wrests

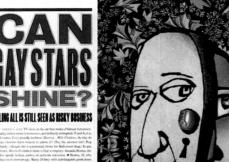
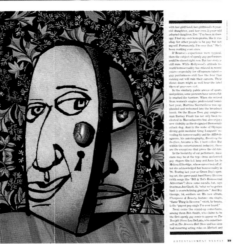

CAN GAY STARS SHINE?

TELLING ALL IS STILL SEEN AS RISKY BUSINESS

BY DANA KENNEDY

Blinded by the Height

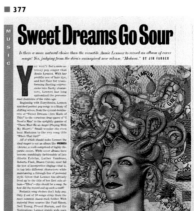

DEFINITELY MIGHT BE HUGE

SELLING 'OUT'

POP CULTURE LOOSENS ITS STRAIGHT JACKET

Sweet Dreams Go Sour

GETTING THE IRISH UP

■ 374
Publication Entertainment Weekly
Design Director Robert Newman
Designer Michael Picon
Illustrator Scott Menchin
Publisher Time Inc.
Issue September 5, 1995
Category Story

■ 375
Publication
Entertainment Weekly
Design Director Robert Newman
Art Director Elizabeth Betts
Designer Joe Kimberling
Illustrator Sue Coe
Publisher Time Inc.
Issue February 17, 1995
Category Spread

■ 376
Publication
Entertainment Weekly
Design Director Robert Newman
Art Director Elizabeth Betts
Designer Joe Kimberling
Illustrator Hanoch Piven
Publisher Time Inc.
Issue March 10, 1995
Category Spread

■ 377
Publication
Entertainment Weekly
Design Director Robert Newman
Art Director Elizabeth Betts
Designer Joe Kimberling
Illustrator Janet Woolley
Publisher Time Inc.
Issue March 17, 1995
Category Spread

Art in the Right Place

The Green Day After

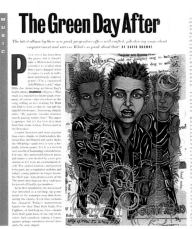

Computer Literate

comics

ILLUSTRATION MERIT

HE MAY HAVE BEEN THE greatest caricaturist of all time—he has imitators to this day—but his true passion was for a very different discipline

BY EDWARD SOREL

Covarrubias

Miguel Covarrubias at his drawing table at Condé Nast Oposite: in a 1932 "Impossible Interview," Clark Gable and Edward, Prince of Wales, join in mutual commiseration on the burdens of being adored.

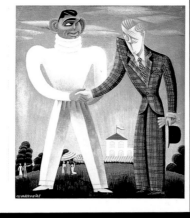

THE DEADLY DIET

High cholesterol is all hype, according to a renegade scientist. It's too much iron that can kill you

BY TERENCE MONMANEY

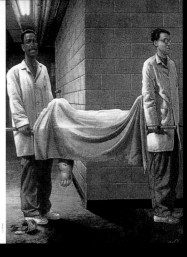

THE STYLE OF CARICATURE that the young Mexican brought north was unlike any that had come before, and the public found it irresistible.

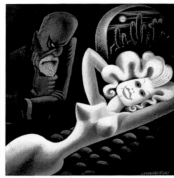

Eugene O'Neill meets Jimmy Durante, who, in Vanity Fair's accompanying text, says to the playwright, "If I could be as funny when I try, Gene, as you are when you ain't trying—Haa Chaaaaaa!"

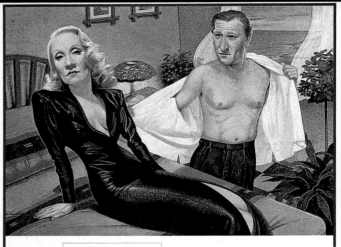

FICTION

The Long Voyage Home

Dietrich and the Duke? A-yup

BY DAN BARDEN

WHEN MARLENE DIETRICH FIRST SAW JOHN WAYNE, he was wearing a suit. This was at the Universal Pictures commissary in the late '30s, before John Wayne was John Wayne. Duke wore a suit because he wasn't in production. Dietrich, in a suit that cost a lot more than Wayne's, watched him from across the room. Her agent, Charlie Feldman, sat beside her. As she finished chewing a lance of asparagus dipped in Hollandaise sauce, she condescended to smile in a way that had already brought her to Hollywood, had already made her more money than the rest of the employees in the commissary put together. She watched John Wayne (he looked good in suits, but not so good in ties—he wore the suit without the tie, the collar buttoned to his neck), and she said, "Charlie, I've just seen what I want for Christmas."

Wayne was younger than Dietrich. Wayne was less successful. Wayne was married.

A FEW DAYS AFTER THAT, an actor named Rick Rorbach offered to lend Duke a bicycle to get around the studio. Duke was embarrassed because he couldn't remember Rick's screen name—he'd never seen any of his movies—and he wasn't too interested in bicycles. Duke Wayne wasn't one to keep up with the fads of the younger actors. He'd always been more comfortable with the older men around town. Except for his buddy from USC, Ward Bond, Duke's friends were the stuntmen, character actors and directors. At that time, he was tight enough with John Ford that Ford took both him and Bond out for Catalina weekends aboard his sailboat, Araner. Besides, Rorbach seemed fruity, and Duke was afraid there was more to the offer than just a ride on a bike. (continued on page 134)

THE SCHEME TEAM

SURE, CHEATING AT THE OLYMPICS IS DISHONEST, BUT IT'S A TRADITION AS OLD AS THE MODERN GAMES — AND ONE THAT MANY SPORTS OFFICIALS ARE LOATH TO CHANGE. A LOOK AT HOW ATHLETIC SCOUNDRELS WILL GO SCAMMING FOR GOLD AT ATLANTA '96.

BY JOHN McLAUGHLIN

ILLUSTRATIONS BY TERRY ALLEN

■ 383
Publication American Heritage
Art Director Peter Morance
Designer Peter Morance
Illustrator Miguel Covarrubias
Publisher American Heritage
Issue December 1995
Category Story

■ 384
Publication Men's Journal
Art Director Mark Danzig
Designer Mark Danzig
Illustrator Terry Allen
Publisher Wenner Media
Issue November 1995
Category Spread

■ 385
Publication GQ
Creative Director Robert Priest
Designer Robert Priest
Illustrator C. F. Payne
Publisher Condé Nast Publications Inc.
Issue February 1995
Category Spread

■ 386
Publication GQ
Art Director John Korpics
Designer Rina Migliaccio
Illustrator C. F. Payne
Publisher Condé Nast Publications Inc.
Issue October 1995
Category Single Page

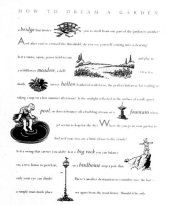

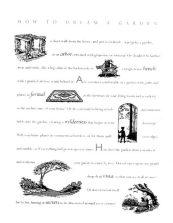

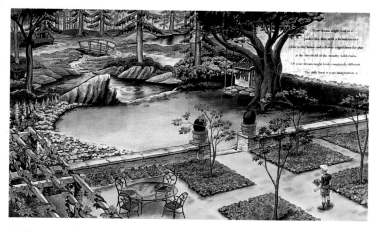

FLOODS

Dams break and walls of water sweep away cars like matchboxes. Time to call off the shaman.

BY WILLIAM S. BURROUGHS

slick Philly

ILLUSTRATION MERIT ■

■ 387
Publication Garden Design
Creative Director Michael Grossman
Art Director Paul Roelofs
Illustrator Ross McDonald
Publisher Meigher Communications
Issue February/March 1995
Category Story

■ 388
Publication Outside
Creative Director Susan Casey
Designer Susan Casey
Illustrator Jonathan Rosen
Publisher Mariah Media
Issue March 1995
Category Spread

■ 389
Publication New Yorker
Art Director Chris Curry
Illustrator Josh Gosfield
Studio Joshua Simon Gosfield's
Mighty House of Pictures
Publisher Condé Nast Publications Inc.
Issue October 1995
Category Single Page

■ 390
Publication Mother Jones
Creative Director Kerry Tremain
Design Director Marsha Sessa
Designer Marsha Sessa
Illustrator Richard Thompson
Publisher Foundation For
National Progress
Issue August 1995
Category Spread

The Future Will Be Quaint
21st-Century New York? Ferries and Trolleys and Pedicabs, of Course BY JON GERTNER

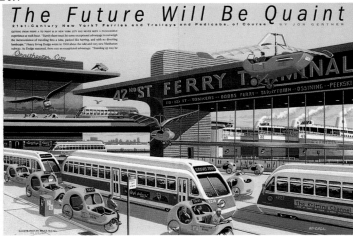

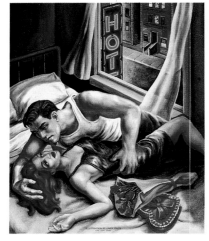

*Those days, casual, zipless sex is in every channel, every chat-line,
every billboard. Everywhere, that is, but in our own lives.
How the sexual revolution was both won and lost*

The End of The Affair

BY JAMES KAPLAN

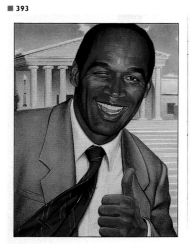

HEY, O.J.!

YOU'VE JUST BEEN ACQUITTED OF DOUBLE HOMICIDE! WHAT ARE YOU GOING TO DO NOW? A PUBLICIST ROUNDTABLE
BY BRUCE HANDY

It's hard to imagine, but at some point in the not-too-distant future, the O. J. Simpson trial will end. If Simpson is acquitted, and he wants to continue his career drawing on the public's goodwill—as a sportscaster, as a pitchman, as a D-list actor—he will soon face a battle even tougher and far more morbidly fascinating than the one he has waged for the past year

ILLUSTRATED BY TIM O'BRIEN

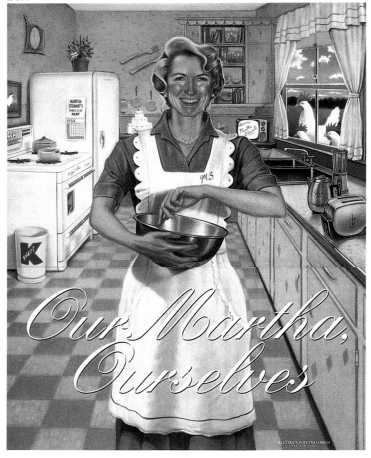

Our Martha, Ourselves

*It's no longer sufficient to dismiss Martha Stewart as a control-freakish middlebrow
tastemaker. She's bigger, much bigger. Coming to terms with an emblematic figure of our times.*

If you've noticed lately that the radiant presence of Martha Stewart seems to be infinite, like that of the Almighty, or of Starbucks, you're right. Martha has advanced way beyond the Kmart deals and coffee-table books to achieve the highest state of marketing grace there is. More than a franchise, more than a "lifestyle," more than an attitude, *she's a living trademark*. That means that the sun never sets on brand Martha. Every appearance or publication or bit of publicity works to sell the ever-growing—yet controlled and coherent—brand identity. For example, if she's seen at the bottom of an empty pool on an American Express commercial,

By Barbara Lippert

HIGH TECH

THE GREAT MANHATTAN GEEK RUSH OF 1995

THE CYBER GOLD RUSH WAS SUPPOSED TO HAPPEN IN CALIFORNIA. BUT THEN, LESS THAN A YEAR AGO, THE CRY OF THE HIGH-TECH PROSPECTORS CHANGED TO "GO EAST, YOUNG MAN."

BY MICHAEL KRANTZ

■ 391
Publication New York
Design Director Robert Best
Art Director Syndi Becker
Designer Rommel Alama
Illustrator Bruce McCall
Publisher K-III Publications
Issue January 16, 1995
Category Spread

■ 392
Publication New York
Design Director Robert Best
Art Director Syndi Becker
Designer Syndi Becker
Illustrator Owen Smith
Publisher K-III Publications
Issue March 6, 1995
Category Spread

■ 393
Publication New York
Design Director Robert Best
Art Director Syndi Becker
Designer Deanna Lowe
Illustrator Tim O'Brien
Publisher K-III Publications
Issue October 2, 1995
Category Spread

■ 394
Publication New York
Design Director Robert Best
Art Director Syndi Becker
Designer Syndi Becker
Illustrator Tim O'Brien
Publisher K-III Publications
Issue May 15, 1995
Category Single Page

■ 395
Publication New York
Design Director Robert Best
Art Director Syndi Becker
Designer Syndi Becker
Illustrator David Plunkert
Publisher K-III Publications
Issue November 13, 1995
Category Spread

ILLUSTRATION MERIT ■

RS703ALLTHENEWSTHATFITS

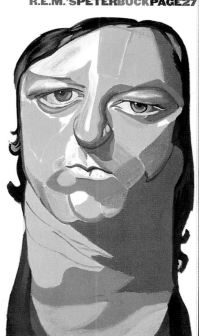

ROCK & ROLL

THE BRITISH AREN'T COMING *By David Sinclair* ... 25
England is exploding with bands — Blur, the London Suede, Oasis, Echobelly, Pulp, Portishead and Primal Scream. So why are they having such a hard time making it in America?
PLUS: PEARL JAM ... 56

NATIONAL AFFAIRS

SOUTHERN COMFORT *By William Greider* ... 40
The United States is willing to send billions to Mexico but nada to its own cities. Washington claims it's defending American jobs. But the bailout is really about rescuing Wall Street.

FEATURE STORIES

ETHAN HAWKE *By Chris Mundy* ... 44
Whether it's Nina Simone's singing, Jack Kerouac's *On the Road* or Sam Shepard's plays, Ethan Hawke is a fool for love. For the filmmaker, writer, theatrical impresario and, oh, yes, actor, happiness is an art.

THROWING MUSES *By Neil Strauss* ... 52
With the breathtaking *University,* Throwing Muses' Kristin Hersh finds the common ground between motherhood and rock & roll.

LOST IN AMERICA *By Robert Sabbag* ... 56
A generation ago, Nu Yeng Yang helped fight the CIA's secret war in Laos. Now resettled in America, he struggles with a new enemy — his own son.

REVIEWS

VOODOO CHILD *By Barbara O'Dair* ... 63
Strange, skewed and solitary — that's PJ Harvey's blues-inspired album *To Bring You My Love.*

SHARON AND THE WILD BUNCH
Movies by Peter Travers ... 69
Sharon Stone keeps her panties on in *The Quick and the Dead* — a trippy treatise on western movies that ends up deeply silly. For the genuine article, try the revival of *The Wild Bunch.*

PLUS: THE SUNDANCE FILM FESTIVAL ... 70

DEPARTMENTS

CORRESPONDENCE ... 16
RANDOM NOTES ... 20
CHARTS ... 80

COVER: Photograph of Ethan Hawke by Mark Seliger, Laurel Valley Plantation, New Orleans, January 1995. Styling by Patti O'Brien. Grooming by Stacy Stewart Kelly. Sweater by DKNY Men's.

THROWINGMUSES'KRISTINHERSHPAGE52

ILLUSTRATION BY PHILIP BURKE · ROLLING STONE, MARCH 9, 1995 · 11

RS704ALLTHENEWSTHATFITS

R.E.M.'SPETERBUCKPAGE27

ROCK & ROLL

"MONSTER" DOWN UNDER *By David Fricke* ... 27
Stipe and Co. open their first tour in five years in Australia.

NATIONAL AFFAIRS

A VIEW TO A KILL *By Eric Alterman* ... 48
When the data the CIA collects are available for the price of a bus ticket in Turkmenistan, why should U.S. taxpayers shell out billions to support it? Even Congress is beginning to wonder.

FEATURE STORIES

THE CRANBERRIES *By Alec Foege* ... 56
Ireland's biggest musical export since U2, the Cranberries are putting attitude at the top of the charts.

WEEZER *By Matt Udwitch* ... 62
They're not punk, they're not pop, they're not pretty — but they're huge. That's Weezer.

SPRING COLLEGE

LET'S GO . . . *By Dan Zevin* ... 72
. . . or let's not and say we did. The best-selling Harvard travel guides may trip you up.

GENERATION LATEX *By David Lipsky* ... 80
Despite rotten news about AIDS and date rape, sex on campus still roars. In some places it's the only thing that matters.

WHIP SMART *By Lamar Graham* ... 89
Time management? Yes! Highlighters? No! Herewith, the tricks of the trade for better grades.

INTO THE LOOP *By Charlie Drozdyk* ... 95
Forget about blindly sending out résumés. To land your dream job, you have to make connections.

PLUS: COLLEGE NOTEBOOK, 67 ... STYLE, 102

REVIEWS

VOICES CARRY *By Matt Diehl and Michael Azerrad* ... 119
Guided by Voices and Mike Watt bring it all back underground on *Alien Lanes, Bee* and *Ball-Hog or Tugboat?*

HE SHOOTS, HE SCORES *Movies by Peter Travers* ... 127
Leonardo DiCaprio — who gives an electrifying performance as a teen junkie in the film of Jim Carroll's *Basketball Diaries* — is one of seven maverick movie talents to watch.

PLUS: TELEVISION'S NETWORST, 131

DEPARTMENTS

CORRESPONDENCE ... 18
RANDOM NOTES ... 24
HOT STUFF ... 154
CHARTS ... 144

COVER: Photograph of Dolores O'Riordan of the Cranberries by Corrine Day, Madrid, Spain, February 1995. Hair and makeup by Raul Martin for Prescriptives. Styling by Tara St. Hill.

ILLUSTRATION BY PHILIP BURKE · ROLLING STONE, MARCH 23, 1995 · 13

MOVIESFIGHTTHEPOWER
BY PETER TRAVERS

PANTHER

STARRING
KADEEM HARDISON, MARCUS CHONG, COURTNEY B. VANCE

WRITTEN BY
MELVIN VAN PEEBLES

DIRECTED BY
MARIO VAN PEEBLES

GRAMERCY PICTURES

CONSIDER IT PAYBACK TIME. That's the quickest way to get a handle on *Panther,* a riveting two hours of revisionism that's fired up to show us what really went down when the Black Panther Party rolled out in Oakland, Calif., during the late 1960s. Director Mario Van Peebles and his father, Melvin, who adapted the script from his just-published novel, know that white media power still paints the Panthers as armed black devils. The elder Van Peebles, who revolutionized black cinema with *Sweet Sweetback's Baadasssss Song* in 1971, has joined with his son to fight that power. The film commendably accentuates the positives — from Panther breakfast programs to housing, health and employment agendas. What isn't commendable is minimizing the negatives — from drug dealing to homicide — that led to the party's disintegration.

Panther uses propaganda to fight propaganda. It's a film of selective truth. The script revolves around a fictional character named Judge (Kadeem Hardison). He's a Vietnam vet who gets swept into the movement to interact with Panther leaders Huey Newton (Marcus Chong) and Bobby Seale (Courtney B. Vance), as well as racist cops and FBI agents out to turn Judge into Judas. Though strongly played by Hardison, formerly of TV's *A Different World,* Judge is a melodramatic contrivance geared to give *Panther* an action-flick kick and an Everyman to root for.

Why would the film cheat on the potent facts to do the trite thing? Wake

ILLUSTRATION BY ANITA KUNZ · ROLLING STONE, MAY 18, 1995 · 95

MOVIESBRIDGEOFTIDES
BY PETER TRAVERS

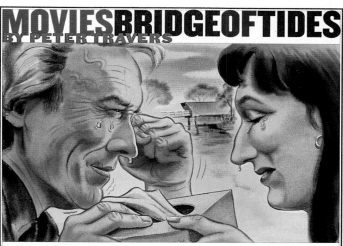

THE BRIDGES OF
MADISON COUNTY

STARRING
CLINT EASTWOOD AND MERYL STREEP

BASED ON THE NOVEL BY
ROBERT JAMES WALLER

DIRECTED BY
CLINT EASTWOOD

WARNER BROS.

MAYBE ROBERT JAMES Waller's best-selling novel of love forsaken, *The Bridges of Madison County,* had you crying in your beer along with 5.6 million other readers. It's more likely that the slim but famously fatuous volume depicting the ill-fated four-day affair between globe-trotting photographer Robert Kincaid

and Iowa farm wife Francesca Johnson had you puking on Waller's deep-purple prose. "There are songs that come free from the blue-eyed grass," writes Waller in an opening sentence that reveals the author's strain to wax Walt Whitman lyrical when what comes out is greeting-card gush. "I live with dust on my heart," Robert tells Francesca after making the supreme sacrifice of giving her up to her husband and children. The sentiment is part of a tradition — not of poetry but of great romantic crocks, from Erich Segal's *Love Story* ("Love means never having to say you're sorry") to Pat Conroy's *Prince of Tides,* with its now notorious camp incantation of "Lowenstein, Lowenstein."

As star and director of *Tides,* Barbra Streisand gave herself up to wretched soap-opera excess. As star and director of *Bridges,* Clint Eastwood tries valiantly to play it for real and not to wallow in Waller. He almost succeeds. The script, by Richard LaGravenese (*The Fisher King, A Little Princess*), dumps Waller's more florid fancies. Writer-photographer Robert Waller crafted writer-photographer Robert Kincaid as a hymn to him-

self, 52 when the book was published in 1992. "At 52, his body was all lean muscle . . . belly flat as a knife blade. . . . She noticed how small his rear was in his tight jeans . . . He was tall and thin and hard, and he moved like the grass itself, without effort, gracefully." During sex with Francesca, he "alternately kissed her lips or ears or ran his tongue along her neck, licking her as some fine leopard might do in long grass out on the veld." And here's the clincher: "Sometimes I write poetry, just for myself." Hey, he cooks, too.

It's an impossible role — a male fantasy cooked up by a preening peacock — yet Eastwood lends the character a well-spring of humor and humanity. Waller pumps up Robert as the "last cowboy," a former combat Marine who roams the world and leaves women squealing: "You're the best, Robert, no competition, nobody even close." Eastwood wisely brushes past the blather to focus on the cowboy at sunset, as much a relic of the romantic past as the covered bridges of Madison County, Iowa, that *National Geographic* has sent Robert to photograph. Characters at emotional risk

bring out the best in Eastwood as an actor (*Unforgiven, Tightrope, In the Line of Fire*), and under the towering heap of hokum that is *Bridges,* he still finds a heartbeat.

So does Meryl Streep, on record as disliking the book. She uses a dark wig, added pounds and an Italian accent — Anna Magnani lite — to play Francesca, the 45-year-old war bride raising two kids in Iowa with her dull, decent husband, Richard (Jim Haynie). Streep's technique is expert but distracting. While Eastwood digs inside himself for authenticity, Streep must first fuss with surface detail. Still, her performance steadily deepens, drawing us close to a woman whose life isn't "what I dreamed about as a girl."

Francesca feels "something jump inside" when the stranger with the Nikon rides up in his truck on an August day in 1965. Her family is off for a week at a state fair, so when the lost Robert asks directions to Roseman Bridge, she impulsively offers to go with him. Sharing a smoke and conversation, they take measure of each other with charming awkwardness. Francesca has felt like an alien since her husband

ILLUSTRATION BY ROSS MACDONALD · ROLLING STONE, JUNE 29, 1995 · 47

■ 396
Publication Rolling Stone
Creative Director Fred Woodward
Illustrator Philip Burke
Publisher Wenner Media
Issue March 9, 1995
Category Single Page

■ 397
Publication Rolling Stone
Creative Director Fred Woodward
Illustrator Philip Burke
Publisher Wenner Media
Issue March 23, 1995
Category Single Page

■ 398
Publication Rolling Stone
Creative Director Fred Woodward
Illustrator Anita Kunz
Publisher Wenner Media
Issue May 18, 1995
Category Single Page

■ 399
Publication Rolling Stone
Creative Director Fred Woodward
Illustrator Ross MacDonald
Publisher Wenner Media
Issue June 29, 1995
Category Single Page

RS712/713ALLTHENEWSTHATFITS

ROCK & ROLL

BUSH *By Christina Kelly* 29
Critics have called Bush's *Sixteen Stone* passionless second-generation Brit grunge. So why is it about to go platinum?

NATIONAL AFFAIRS

WHY I BELIEVE WHAT I BELIEVE
By P.J. O'Rourke 53
Conservatives believe in the rights of individuals and a government that allows them the maximum possible freedom.

WHY I DON'T BELIEVE WHAT HE BELIEVES
By William Greider 60
In focusing on government's flaws, conservatives ignore the threat to freedom posed by other powerful forces.

FEATURES

JIM CARREY *By Fred Schruers* 68
Humor, compulsive energy and rage — that's Jim Carrey, who stars as the Riddler in *Batman Forever*.

BJÖRK *By Mim Udovitch* 76
Björk has a mind like a kaleidoscope and a musicality that seems to bubble up, pure as Perrier, straight from the spring of her soul. Just listen to her new album, *Post*.

STEVIE WONDER *By David Ritz* 80
In a gangsta-rap world, Stevie Wonder still has faith in the healing power of music.

RWANDA *Photographs by Sebastião Salgado* 86
Although a new government took power after hundreds of thousands of Rwandans died in the genocide of 1994, the country remains trapped in a cycle of ethnic hatred and revenge — with no hope for justice or peace.

THE DEVIL AND ANNE RICE 92
A soul-searching interview with the pre-eminent author of the supernatural. Plus an excerpt from her new book, *Memnoch the Devil*.

REVIEWS

NEIL YOUNG *By J.D. Considine* 107
By hiring Pearl Jam as his backup band, Young turned *Mirror Ball* into a dialogue between rock generations.

FIRE ROCKETS 1, 2, 3 115
Movies by Peter Travers
Say this for the summer's Big Three movies — *Batman Forever*, *Pocahontas* and *Apollo 13* — Bob Dole couldn't accuse any of them of mainstreaming depravity.

BEYOND COOL *Television by David Wild* 119
Too old for Beavis, too young to die? Try the new VH1.

DEPARTMENTS

CORRESPONDENCE 20
RANDOM NOTES 25
TOYS OF SUMMER 121
CHARTS 132

COVER: Photograph of Jim Carrey by Herb Ritts, Los Angeles, March 1995. Hair by Pauletta Lewis. Makeup by Sheryl Ptak. Styling by L'Wren Scott for Visages. Set direction by Oliver Martin and Pascale Vaquette. Set construction by Waldaus. Poundcake the dog provided by Studio Animal Services.

BJÖRKPAGE76

ILLUSTRATION BY PHILIP BURKE — ROLLING STONE, JULY 13-27, 1995 · 13

MOVIESKIDSTODAY
BY PETER TRAVERS

KIDS

STARRING

LEO FITZPATRICK, JUSTIN PIERCE, CHLOE SEVIGNY

WRITTEN BY

HARMONY KORINE

DIRECTED BY

LARRY CLARK

MIRAMAX FILMS

CLUELESS

STARRING

ALICIA SILVERSTONE, JEREMY SISTO, STACEY DASH

WRITTEN AND DIRECTED BY

AMY HECKERLING

PARAMOUNT

L IKE A MILLION MOVIES BEFORE it, *Kids* starts with a kiss. But none quite like this graphic game of tonsil hockey. The boy, Telly (Leo Fitzpatrick), is 17 and eager for a more intimate exchange of bodily fluids. "Know what I want?" he asks the girl (Sarah Henderson), about 14 to judge by her looks and the stuffed animals in her bedroom. "Yeah," she says. "You wanna fuck me." The girl is a virgin, scared ("I don't want a baby") and pitifully susceptible to sweet talk, of which the skinny, slurred-of-speech Telly — wearing white socks and no condom — is a master. "It'll feel good. . . . I care about you. . . . It won't hurt." He pumps away with all the romantic fervor of a recruit doing push-ups. For Telly, HIV positive though he doesn't know it yet, sex is a contest. He collects virgins. Telly brags to Casper (Justin Pierce) about busting two cherries in one day, letting his envious pal sniff his fingers, which are fresh from his latest conquest. It's not fucking, it's telling about it that really turns Telly on.

So begins this astonishment of a movie from Larry Clark, the 52-year-old photographer making his debut as a director

ILLUSTRATION BY BOB AND VAL TILLERY — ROLLING STONE, AUGUST 10, 1995 · 61

RECORDINGSKINGOFPAIN
BY JAMES HUNTER

★★★ 1/2
HISTORY: PAST, PRESENT AND FUTURE, BOOK I
Michael Jackson
Epic

A DECADE AFTER "THRILLER" and MTV transformed pop, Michael Jackson releases a collection that combines a classic greatest-hits anthology with a jarring and uneven new album. Throughout *HIStory* we're reminded of the Michael Jackson who helped groove music go mainstream with *Off the Wall*, fused high-tech New Wave and Caribbean rhythms with the aid of producer Quincy Jones in *Thriller* and *Bad*, and communed with trancelike '90s soul and New Jack Swing inventor Teddy Riley on 1991's underpraised *Dangerous*. A decade after *Thriller*, Jackson's still the same: the apolitical universalist who never shared the hip-hop generation's politics, the pop figurehead who bends the latest mass flavors to his creative will, the Spielbergian artist tycoon who's drawn to Old Hollywood glamour and New Hollywood balance sheets. He still wants to be the King of Pop and to be left alone.

And now, Jackson is more embattled than ever, as the furor over the epithet slinging of "They Don't Care About Us," a new track from *HIStory*, demonstrates. In the past, Jackson's albums defined their pop surroundings so a fan could hear past their oddness. *HIStory* doesn't offer that option; these days, whiz-bang *Thriller*-style kicks exist more on computer screens than on radios. Instead of ignoring his troubles or attacking them from interesting angles, Jackson obsesses *[Cont. on 57]*

ILLUSTRATION BY BLAIR DRAWSON — ROLLING STONE, AUGUST 10, 1995 · 55

MOVIESCRIMEFICTION
BY PETER TRAVERS

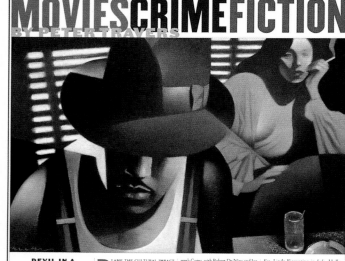

DEVIL IN A BLUE DRESS

STARRING

DENZEL WASHINGTON, JENNIFER BEALS, DON CHEADLE

DIRECTED BY

CARL FRANKLIN

TRISTAR PICTURES

SEVEN

STARRING

BRAD PITT, MORGAN FREEMAN, GWYNETH PALTROW

DIRECTED BY

DAVID FINCHER

NEW LINE CINEMA

B LAME THE CULTURAL IMPACT of Quentin Tarantino's *Pulp Fiction* for the current crime wave at the movies. This new age of renegade film noir is immune to Bob Dole's brimstone. You can't hit the cineplex these days without being boogied by blood spray and gobs of lurid dialogue. An upcoming skit on *Mad TV*, Fox's threat to *Saturday Night Live*, bills itself as "Gump Fiction," a bang-on parody in which Forrest, sitting primly on a park bench, pulls a gun on a guy who calls him a retard for yammering about his mama's damned box of chocolates.

Everybody's packin' heat at the flicks: pulp pretenders, such as *Bad Boys*, and real contenders, such as the dazzling *Usual Suspects*. The fall film season is a pulp pileup. Barry Sonnenfeld's *Get Shorty*, starring John Travolta as a hood who goes Hollywood, is the best bun movie so far this year. The word is also hot on Martin Scor- sese's *Casino*, with Robert De Niro and Joe Pesci; Michael Mann's *Heat*, with De Niro and Al Pacino; Terry Gilliam's *Twelve Monkeys*, with Bruce Willis and Brad Pitt; Gary Fleder's wittily titled *Things to Do in Denver When You're Dead*, with Andy Garcia; and *Four Rooms*, a quarter of pulp tales directed by Robert Rodriguez, Allison Anders, Alexandre Rockwell and Tarantino himself.

It's no surprise to find the Hughes brothers directing *Dead Presidents* or Sly Stallone starring in *Assassins* or Pierce Brosnan taking on the 007 role in *GoldenEye*. But look who else is going gonzo: Johnny Depp in *Nick of Time*, Ralph Fiennes in *Strange Days*, and Sir Peter Hall directing Rebecca De Mornay and Antonio Banderas in *Never Talk to Strangers*. Next for China's Zhang Yimou is *Shanghai Triad*, a gangster epic starring Gong Li. Other women are joining the crime fray: Nicole Kidman in *To Die For*, Linda Fiorentino in *Jade*, Holly Hunter and Sigourney Weaver in *Copycat* and Demi Moore in *The Juror*.

Tarantino will end the year by teaming with George Clooney as vampire-killing thugs in *From Dusk Till Dawn*, an early Tarantino script that promises to push pulp to the limit. That's the problem. How long before audiences get fed up with the stuff? *Apollo 13* could nab the Oscar for *not* being pulp. Two ambitious films mean to show how crime fiction can go beyond bang hang to give us new ways to think about the bad old world.

"DEVIL IN A BLUE DRESS" IS THE WHIP-smart and sexy film version of Walter Mosley's acclaimed 1990 debut novel. Set in Los Angeles in 1948, *Devil* puts a spin on *Chinatown* to provide a black perspective on the layers of corruption that stretch from the streets to the corridors of power. Denzel Washington is flat-out

ILLUSTRATION BY GARY KELLEY — ROLLING STONE, OCTOBER 5, 1995 · 75

■ 400
Publication Rolling Stone
Creative Director Fred Woodward
Illustrator Philip Burke
Publisher Wenner Media
Issue July 13-27, 1995
Category Single Page

■ 401
Publication Rolling Stone
Creative Director Fred Woodward
Illustrator HungryDogStudios
Publisher Wenner Media
Issue August 10, 1995
Category Single Page

■ 402
Publication Rolling Stone
Creative Director Fred Woodward
Illustrator Blair Drawson
Publisher Wenner Media
Issue August 10, 1995
Category Single Page

■ 403
Publication Rolling Stone
Creative Director Fred Woodward
Illustrator Gary Kelley
Publisher Wenner Media
Issue October 5, 1995
Category Spread or Single Page

RECORDINGSALICECOMESCLEAN
BY JON WIEDERHORN

★ ★ ★ ★
ALICE IN CHAINS
Columbia

THE OLDER GENERATION always complains that hard rockers are an angry, unstable bunch prone to violent, antisocial and frequently self-destructive behavior. In the case of most good loud bands, they're right. There's an inherent volatility that is key to the appeal of heavy rock. Without this degenerate element, the music loses its impact, becoming little more than the deafening noise our elders suppose it to be. Sometimes the vicarious aspect is there, and the performers look like suicides waiting to happen – as is the case with Alice in Chains. On the band's fourth album, the lyrics deal with drugs, danger and death – and the songs achieve a startling, staggering and palpable impact.

Since 1987 the members of Alice in Chains – Layne Staley (vocals), Jerry Cantrell (guitar), Mike Inez (bass) and Sean Kinney (drums) – have been channeling their aggressive impulses within a forum of dense rhythms and soaring, resentment-riddled vocals. Theirs are songs of the flesh injected with Gothic metal riffs and seamy harmonies that quiver and squirm in an insatiable quest for self-immolation. Yet Alice in Chains aren't truly suicidal. They're like a slashed wrist – stark, bloody and dramatic but more indicative of a cry for help than of a true desire to spiral into the void. Even their most despairing tunes resound with the lust to live, as Staley proclaims in the

ILLUSTRATION BY CHRISTOPH NIEMANN

ROLLING STONE, NOVEMBER 30, 1995 · 63

loosetalk
COMPILED BY CAROL DITTBRENNER

"I don't handle alcohol very well. One drink and I have to go to my bed. Two drinks and I have to go to your bed."
CHRISSIE HYNDE

"I love nudity, especially female nudity. I love to look at naked girls. I love tits and ass. Mostly tits."
'Showgirls' director
PAUL VERHOEVEN

"We were talking the other day, and she was all upset because some magazine gave out her age. Like them, I didn't realize that she gave birth to me 35 years before she was born."
SYLVESTER STALLONE,
on his mother

"Fame is something that you get chosen for. You're chosen by the people and by coincidence and by timing and by fate, and it's not something you can do anything about."
REBECCA DE MORNAY

"I think anybody who throws their fists is a fool, and I've been a fool many times."
SEAN PENN

"I think when I was younger, I wanted to tell everybody everything because I thought I was so damn interesting. Then I heard the snoring."
DAVID DUCHOVNY

"I suppose it gets a popular chuckle – that it was over between Lyle and me in two years. I say, 'Good for us that we were able to recognize our mistakes and get on with it.'"
JULIA ROBERTS,
on ex-husband Lyle Lovett

"Being confined and unable to breathe fresh air. Like living full time in Hollywood, for instance."
KIM NOVAK,
when asked what is her greatest fear

"Nothing's really going to drive me crazy, I don't think. And I didn't grow up or come from a place where anybody I knew *knew* anybody who was getting therapy. Couldn't anybody afford it. We were talking about 'Get out there and get a job!'"
DENZEL WASHINGTON

"Men will crawl on their bellies to get their women back. I crawled."
MICKEY ROURKE,
on wife Carré Otis

"I just smoke pot. That's all I need; my head is so f—ing weird as it is, that does it for me."
LENNY KRAVITZ

"I'm a flasher at heart. I'm a dirty girl."
DEBORAH HARRY

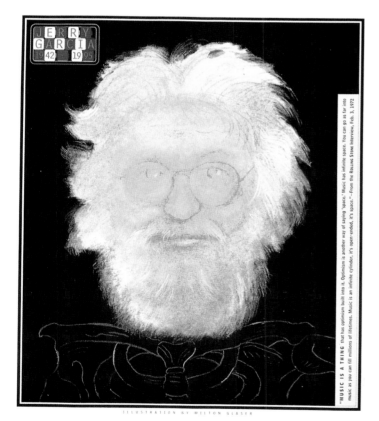

JERRY GARCIA 1942 1995

"MUSIC IS A THING that has optimism built into it. Optimism is another way of saying 'space.' Music has infinite space. You can go as far into music as you can fill millions of lifetimes. Music is an infinite cylinder, it's open-ended, it's space."—From the ROLLING STONE Interview, Feb. 3, 1972

ILLUSTRATION BY MILTON GLASER

Publication Rolling Stone
Creative Director Fred Woodward
Illustrator Christoph Niemann
Publisher Wenner Media
Issue November 30, 1995
Category Single Page

Publication Rolling Stone
Creative Director Fred Woodward
Illustrator Milton Glaser
Publisher Wenner Media
Issue December 28, 1995
Category Single Page

Publication US
Art Director Richard Baker
Designer Daniel Stark
Illustrator Gary Panter
Publisher US Magazine Co., L.P.
Issue November 1995
Category Single Page

Publication Ray Gun
Design Director David Carson
Designer David Carson
Illustrator Hayes Henderson
Issue September 20, 1995
Category Single Page

ILLUSTRATION MERIT

SHELTER FROM THE STORM?

408
Publication Texas Monthly
Creative Director D. J. Stout
Designers D. J. Stout, Nancy McMillen
Illustrator Steve Brodner
Publisher Texas Monthly
Issue April 1, 1995
Category Story

409
Publication Smart Money
Art Director Amy Rosenfeld
Designer Nancy Steiny
Illustrator Josh Gosfield
Publisher Smart Money
Issue December 1995
Category Story

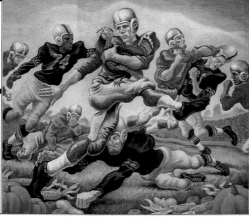

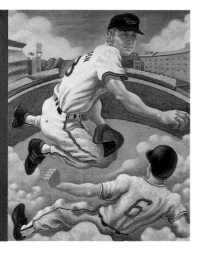

ILLUSTRATION MERIT ■

■ 410
Publication Sports Illustrated Classic
Design Director Steven Hoffman
Art Director Craig Gartner
Designer Craig Gartner
Illustrator Loren Long
Publisher Time Inc.
Issue Fall 1995
Category Spread

■ 411
Publication Sports Illustrated
Design Director Steven Hoffman
Designer Katherine Van Itallie
Illustrator Loren Long
Publisher Time Inc.
Issue September 11, 1995
Category Spread

■ 412
Publication Adweek
Design Director Blake Taylor
Designer Blake Taylor
Illustrator Russell Christian
Publisher BPI Publications
Issue March 27, 1995
Category Story

THE ARTS & MEDIA

■ TELEVISION

Talking
TRASH

Ricki Lake and her disciples have achieved the impossible: lowered the standards of TV gabfests

BY RICHARD ZOGLIN

"He started callin' me a nasty little bitch and everything else!" "Shut up!" "You shut up!"

C H R O N I C L E S

THE WEEK
FEBRUARY 12 – 18

NATION

The House on Crime
Brushing aside threats of a presidential veto, House Republicans passed the most controversial portion of their rewrite of last year's Crime Bill (not including, that is, a possible repeal of the assault-weapons ban). By a vote of 238 to 192, the House scrapped a $13 billion outlay for new police officers and crime-prevention programs in favor of doling out $10 billion worth of block grants that communities could spend as they saw fit. Some Senate Republicans—worried that voting down money earmarked for police might not play too well to the public—indicated the measure might be reworked when it arrives in the upper chamber.

The House on Defense
Brushing aside still more White House warnings, House Republicans also passed a defense and foreign policy bill that would cut back U.S. financing of U.N. peacekeeping operations, restrict American troops from serving under U.N. command, and create a $1.5 million bipartisan commission to study national-security strategy. The usually solid Republican majority cracked, however, when two dozen party members helped defeat a provision that would have required prompt deployment of a national missile-defense system.

The Senate on the Budget
After two weeks of debate, Senators finally agreed to vote on a balanced-budget amendment to the Constitution at the end of this month. Unofficial tallies showed the amendment's Republican sponsors still just short of the two-thirds majority needed.

OSCAR FRONT RUNNERS OF THE WEEK: *Will John Travolta, playing a two-bit hit man, or Tom Hanks, playing a chocoholic simpleton, win the Big One?*

INSIDE WASHINGTON

The "Henry Foster" Re-Election Strategy
White House deputy chief of staff **HAROLD ICKES** is masterminding a plan to have President Clinton make a more overt appeal to women voters, many of whom stayed home in 1994, sinking Democrats. "Ickes wants one event each month for women at which Clinton might appear," says a source. Democratic strategists believe the bungled nomination of Dr. Henry Foster for Surgeon General may have a silver lining: the brouhaha has so alarmed pro-choice women, the thinking goes, that it will galvanize them into supporting Clinton in 1996.

C H R O N I C L E S

THE WEEK
APRIL 9 – 15

NATION

The Simpson Trial
The high drama that has overtaken the O.J. Simpson murder trial played itself out on two stages, both dangerous to the prosecution. Pugilistic defense attorney Barry Scheck forced Los Angeles criminalist Dennis Fung to admit to a series of apparent oversights, slips and errors made in gathering and preserving physical evidence. Meanwhile, Judge Lance Ito summoned ousted juror Jeanette Harris to a special hearing in order to quiz her about her allegations of racial tensions on the jury. Among her complaints: a system of segregated gyms and video-viewing rooms was set up because of disagreements between white and black jurors; she also alleged that whites were given preferential treatment on a shopping trip. All of which could lead to more juror dismissals and even the outside possibility of a mistrial.

Spying on the Spies
The latest fallout from the CIA's Aldrich Ames spy scandal could be a cutback in the privacy rights of national security employees. The Clinton Administration said it was drafting new rules that would let investigators peer more easily into the financial records of the 2 million or more civilian and military personnel with access to classified information, and also require those with top security clearances to file regular financial disclosure statements. This is in response to the CIA's failure to detect Ames' extravagant spending of his Soviet-supplied supplemental income.

Campaign '96
Senate majority leader Bob Dole, the current Republican front runner, made it official and formally declared he is a candidate for President. He

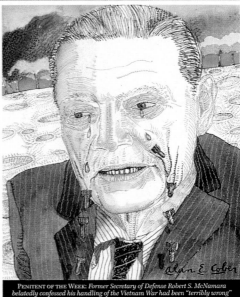

PENITENT OF THE WEEK: *Former Secretary of Defense Robert S. McNamara belatedly confessed his handling of the Vietnam War had been "terribly wrong"*

✂ MEET THE BUDGET CUTTERS

This Week: $8 Million in "Leadership Skills"
SENATOR ARLEN SPECTER (R., Pa.) announced his bid for the presidency by pledging to "balance the budget through spending reduction." Back in 1992, however, he sponsored an $8 million program to achieve the vague goal of "teaching critical leadership skills." One participant has called it "a perfectly formed specimen" of pork. A House report concluded that "activities supported by this program are [already] part of many higher education institutions' curriculum." Surprise: a substantial chunk of funding went to Pennsylvania colleges.

THE ARTS & MEDIA

■ TELEVISION

Network
Crazy!

It's so hot even Hollywood wants a piece of the TV business; here come Paramount and Warner

BY RICHARD ZOGLIN

■ 413
Publication TIME
Art Director Arthur Hochstein
Designer Thomas M. Miller
Illustrator Eric White
Publisher Time Inc.
Issue January 30, 1995
Category Spread

■ 414
Publication TIME
Art Director Arthur Hochstein
Designer Kenneth Smith
Illustrator C. F. Payne
Publisher Time Inc.
Issue February 27, 1995
Category Single Page

■ 415
Publication TIME
Art Director Arthur Hochstein
Designer Kenneth Smith
Illustrator Alan E. Cober
Publisher Time Inc.
Issue April 24, 1995
Category Single Page

■ 416
Publication TIME
Art Director Arthur Hochstein
Designer Thomas M. Miller
Illustrator Seymour Chwast
Issue January 16, 1995
Category Spread

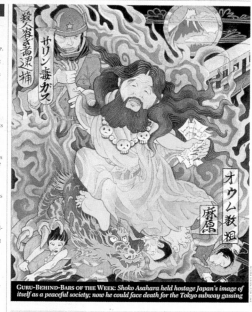

CHRONICLES

THE WEEK
MAY 14 - 20

NATION

Budget: One Down
By a vote of 238 to 193, G.O.P. leaders pushed their bold, seven-year balanced-budget plan through the House of Representatives. Democrats bitterly complained that the package of $1.4 trillion in spending cuts and $350 billion in tax cuts would sacrifice the needs of the middle and lower classes to benefit the wealthy; Republicans countered that the Democrats had no viable alternative.

Clinton's First Veto?
President Clinton launched his own budget salvo when his Administration announced he would veto the first major set of G.O.P. spending cuts that both houses of Congress are expected to send to his desk: $16.4 billion worth of recisions from the current budget. Proposing a set of alternative cuts, the President said the G.O.P. package was unacceptable because it would slash education, environmental and crime-prevention programs at the same time that it spares road- and courthouse-construction projects.

Closing Down the Avenue
Clinton agreed, for the first time in history, to ban vehicular traffic from a two block stretch of Pennsylvania Avenue in front of the White House. The building is vulnerable to a truck bomb, like that used in Oklahoma, which could injure scores of people and seriously damage the structure. An estimated 26,000 cars and buses will have to be rerouted each day.

Saved by the Deadline
Kenneth Starr, the independent counsel looking into allegations of wrongdoing in the Whitewater affair, has decided not to indict Presidential aide Bruce Lindsey on federal banking charges

GURU-BEHIND-BARS OF THE WEEK: *Shoko Asahara held hostage Japan's image of itself as a peaceful society; now he could face death for the Tokyo subway gassing*

INSIDE HOLLYWOOD

A Quarter of a Billion Dollars—Sound O.K.?
MIKE OVITZ, head of Creative Artists Agency, has been asked to run MCA and its Universal Studios, according to a well-placed source. Ovitz has apparently been offered more than $250 million, much of it, presumably, in equity. Meanwhile, another source reports that DreamWorks SKG has told Edgar Bronfman Jr. it would try to work out a distribution deal with an Ovitz-led MCA, but only if Steven Spielberg's mentor, MCA President Sid Sheinberg, is kept happy. Still uncommitted, Ovitz has told friends he is ready to leave CAA.

CHRONICLES

THE WEEK
JUNE 25 - JULY 1

NATION

Out with a Bang
Ending its term with the usual flurry of opinions, the U.S. Supreme Court announced some of its most important decisions of the year. The most immediately controversial: a ruling in a Georgia case that declared racial gerrymandering unconstitutional under the 1965 Voting Rights Act—a decision that is certain to alter the country's political landscape. By a 5-to-4 vote the Justices ruled that legislative districts drawn with race as the "predominant" motivating factor should generally be struck down. Black officials, many of whom owe their first-time election to racially conscious redistricting, were stunned and outraged. President Clinton called the ruling a "setback."

The Other Decisions
By a 5-to-4 vote, the court also decided that the University of Virginia violated free-speech guarantees when it refused to subsidize a student-run Christian magazine while subsidizing other student groups. And in a Fourth Amendment case, the court upheld by 6 to 3 a local school plan in Oregon that requires all student athletes to submit to random drug testing.

G.O.P. Budget Plan Passes
On party-line votes, both the House and Senate adopted the Republican seven-year balanced-budget plan that would slash spending by nearly $1 trillion and taxes by $245 billion. President Clinton warned that he would wield his veto power in the months ahead to refashion the spending and tax bills that will be required to implement the plan, which only sets budgetary outlines. In other budget matters, a $16.4 billion package of cuts in the current year's budget—

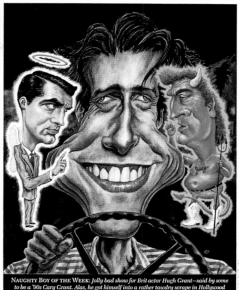

NAUGHTY BOY OF THE WEEK: *Jolly bad show for Brit actor Hugh Grant—said by some to be a '90s Cary Grant. Alas, he got himself into a rather tawdry scrape in Hollywood*

TIME ON CAPITOL HILL

Flag Burning and You

Last week, by a vote of 312 to 120, the House adopted a constitutional amendment that would allow Congress and the states to "prohibit the physical desecration of the flag." The measure must be approved by the Senate before going to the states for ratification.

If this were your personal subscription copy of TIME magazine, this space would contain the voting record of your Representative on this issue.

If you are a subscriber, please call 1-800-843-TIME (8463) and provide the TIME Customer Services operator with the name of your Representative or your congressional district, and we will correct our records.

■ COVER STORY

The Estrogen Dilemma

America's No. 1 drug is an elixir of youth, but women must decide if it's worth the risk of cancer

By CLAUDIA WALLIS

■ COVER STORY

THE EQ FACTOR

New brain research suggests that emotions, not IQ, may be the true measure of human intelligence

By NANCY GIBBS

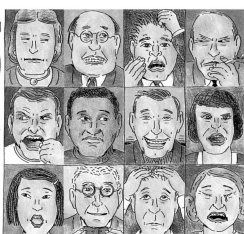

■ 417
Publication TIME
Art Director Arthur Hochstein
Designer Kenneth Smith
Illustrator Moira Hahn
Publisher Time Inc.
Issue May 29, 1995
Category Single Page

■ 418
Publication TIME
Art Director Arthur Hochstein
Designers Sharon Okamoto, Janet Parker
Illustrator Anita Kunz
Publisher Time Inc.
Issue June 26, 1995
Category Spread

■ 419
Publication TIME
Art Director Arthur Hochstein
Designer Kenneth Smith
Illustrator Eric White
Publisher Time Inc.
Issue July 10, 1995
Category Single Page

■ 420
Publication TIME
Art Director Arthur Hochstein
Designer Sharon Okamoto
Illustrator Seymour Chwast
Publisher Time Inc.
Issue October 2, 1995
Category Spread

ILLUSTRATION MERIT ■

C H R O N I C L E S

THE WEEK
JULY 16 - 22

WORLD

Advance and Response
As Bosnian Serbs fought to take the U.N. safe area of Zepa, Western allies met in London at week's end, threatening a "substantial and decisive response"—including air strikes—if the Serbs moved against Gorazde, the last Muslim enclave in eastern Bosnia. But the allies also fretted about the "serious risks involved" in opposing the Serbs. On Sunday, July 23, after two French peacekeepers in Sarajevo were killed by Serb shelling, the U.N. sent elements of its rapid-reaction force to the Bosnian capital.

A Japanese Apology
Prime Minister Tomiichi Murayama apologized to the estimated 200,000 women forced into prostitution by Japanese armed forces during World War II. The government also appointed a group hoping to collect at least $22.7 million to compensate the "comfort women" of whom about 1,000 are believed to survive.

More Pain in Spain
The Spanish political crisis deepened as Prime Minister Felipe González was again accused of having inside knowledge about the police death squads that hunted down Basque terrorists in the 1980s. His accuser this time was Ricardo García Damborenea, the former head of the Socialist Party in the Basque province of Vizcaya. García Damborenea, under investigation in connection with the killings, claimed that he had discussed the death squads with González several times and that the Prime Minister voiced approval of the operations. González continued to deny any knowledge of the squads' activities and said he would call a special session of

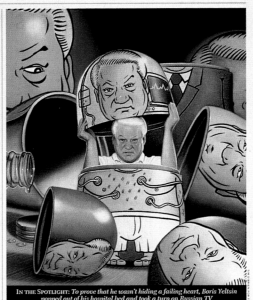

IN THE SPOTLIGHT: *To prove that he wasn't hiding a failing heart, Boris Yeltsin popped out of his hospital bed and took a turn on Russian TV*

FROM THE WORLD'S HEADLINES
Reports that a secret tribunal in NIGERIA CONVICTED 40 ALLEGED COUP PLOTTERS—and sentenced some to die—provoked widespread consternation

A.M. NEWS, NIGERIA: "Let the carnage stop."

CHRISTIAN SCIENCE MONITOR, U.S.: "If Nelson Mandela's South Africa is the shining star of the continent, General Sani Abacha's Nigeria is bidding for the title of Africa's darkest black hole."

SOWETAN, SOUTH AFRICA: "It is now up to Africa and the world to stop this dictator before he pushes [Nigeria] into civil chaos and disintegration."

THE TIMES, BRITAIN: "If [Abacha] does not revoke the sentences handed out to Generals Obasanjo and Yar'Adua, and to the scores of other pro-democracy 'plotters,' his regime can expect odium and severe sanction."

DAILY NATION, KENYA: "General Abacha probably will not give a hoot what anyone says … He may even be deriving some morbid pleasure from the attention that his decisions are bringing Nigeria."

C H R O N I C L E S

THE WEEK
SEPTEMBER 3-9

NATION

Packing It In
Before a hushed and somber Senate, a teary Bob Packwood told his colleagues, "It is my duty to resign." The Oregon Republican's decision followed a stunning and unanimous vote by the Ethics Committee to recommend his expulsion. The committee issued its final report on the case, which found that Packwood had engaged in sexual misconduct against nearly a score of women, improperly sought a job for his wife from lobbyists and altered pertinent evidence. What ensued was a gripping 24-hour endgame that saw Packwood first declaring his intention to fight on in the full Senate, then slowly realizing he lacked the votes to keep his seat, which he will formally vacate on Oct. 1. Delaware's William Roth is poised to assume Packwood's chairmanship of the powerful Finance Committee—at a time when the committee has Medicare and welfare reform on its plate.

Congress to the Defense
Back from summer vacation, Congress rolled up its sleeves to begin tackling the nation's toughest issue: the budget. Though generally trumpeting their frugality, both the Senate and the House passed defense-spending bills that exceed the President's request by more than $6 billion each. Numerous differences remain to be resolved between the Senate's $243 billion defense measure and the House's $244 billion version. Among them: a Senate decision to stop funding more B-2 bombers.

First Waco, Now Ruby Ridge
A rapt Senate panel listened sympathetically to white separatist Randy Weaver's account of the deadly standoff

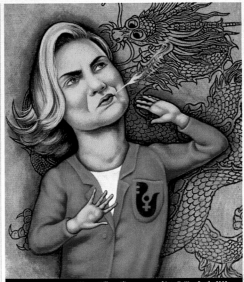

SPEECHIFIER OF THE WEEK: *Hillary Clinton swooped into Beijing for the U.N. women's conference, scolded Chinese leaders and emboldened women everywhere*

NERD POLL '95
Percentage of cyberspace users who agree with the following statements:

Information superhighway revolution is as important as the Industrial Revolution	**80%**
Online services give better information and news because they are not edited	**75%**
I worry that things will be available that are not appropriate for children	**69%**
Information superhighway has had a positive impact on my business life	**57%**
Impact of information superhighway has been overstated by the press	**46%**
Information superhighway has had a positive impact on my social life	**29%**

From the Yankelovich CyberCitizen Report; a telephone poll of 604 online users conducted between May 24 and June 1, 1995. Sampling error ±4.5%.

C H R O N I C L E S

THE WEEK
JANUARY 8 - 14

NATION

California Dreaming—Not
This time it wasn't an earthquake or wildfires that ravaged California, but simple rain—a merciless deluge. The downpour unleashed treacherous floods and mud slides up and down the state, killing 11 people, displacing thousands from their homes and wreaking property damage in the hundreds of millions of dollars.

Political Reality Bites
No one ever said governing would be easy. Two weeks into the new Congress, fissures began to appear in the once seemingly rock-solid Republican majority in the House as members started squabbling over just how limiting term limits should be. Fault lines also became apparent regarding the proposed balanced-budget amendment, with moderate Republicans (joined by some Democrats) objecting to a provision that would mandate a three-fifths majority of both houses to approve tax increases. Of course, Republicans' differences weren't so great that they couldn't deflect Democratic demands that a balanced-budget amendment include a detailed plan laying out proposed spending cuts. And in the Senate, G.O.P. leaders marshaled through a measure adopted by the House that would subject Congress to employment laws already applicable to the private sector.

Newt's History Lesson
Speaker Gingrich's choice for House historian, Kennesaw State professor Christina Jeffrey, quickly became a footnote to history when her controversial evaluation of a 1980s Holocaust education program surfaced, triggering a gleeful fusillade of criticism

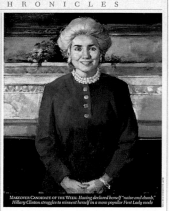

MAKEOVER CANDIDATE OF THE WEEK: *Having declared herself "naïve and dumb," Hillary Clinton struggles to reinvent herself in a more popular First Lady mode*

INSIDE WASHINGTON

Threatening John Paul and the Friendly Skies
The CIA was privately warning last week that two Pakistanis arrested in a Manila apartment earlier this month may be part of a sophisticated Islamic terror cell targeting Pope John Paul II during his Philippine visit, as well as U.S. airlines. The evidence? U.S. intelligence sources say that not only were bombmaking materials found in the apartment, so too were order forms for clerical robes and schedules for various U.S. airlines. "This is causing very serious concern here," said a State Department aide in Washington.

MAN OF THE YEAR MAN OF THE YEAR

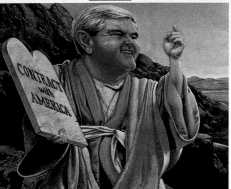

By JOHN F. STACKS

GOOD NEWT, BAD NEWT

Is the Gingrich vision of a brighter future worth the risk of a radically new direction in American governance?

Here's the way the world used to work: Liberals dreamed of making things better. They believed human beings, if not perfectible, were at least subject to improvement. History moved positively, onward and upward. The role of government was to engineer progress by spending public money for the common good. Social problems like poverty could be cured through government action.

Conservatives, on the other hand, thought the liberals were hopeless romantics. Conservatives believed human beings were fundamentally flawed. Public spending aimed at correcting these flaws was a waste of money. The best anyone could hope for was that the human condition would get no worse. Conservatives mocked liberals for not recognizing the evil inherent in our souls.

Liberals, on the other hand, believe conservatives are dangerous romantics. Liberals have been discouraged by the failure of many of their do-good programs, and they don't believe any of the conservative solutions will work either. Liberals want to keep things as they are, and just tinker at the margins—maybe. And after episodes like Susan Smith's drowning of her children, and the ripping of a child from his murdered mother's womb in Chicago, they are ready to believe some souls are inherently evil and beyond redemption.

More than any other single person, Newt Gingrich has brought about this historic reversal of roles. In the process, he has just about finished off the political consensus initiated 60 years ago by Franklin D. Roosevelt. Gingrich's success was fed by the smoldering anger of a nation suffering from stagnant wages, chronic overspending by the Federal Government, the failure of the public schools, the decline of public

decency and the stubborn inability of the American underclass to rise out of poverty. He bundled up these anxieties cleverly, even brilliantly, and set them ablaze. "I want to encourage you to be a little anxious," he writes in his book To Renew America, "and then I want to encourage you to turn that anxiety into energy."

Gingrich has coupled his own campaign for power with the recognition that

conservative skepticism was not a sufficiently upbeat message. In chronically optimistic America, he needed something more upon which to build a mass movement. In place of the old conservative caution, Gingrich, one of the most absorbent if not always discriminating minds in national politics, has concocted a stew of beliefs that blends the sunny economics of Ronald Reagan and Jack Kemp, the stern moralism of the Christian right and enough giddy futurism either to excite or to frighten his followers. He dubbed himself a "conservative revolutionary," one of the greatest political oxymorons ever invented. He saw that it simply wouldn't do to rarp about the Great Society. He invented something to replace it, something, he says, that is better: the Conservative Opportunity Society.

The road to that society is clear-cut, straight and narrow: tear down the liberal

■ 458
Publication TIME
Art Director Arthur Hochstein
Designer Kenneth Smith
Illustrator Tim O'Brien
Publisher Time Inc.
Issue July 31, 1995
Category Single Page

■ 422
Publication TIME
Art Director Arthur Hochstein
Designer Kenneth Smith
Illustrator Burt Silverman
Publisher Time Inc.
Issue September 23, 1995
Category Single Page

■ 423
Publication TIME
Art Director Arthur Hochstein
Designer Kenneth Smith
Illustrator Anita Kunz
Publisher Time Inc.
Issue September 18, 1995
Category Single Page

■ 424
Publication TIME
Art Director Arthur Hochstein
Designer Sharon Okamoto
Illustrator C. F. Payne
Publisher Time Inc.
Issue December 25, 1995
Category Spread

■ 425

THE FIRST 100 DAYS
He slipped into the House in 1979 and started calling in reinforcements

The Warrior

Newt Gingrich, an army brat, sees politics as a matter of life or death, good or evil. A look into the life and mind of the speaker of the House, and at the revolution he is about to launch in Washington

■ 428

FEDS ARE COMING TO TOWN

By David Lieberman

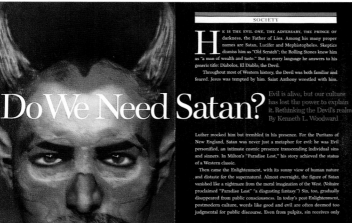

■ 426

SOCIETY

H E IS THE EVIL ONE, THE ADVERSARY, THE PRINCE OF darkness, the Father of Lies. Among his many proper names are Satan, Lucifer and Mephistopheles. Skeptics dismiss him as "Old Scratch"; the Rolling Stones knew him as "a man of wealth and taste." But in every language he answers to his generic title: Diabolos, El Diablo, the Devil.

Do We Need Satan?

Evil is alive, but our culture has lost the power to explain it. Rethinking the Devil's realm.
By Kenneth L. Woodward

■ 429

M A R K E T M O V E R S

11

BILL GATES
Chairman and CEO,
Microsoft Corp.

ILLUSTRATION BY
HANOCH PIVEN

PROFILE: Gates's near hammerlock on the personal-computer industry comes from Microsoft's dominance in operating-system software and applications. Now Gates is tooling up Microsoft to expand into broadcast media and financial services. **POWER MOVE:** When Microsoft can't compete with an innovative product, it buys its competitor, as it did with Intuit, the maker of Quicken personal-finance software. Gates's clout is best seen in the behavior of others: The rest of the computer software industry continues to consolidate in order to defend itself from and do battle with Microsoft. Last year, Novell acquired WordPerfect, and Apple, IBM, and Motorola dragged one another into a pact to prevent Microsoft from dominating the industry completely. Microsoft is the main reason many once high-flying software stocks, like Lotus, have faltered. **CAVEAT:** The Justice Department recently settled an antitrust case with Microsoft on cushy terms, but that doesn't mean it isn't watching the company's moves closely. A new inquiry stalled the Intuit deal.

FEBRUARY 1995 **worth** 65

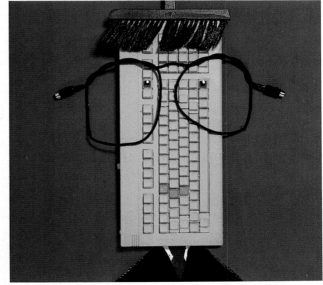

■ 427

POWER
TO THE
F·C·C

Just a few short months ago, the Federal Communications Commission was frantically circling the wagons to fend off conservative attacks on its very existence. Morale was sagging. "Dump the FCC!" cried conservatives, egged on by House Speaker Newt Gingrich, who wanted to loose market forces on the converging computer, communications and cable industries. In the gospel according to the

By George Leopold

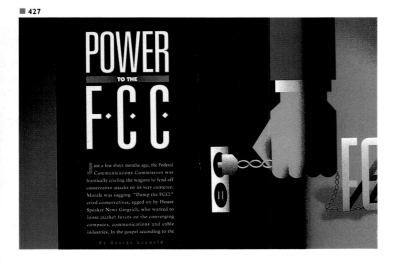

■ 425
Publication Newsweek
Design Director Lynn Staley
Art Director Alex Ha
Illustrator Mark Hess
Publisher Newsweek Inc.
Issue January 9, 1995
Category Spread

■ 426
Publication Newsweek
Design Director Lynn Staley
Art Director Alex Ha
Illustrator Amy Guip
Publisher Newsweek Inc.
Issue November 13, 1995
Category Spread

■ 427
Publication OEM Magazine
Art Director Mira Ramji-Stein
Designer Mira Ramji-Stein
Illustrator Terry Allen
Publisher CMP Publications Inc.
Issue October 1995
Category Spread

■ 428
Publication OEM Magazine
Art Director Mira Ramji-Stein
Designer Mira Ramji-Stein
Illustrator Tungwai Chay
Publisher CMP Publications Inc.
Issue April 1995
Category Spread

■ 429
Publication Worth
Art Director Ina Saltz
Designer Lynette Cortez
Illustrator Hanoch Piven
Publisher Capital Publishing
Issue February 1995
Category Single Page

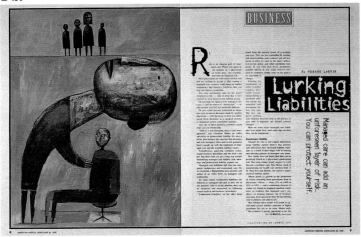

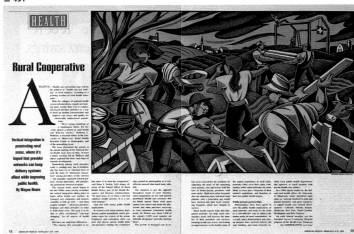

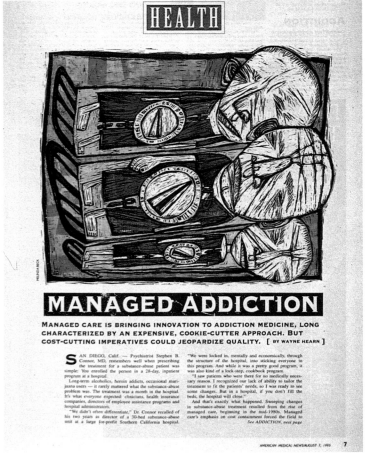

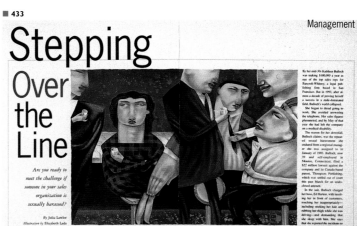

■ 430
Publication American Medical News
Art Director Jeff Capaldi
Designer Jeff Capaldi
Illustrator Jordin Isip
Publisher American Medical News
Issue June 26, 1995
Category Spread

■ 431
Publication American Medical News
Art Director Jeff Capaldi
Designer Jeff Capaldi
Illustrator Chris Gall
Publisher American Medical News
Issue July 1995
Category Spread

■ 432
Publication American Medical News
Art Director Jeff Capaldi
Designer Jeff Capaldi
Illustrator Melinda Beck
Publisher American Medical News
Issue August 7, 1995
Category Single Page

■ 433
Publication Sales & Marketing Management
Art Director Anna Kula
Designer Anna Kula
Illustrator Elizabeth Lada
Publisher Bill Communications
Issue October 1995
Category Spread

Havoc in the Hormones

Pollutants like dioxin and pesticides have upset the reproductive systems of alligators and gulls. Now, researchers theorize, the contaminants may be threatening humans. **BY JON R. LUOMA**

ILLUSTRATIONS BY JAMES MARSH

"A chill went up my spine. It was the same pattern I'd seen in female alligators. I wondered where in the world they were getting estrogen."

DEVELOPING | INTERACTIVE BOOKS

USING PRE-MADE CONTENT TO SAVE TIME & MONEY

BY MARIE A. D'AMICO

'A Stunned, Immense Silence': Oklahoma City, April 22–24

Drawings and text by Lynn Pauley

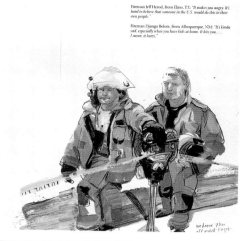

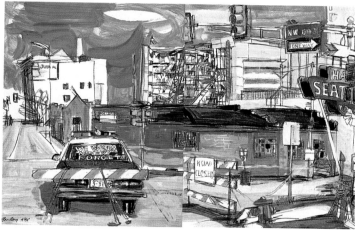

ILLUSTRATION MERIT

■ 434
Publication Audubon
Art Director Suzanne Morin
Designers Jonathan B. Foster, Suzanne Morin
Illustrator James Marsh
Issue July/August 1995
Publisher National Audubon Society
Category Story

■ 435
Publication InterActivity
Art Director John Ueland
Illustrator Chris Lensch
Publisher Miller Freeman, Inc.
Issue September/October 1995
Category Spread

■ 436
Publication Print Magazine
Creative Director Andrew Kne
Designer Andrew Kner
Illustrator Lynn Pauley
Publisher RC Publications
Issue September 1995
Category Story

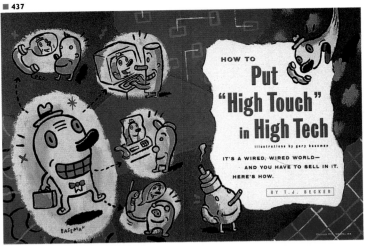

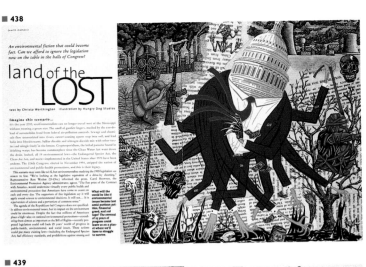

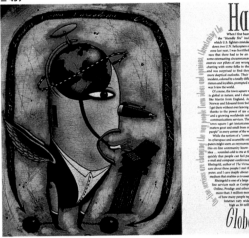

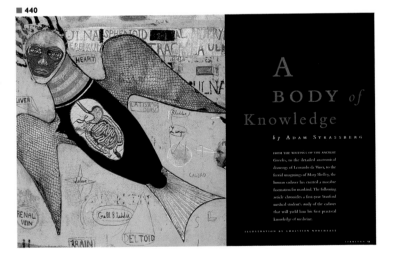

Publication Selling
Art Director Linda Root
Designer Robin Terra
Illustrator Gary Baseman
Publisher Disney
Issue December 1995
Category Story

Publication Aveda
Creative Directors Robb Allen, John Farley
Art Director Darcy Doyle
Illustrator HungryDogStudios
Publisher Hachette Filipacchi Magazines, Inc.
Photo Editor Andrea Jackson
Category Spread

Publication Profiles
Design Director John Sizing
Designer John Sizing
Illustrator Pol Turgeon
Client Continental Airlines
Publisher JS Publication Design
Issue January 1995
Category Spread

Publication Stanford Magazine
Art Director Paul Carstensen
Designer Paul Carstensen
Illustrator Christian Northeast
Publisher Stanford Alumni Association
Issue March 1995
Category Spread

While building a reputation for excelling at the

latest treatments for infertility, stanford fertility

experts are cultivating new ways of bringing

eggs and sperm together to make babies.

giving nature a nudge

BY ROSANNE SPECTOR

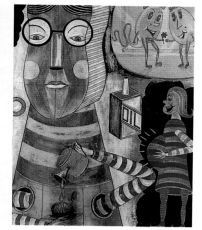

O McKinley Overwhelmed by Debts !

Bill Clinton isn't the first politician to be threatened by revelations about his personal finances. A century-old story shows how it happened—and was successfully handled—in the past. by Charles W. Bailey

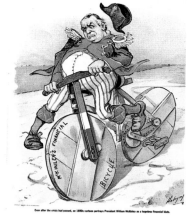

Unmasking Thyroid Disease

With symptoms that masquerade as myriad medical and mental disorders, **thyroid disease** often eludes diagnosis.

By Alana Mikkelsen

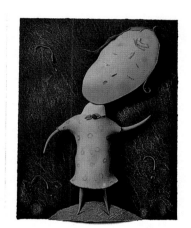

COMPUTERS HELP PAIN SPECIALISTS

FIND THE MIDDLE GROUND WHERE A

DRUG RELIEVES ENOUGH PAIN TO MAIN-

WIRED FOR PAIN MANAGEMENT

TAIN QUALITY OF LIFE AND STILL ALLOW

THE PATIENT TO FUNCTION IN SOCIETY.

BY ROBERT TOKUNAGA

ILLUSTRATIONS BY DAVID PLUNKERT

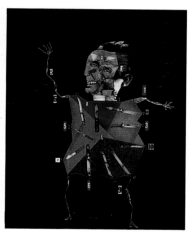

Where Clinton Went Wrong

Publication Stanford Medicine
Art Director David Armario
Designer David Armario
Illustrator Christian Northeast
Publisher Stanford Medicine
Issue Spring 1995
Category Spread

Publication Stanford Medicine
Art Director David Armario
Designer David Armario
Illustrator Alexa Grace
Publisher Stanford Medicine
Issue Summer 1995
Category Spread

Publication Stanford Medicine
Art Director David Armario
Designer David Armario
Illustrator David Plunkert
Publisher Stanford Medicine
Issue Winter 1995
Category Spread

Publication Audacity Magazine
Art Director Wylie Nash
Designer Wylie Nash
Issue Winter 1995
Category Story

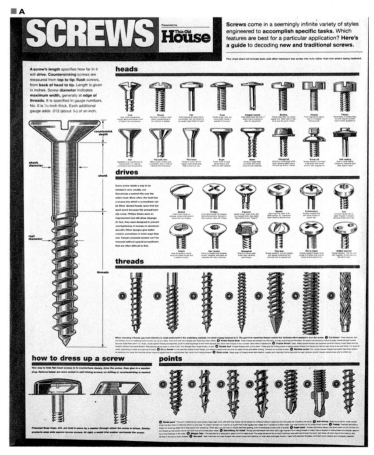

■ 445
Publication Ringling Bros. and
Barnum & Bailey Souvenir Program
Design Directors Will Hopkins, Mary K. Baumann
Designer John Baxter
Studio Hopkins/Baumann
Category Information Graphics

■ 446
Publication This Old House
Design Director Matthew Drace
Illustrators Clancy Gibson, John Murphy
Publisher Time Inc.
Issue November/December 1995
Category Information Graphics
　　■ A Merit Single Page

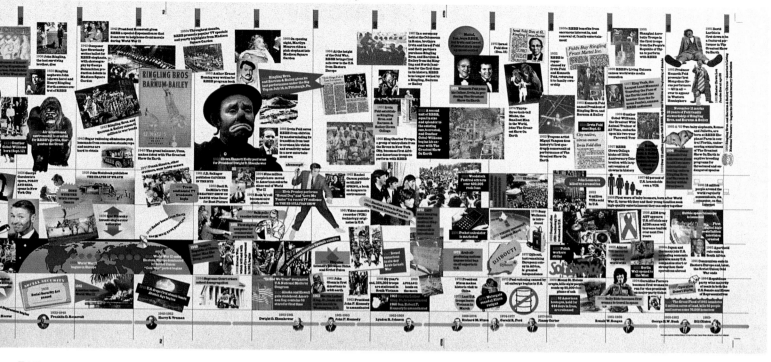

■ 447

■ 448

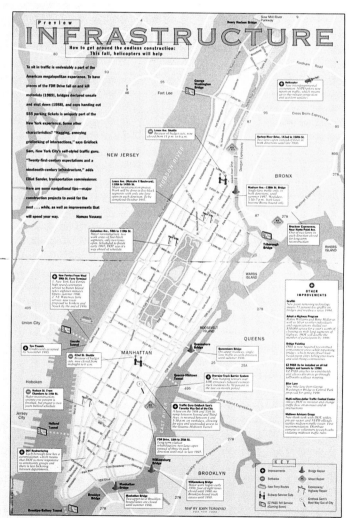

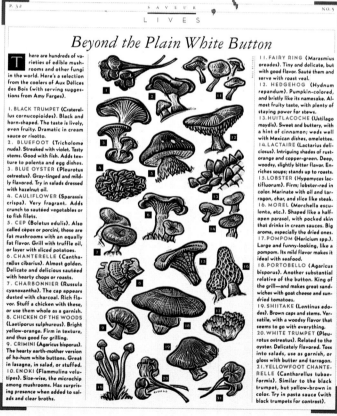

■ 447
Publication New York
Design Director Robert Best
Art Director Syndi Becker
Designer Deanna Lowe
Illustrators John Tomanio, Eliot Bergman
Publisher K-III Publications
Issue September 11, 1995
Category Information Graphics

■ 448
Publication Saveur
Creative Director Michael Grossman
Art Director Jill Armus
Designer Jill Armus
Illustrator Bill Russell
Publisher Meigher Communications
Issue March/April 1995
Category Information Graphics

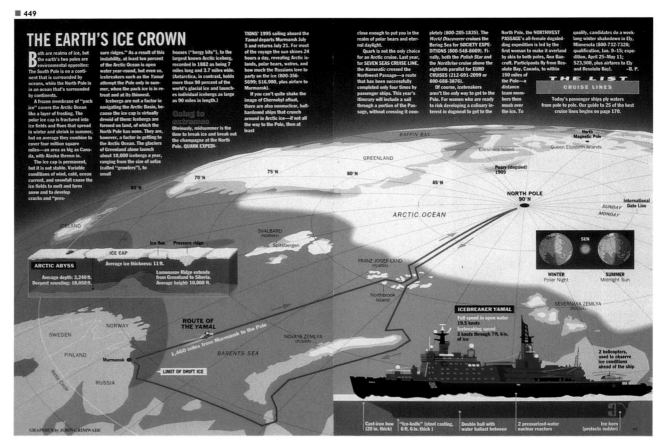

THE EARTH'S ICE CROWN

GRAPHICS by JOHN GRIMWADE

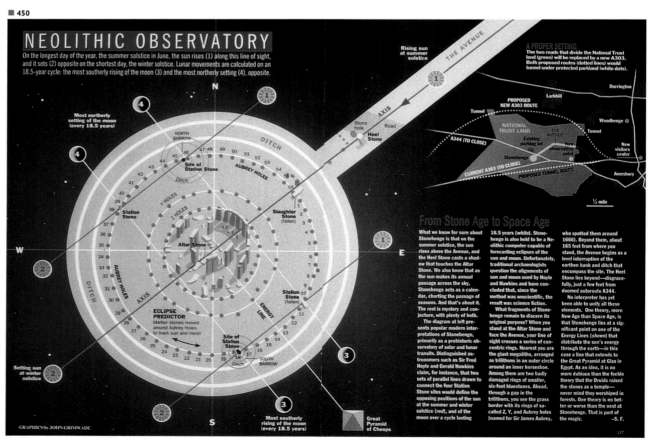

NEOLITHIC OBSERVATORY

GRAPHICS by JOHN GRIMWADE

■ 449
Publication Condé Nast Traveler
Design Director Diana LaGuardia
Art Director Christin Gangi
Designer Stephen Orr
Illustrator John Grimwade
Publisher Condé Nast Publications Inc.
Issue January 1995
Category Information Graphics

■ 450
Publication Condé Nast Traveler
Design Director Diana LaGuardia
Art Director Christin Gangi
Designer Stephen Orr
Illustrator John Grimwade
Publisher Condé Nast Publications Inc.
Issue February 1995
Category Information Graphics

PHOTOGRAPHY

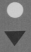

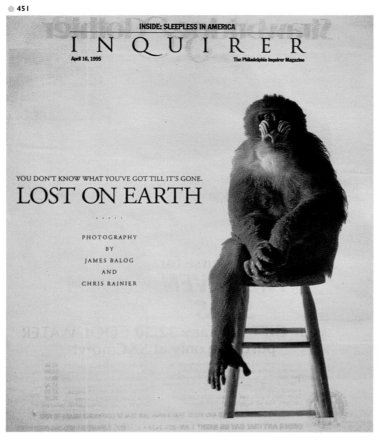

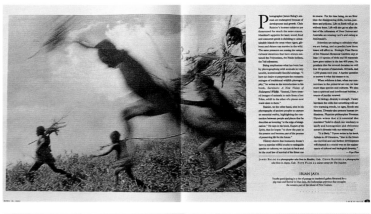

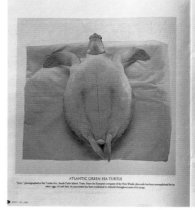

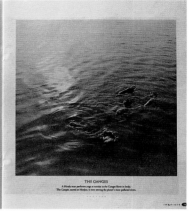

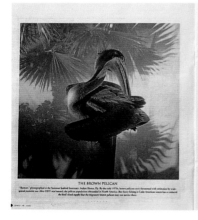

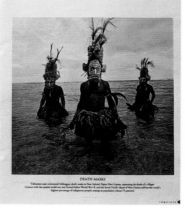

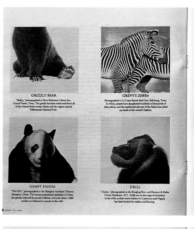

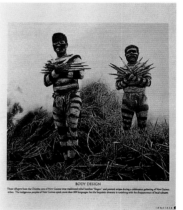

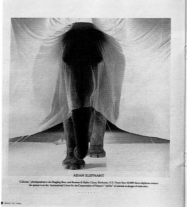

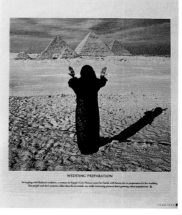

451
Publication Philadelphia Inquirer Magazine
Design Director Christine Dunleavy
Art Director Bert Fox
Designer Christine Dunleavy
Photo Editor Bert Fox
Photographers James Balog, Chris Rainier
Publisher Philadelphia Inquirer
Issue April 16, 1995
Category Story/Reportage & Travel

CASUALTIES of WAR

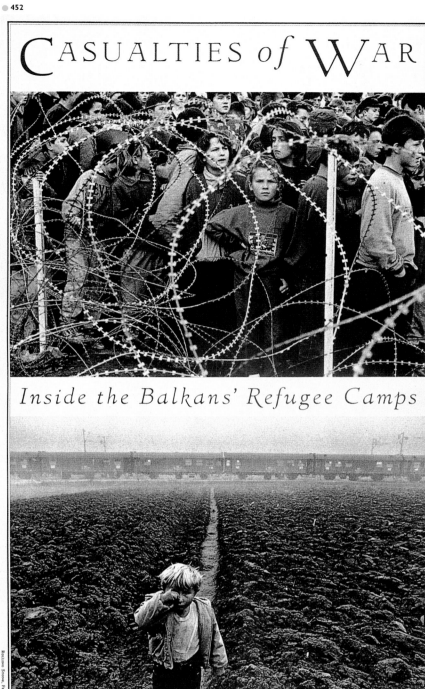

Inside the Balkans' Refugee Camps

PHOTOGRAPHS *by* SEBASTIÃO SALGADO

"TWENTY YEARS AGO, in 1975, there were 2.5 million. Today there are more than 20 million refugees [in the world]. And that's not counting those who can't cross the border into another country. It's a tidal wave!" – SEBASTIÃO SALGADO

● 452
Publication Rolling Stone
Creative Director Fred Woodward
Designers Fred Woodward, Gail Anderson
Photo Editor Jodi Peckman
Photographer Sebastião Salgado
Publisher Wenner Media
Issue February 23, 1995
Category Story/Reportage & Travel

PHOTOGRAPHY GOLD ●

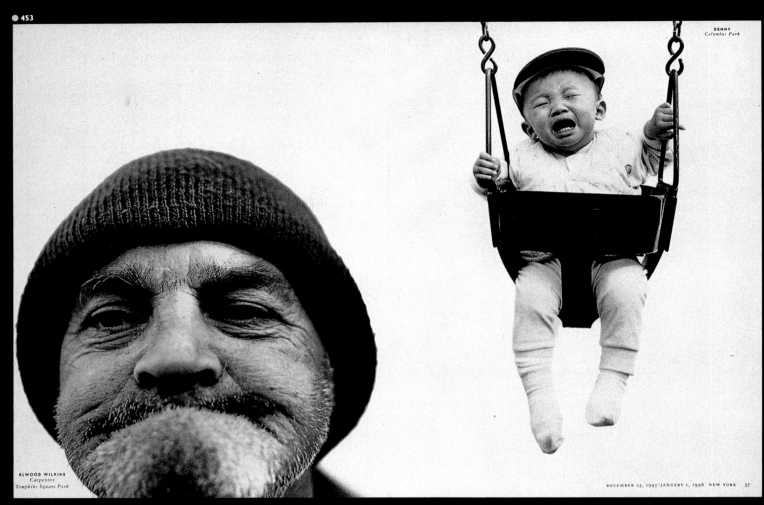

DENNY
Columbus Park

ELWOOD WILKINS
Carpenter
Tompkins Square Park

DECEMBER 25, 1995–JANUARY 1, 1996 NEW YORK 57

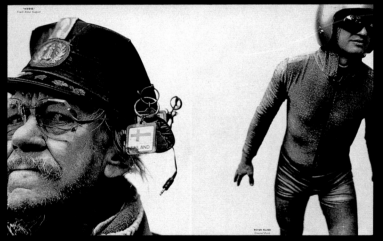

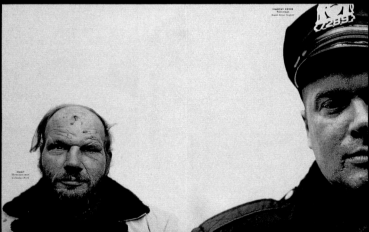

● 453
Publication New York
Design Directors Robert Best, Syndi Becker
Designers Robert Best, Syndi Becker, Deanna Lowe
Photo Editor Margery Goldberg
Photographer Christian Witkin
Publisher K-III Publications
Issue December 25, 1995-January 1, 1996
Category Story/Portraits

apart

It's no illusion—streamlined, graphic looks and high-tech fabrics are making a major impact.

PHOTOGRAPHED BY RAYMOND MEIER

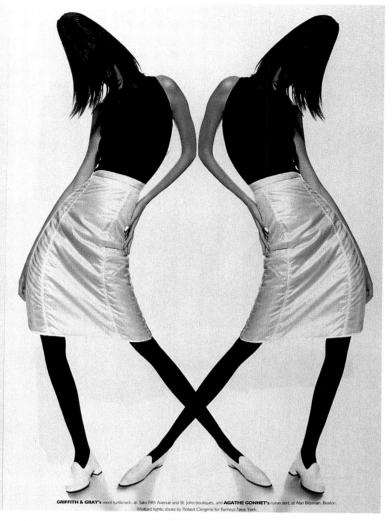

GRIFFITH & GRAY's wool turtleneck, at Saks Fifth Avenue and St. John boutiques, and AGATHE GONNET's nylon skirt, at Alan Bilzerian, Boston. Wolford tights; shoes by Robert Clergerie for Barneys New York.

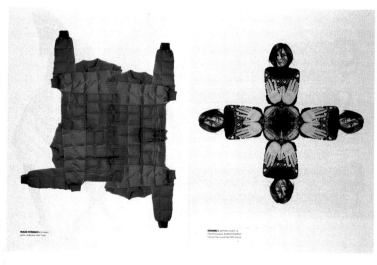

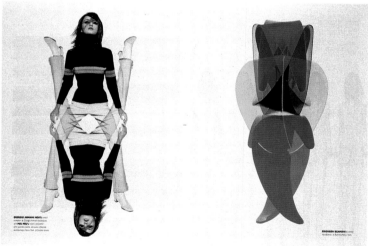

●454
Publication W
Creative Director Dennis Freedman
Design Director Edward Leida
Designer Edward Leida
Photographer Raymond Meier
Publisher Fairchild Publications
Issue December 1995
Category Story/Photo Illustration

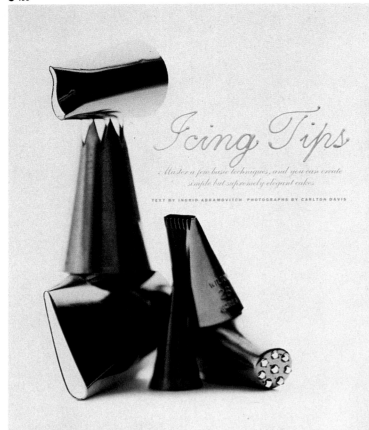

Icing Tips

Master a few basic techniques, and you can create simple but supremely elegant cakes

TEXT BY INGRID ABRAMOVITCH PHOTOGRAPHS BY CARLTON DAVIS

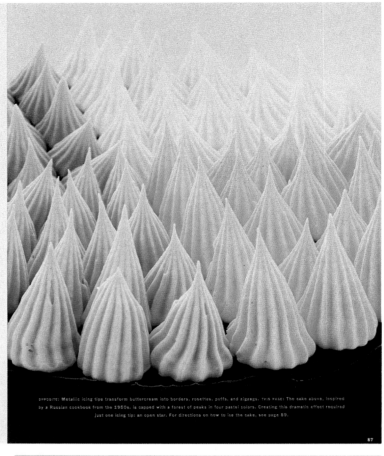

OPPOSITE: Metallic icing tips transform buttercream into borders, rosettes, puffs, and zigzags. THIS PAGE: The cake above, inspired by a Russian cookbook from the 1950s, is capped with a forest of peaks in four pastel colors. Creating this dramatic effect required just one icing tip: an open star. For directions on how to ice the cake, see page 89.

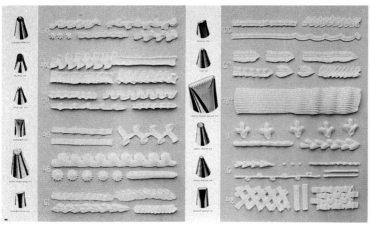

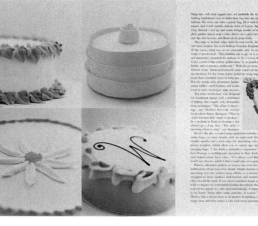

● 455

Publication Martha Stewart Living
Creative Director Gael Towey
Art Director Anne Johnson
Designer Anne Johnson
Photo Editor Heidi Posner
Photographer Carlton David
Publisher Time Inc.
Issue May 1995
Category Story/Still Life & Interiors

PHOTOGRAPHY GOLD ●

Clusters of plump blueberries ripen on the branch. OPPOSITE: Layers of meringue, whipped cream, and berries are piled into a lofty vacherin, so called because its shape resembles the cheese of the same name.

70

BERRY DESSERTS

TEXT BY CELIA BARBOUR PHOTOGRAPHS BY MARIA ROBLEDO

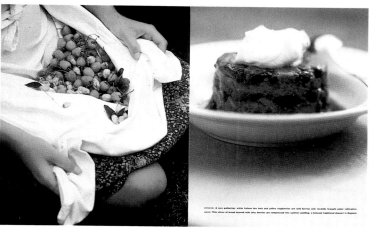

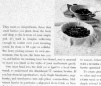

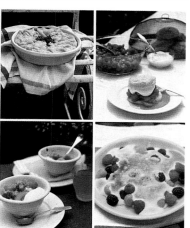

▼ 456
Publication Martha Stewart Living
Creative Director Gael Towey
Art Director Eric A. Pike
Designer Agnethe Glatved
Photo Editor Heidi Posner
Photographer Maria Robledo
Publisher Time Inc.
Issue June 1995
Category Story/Still Life & Interiors

PHOTOGRAPHY SILVER ▼

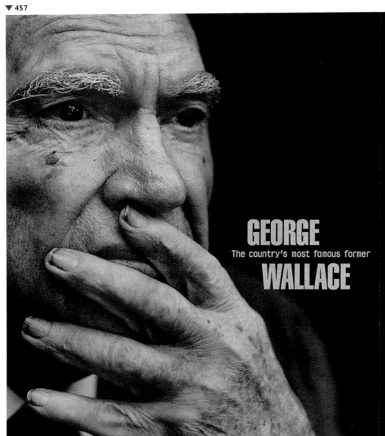

GEORGE

The country's most famous former segregationist talks to John Kennedy about race and redemption. Photographed by Herb Ritts

WALLACE

▼ 457
Publication George
Creative Director Matt Berman
Photo Editor Bridget Cox
Photographer Herb Ritts
Publisher Hachette Filipacchi Magazines, Inc.
Issue October/November 1995
Category Story/Portraits

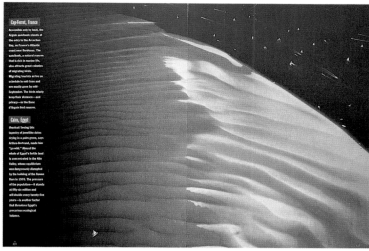

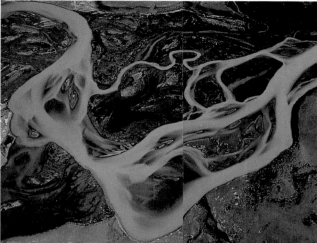

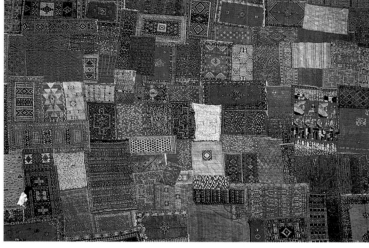

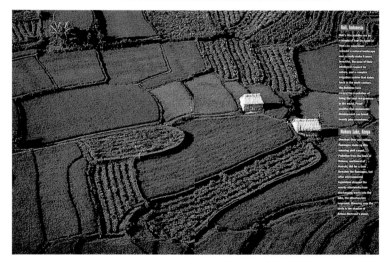

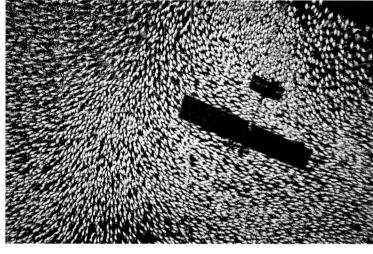

PHOTOGRAPHY SILVER ▼

▼ 458
Publication Condé Nast Traveler
Design Director Diana LaGuardia
Art Director Christin Gangi
Designer Stephen Orr
Photographer Yann Arthus-Bertrand
Photo Editor Kathleen Klech
Publisher Condé Nast Publications Inc.
Issue June 1995
Category Story/Reportage & Travel

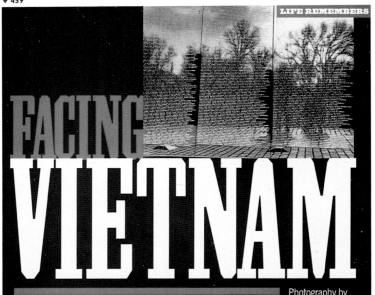

FACING VIETNAM

Photography by
Derek Hudson

The recent anniversary of the dreadful war that ended so ambiguously 20 years ago let loose a tide of articles, interviews, photographs and highly publicized regrets. They engaged us at the moment but then, inevitably, began to fade into the shadowlands of memory. Too bad. There is still something to be divined from a conflict that leveled one country and bitterly divided another, that killed the body, seared the mind or crushed the soul of so many, that ennobled so few and brought suffering to all. Gaze upon their faces—American and Vietnamese, men and women, young and old—and let us vow to do better next time.

59

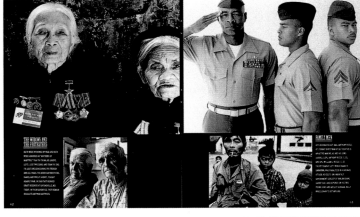

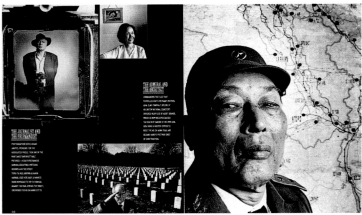

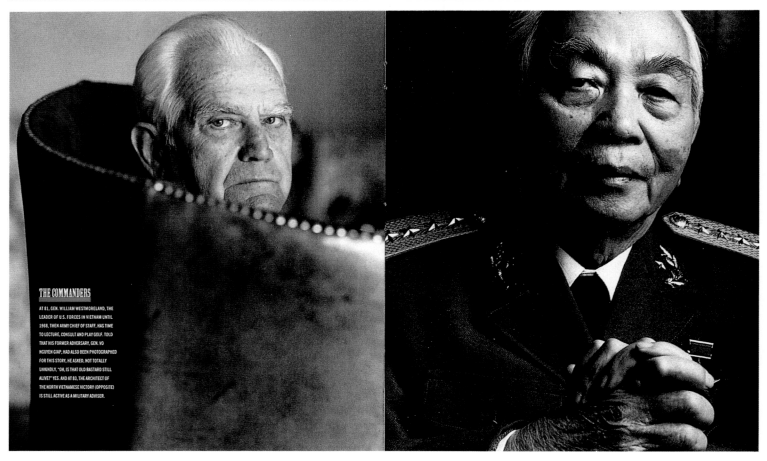

THE COMMANDERS

AT 81, GEN. WILLIAM WESTMORELAND, THE LEADER OF U.S. FORCES IN VIETNAM UNTIL 1968, THEN ARMY CHIEF OF STAFF, HAS TIME TO LECTURE, CONSULT AND PLAY GOLF. TOLD THAT HIS FORMER ADVERSARY, GEN. VO NGUYEN GIAP, HAD ALSO BEEN PHOTOGRAPHED FOR THIS STORY, HE ASKED, NOT TOTALLY UNKINDLY, "OH, IS THAT OLD BASTARD STILL ALIVE?" YES. AND AT 83, THE ARCHITECT OF THE NORTH VIETNAMESE VICTORY (OPPOSITE) IS STILL ACTIVE AS A MILITARY ADVISER.

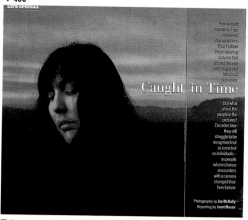

Caught in Time

Four historic moments. Four renowned photographers. Four Pulitzer Prize-winning pictures that altered the way we thought and felt about ourselves.

But what about the people in the pictures? Decades later they still struggle to be recognized not as icons but as individuals— as people whose chance encounters with a camera changed their lives forever.

Photography by Joe McNally
Reporting by Janet Mason

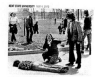
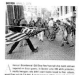
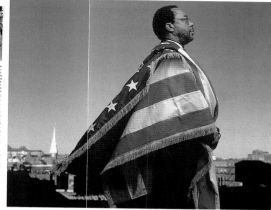

■ A

SOUTH VIETNAM JUNE 8, 1972

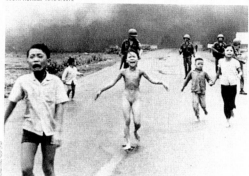

It almost didn't run. An Associated Press staffer thought newspaper editors would find the girl's nakedness offensive. But hundreds of papers did print it. People were offended, and ashamed. South Vietnamese aircraft had dropped U.S. napalm near the Buddhist temple where nine-year-old Phan Thi Kim Phuc and her family had been holding in Trang Bang, a village besieged by the North Vietnamese Army. AP photographer NICK UT took this picture just before Kim Phuc passed out. He remembers: "Her whole back, neck and arm were black like a barbecue." Ut took her to a hospital. "Chu Ut," she calls him—Uncle Ut. He was the first person she phoned after defecting to Canada in 1992.

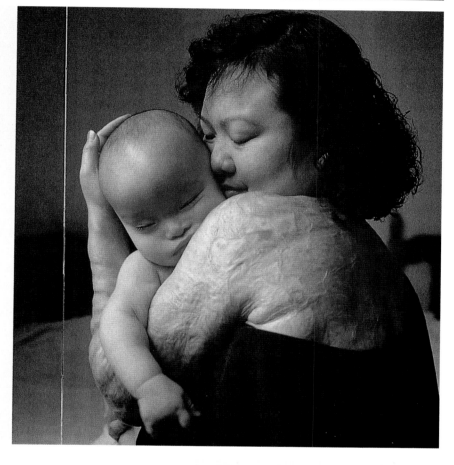

▼ 459
Publication LIFE
Design Director Tom Bentkowski
Designer Marti Golon
Photo Editor David Friend
Photographer Derek Hudson
Publisher Time Inc.
Issue June 1995
Category Story/Portraits

▼ 460
Publication LIFE
Design Director Tom Bentkowski
Designer Mimi Park
Photo Editor Joe McNally
Photographer Joe McNally
Publisher Time Inc.
Issue May 1995
Category Story/Portraits
 ■ A Merit Spread/Portrait

PHOTOGRAPHY SILVER ▼

HEBER SPRINGS, 1995

CONTEMPORARY CLOTHES, TIMELESS FACES — AND THE
ENIGMATIC MIKE DISFARMER FASHION BY POLLY HAMILTON

PHOTOGRAPHS BY KURT MARKUS

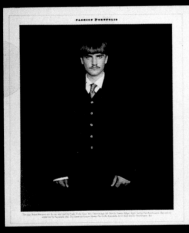
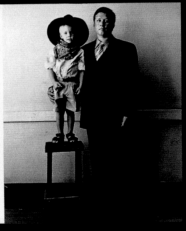

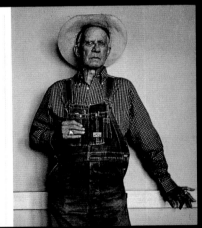
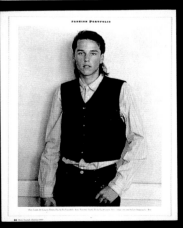

461
Publication Men's Journal
Art Director Mark Danzig
Designer Mark Danzig
Photo Editor Deborah Needleman
Photographers Kurt Markus, Mike Disfarmer
Publisher Wenner Media
Issue October 1995
Category Story/Fashion & Beauty

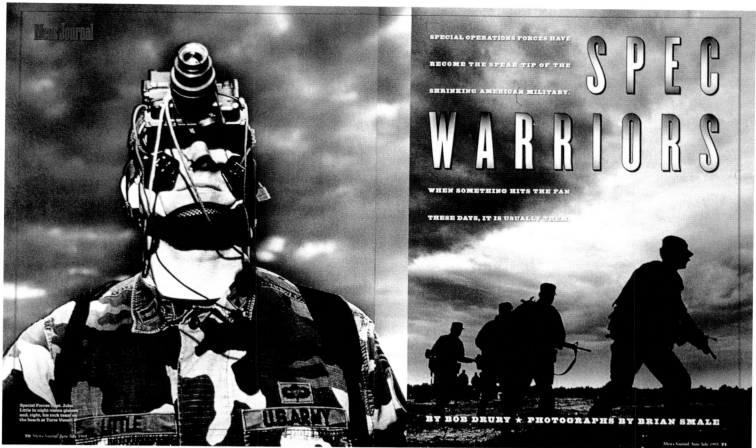

SPECIAL OPERATIONS FORCES HAVE
BECOME THE SPEAR TIP OF THE
SHRINKING AMERICAN MILITARY.

SPEC
WARRIORS

WHEN SOMETHING HITS THE FAN

THESE DAYS, IT IS USUALLY THEM.

BY BOB DRURY ★ PHOTOGRAPHS BY BRIAN SMALE

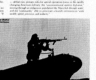

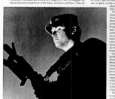

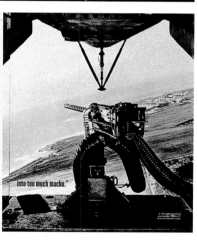

"We have gone from world order to world disorder," says Connolly. "And

Special Operations Forces are better equipped to handle that disorder."

Mogadishu was ominous, says David Hackworth. "The command was

into too much macho."

▼ 462
Publication Men's Journal
Art Director Mark Danzig
Designer Susan Dazzo
Photo Editor Deborah Needleman
Photographer Brian Smale
Publisher Wenner Media
Issue June 1995
Category Story/Reportage & Travel

PHOTOGRAPHY SILVER ▼

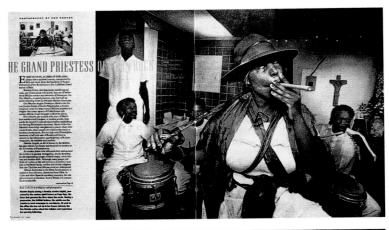

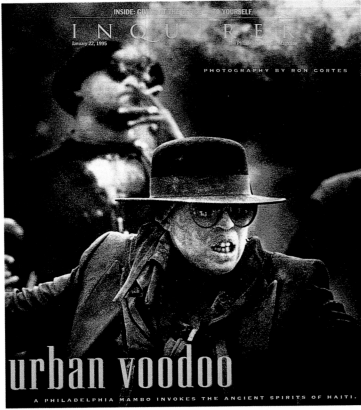

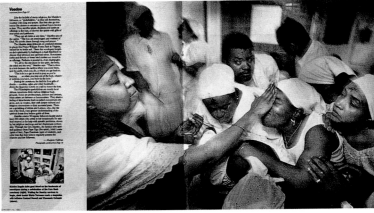

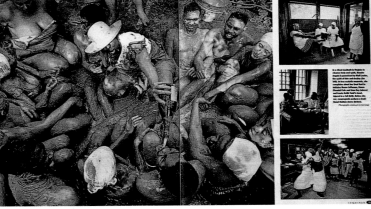

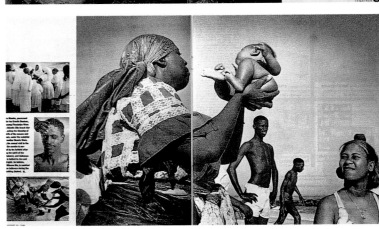

▼ 463
Publication Philadelphia Inquirer Magazine
Design Director Christine Dunleavy
Art Director Bert Fox
Designer Bert Fox
Photo Editor Bert Fox
Photographer Ron Cortes
Publisher Philadelphia Inquirer
Issue January 22, 1995
Category Story/Reportage & Travel

How They See Themselves

PHOTOGRAPHS BY LARS TUNBJÖRK
TEXT BY MARK STEVENS

Big Boys Will Be Cowboys

Forget the penthouse: too urbane. Forget the beach house: not enough privacy.
The fortune makers want ranches — as long as there's a nearby jetport.

A ranch in the Rockies is now one of the proudest trophies of the rich. Ten years ago, only neighbors and hunters would come down the winding road to my grandfather's place in Montana. Now, smiling realtors often knock on the door, hoping someone has died, the family has fallen to squabbling or low cattle prices have driven us to greed and despair. Although no close neighbors have sold out, a wealthy newcomer has constructed a Texas-style entrance with plantings, a service road and a fancy painted sign not far from the old Lutheran church. Another pilgrim is building a 10,000-square-foot house. Last summer, I noticed a man in town wearing a Red Sox cap and an existential smile in the new fly fishing store. I dimly recognized him: Hollywood? The local supermarket now sells shiitake mushrooms. In Montana, the ice cream used to be vanilla, chocolate and strawberry. And the ranches were too cold, remote and inconvenient for big-city money. Jets now make the western *Text continued on page 130*

Mark Stevens, New York magazine's art critic, spends his free time in Montana.

The Old West meets the New West: If Wyoming and Montana once made men of boys, today they often make boys of men. The accouterments of the ranching life – big spreads, horses, Stetsons, trampolines (trampolines?) – are their stylish toys. Louis (Bo) Polk, a venture capitalist at home in Wyoming.

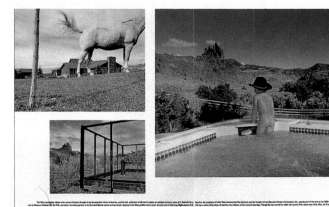

Publication The New York Times Magazine
Art Director Janet Froelich
Designer Joel Cuyler
Photo Editor Kathy Ryan
Photographer Lars Tunbjörk
Publisher The New York Times
Issue November 19, 1995
Category Story/Reportage & Travel

PHOTOGRAPHY SILVER ▼

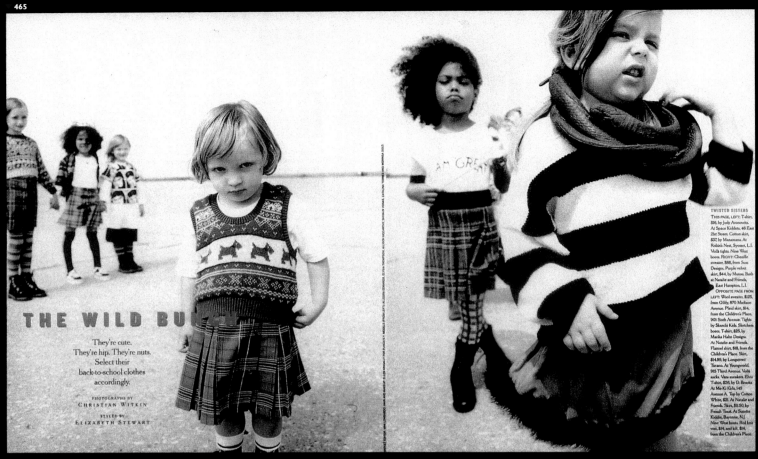

THE WILD BUNCH

They're cute.
They're hip. They're nuts.
Select their
back-to-school clothes
accordingly.

PHOTOGRAPHS BY
CHRISTIAN WITKIN

STYLED BY
ELIZABETH STEWART

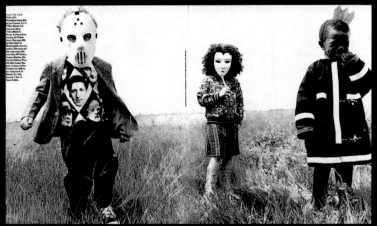

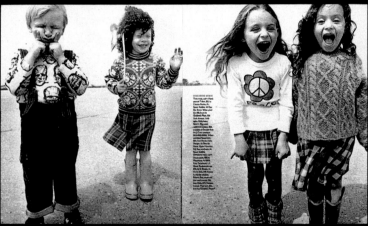

465
Publication The New York Times Magazine
Art Director Janet Froelich
Designer Miriam Campiz
Photographer Christian Witkin
Publisher The New York Times
Issue August 6, 1995
Category Story/Fashion & Beauty

466
Publication The New York Times Magazine
Art Director Janet Froelich
Designer John Walker
Photographer Rodney Smith
Publisher The New York Times
Issue October 29, 1995
Category Spread/Fashion & Beauty

467
Publication Boston
Art Director Gregory Klee
Designer Gregory Klee
Photographer Erica Freudenstein
Publisher METROCORP
Issue April 1995
Category Spread/Reportage & Travel

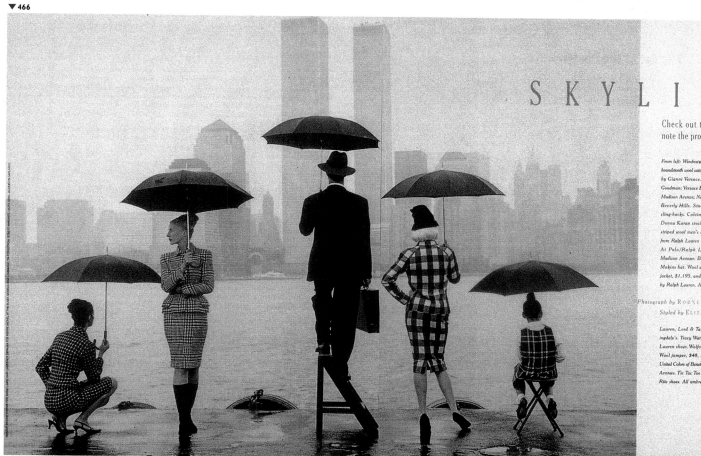

SKYLINE

Check out the view,
note the proportions.

From left: Windowpane-plaid and
houndstooth wool suits, both $2,450,
by Gianni Versace. At Bergdorf
Goodman; Versace Boutique, 817
Madison Avenue; Neiman Marcus,
Beverly Hills. Stuart Weitzman
sling-backs. Calvin Klein boots.
Donna Karan stockings. Chalk-
striped wool men's suit, $1,595,
from Ralph Lauren Purple Label.
At Polo/Ralph Lauren, 867
Madison Avenue. Bally briefcase.
Makins hat. Wool and cashmere
jacket, $1,195, and skirt, $545,
by Ralph Lauren. At Polo/Ralph

Photograph by RODNEY SMITH
Styled by ELIZABETH STEWART

Lauren, Lord & Taylor, Bloom-
ingdale's. Tracy Watts hat. Ralph
Lauren shoes. Wolford stockings.
Wool jumper, $48, by 012 from
United Colors of Benetton, 542 Fifth
Avenue. Tic Tac Toe socks. Stride
Rite shoes. All umbrellas, Liberty.

Boston
Magazine

A Death in the Family

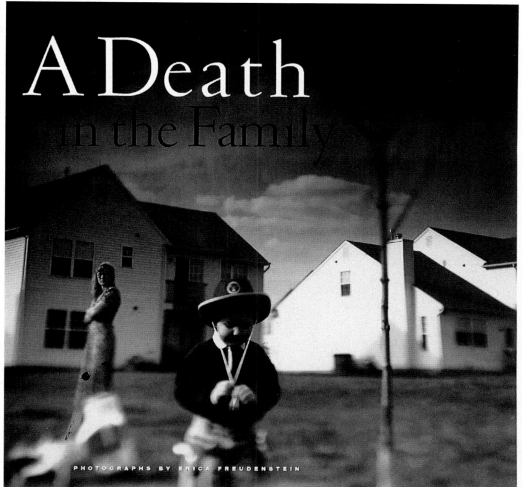

PHOTOGRAPHS BY ERICA FREUDENSTEIN

A year ago, Steven and Sandra Dostie
looked like any other couple trying
to build a good life on Golden Drive.
Then someone killed five-year-old Eric
Dostie. Sandra has a story about two
armed intruders—a college roommate
has a story about Sandra. BY PIPPIN ROSS

THE MORIBUND CAST that hangs over much of Easthampton seems to lift
suddenly upon entering Hendricks Estates. Only two years ago, this dense,
insular settlement on the southwestern edge of a western Massachusetts mill
town was a scruffy prairie at the foot of Mount Tom. Today it stands as a
sunny preserve for young middle-class families drawn to Easthampton's
public schools and such small town niceties as a supermarket where shop-
pers still tell the store manager the various items they would like to see
stocked on the shelves. • Rarely a week goes by on Hendricks Estates that a
bulldozer isn't busy clearing a new lot. Most of the new houses are built
from prefab kits and arrive in two or three sections on the backs of huge
flatbed trucks. A work in progress, Hendricks Estates is a labyrinth of

BOSTON MAGAZINE 3

PHOTOGRAPHY SILVER ▼

187

The Martyrdom of
LEONARD PELTIER

HE BECAME A RALLYING CRY FOR CENTURIES OF OPPRESSION AGAINST HIS PEOPLE, ONE OF AMERICA'S MOST POTENT POLITICAL SYMBOLS. BUT NOW, 20 YEARS AFTER THE MURDER OF TWO FBI AGENTS THAT PUT HIM IN PRISON FOR LIFE, HE'S MORE IMPORTANT AS A LEGEND THAN AS A MAN, AND THE LEGEND HAS BEGUN TO UNRAVEL.

IN THE SHADOW OF THE HIGH WESTERN WALL OF LEAVENWORTH PENITENTIARY, THERE IS A LARGE FIELD SURROUNDED BY A TEN-FOOT-HIGH CHAIN-LINK FENCE. WITHIN THIS ENCLOSURE, FIVE BISON GRAZE. ¶ AT ONE TIME THIS BLUFF OVER THE MISSOURI RIVER MARKED THE EDGE OF THE WESTERN FRONTIER, THE BEGINNING OF A VAST AMERICAN PRAIRIE. TODAY, THE PRAIRIE IS PLANTED IN CORN, THE FIVE BISON ARE MERE CURIOSITIES, AND THE BLUFF IS HOME TO THE MOST FAMOUS PRISON IN AMERICA. ¶ BY ODD

PHOTOGRAPHS BY RAYMOND MEEKS

BY SCOTT ANDERSON

THE GREAT IRONY IS THAT THE STORY THAT HAS BROUGHT PELTIER WORLD-WIDE ATTENTION MAY KEEP HIM IN PRISON FOR A LONG TIME TO COME.

"I WAS THERE," PELTIER SAYS. "I'VE NEVER DENIED THAT. BUT WE WERE ATTACKED, AND WE HAD A RIGHT TO DEFEND OURSELVES, SO I FIRED BACK."

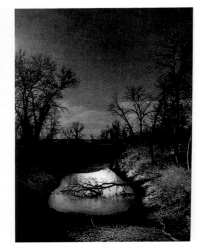

▼ 468
Publication Outside
Creative Director Susan Casey
Photo Editor Susan B. Smith
Photographer Raymond Meeks
Publisher Mariah Media
Issue July 1995
Category Story/Reportage & Travel

Outside

TORCHED

Summer after summer, the smoke-jumpers head for the front lines as the tinderbox forests of the West explode. Fire is the killer and the ally, and every time they escape it, they can't wait for the inferno to begin again.

BY MICHAEL PATERNITI

PHOTOGRAPHS BY RAYMOND MEEKS

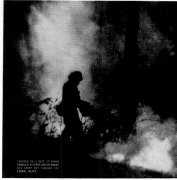

▼ 469

Publication Outside
Creative Director Susan Casey
Photo Editor Susan B. Smith
Photographer Raymond Meeks
Publisher Mariah Media
Issue September 1995
Category Story/Reportage & Travel

PHOTOGRAPHY SILVER ▼

THE GATEKEEPERS

by rick clogher photography by dan winters

ON MAY 27, 1937, TWO HUNDRED THOUSAND PEOPLE WALKED THE BRIDGE ON OPENING DAY. ON MAY 24, 1987, THREE HUNDRED THOUSAND PEOPLE DID THE SAME TO CELEBRATE ITS FIFTIETH ANNIVERSARY. MORE THAN A BILLION CARS HAVE DRIVEN THE GOLDEN GATE BRIDGE OVER SIX DECADES. WE MAY CROSS IT DAILY TO GO TO WORK OR, ON OCCASION, TO HEAD TO THE GREAT OUTDOORS. BUT ONLY A SELECT FEW PEOPLE HAVE AN INTIMATE RELATIONSHIP WITH THE SPAN—ONE THAT COMES FROM KNOWING IT CABLE BY CABLE, BOLT BY BOLT.

"FOR TRADE UNIONS, IT'S SEEN AS THE PLACE TO WORK," SAYS BRIDGE DIVISION MANAGER BOB WARREN, WHO SUPERVISES THE PAINTERS, IRON-WORKERS, AND OTHER FOLKS WHO CARE FOR OUR NO. 1 LANDMARK. "MOST PEOPLE WHO COME TO WORK HERE STAY FOR THEIR WHOLE CAREER."

"IT'S THE WORLD'S LARGEST SET OF MONKEY BARS TO CLIMB ON," SAYS IRONWORKER WOODY BECKER. "AND IT'S THE BEST JOB SECURITY I'VE EVER HAD."

THE GATEKEEPER'S JOB IS A CONTINUOUS ONE AND A CRITICAL ONE: SANDBLASTING, PAINTING, STRENGTHENING, REPAIRING THE BRIDGE, ALL IN A NEVER-ENDING BATTLE AGAINST THE ELEMENTS.

GLEN SIEVERT

"AFTER SPENDING SO MANY HOURS OUT HERE, YEAR IN AND YEAR OUT, WE ALL FEEL THAT IT'S OUR BRIDGE. WE SET UP RIGGING AND SCAFFOLD-ING. WE TAKE OFF LACINGS AND PLATES SO THE PAINTERS CAN GET INTO TIGHT SPOTS TO BLAST. AND WE DO A LOT OF REPAIRS: REPLACING WORN-OUT RIVETS WITH BOLTS. BOT-TOM LINE, IT'S A GOOD LIVING."

SIEVERT (FAR RIGHT IN PHOTO) IS FORTY-SEVEN. HE STARTED WORKING IN BUILD-ING TRADES TO PAY FOR COL-LEGE, THEN LEFT SCHOOL IN HIS SENIOR YEAR TO JOIN THE IRONWORKERS LOCAL. HE APPRENTICED ON THE GOLDEN GATE BRIDGE IN 1971 AND HAS WORKED ON IT FOR TWENTY YEARS.

MIKE YERBIC

"SAFETY IS A BIG CONCERN FOR US—AND NOT JUST FOR OURSELVES BUT THE PEOPLE WHO ARE USING THE BRIDGE. IF WE'RE WORKING UP ON A TOWER OR ON A CABLE, WE TAKE PARTICULAR CARE NOT TO DROP ANYTHING."

YERBIC IS A FORTY-SIX-YEAR-OLD IRONWORKER. HE HELPED BUILD THE HYATT REGENCY IN 1971 AND HAS WORKED ON THE GOLDEN GATE BRIDGE FOR EIGHTEEN YEARS.

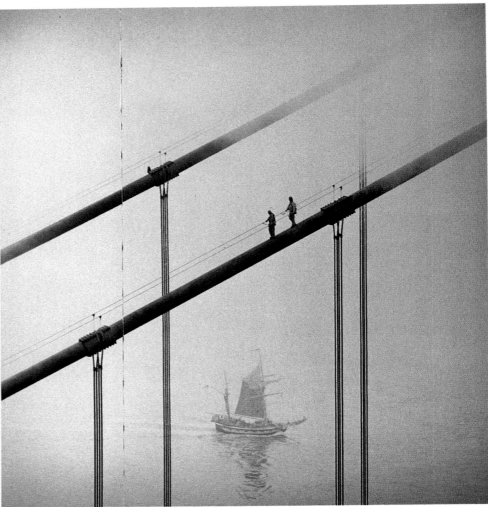

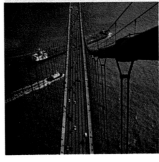

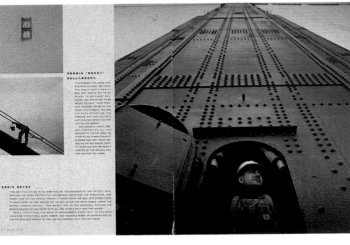

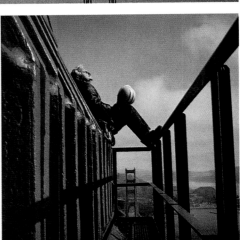

▼ 470
Publication San Francisco Focus
Art Director David Armario
Designer David Armario
Photographer Dan Winters
Publisher KQED, Inc.
Issue May 1995
Category Story/Reportage & Travel

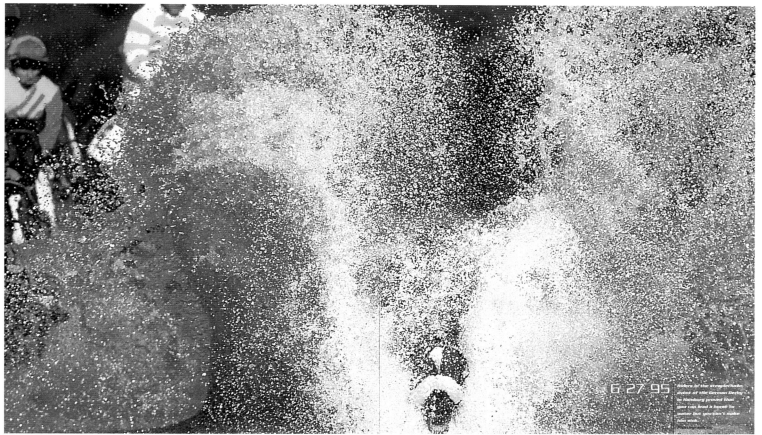

6 27 95

Riders in the steeplechase event of the German Derby in Hamburg proved that you can lead a horse to water but you can't make him sink. Photograph by

▼471
Publication Sports Illustrated Presents
Art Director F. Darrin Perry
Designer Michael D. Schinnerer
Photo Editor Jeffrey Weig
Photographer Hassenstein/Bangarts
Publisher Time Inc.
Issue Fall 1995
Category Spread/Reportage & Travel

VIBEFASHION

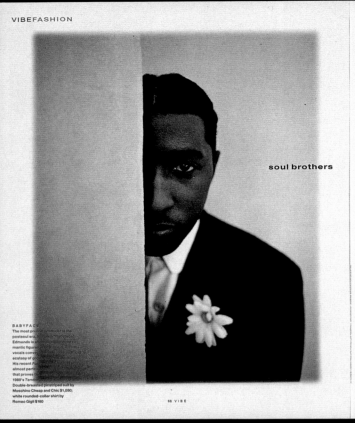

soul brothers

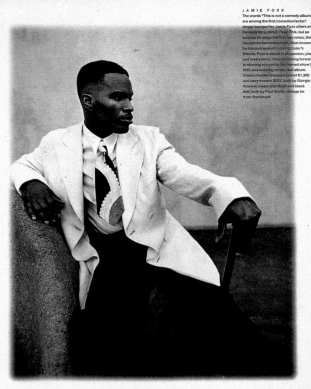

JAMIE FOXX
The words "This is not a comedy album" are among the first comedian/actor/singer/songwriter Jamie Foxx utters on his surprising debut, Peep This, but as soon as he sings the first few notes, the disclaimer becomes moot. Best known for his portrayal of In Living Color's Wanda, Foxx's album is all passion, piano, and lovely tenor. Foxx is looking forward to starring in a yet-to-be-named show for NBC and working on his next album. Cream double-breasted jacket $1,300 and navy trouser $525, both by Giorgio Armani; cream shirt $220 and black belt, both by Paul Smith; vintage tie from Starstruck

BABYFACE
The most prolific producer in the postsoul era, Kenneth "Babyface" Edmonds is also the quintessential romantic figure. His tender, soulful vocals convey the kind of blissful ecstasy of great pop and soul. His recent For the Cool in You is almost perfect in its execution, that proves to be a throwback to 1960's Tenderness. Double-breasted pinstriped suit by Moschino Cheap and Chic $1,050; white rounded-collar shirt by Romeo Gigli $160

68 VIBE

VIBE 69

photographs by ruven afanador

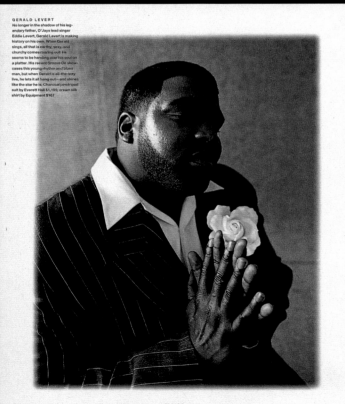

GERALD LEVERT
No longer in the shadow of his legendary father, O'Jay's lead singer Eddie Levert, Gerald Levert is making history on his own. When Gerald sings, all that is earthy, sexy, and churchy comes pouring out. He seems to be handing over his soul on a platter. His recent Groove On showcases this young rhythm and blues man, but when Gerald is all-the-way live, he lets it all hang out—and shines like the star he is. Charcoal pinstriped suit by Everett Hall $1,195; cream silk shirt by Equipment $167

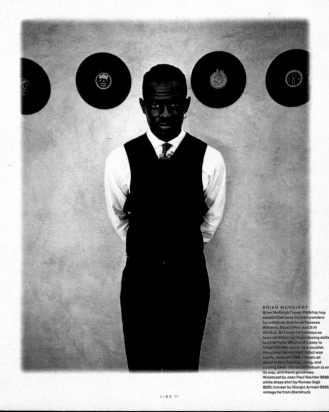

BRIAN MCKNIGHT
Brian McKnight's pop/R&B/hip hop sensibilities have worked wonders for artists as diverse as Vanessa Williams, Boyz II Men, and Ill Al Skratch. But since he's always so busy contributing his producing skills to other folks' albums, it's easy to forget his own career as a vocalist. His completely titled debut was subtle, nuanced R&B—music all about loving, leaving, crying, and coming back. His second album is on its way, and thank goodness. Waistcoat by Jean Paul Gaultier $589; white dress shirt by Romeo Gigli $220; trouser by Giorgio Armani $525; vintage tie from Starstruck

70 VIBE

VIBE 71

▼ **472**
Publication Vibe
Art Director Diddo Ramm
Designer Diddo Ramm
Photo Editor George Pitts
Photographer Ruven Afanador
Publisher Time Inc.
Issue March 1995
Category Story/Fashion & Beauty

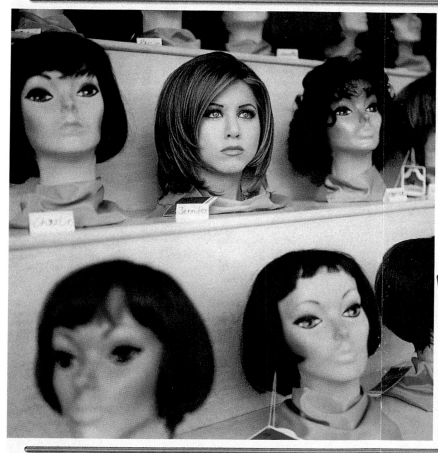

"STAY WITH ME," says Jennifer Aniston, as the small actress climbs into her huge Land Rover. "I drive fast." Well, yeah, she does. A few L.A. blocks later and——bonk!——she bumps the rear of a Ford Taurus. The other driver jumps out, inspects her own car, and glares at the Land Rover. Aniston opens her door and warily offers apologies. But the aggrieved driver wants more: an autograph. Aniston produces a black-and-white photo and scribbles her name. And all is forgiven. "Thank God I had head shots in my car, huh?" Aniston says later with a laugh. ◆ Aniston's insurance company can be thankful that *Friends*—TV's much-copied, much-hyped, No. 3-ranked series—has made her so recognizable. Her role as rich-girl-turned-waitress Rachel has put her, with David Schwimmer as mensch Ross, at the heart of TV's most talked-about romance. Beyond the series, Aniston has become the most sought-after Friend: She just wrapped supporting roles in two movies (Edward Burns' *She's the One*, and *Til There Was You*—both due in mid-'96), stars in the upcoming indie film *Dream for an Insomniac*, and will play the leads in *Picture Perfect*

tv WINNERS & LOSERS

PHOTOGRAPH BY ROBERT TRACHTENBERG

big wig

In the hairy world of prime time

JENNIFER ANISTON

is a cut above the rest

BY BRET WATSON

▼ 473
Publication Entertainment Weekly
Design Director Robert Newman
Designer Michael Picon
Photo Editors Mary Dunn, Michael Kochman
Photographer Robert Trachtenberg
Publisher Time Inc.
Issue December 15, 1995
Category Spread/Portrait

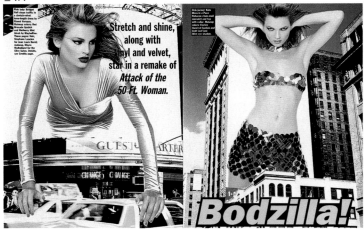

Stretch and shine, along with vinyl and velvet, star in a remake of *Attack of the 50-Ft. Woman.*

Bodzilla!

Hue
New

Makeup artist Kevyn Aucoin sorts through acres of makeup to call the new look for fall: Mod as hell.

By Lindsy Van Gelder

Brown Now

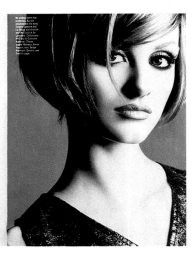

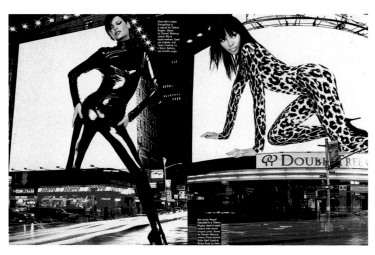

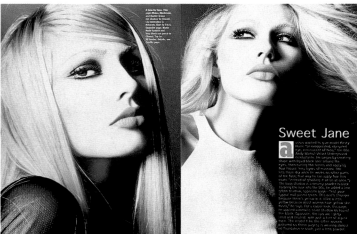

Short and sleek or long and lean, black stands tall.

Sweet Jane

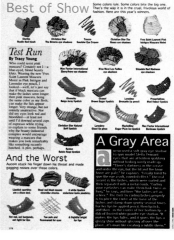

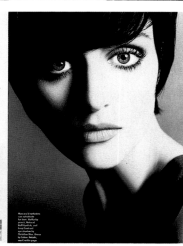

Best of Show

Test Run
By Tracy Young

And the Worst

A Gray Area

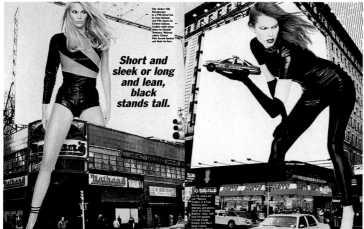

■474

Publication Allure
Design Director Shawn Young
Designer Shawn Young
Photo Editor Claudia Lebenthal
Photographer Thierry Le Gowes
Publisher Condé Nast Publications Inc.
Issue July 1995
Category Story/Fashion & Beauty

■475

Publication Allure
Design Director Shawn Young
Designer Shawn Young
Photo Editor Claudia Lebenthal
Photographers Miles Aldridge, David Cook
Publisher Condé Nast Publications Inc.
Issue September 1995
Category Story/Fashion & Beauty

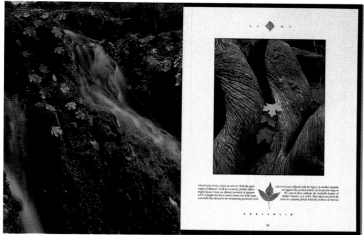

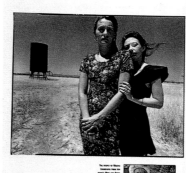

PHOTOGRAPHY MERIT ■

■476
Publication Arizona Highways
Art Director Mary Winkelman Velgos
Photo Editor Peter Ensenberger
Photographer Mark S. Thaler
Publisher Arizona Highways
Issue October 1995
Category Story/Reportage & Travel

■477
Publication Audubon
Art Director Suzanne Morin
Designers Suzanne Morrin, Jonathan B. Foster
Photo Editor Peter Howe
Photographer Mary Ellen Mark
Publisher National Audubon Society
Issue September/October 1995
Category Story/Reportage & Travel

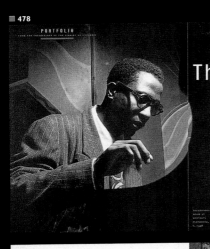
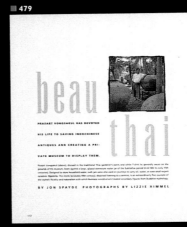

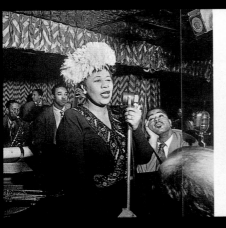

■ 478

Publication Civilization
Art Director David Herbick
Designer Maggie Gamboa
Photo Editor Blaine Marshall
Photographer William Gottlieb
Publisher L.O.C. Associates, L. P.
Issue September/October 1995
Category Story/Portraits

■ 479

Publication Departures
Art Directors Bernard Scharf, Marc Kehoe
Photo Editor Amy Koblenzer
Photographer Lizzie Himmel
Publisher American Express Publishing
Issue March/April 1995
Category Story/Reportage & Travel

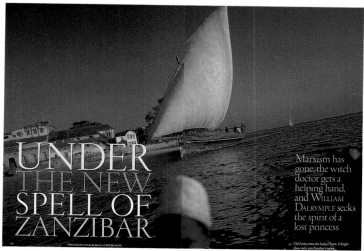

UNDER THE NEW SPELL OF ZANZIBAR

Marxism has gone, the witch doctor gets a helping hand, and WILLIAM DALRYMPLE seeks the spirit of a lost princess

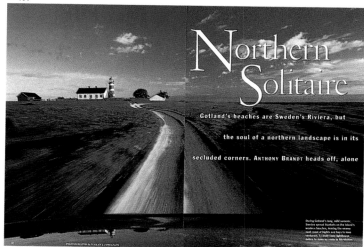

Northern Solitaire

Gotland's beaches are Sweden's Riviera, but the soul of a northern landscape is in its secluded corners. ANTHONY BRANDT heads off, alone

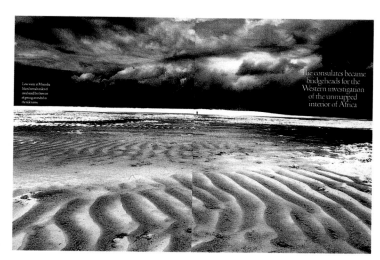

The consulates became bridgeheads for the Western investigation of the unmapped interior of Africa

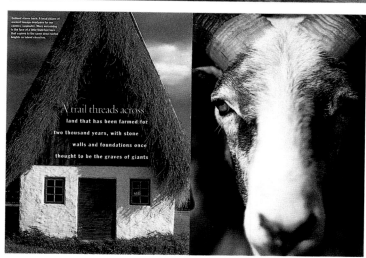

A trail threads across land that has been farmed for two thousand years, with stone walls and foundations once thought to be the graves of giants

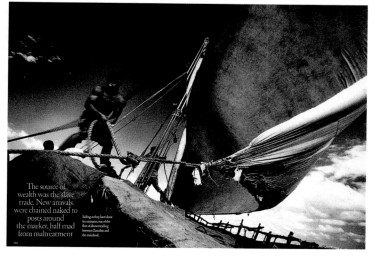

The source of wealth was the slave trade. New arrivals were chained naked to posts around the market, half mad from maltreatment

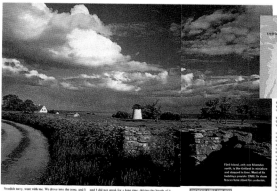

SWEDEN'S LITTLE SUN BELT

BEING A SUMMER RESORT, GOTLAND attracts crowds, but almost all of its hotels are in Visby, and they're booked up months ahead.

■ 480
Publication Condé Nast Traveler
Design Director Diana LaGuardia
Art Director Christin Gangi
Designer Christin Gangi
Photo Editor Kathleen Klech
Photographer Hakan Ludwigsson
Publisher Condé Nast Publications Inc.
Issue April 1995
Category Story/Reportage & Travel

■ 481
Publication Condé Nast Traveler
Design Director Diana LaGuardia
Art Director Christin Gangi
Designer Stephen Orr
Photo Editor Kathleen Klech
Photographer Hakan Ludwigsson
Publisher Condé Nast Publications Inc.
Issue August 1995
Category Story/Reportage & Travel

PHOTOGRAPHY MERIT

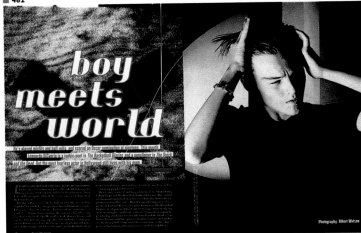

boy meets world

He's played misfits and ball-wits, and scored an Oscar nomination at nineteen. This month, Leonardo DiCaprio is a junkie-poet in *The Basketball Diaries*, and a gunslinger in *The Quick and the Dead*. But the most fearless actor in Hollywood still lives with his mom.

Photography: Albert Watson

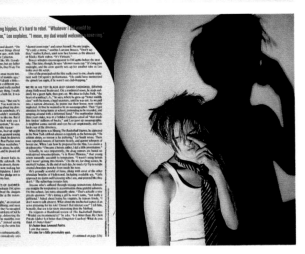

When your parents were pot-smoking hippies, it's hard to rebel. "Whatever I did would be something they'd already done," Lee explains. "I mean, my dad would welcome it."

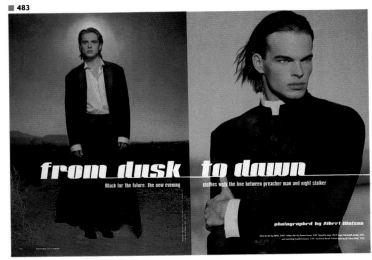

from dusk to dawn

Black for the future: the new evening clothes walk the line between preacher man and night stalker

photographed by Albert Watson

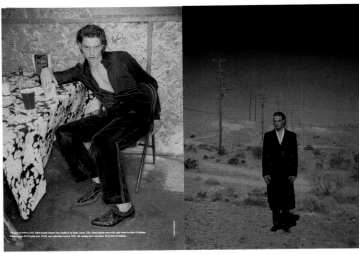

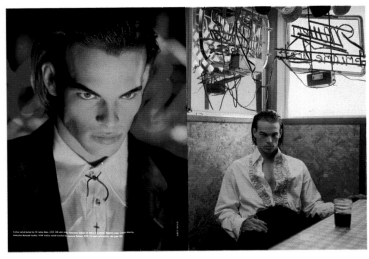

■ 482
Publication Details
Creative Director William Mullen
Art Director Markus Kiersztan
Photo Editor Greg Pond
Photographer Albert Watson
Publisher Condé Nast Publications Inc.
Issue March 1995
Category Story/Portraits

■ 483
Publication Details
Creative Director William Mullen
Art Director Markus Kiersztan
Photo Editor Greg Pond
Photographer Albert Watson
Publisher Condé Nast Publications Inc.
Issue December 1995
Category Story/Fashion & Beauty

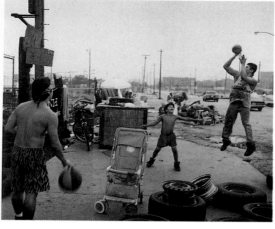

BARRIO

PHOTOGRAPHS

BY

PAUL D'AMATO

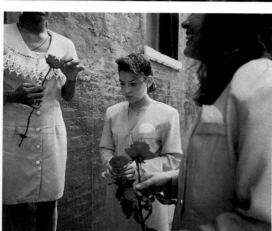

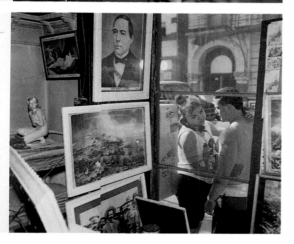

HELEN LEVITT

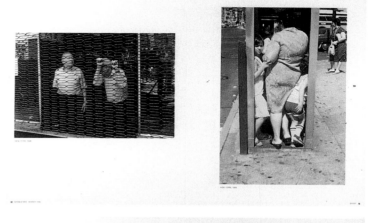

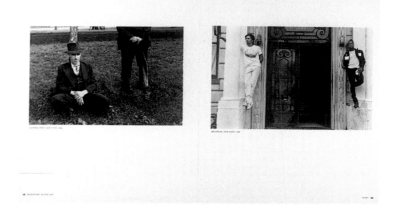

PHOTOGRAPHY MERIT ■

■ 484
Publication DoubleTake
Design Director Molly Renda
Designer Molly Renda
Photo Editor Alex Harris
Photographer Paul D'Amato
Publisher DoubleTake/Center for Documentary Studies
Issue Summer 1995
Category Story/Reportage & Travel

■ 485
Publication DoubleTake
Design Director Molly Renda
Designer Molly Renda
Photo Editor Alex Harris
Photographer Helen Levitt
Publisher DoubleTake/Center for Documentary Studies
Issue Winter 1995-96
Category Story/Reportage & Travel

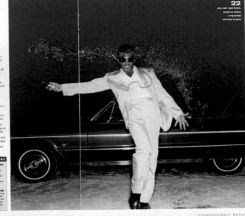

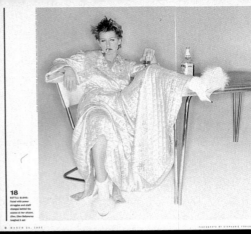

487
Publication Entertainment Weekly
Design Director Robert Newman
Designer Elizabeth Betts
Photo Editor Doris Brautigan
Photographer Stephanie Pfriender
Publisher Time Inc.
Issue October 6, 1995

487
Publication Entertainment Weekly
Design Director Robert Newman
Designer Elizabeth Betts
Photo Editor Michele Romero
Photographer Anton Corbijn
Publisher Time Inc.
Issue July 14, 1995

488
Publication Entertainment Weekly
Design Director Robert Newman
Designer Elizabeth Betts
Photo Editor Alice Babcock
Photographer Stephanie Pfriender
Publisher Time Inc.
Issue March 24, 1995

489
Publication Entertainment Weekly
Design Director Robert Newman
Designers George Karabotsos, Florian Bachleda
Photo Editor Doris Brautigan
Photographer Dan Winters
Publisher Time Inc.

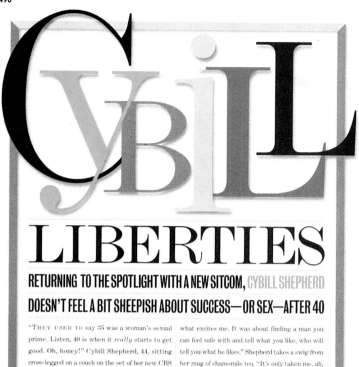

CYBILL
LIBERTIES

RETURNING TO THE SPOTLIGHT WITH A NEW SITCOM, CYBILL SHEPHERD DOESN'T FEEL A BIT SHEEPISH ABOUT SUCCESS—OR SEX—AFTER 40

"THEY USED TO say 35 was a woman's sexual prime. Listen, 40 is when it *really* starts to get good. Oh, honey!" Cybill Shepherd, 44, sitting cross-legged on a couch on the set of her new CBS sitcom, spears a limp stalk of broccoli from a plastic takeout container on her lap. She sneaks a look around the fake living room to see if the crew can hear, then lowers her voice—but not by much. "For me, it was about getting over the fear of saying

what excites me. It was about finding a man you can feel safe with and tell what you like, who will tell you what he likes." Shepherd takes a swig from her mug of chamomile tea. "It's only taken me, uh, like 20 years to figure all this out. Twenty years to figure out how to be myself." ✦ Talk about timing. Her new series, titled simply *Cybill* (Mondays, 9:30–10 p.m.), is loosely modeled on Shepherd's real life, so now she has to figure out how to be herself

BY DANA KENNEDY

PHOTOGRAPHS BY MICHAEL TIGHE

22 JANUARY 20, 1995

BY DANA KENNEDY

King
OF THE
JUNGLE

A NEW ACE VENTURA, ANOTHER $40 MILLION IN THE BANK, AND RAW ANIMAL MAGNETISM MAKE JIM CARREY MORE THAN A LAUGHING MATTER

PHOTOGRAPHS BY DAN WINTERS

"I REFUSE TO FEEL **FEEL GUILTY.** I FEEL GUILTY ABOUT TOO MUCH IN MY LIFE, BUT NOT ABOUT **MONEY.**"

■ 490
Publication Entertainment Weekly
Design Director Robert Newman
Designer Michael Picon
Photo Editor Alice Babcock
Photographer Michael Tighe
Publisher Time Inc.
Issue January 20, 1995
Category Portrait

■ 491
Publication Entertainment Weekly
Design Director Robert Newman
Designer George Karabotsos
Photo Editor Doris Brautigan
Photographer Dan Winters
Publisher Time Inc.
Issue November 10, 1995
Category Portrait

■ 492
Publication Entertainment Weekly
Design Director Robert Newman
Designer George Karabotsos
Photo Editor Doris Brautigan
Photographer Dan Winters
Publisher Time Inc.
Issue November 10, 1995
Category Portrait

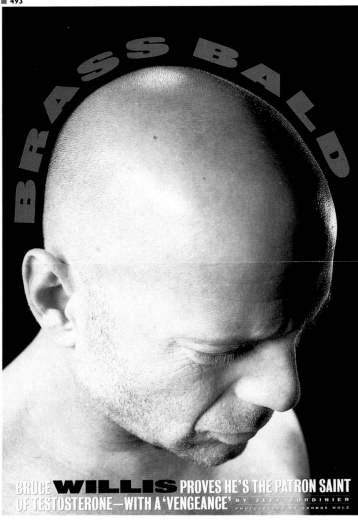

BRASS BALD

BRUCE **WILLIS** PROVES HE'S THE PATRON SAINT OF TESTOSTERONE—WITH A 'VENGEANCE' BY JEFF GORDINIER
PHOTOGRAPHS BY GEORGE HOLZ

DANGEROUS WHEN WET

BY JESS CAGLE
PHOTOGRAPH BY GEORGE LANGE

FISH GOTTA SWIM. BIRDS GOTTA FLY. KEVIN COSTNER'S GOTTA PLAY THE HERO. BUT INSIDE WATERWORLD, TELLING THE GOOD GUYS FROM THE BAD ISN'T THAT SIMPLE.

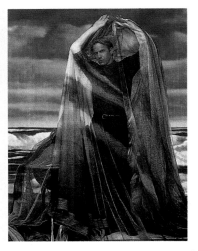

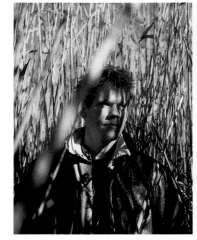

breakout STAR

BRUISING, FLOGGING, HANDCUFFS, SOLITARY CONFINEMENT—YOU NAME IT. **KEVIN BACON** BRAVES ALL IN 'MURDER IN THE FIRST' TO SHED HIS NICE-GUY SHACKLES.

BY JEFF GORDINIER

WILL THE REAL ELLEN PLEASE STAND UP?

AFTER A SERIES OF SHAKE-UPS, A NEWLY ASSERTIVE **ELLEN DEGENERES** FIGHTS FOR CONTROL OF HER HIT SITCOM
BY A.J. JACOBS
PHOTOGRAPHS BY STEPHANIE PFRIENDER

■ 493
Publication Entertainment Weekly
Design Director Robert Newman
Designer Jennifer Gilman
Photo Editor Doris Brautigan
Photographer George Holz
Publisher Time Inc.
Issue May 19, 1995
Category Story/Portraits

■ 494
Publication Entertainment Weekly
Design Director Robert Newman
Designer George Karabotsos
Photo Editor Doris Brautigan
Photographer George Lange
Publisher Time Inc.
Issue July 14, 1995
Category Portrait

■ 495
Publication Entertainment Weekly
Design Director Robert Newman
Designer Carla Frank
Photo Editor Doris Brautigan
Photographer Antonin Kratochvil
Publisher Time Inc.
Issue January 27, 1995
Category Portrait

■ 496
Publication Entertainment Weekly
Design Director Robert Newman
Designer George Karabotsos
Photo Editor Alice Babcock
Photographer Stephanie Pfriender
Publisher Time Inc.
Issue March 24, 1995
Category Portrait

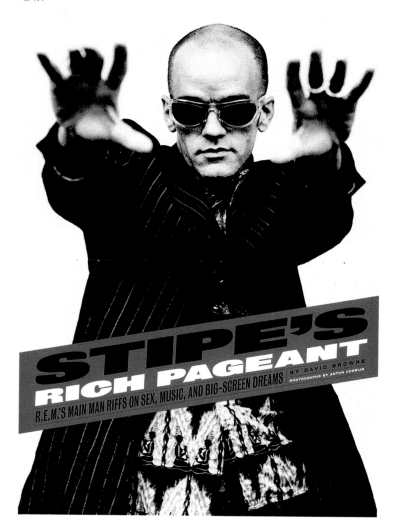

STIPE'S RICH PAGEANT
R.E.M.'S MAIN MAN RIFFS ON SEX, MUSIC, AND BIG-SCREEN DREAMS | BY DAVID BROWNE
PHOTOGRAPHS BY ANTON CORBIJN

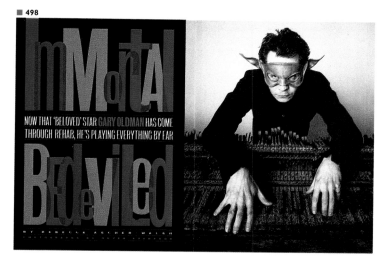

ImMortal Bedeviled
NOW THAT 'BELOVED' STAR GARY OLDMAN HAS COME THROUGH REHAB, HE'S PLAYING EVERYTHING BY EAR

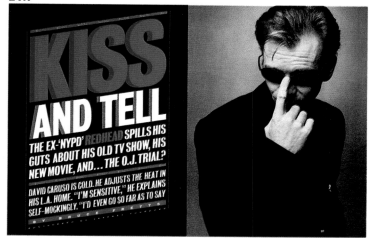

WAITING TO Exhale
BURNED IN THE RATINGS, DAVID LETTERMAN PUFFS AND HUFFS, EATS CAVIAR WITH A SURPRISE GUEST, AND ANSWERS ALL OUR QUESTIONS (EVEN THE PERSONAL ONES)
BY KEN TUCKER

KISS AND TELL
THE EX-'NYPD' REDHEAD SPILLS HIS GUTS ABOUT HIS OLD TV SHOW, HIS NEW MOVIE, AND... THE O.J. TRIAL?
DAVID CARUSO IS COLD. HE ADJUSTS THE HEAT IN HIS L.A. HOME. "I'M SENSITIVE," HE EXPLAINS SELF-MOCKINGLY. "I'D EVEN GO SO FAR AS TO SAY
BY BRUCE FRETTS

PHOTOGRAPHY MERIT ■

■ 497
Publication Entertainment Weekly
Design Director Robert Newman
Designer Florian Bachleda
Photo Editor Michele Romero
Photographer Anton Corbijn
Publisher Time Inc.
Issue July 14, 1995
Category Portrait

■ 498
Publication Entertainment Weekly
Design Director Robert Newman
Designer George Karabotsos
Photo Editors Doris Brautigan,
Mary Dunn
Photographer Ruven Afanador
Publisher Time Inc.
Issue February 10, 1995
Category Portrait

■ 499
Publication Entertainment Weekly
Design Director Robert Newman
Designer Michael Picon
Photo Editor Mary Dunn
Photographer Christopher Little
Publisher Time Inc.
Issue December 1, 1995
Category Portrait

■ 500
Publication Entertainment Weekly
Design Director Robert Newman
Designer Michael Picon
Photo Editor Doris Brautigan
Photographer Jeffrey Thurnher
Publisher Time Inc.
Issue April 28, 1995
Category Portrait

When we speak of the
factors that influence us—nature, nurture, family, culture—rarely do we speak of light.

Might it not be wise to ask, at least once in a while, to what extent is the character of an individual shaped, even determined, by the quality of light that illuminates the world he or she occupies and describes? And if we agree that light has an important influence on each individual's development, doesn't it follow that it may function as a formative aspect of cultural identity as well?

Communications theorist Marshall McLuhan was fond of saying, "Whoever discovered water, it wasn't a fish," meaning that we all tend to take for granted our everyday environment. Few people learn to pay attention to the light by which they see; they may be aware of quantity, but rarely of quality. Photographers, of course, often talk about the quality of light, discussing it with the discrimination, affection and connoisseurship common among

LUMINOSITÉ FRANÇAISE

oenophiles. After all, the light reflected off physical surfaces constitutes both the photographer's raw material and his or her true subject matter. Small wonder that those whose poetry is inscribed on light-sensitive materials should develop sophisticated visual palates and choose their light as carefully as a gourmet might select a vintage bottle.

Among the première connoisseurs of light is Ralph Gibson, author of more than 20 books, many of them devoted to French themes. When Gibson first visited France in 1972, he immediately felt himself optically chez lui. He has returned again and again, making pictures and even centering major projects around the process of working in that light. What he calls la luminosité française is therefore neither an unconscious experience nor a pre-

plexity and richness of French light and its infinite variety, he found French attitudes toward the quality of life, the life of the mind and the place of photography in intellectual affairs no less sympathique. In France, perhaps more than in any other culture, photography is understood and treated not only as a form of visual art but as a branch of literature, a means of writing with light.

Gibson's pictures are very much about seeing, but they are equally concerned with ideas—a thinking man's visions, if you will. His experiments over the years with metaphor, visual poetry and fiction, narrative structure and book form have proven both seminal and masterful. Nowhere has he found a more supportive audience for his experiments than in France, where a younger generation of photographers embraced the paradigm he pro-

THE PHOTOGRAPHS OF RALPH GIBSON · BY A.D. COLEMAN

sumed birthright; instead, it is for him—a Californian who transplanted himself to New York—a consciously chosen influence on his seeing, an elective affinity. In its deliberateness, his decision demands to be understood as equivalent to, and given the same weight as, a classical violinist's decision to play a Stradivarius, a rock guitarist's choice to play a Fender.

Although Gibson was immediately drawn to the depth, com-

posed almost as quickly as did their counterparts in the United States, and where critics understood him even more rapidly than did those (with a few exceptions) from his native land.

Today Gibson's work is represented in more than 100 museums worldwide, including the prestigious collection at France's Bibliothèque Nationale. In 1986, France further honored the photographer by making him Officier des Arts et des Lettres, and this June, the French Cultural Services in New York City will host "Luminosité Française," a show surveying Gibson's responses to French light and culture between 1972 and 1994 (see "Calendrier" for details). Sponsored by the Murray and Isabelle Rayburn Foundation, the exhibit will include images from many of Gibson's monographs, among them L'Histoire de France (1991), his first exploration of the potentials of color.

When I visited Gibson earlier this year, there were French books and a French dictionary on his coffee table. Over the years, he has studied the language and now both reads and speaks French with ease. But as the photographs in this exhibit reveal, he was fluent in one of France's subtlest dialects, the language of its light, from the moment he first set foot on Gallic soil. •

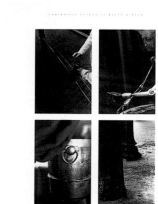

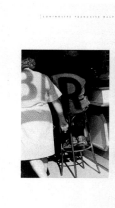

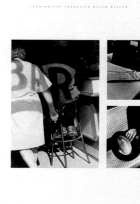

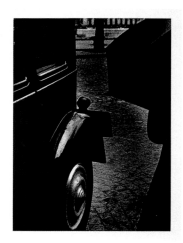

■ 501
Publication France
Creative Director Kelly Doe
Art Director Susan Langholz
Designer Kelly Doe
Photo Editor Kelly Doe
Photographer Ralph Gibson
Publisher French Embassy
Issue Summer 1995
Category Story/Reportage & Travel

G R O W I N G

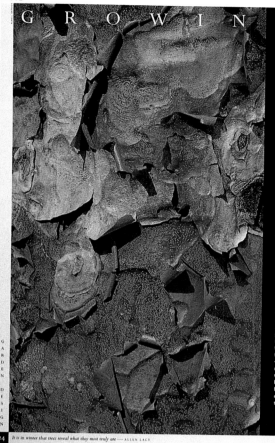

BARKING UP THE RIGHT TREE

The famous British plantsman E. H. "Chinese" Wilson earned his nickname at the turn of the century, when he traveled to China on plant-collecting missions for the English nursery James Veitch & Sons and Harvard's Arnold Arboretum. Among his discoveries: *Acer griseum*, which he declared "easily the most outstanding of the Chinese maples."

Indeed, there's plenty to recommend this slow-growing tree, pictured here. Even at maturity, it's usually only about 30 feet tall, so it won't overpower small gardens. Its leaflets are two-toned—deep green on top with a lighter gray-green underneath—and turn vivid shades of red and orange come fall. But Wilson wasn't raving about foliage or growth habit; he prized *A. griseum* (also called "the paperbark maple") for its bark, left. Thin sheets peel off in shades of copper, cinnamon, and brown; the texture ranges from shiny and smooth to matte and rough. And though these trees exfoliate year-round, they're most striking during winter. With the leaves gone, the bark stands out—especially against a snowy backdrop, right.

Hard to come by for years, *A. griseum* is now more readily available in the nursery trade, but not all specimens are outstanding. Be sure to request a young tree with plenty of peeling bark, and plant it next spring in a spot that's shaded from afternoon sun and protected from winter wind. Hardy in zones 4 to 8, these maples also prefer moist, humus-rich soil. If you want to check out a mature tree now, head to the Arnold Arboretum in Boston. One of Chinese Wilson's original specimens still grows there on Bussey Hill. —*FRH*

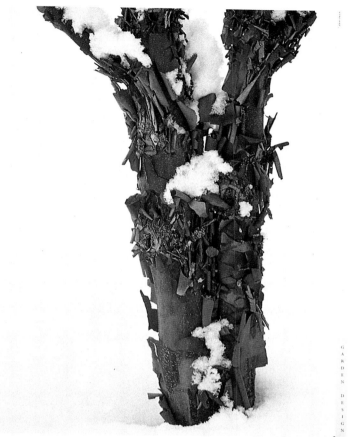

It is in winter that trees reveal what they most truly are — ALLEN LACY

All trees are sacredly possessed by an unseen life — ANN KENT RUSH

G R O W I N G

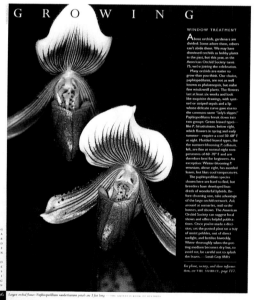

WINDOW TREATMENT

About orchids, gardeners are divided: Some adore them, others can't abide them. We may have dismissed orchids as hobby plants in the past, but this year, as the American Orchid Society turns 75, we're joining the celebration.

Many orchids are easier to grow than you think. Our choice, paphiopedilum, are not as well known as phalaenopsis, but make fine windowsill plants. The flowers last at least six weeks and look like exquisite drawings, with spotted or striped sepals and a lip whose delicate curve gave rise to the common name "lady's slipper." Paphiopedilum break down into two groups: Green-leaved types—like *P. hirsutissimum*, below right, which flowers in spring and early summer—require a cool 50–60° F at night. Mottled leaved types, like the summer-blooming *P. callosum*, left, are fine at normal night temperatures of 60–70° F and are therefore best for beginners. An exception: Winter-blooming *P. armeniacum*, above right, has mottled leaves, but likes cool temperatures.

The paphiopedilum species shown here are hard to find, but breeders have developed hundreds of wonderful hybrids. Before choosing one, take advantage of the large orchid network. Ask around at nurseries, mail-order houses, and shows. The American Orchid Society can suggest local shows and offers helpful publications. Once you've made a decision, set the potted plant on a tray of moist pebbles, out of direct sunlight, and fertilize biweekly. Water thoroughly when the potting medium becomes dry but, to avoid rot, be careful not to splash the leaves. —*Sarah Gray Miller*

For plants, society, and show information, see THE SOURCE, *page 117.*

Largest orchid flower: Paphiopedilum sanderianum petals are 3 feet long — THE GUINNESS BOOK OF RECORDS

ELLE TALKATHON

mr. smith feels up washington

Would the distinguished senator stop groping my thigh? Meryl Gordon moderates a roundtable on post-Packwood sexual harassment in the nation's capital

WASHINGTON, DC, has certainly had its torrid sex scandals over the years, but the Bob Packwood affair has topped them all, thanks to his explosive diary descriptions of Capitol Hill as a sexual playground. The Republican senator proudly bragged that he had made love to twenty-two staffers—and that didn't include all the unwilling women he assaulted with his tongue and hands.

Packwood's outlandish impositions weren't limited to sex: he writes in his diaries of expecting his chief of staff to vacuum and clean his home in her off-hours. Even the infamous Congressman Wayne Hays, who was ousted for putting his lover, Elizabeth Ray, on the government payroll, didn't expect her to do windows.

Amazingly, Packwood nearly got away with just a reprimand for his extraordinarily abusive actions, conducted at taxpayers' expense. Instead, due in part to pressure brought by angry women senators, he was forced to resign last September. Congress has traditionally been loath to discipline its members for "boys will be boys" transgressions, so perhaps Packwood's departure is a harbinger of better times to come.

Is boorish behavior like Packwood's a thing of the past? To find out, ELLE gathered five Capitol Hill women staffers for a dinner discussion of sexual harassment and abuse of power. Not only did they dish up some crude and lewd stories about several of the country's most respected legislators, they also talked about the uneasy and awkward relationship between the sexes in Washington and how women can be part of the problem, too.

"You give a man a Member of Congress pin, and he thinks he's Brad Pitt," said Abby, a twenty-six-year-old staffer for a Democratic congressman. (For obvious reasons, the women's names have been changed.) Emily, also twenty-six, who recently left a Senate job, described how her boss tried to seduce the women on the staff. "I heard the stories before I went to work there, so I wasn't surprised when he made a play for me." Jill, thirty-nine, and Marci, thirty, Republican Hill veterans, recalled their humiliation at being required to do demeaning personal errands for their bosses. Only Laurie, a thirty-one-year-old Democratic House staffer who hopes to run for Congress herself, painted an upbeat version of life in the nation's capital.

MERYL: Was Bob Packwood's strange behavior with women well-known before he was brought up on ethics charges?

[Several cries of "Yes"]

JILL: He was known for any number of things, including making unwanted advances to women. But frankly, what bothers me the most about sexual harassment is that as long as there are these women on Capitol Hill who are *trying* to sleep with the boss to get ahead, nothing will change for the better.

ABBY: One of them sets back a hundred of us who are just there to do our job.

MARCI: I haven't run into that.

ABBY: Those women just think that it's like sleeping with a rock star—they're going to get a commercial someone, or . . .

JILL: Or they'll get a better job, or get married.

ABBY: They should be shot.

EMILY: But it's not all women making the move. There was a hand put on my leg in a car by someone whose hand should not have been there—my boss, a senator. I thought it was sickening. But at the same time, there was never one second where I had any doubt about what to do. I said, "I work for you," and I pushed his hand off my leg. He said, "Thank you for driving me here." Never happened again. And after that, he treated me with so much respect. It was the easiest thing I'd ever done in my life.

ABBY: When I first started working with my current boss, I had just broken up with my boyfriend. My boss is the kind who asks about your personal life, and so I told him about the split, and he says, "Well, I'm going to set you up with somebody. Who do you want to date?" And just off the top of my head, I said, "Oh, Patrick Kennedy." So the next thing I know, I'm working late one night, and here comes my boss with Patrick Kennedy. It was the most embarrassing thing.

A few days later I'm sitting there washing the floor vote, and I see my boss talking with Patrick. . . . He

■ 502
Publication Garden Design
Creative Director Michael Grossman
Art Director Paul Roelofs
Photo Editor Susan Goldberger
Photographers Alan L. Detrick, Jerry Pavia
Publisher Meigher Communications
Issue December 1995/January 1996
Category Spread/Still Life & Interiors

■ 503
Publication Garden Design
Creative Director Michael Grossman
Art Director Paul Roelofs
Designer Paul Roelofs
Photo Editor Susan Goldberger
Photographers Charles Marden Fitch, Alan L. Detrick, Judy White
Publisher Meigher Communications
Issue December 1995/January 1996
Category Single Page/Still Life & Interiors

■ 504
Publication Elle
Art Director Nora Sheehan
Designer Nora Sheehan
Photo Editor Alison Morley
Photographer Andrew Eccles
Publisher Hachette Filipacchi Magazines, Inc.
Issue February 1995
Category Spread/Reportage & Travel

PHOTOGRAPHY MERIT ■

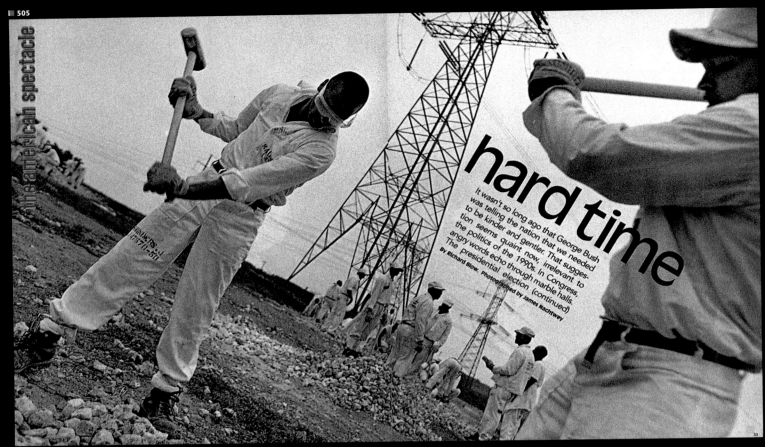

the american spectacle

hard time

It wasn't so long ago that George Bush was telling the nation that we needed to be kinder and gentler. That suggestion seems quaint now, irrelevant to the politics of the 1990s, in Congress, angry words echo through marble halls. The presidential election (continued)

BY Richard Blow. Photographed by James Nachtwey

■ 505
Publication George
Creative Director Matt Berman
Photo Editor Bridget Cox
Photographer James Nachtwey
Publisher Hachette Filipacchi Magazines, Inc.
Issue December 1995/January 1996
Category Story/Reportage & Travel

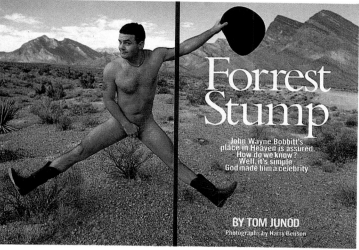

Forrest Stump

John Wayne Bobbitt's place in Heaven is assured. How do we know? Well, it's simple. God made him a celebrity

BY TOM JUNOD
Photographs by Harry Benson

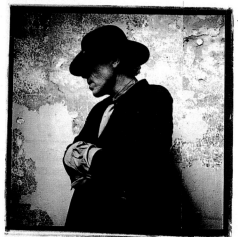

Waiting for Nic Cage

The fate of an irredeemably independent filmmaker like Abel Ferrara hinges on a million long shots. Like raising the money. And finding a distributor. And praying a name star will finally return your call

By Scott Raab

Harris Todd In Hell

When a man's child is abducted and later hidden away by a sprawling, fanatic underground movement, he does everything he can to get her back. Right?

By Peter Richmond

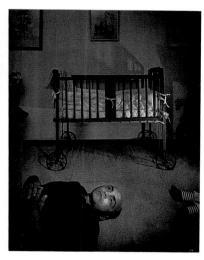

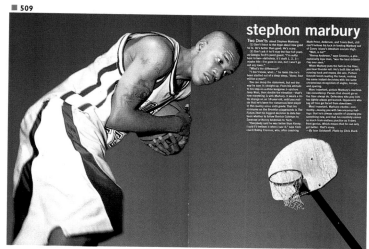

stephon marbury

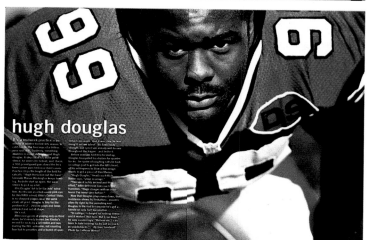

hugh douglas

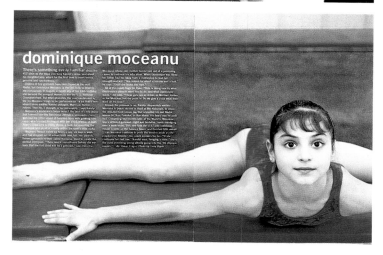

dominique moceanu

506
Publication GQ
Creative Director Robert Priest
Designer Robert Priest
Photo Editor Karen Frank
Photographer Harry Benson
Publisher Condé Nast Publications Inc.
Issue March 1995
Category Portrait

507
Publication GQ
Art Director John Korpics
Designer John Korpics
Photo Editor Karen Frank
Photographer Karen Kuehn
Publisher Condé Nast Publications Inc.
Issue October 1995
Category Portrait

508
Publication GQ
Art Director John Korpics
Designer John Korpics
Photo Editor Karen Frank
Photographer Dan Winters
Publisher Condé Nast Publications Inc.
Issue November 1995
Category Portrait

509
Publication ESPN
The Year In Sports
Art Director Nancy Kruger Cohen
Designers Robin L. Helman,
Nicole Salzano
Photo Editors Maisie Todd,
Deborah Gottesfeld
Photographers Chirs Buck,
Terry Doyle, John Dyer,
Kristine Larsen, Kathrine Wessel
Publisher The Hearst Corporation-
Magazines Division
Issue December 1995
Category Story/Portraits

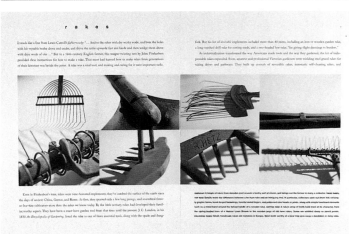

r a k e s

They're the drill sergeants of the garden, ordering unruly soil into precise rows, breaking up stubborn clods, and banishing leaves or unsightly debris. Yet in spite of their controlling nature—indeed, because of it—these taskmasters have been favored for centuries.

TEXT BY LINDA JOAN SMITH PHOTOGRAPHS BY KING AU

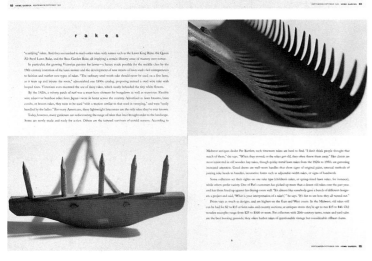

FairMarketValues

"Big is beautiful," says Phillip G. Andrews. "The biggest pumpkin. The biggest squash. The biggest aster. Anybody can raise the early stuff, but this is a contest. Big is part of the competition." Mr. Andrews, a retired dairy farmer, has been involved in one way or another with the Fryeburg Fair in Maine for 45 of his 81 years. Mostly it's been the finance committee. But for the last four years he's been president of this week-long extravaganza that celebrates its 145th anniversary October 1-8.

The Fryeburg Fair is the largest agricultural fair of its type in New England "and possibly the East," he says. But, he adds quickly tempering this un-Mainelike flourish, "at least I'm sure I can brag that we do have the country's largest Draft Ox Show and Pull. It may even be the biggest in the world. Anyway, no one has disputed me on this."

One thing at least is beyond dispute. As the Maine maples don their crimson autumn hues, enough American and Canadian visitors flock to this tiny town at the edge of the White Mountains to swell its regular population of almost 3,000 to nearly 300,000. Now that is big.

Big quality also counts, as the fair catalog makes clear. For example, it exhorts those entering Department 26: Plants and Flowers to "Be sure you

TEXT BY LINDA LING PHOTOGRAPHS BY BILL HOLT
PRODUCED BY DEBRA P. MESSLER

FairMarket

There is nothing like a country fair to provide a sense of wonder in children and inspiration in adults—not to mention some serious vegetable garden competition.

get the best your garden has to offer." Among the houseplant categories are fruiting species and hanging containers. Flowers qualifying for the Best Single Bloom competition include sweet peas, clovers, and dahlias.

Then there is Department 21: Grains, Fruits, and Vegetables, Item 38 is Squash, Summer Variety, and Item 36 is Squash, Winter Variety. The serious squash lover, wondering at the classification, may simply query an exhibitor and the nomenclature becomes clear: the soft-skinned summer squash dies easily, is usually delicious raw or cooked, and, as its name implies, typically matures from mid to late summer. Winter squash—always a fair favorite—is very hard-shelled, must be cooked before eating, and yes, matures in the autumn.

Once the exhibitor gets talking, the squash aficionado may also learn that winter squash must mature on the

■ 510
Publication Home Garden
Art Director Brad Ruppert
Photographer King Au
Publisher Meredith Corporation
Issue September/October 1995
Category Story/Still Life & Interiors

■ 511
Publication Home Garden
Art Director Brad Ruppert
Designers Paul Niski, Brad Ruppert
Photographer Bill Holt
Publisher Meredith Corporation
Issue September/October 1995
Category Story/Still Life & Interiors

ACTS OF FAITH

They flock by the millions to the holy places of the world, in search of salvation or simply in adoration. And so photographer GIANNI GIANSANTI, who has accompanied Pope John Paul II on more than 40 trips abroad, decided to set out on a pilgrimage of his own. Over the past three years, he has followed the Catholic people, capturing the spirit of mystical, ecstatic worship at its height, such as in the week before Easter. Giansanti, like his subjects, was looking for the miraculous. He found it, he says, in unexpected form: "The real miracle I witnessed is faith."

During Pentecost, as many as a million pilgrims converge on El Rocio in southern Spain's Andalusia. During the Procession of the Virgin, the throng fights for the honor of bearing the statue through the city.

Crough Patrick, Ireland

Since the Middle Ages, barefoot pilgrims have stumbled up the steep shale slopes of the Reek, or mountain, where Saint Patrick is said to have spent the 40 days of Lent in the year 441. Legend holds that he fasted, prayed and ultimately hurled the spirits of paganism (like many Christian sites, the Reek has a pagan past) into a lake below. The faithful may make the climb at any time, but on the Last Sunday in July, known as Reek Sunday, as many as 60,000 people come to commemorate the Christianizing of Ireland.

The ascent of the 2,500-foot cone can be made in two hours (top), but many worshipers stop and circle each of three holy sites to pray and to chant paternosters and Ave Marias. Some (bottom) keep an all-night vigil at the summit, celebrating dawn mass with Communion near the shrine called Saint Patrick's Bed.

■ 512
Publication LIFE
Design Director Tom Bentkowski
Designer Tom Bentkowski
Photo Editor Barbara Baker Burrows
Photographer Gianni Giansanti
Publisher Time Inc.
Issue April 1995
Category Story/Reportage & Travel
■ **A** Spread/Reportage & Travel

PHOTOGRAPHY MERIT ■

The chain are strangely beautiful. They be tangled in large crates, glittering in the light of day. Each is eight feet long, and at both ends there are ankle irons that look like big handcuffs. The shackles are worn by 415 convicts who live in barracks at Limestone Correctional Facility near Huntsville, Ala. Here, as in one other medium-security prison in the state, repeat offenders must spend between three and six months of their sentences on a chain gang. At 4:30 a.m., six days a week, prisoners are bused to sites along highways and chained in groups of five...

CHAIN GANGS

Photography by
JAMES NACHTWEY

Text by
BRAD DARRACH

Chain gangs provide, who never miss a meal and earn cheap services, never get close to convicts. They don't carry their weapons when chaining or disciplining prisoners. If an inmate attempts to escape, guards have strict orders. Guardians down. So far, no one has risked a break.

On a chain gang, a good catch-as-catch-as-a-prisoner's. In the morning he switches chains and stretches them in the shape of a V. In the evening he removes the bone and lugs them back. At forty he checks himself three time watches him do his work. Now and then he goes to an infield. Most of the time he is out much and watches.

CHAIN GANGS SAVE MONEY. A GUARD WORKING INSIDE THE WALLS OF A PRISON CAN WATCH NO MORE THAN 20 MEN. OUTSIDE, HE CAN OVERSEE AS MANY AS **40.**

3 OF EVERY FOUR ALABAMIANS FAVOR CHAIN GANGS, BUT CONVICTS HATE BEING ON DISPLAY AND GIVING UP TV, SMOKING AND COFFEE PRIVILEGES.

Prisoners who threaten orders or refuse to work are chained to a pipe and forced to stand for as long as 12 hours under a broiling sun. Guards occasionally offer a cup of water.

6 HOURS OF HARD LABOR BEFORE LUNCH

The chains are not heavy—each weighs only three pounds—but they are easy to step over. When prisoners walk are shorter, they tie the chains so their belts with shoelaces.

▼ 1987 1991 ▶

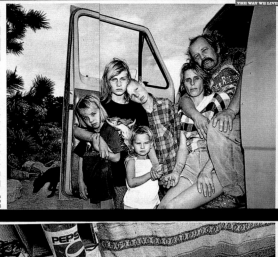

Eight years ago LIFE spent a week with the Damms, a deeply troubled family in Los Angeles. Last fall we tracked them down again: Their lives had gone from grim to intolerable. Their story now is not just one of welfare or drug abuse, or of homelessness, but of an equally desperate social problem: What happens to children whose parents are unfit to care for them?

THE SINS OF THE FATHERS

Photography by **Mary Ellen Mark**
Reporting by **Barbara Maddux**
Text by **Claudia Glenn Dowling**

Crazy, Joe says father. Dean, and mother, Linda, nap in the afternoon, at night. Crissy and Ashley sleep in a twin bed. Summer sleeps on the double bed with her parents, and Jesse sleeps on the living room couch.

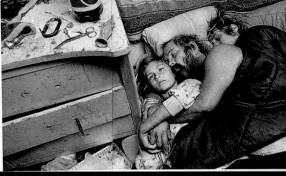

Deep in the desert, two hours north of Disneyland, down a dirt track through the cacti, mesquite and Joshua trees, is a former pig farm. Over the door is a sticker reading House of Pain. Here, with no running water, no phone, no electricity, lives the Damm family: Dean, 40, and Linda, 34, her two children from a first marriage, Crissy, 13, and Jesse, 12; the couple's two children, Ashley, six, and Summer, four; and seven dogs, including Dean's pit bull, Master, and Linda's chow, Rapper.

The dogs are barking. An unfamiliar vehicle is coming up the road. Dean and Linda yell to the children to hide in the canyon, and then the two with—amid broken glass, garbage, junk furniture, tattered pots magazines and dog feces. For four months, this place has been home.

Eight years ago, when LIFE first met the Damms, at the Valley Shelter for the homeless in North Hollywood, Calif., Dean Damm vowed, "We're going to get the hell out of this lifestyle and never look back." Touched by the couple's struggle to get job training and finally move into an apartment of their own, readers sent them $9,000, two used cars, toys and job offers. A plastic surgeon volunteered to remove Linda's tattoos. Actress Cindy Williams donated bunk beds. It looked like the hard times were over.

Four months later, the Damms were on the street again. The money was gone; the cars and furniture were gone, trashed or sold for drugs. In 1989, Dean and Linda were convicted of...

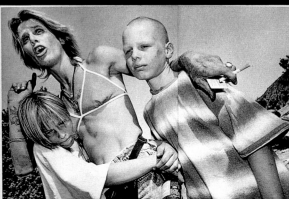

...willful cruelty to a child, because of neglect and unkempt conditions in the RV that was their home. One-year-old Ashley went to a foster home. Crissy and Jesse were placed with Linda's mother, a former security guard who lives near L.A. After seeking a few weeks' time, the couple was put on probation. When the children could be returned, the two had to take weekly parenting classes. Linda also had to attend Narcotics Anonymous meetings. They got the children back in 1990, after having another baby. Linda, who had her tubes tied, bitterly recalls a social worker's remark: "Keep taking them, and you keep making them."

This morning's visitor is not, as they fear, a caseworker checking on them. A real estate agent, informed by the sheriff that there are squatters on the ranch, has come to clear the Damms out. Dean talks fast, saying he is turning the place into a foster home called Broken Wing. The agent leaves but says he'll be back. "This is our life," says Linda. "We go through our trial, and a worse one comes along."

Linda gets ready to go into town to pick up $2.99 worth of food stamps. Yesterday she got her $904 check from Aid to Families with Dependent Children. Dean breaks down what he says he's spent: $526 down payment for an unregistered, uninsured, inoperative 1974 Ford van with cracked windshield, $65, battery, $20, gas, $129, used clothes at the American Way thrift shop, $18, T-shirts, $64, meal to a friend, $29, lunch at a burger place, $90, groceries, Left for the month, $86. Dean started a towing business when the children were in foster care and Linda didn't pay her AFDC check. "Once they take the kids, boom, your income's gone." he says. Since that business venture failed, Dean has been salvaging deserted cars for cash.

Looking for her boots, Linda pokes through garbage in the van. "Ashley Damm," she yells. "Dean, look what that monster child did." The binds her husband a cardboard box. "She deeded in it." The six-year-old squats beams. Her father throws the box across the yard.

Linda and the kids make the 20-mile drive into Lancaster. Next stop is the welfare office in a Laundromat. Ashley and her little sister...

Linda has, 34 tattoos, including the names and birth dates of her two sons protective-order Ashley's name on her leg. Summer is, but a diehard by now.

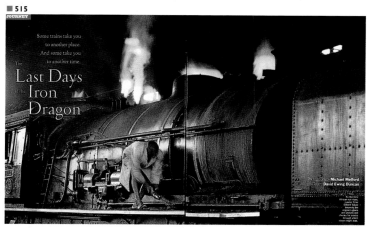

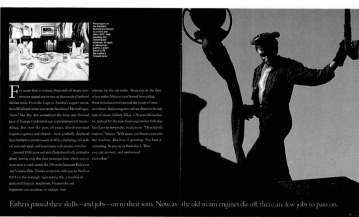

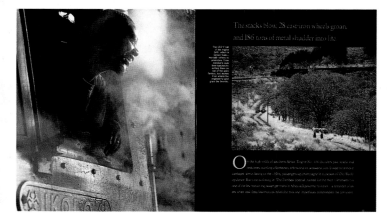

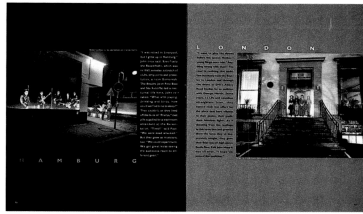

PHOTOGRAPHY MERIT ■

■515
Publication LIFE
Design Director Tom Bentkowski
Designers Linda Bell, Marti Golon
Photo Editor Barbara Baker Burrows
Photographer Michael Melford
Publisher Time Inc.
Issue November 1995
Category Story/Reportage & Travel

■516
Publication LIFE
Design Director Tom Bentkowski
Art Director Mimi Park
Designers Mimi Park, Tom Bentkowski
Photo Editor Barbara Baker Burrows
Photographer Shimon Attie
Publisher Time Inc.
Issue December 11, 1995
Category Story/Reportage & Travel

LIFE GOES TO THE...

Million Man March

On a day of atonement and renewal, black men inspired one another—and the nation.

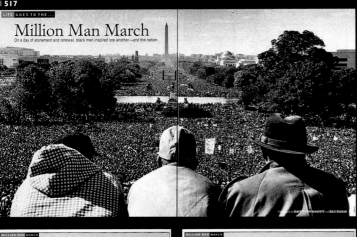

LIFE SPECIAL

THE

TINY VICTIMS

OF

DESERT STORM

When our soldiers risked their lives in the Gulf, they never imagined that their children might suffer the consequences—or that their country would turn its back on them.

Photography by Derek Hudson Text by Kenneth Miller Reporting by Jimmie Briggs

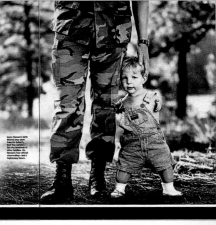

MILLION MAN MARCH

MILLION MAN MARCH

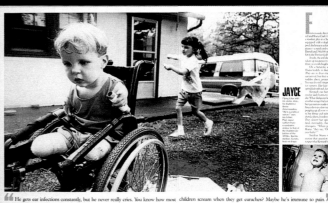

JAYCE

" He gets ear infections constantly, but he never really cries. You know how most children scream when they get earaches? Maybe he's immune to pain. "

MILLION MAN MARCH

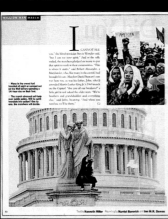

Text by Kenneth Miller Reporting by Harriet Barovick and Jon M.R. Bosse

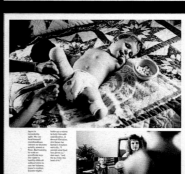

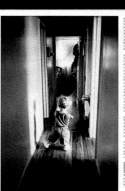

" [The veterans] need to keep the pressure on because . . . the companies who stand to be found liable will be in there lobbying. "

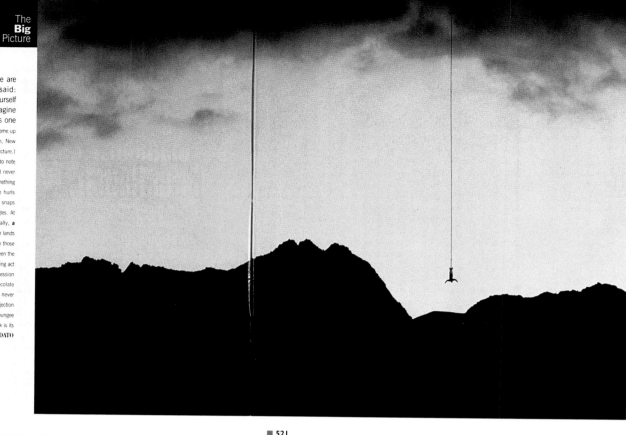

The Big Picture

Why Ask **Why?**

ABOUT THIS PHOTOGRAPH, there are two things that can be said: "Awesome!" if you can picture yourself in it; or "Why?" if you can't imagine even taking it. Bungee jumping is one of the coolest—or stupidest—things man has come up with thus far. (Yes, it was invented by a man, New Zealander A.J. Hackett, the fellow in this picture.) Think of it: A live human being (it's important to note that this is a human activity; a porpoise could never conceive of it) is strung up by the ankles to something perilously high (in this case a helicopter). He hurls himself earthward on a thin elastic cord that snaps him up and down a few times. Then he dangles. At this point, other humans reel him in. Basically, **a bungee jumper is God's yo-yo.** His leap of faith lands him on the far side of the great chasm between those who seek out risk and those who avoid it. Between the extremes of fearlessness and phobia is a balancing act in which risk is weighed against reward. Obsession with weight gain leads to a life without chocolate mousse. Avoiding rickety little planes means never reaching a secluded island paradise. Fear of rejection means never falling in love. And never to have bungee jumped means . . . um, well . . . sometimes risk is its own inexplicable reward. —ALLISON ADATO

Photographed over the
Remarkable Mountains, New Zealand
by STEPHEN WILKES
12

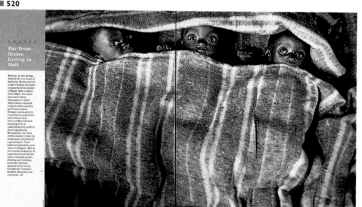

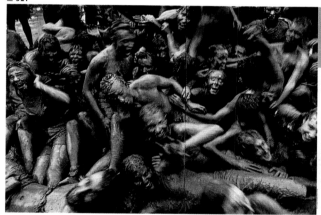

PHOTOGRAPHY MERIT ■

■ 519
Publication LIFE
Design Director Tom Bentkowski
Designer Jean Andreuzzi
Photo Editor Barbara Baker Burrows
Photographer Stephen Wilkes
Publisher Time Inc.
Issue August 1995
Category Spread/Reportage & Travel

■ 520
Publication LIFE
Design Director Tom Bentkowski
Designer Marti Golon
Photo Editor Barbara Baker Burrows
Photographer Sebastião Salgado
Publisher Time Inc.
Issue January 1995
Category Portrait

■ 521
Publication LIFE
Design Director Tom Bentkowski
Designer Marti Golon
Photo Editor Barbara Baker Burrows
Photographer Paul Fusco
Publisher Time Inc.
Issue January 1995
Category Portrait

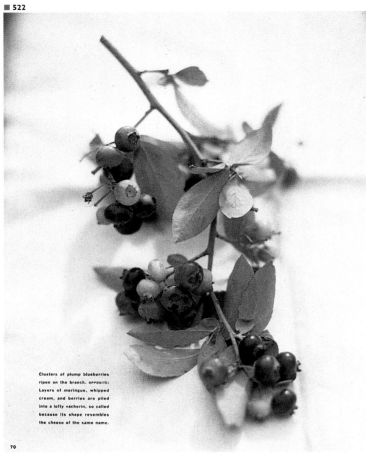

Clusters of plump blueberries ripen on the branch. OPPOSITE: Layers of meringue, whipped cream, and berries are piled into a lofty vacherin, so called because its shape resembles the cheese of the same name.

70

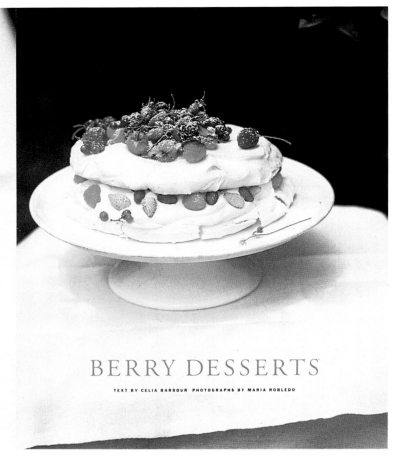

BERRY DESSERTS

TEXT BY CELIA BARBOUR PHOTOGRAPHS BY MARIA ROBLEDO

farmstead cheese

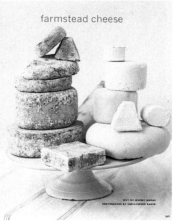

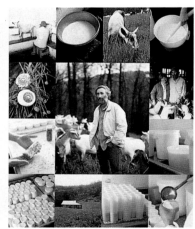

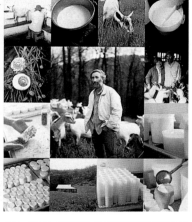

■ 522
Publication Martha Stewart Living
Creative Director Gael Towey
Art Director Eric A. Pike
Designer Agnethe Glatved
Photo Editor Heidi Posner
Photographer Maria Robledo
Publisher Time Inc.
Issue June 1995
Category Spread/Still Life & Interiors

■ 523
Publication Martha Stewart Living
Creative Director Gael Towey
Art Director Eric A. Pike
Designer Agnethe Glatved
Photo Editor Heidi Posner
Photographer Christopher Baker
Publisher Time Inc.
Issue September 1995
Category Story/Still Life & Interiors

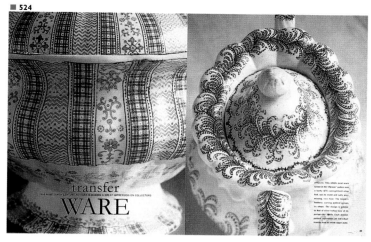

transfer
WARE

THIS NINETEENTH-CENTURY POTTERY IS MAKING A GREAT IMPRESSION ON COLLECTORS

FERNS

TEXT BY MARGARET ERACH. PHOTOGRAPHS AND CYANOTYPES BY VICTOR SCHRAGER

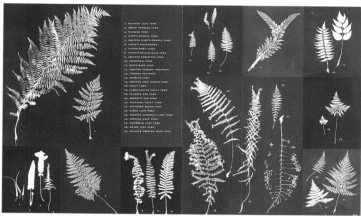

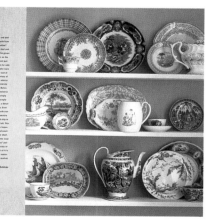

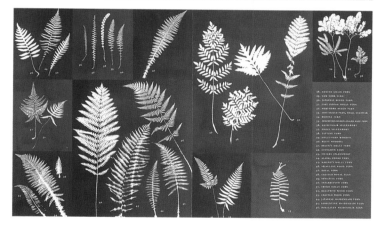

■ 524
Publication Martha Stewart Living
Creative Director Gael Towey
Art Director Eric A. Pike
Designer Claudia Bruno
Photo Editor Heidi Posner
Photographer Maria Robledo
Publisher Time Inc.
Issue November 1995
Category Story/Still Life & Interiors

■ 525
Publication Martha Stewart Living
Creative Director Gael Towey
Art Director Anne Johnson
Designer Anne Johnson
Photo Editor Heidi Posner
Photographer Victor Schrager
Publisher Time Inc.
Issue April 1995
Category Story/Still Life & Interiors

BLUE

By Laurence Gonzales ● Photographs by Keith Carter

The home of Elvis and Al Green and the cradle
of civilization as we now know it

MEMPHIS

THE BLUES CAME OUT OF THE
river like a fog, infecting black and white alike.

NOTEBOOK DIVERSIONS

Pulpier Fiction
The lurid return of Mickey Spillane · By Lamar Graham

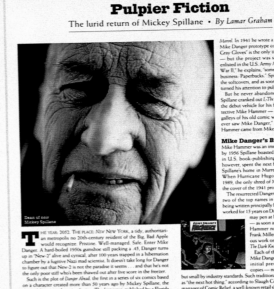

Dean of noir
Mickey Spillane

Mike Danger's Big Sleep

Back to the future: Mike Danger came out of the closet — of Spillane's home — with attitude intact.

PHOTOGRAPH BY GUY AROCH

66 Men's Journal, June-July 1995

BIG BOY IS BACK

PAT CONROY, WHO JUST PUBLISHED HIS FIRST
NOVEL SINCE THE PRINCE OF TIDES, ALWAYS
TELLS BIG STORIES, BUT FIRST HE LIVES THEM.

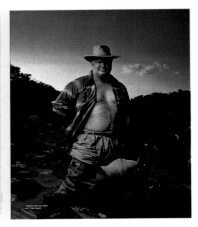

BY THOMAS CARNEY PHOTOGRAPHS BY MARK SELIGER

■ 526
Publication Men's Journal
Art Director Mark Danzig
Designer Susan Dazzo
Photo Editor Deborah Needleman
Photographer Keith Carter
Issue April 1995
Category Story/Reportage & Travel

■ 527
Publication Men's Journal
Art Director Mark Danzig
Designer Dirk Barnett
Photo Editor Kim Gougenheim
Photographer Guy Aroch
Issue June 1995
Category Portrait

■ 528
Publication Men's Journal
Art Director Mark Danzig
Designer Susan Dazzo
Photo Editor Deborah Needleman
Photographer Mark Seliger
Publisher Wenner Media
Issue August 1995
Category Portrait

PHIL JACKS◌N

THE MEN'S JOURNAL INTERVIEW

THE Zen HOOPSTER

BY BILL BRASHLER

PHOTOGRAPHS BY TOM WOLFF

Does Buddhist philosophy have relevance in the rough-and-tumble NBA? Of course, Grasshopper.

On the Trail of Billy the Kid
Driving New Mexico's bandit country

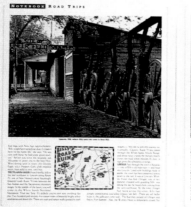

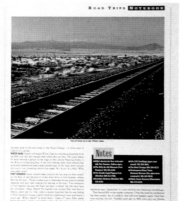

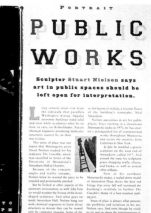

PORTRAIT

PUBLIC WORKS

Sculptor Stuart Nielsen says art in public spaces should be left open for interpretation.

PHOTOGRAPH BY MARC NORBERG

BLACK & WHITE BLUES

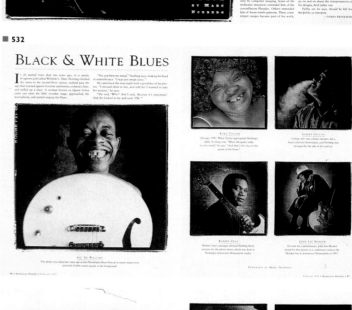

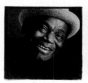
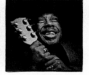
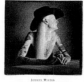

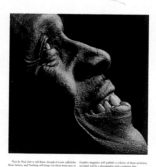

PHOTOGRAPHY MERIT ■

■ 529
Publication Men's Journal
Art Director Mark Danzig
Designer Mark Danzig
Photo Editor Deborah Needleman
Photographer Tom Wolff
Publisher Wenner Media
Issue November 1995
Category Portrait

■ 530
Publication Men's Journal
Art Director Mark Danzig
Designer Susan Dazzo
Photo Editor Deborah Needleman
Photographer Kent Barker
Publisher Wenner Media
Issue February 1995
Category Story/Reportage & Travel

■ 531
Publication Minnesota Monthly
Art Director Mark Shafer
Designer Brian Donahue
Photo Editor Mark Shafer
Photographer Marc Norberg
Publisher Minnesota Monthly Publications
Issue December 1995
Category Portrait

■ 532
Publication Minnesota Monthly
Art Director Mark Shafer
Designers Brian Donahue, Mark Shafer
Photo Editor Mark Shafer
Photographer Marc Norberg
Publisher Minnesota Monthly Publications
Issue February 1995
Category Story/Portraits

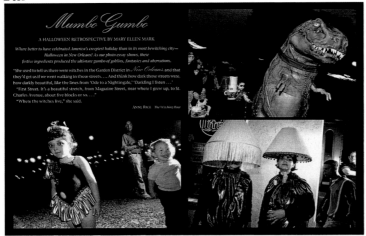

Mumbo Gumbo

A HALLOWEEN RETROSPECTIVE BY MARY ELLEN MARK

Where better to have celebrated America's creepiest holiday than in its most bewitching city—Halloween in New Orleans! As our photo essay shows, these festive ingredients produced the ultimate gumbo of goblins, fantasies and aberrations.

"She used to tell us there were witches in the Garden District in *New Orleans*, and that they'd get us if we went walking in those streets. . . . And think how dark those streets were, how darkly beautiful, like the lines from 'Ode to a Nightingale,' 'Darkling I listen . . .'

"First Street. It's a beautiful stretch, from Magazine Street, near where I grew up, to St. Charles Avenue, about five blocks or so. . . ."

"Where the witches live," she said.

ANNE RICE *The Witching Hour*

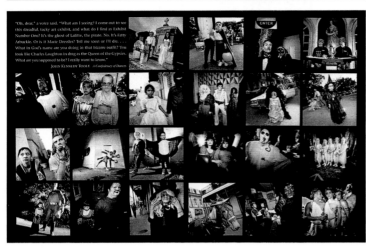

"Oh, dear," a voice said. "What am I seeing? I come out to see this dreadful, tacky art exhibit, and what do I find as Exhibit Number One? It's the ghost of Lafitte, the pirate. No. It's Fatty Arbuckle. Or is it Marie Dressler? Tell me soon or I'll die. . . . What in God's name are you doing in that bizarre outfit? You look like Charles Laughton in drag as the Queen of the Gypsies. What *are* you supposed to be? I really want to know."

JOHN KENNEDY TOOLE *A Confederacy of Dunces*

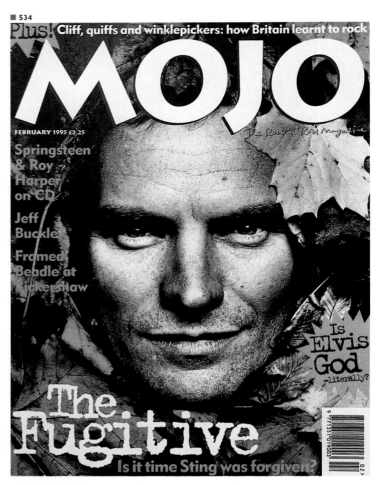

Plus! Cliff, quiffs and winklepickers: how Britain learnt to rock

MOJO

The Rock 'n' Roll Magazine

FEBRUARY 1995 £2.25

Springsteen & Roy Harper on CD

Jeff Buckley

Framed Beadle at Bickershaw

Is Elvis God -literally?

The Fugitive
Is it time Sting was forgiven?

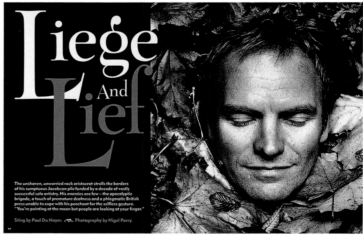

Liege And Lief

The unshaven, unworried rock aristocrat strolls the borders of his sumptuous Jacobean pile funded by a decade of vastly successful solo artistry. His enemies are few – the apocalyptic brigade, a touch of premature deafness and a phlegmatic British press unable to cope with his penchant for the selfless gesture. "You're pointing at the moon but people are looking at your finger."

Sting by Paul Du Noyer. Photography by Nigel Parry.

■ 533
Publication Modern Maturity
Design Directors Walter Bernard, Milton Glaser
Art Director James H. Richardson
Photo Editor Peter Howe
Photographer Mary Ellen Mark
Publisher American Association of Retired Persons
Issue November/December 1995
Category Story/Reportage & Travel

■ 534
Publication Mojo
Creative Director Andy Cowles
Art Director Stephen Fawcett
Designer Stephen Fawcett
Photo Editor Susie Hudson
Photographer Nigel Parry
Publisher EMAP Metro
Issue February 1995
Category Story/Portrait

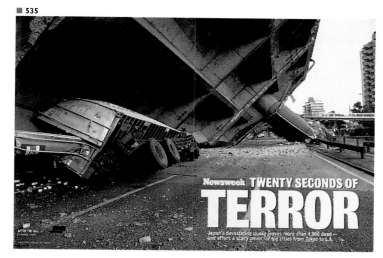

Newsweek TWENTY SECONDS OF
TERROR

Japan's devastating quake leaves more than 4,900 dead — and offers a scary omen for big cities from Tokyo to L.A.

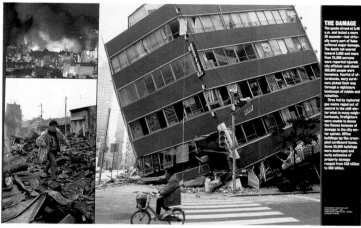

THE DAMAGE

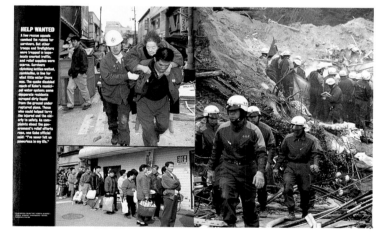

HELP WANTED

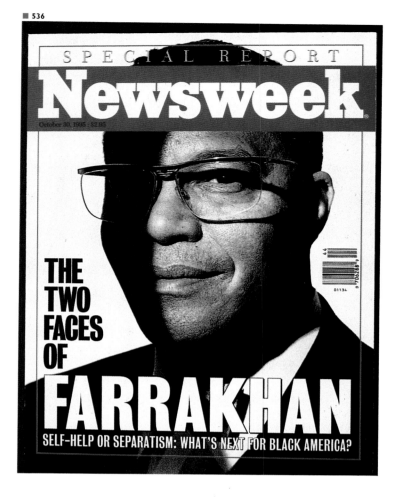

SPECIAL REPORT

Newsweek

October 30, 1995 : $2.95

THE TWO FACES OF FARRAKHAN

SELF-HELP OR SEPARATISM: WHAT'S NEXT FOR BLACK AMERICA?

PHOTOGRAPHY MERIT ■

Publication Newsweek
Design Director Lynn Staley
Art Director Alex Ha
Photo Editor James Colton
Photographers Haruyoshi Yamaguchi,
Natsuko Utsumi, Parick Robert, Noboru Hashimoto
Publisher Newsweek Inc.
Issue January 30, 1995
Category Story/Reportage & Travel

Publication Newsweek
Design Director Lynn Staley
Art Director Kandy Littrell
Designer Nurit Newman
Photo Editor James Colton
Photographer Albert Watson
Publisher Newsweek Inc.
Issue October 30, 1995
Category Portrait

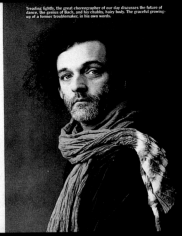

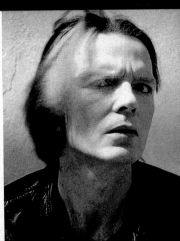

PORTRAITS

OF THE CITY

Lord Jim

537
Publication New York
Design Director Robert Best
Art Director Syndi Becker
Photo Editors
Margery Goldberg, Sabine Meyer
Photographer Jesse Frohman
Publisher K-III Publications
Issue December 11, 1995
Category Portrait

538
Publication New York
Design Director Robert Best
Art Director Syndi Becker
Designers Robert Best,
Syndi Becker, Deanna Lowe
Photo Editor Margery Goldberg
Photographer Dan Winters
Publisher K-III Publications
Issue December 25, 1995
Category Portrait

539
Publication New York
Design Director Robert Best
Art Director Syndi Becker
Designers Robert Best,
Syndi Becker, Deanna Lowe
Photo Editors
Margery Goldberg, Sabine Meyer
Photographer Geoffroy de Boismenu
Publisher K-III Publications
Issue December 25, 1995
Category Spread/Reportage & Travel

540
Publication New York
Design Director Robert Best
Art Director Syndi Becker
Photo Editor Margery Goldberg
Photographer Mark Contratto
Publisher K-III Publications
Issue April 24, 1995
Category Portrait

SPEED

THEY ARE HUMAN BULLETS.
Their world is defined by 100-meter lengths of track.
Their goal? To run as fast as a body can. Then faster.

BY DANIEL COYLE PHOTOGRAPHS BY MICHAEL LLEWELLYN

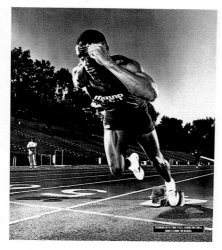

COMPRESSED AS A DIAMOND, THE 100 METERS IS
ABSTRACT EXPRESSIONISM, A VIOLENT ACT OF CREATION.

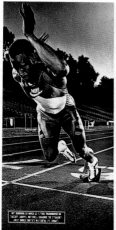

THEY CAN'T REVEAL A CRACK IN THE BRITTLE CUTICLE WRAPPING THE SELF.
AS THE SAYING GOES, THE RACE IS 100 METERS LONG AND ONE LANE WIDE.

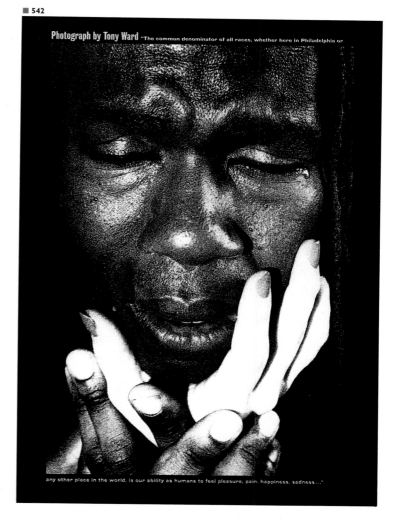

Photograph by Tony Ward "The common denominator of all races, whether here in Philadelphia or

any other place in the world, is our ability as humans to feel pleasure, pain, happiness, sadness ..."

PHOTOGRAPHY MERIT ■

■ 541
Publication Outside
Creative Director Susan Casey
Designer Susan Casey
Photo Editor Susan B. Smith
Photographer Michael Llewellyn
Publisher Mariah Media
Issue June 1995
Category Story/Reportage & Travel

■ 542
Publication Philadelphia Magazine
Creative Directors Frank Baseman, Betsy Brecht
Designers Betsy Brecht, Frank Baseman
Photo Editors Betsy Brecht, Frank Baseman
Photographer Tony Ward
Publisher METROCORP
Issue November 1995
Category Portrait

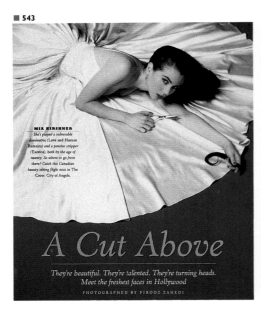

■ 543

MIA KIRSHNER
She's played a vulnerable dominatrix (Love and Human Remains) and a pensive stripper (Exotica), both by the age of twenty. So where to go from there? Catch this Canadian beauty taking flight next in The Crow: City of Angels.

A Cut Above

They're beautiful. They're talented. They're turning heads.
Meet the freshest faces in Hollywood

PHOTOGRAPHED BY FIROOZ ZAHEDI

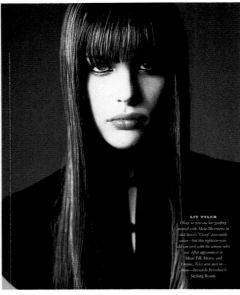

LIV TYLER
Okay, so you saw her goofing around with Alicia Silverstone in dad Steve's "Crazy" Aerosmith video—but this eighteen-year-old can rock with the serious roles too. After appearances in Silent Fall, Heavy, and Empire, Tyler next stars in—ahem—Bernardo Bertolucci's Stealing Beauty.

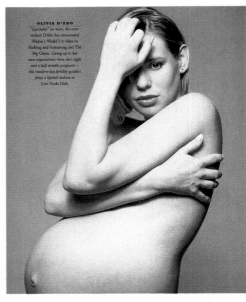

OLIVIA D'ABO
"Garthette" no more; the ever-radiant D'Abo has transcended Wayne's World 2 to shine in Kicking and Screaming and The Big Green. Living up to her own expectations—here she's eight and a half months pregnant—this modern-day fertility goddess plays a lipstick lesbian in Live Nude Girls.

■ 544

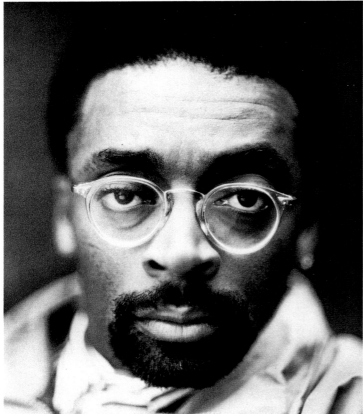

■ 545

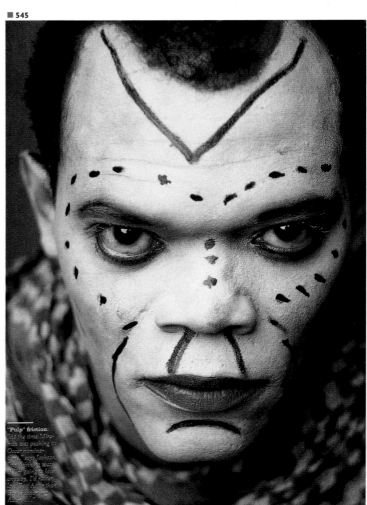

"Pulp" friction: As the time Miramax was pushing its Oscar nomination," says Jackson, "my thinking was, if I'm going to lose anyway, I'd rather lose Best Actor than Best Supporting Actor."

■ 543
Publication Premiere
Art Directors David Matt, Marianna Ochs
Designer Marianna Ochs
Photo Editor Chris Dougherty
Photographer Firooz Zahedi
Publisher Hachette Filipacchi Magazines, Inc.
Issue December 1995
Category Story/Portraits

■ 544
Publication Premiere
Art Director David Matt
Designer David Matt
Photo Editor Chris Dougherty
Photographer Frank Ockenfels 3
Publisher Hachette Filipacchi Magazines, Inc.
Issue October 1995
Category Portrait

■ 545
Publication Premiere
Art Director John Korpics
Designer John Korpics
Photo Editor Chris Dougherty
Photographer Firooz Zahedi
Publisher Hachette Filipacchi Magazines, Inc.
Issue June 1995
Category Portrait

REFUELED & REBORN

WHILE, *LED ZEPPELIN* TAKE THEIR RIGHTFUL PLACE IN THE ROCK & ROLL HALL OF FAME, JIMMY PAGE AND ROBERT PLANT DRAW UP NEW FLIGHT PLANS ~ *BY ANTHONY DeCURTIS*

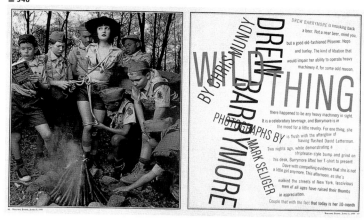

DREW BARRYMORE

WILD THING

BY CINDY MONDY

PHOTOGRAPHS BY MARK SELIGER

DREW BARRYMORE is knocking back a beer. Not a near beer, mind you, but a good old-fashioned Pilsener. Hops and barley. The kind of libation that would impair her ability to operate heavy machinery, if, for some odd reason, there happened to be any heavy machinery in sight. It is a celebratory beverage, and Barrymore is in the mood for a little revelry. For one thing, she is flush with the afterglow of having flashed David Letterman. Two nights ago, while demonstrating a striptease-style bump and grind on his desk, Barrymore lifted her T-shirt to present Dave with compelling evidence that she is not a little girl anymore. This afternoon, as she's walked the streets of New York, lascivious men of all ages have raised their thumbs in appreciation. Couple that with the fact that today is her 10-month

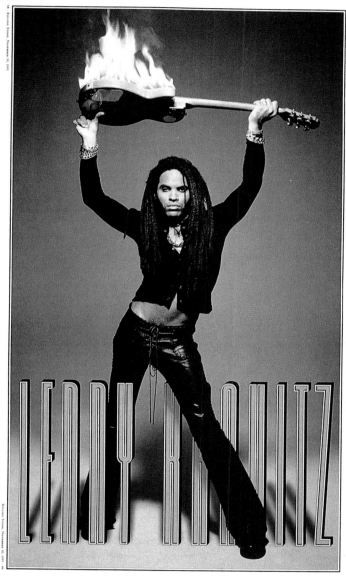

LENNY KRAVITZ

ROLLING STONE, JUNE 15, 1995 · 69

PHOTOGRAPHY MERIT ■

■ 546
Publication Rolling Stone
Creative Director Fred Woodward
Photo Editor Jodi Peckman
Photographer Anton Corbijn
Publisher Wenner Media
Issue February 23, 1995
Category Portrait

■ 547
Publication Rolling Stone
Creative Director Fred Woodward
Designers Fred Woodward,
Geraldine Hessler
Photo Editor Jodi Peckman
Photographer Mathew Rolston
Publisher Wenner Media
Issue November 30, 1995
Category Portrait

■ 548
Publication Rolling Stone
Creative Director Fred Woodward
Designers Fred Woodward,
Geraldine Hessler
Photo Editor Jodi Peckman
Photographer Mark Seliger
Publisher Wenner Media
Issue June 15, 1995
Category Portrait

■ 549
Publication Rolling Stone
Creative Director Fred Woodward
Photo Editor Jodi Peckman
Photographer Mark Seliger
Publisher Wenner Media
Issue June 15, 1995
Category Portrait

HAIL HAIL
Behind the scenes and onstage at the Concert for the Hall of Fame
ROCK & ROLL

By JANCEE DUNN

Photographs by ANTON CORBIJN

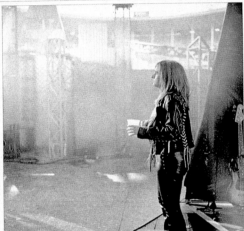

■ 550
Publication Rolling Stone
Creative Director Fred Woodward
Designer Geraldine Hessler
Photo Editor Jodi Peckman
Photographer Anton Corbijn
Publisher Wenner Media
Issue October 19, 1995
Category Story/Reportage & Travel

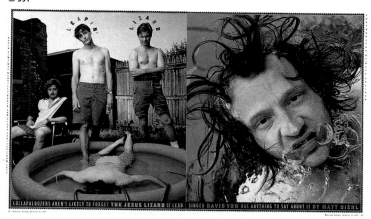

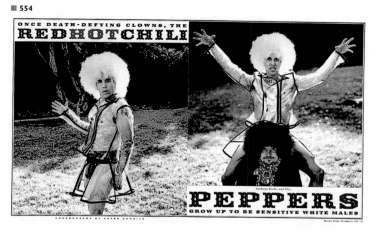

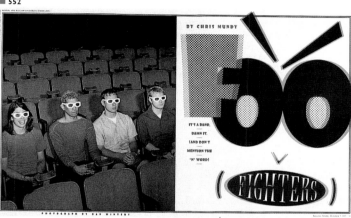

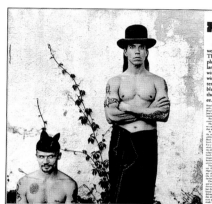

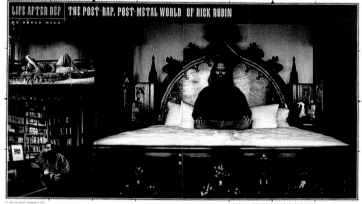
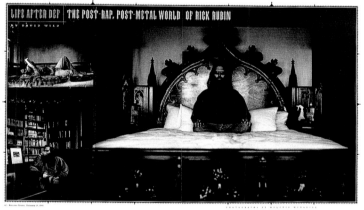

PHOTOGRAPHY MERIT ■

■ 551
Publication Rolling Stone
Creative Director Fred Woodward
Designers Fred Woodward,
Geraldine Hessler
Photo Editor Jodi Peckman
Photographer Mark Seliger
Publisher Wenner Media
Issue August 10, 1995
Category Portrait

■ 552
Publication Rolling Stone
Creative Director Fred Woodward
Designer Gail Anderson
Photo Editor Jodi Peckman
Photographer Dan Winters
Publisher Wenner Media
Issue October 5, 1995
Category Portrait

■ 553
Publication Rolling Stone
Creative Director Fred Woodward
Designers Fred Woodward,
Gail Anderson
Photo Editor Jodi Peckman
Photographer Melodie McDaniel
Publisher Wenner Media
Issue October 19, 1995
Category Portrait

■ 594
Publication Rolling Stone
Creative Director Fred Woodward
Designer Geraldine Hessler
Photo Editor Jodi Peckman
Photographer Anton Corbijn
Publisher Wenner Media
Issue October 19, 1995
Category Story/Portraits

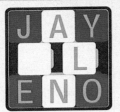

BY DAVID WILD Credit the slumping CBS, the whoring Hugh Grant or the Dancing Itos. Whatever the reason, the end of 1995 finds Jay Leno celebrating a three-month victory streak in his long ratings battle with his old pal David Letterman. A dogged competitor, Leno survived the dark days when his old manager and executive producer, Helen Kushnick, was calling – nay, screaming – the shots. Perhaps as we enter an election year, Leno is simply the better campaigner. After sitting for this interview in the "Tonight Show" greenroom, Leno even insisted on driving this reporter to his car. What a gracious host and stand-up kinda guy. Who could have a beef with that?

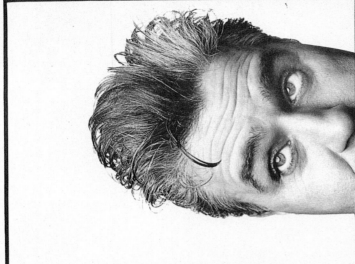

76 · ROLLING STONE, DECEMBER 28, 1995-JANUARY 11, 1996

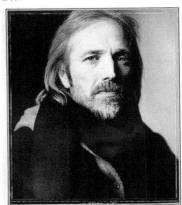
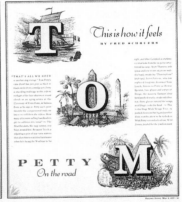

This is how it feels
BY FRED SCHRUERS

TOM
PETTY
On the road

■555
Publication Rolling Stone
Creative Director Fred Woodward
Designers Fred Woodward, Gail Anderson
Photo Editor Jodi Peckman
Photographer Mark Seliger
Publisher Wenner Media
Issue December 12, 1995
Category Portrait

■556
Publication Rolling Stone
Creative Director Fred Woodward
Designers Fred Woodward, Geraldine Hessler
Photo Editor Jodi Peckman
Photographer Mark Seliger
Publisher Wenner Media
Issue November 16, 1995
Category Story/Portraits

■557
Publication Rolling Stone
Creative Director Fred Woodward
Photo Editor Jodi Peckman
Photographer Mark Seliger
Publisher Wenner Media
Issue May 4, 1995
Category Portrait

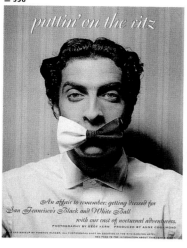

puttin' on the ritz

An affair to remember: getting dressed for San Francisco's Black and White Ball with our cast of nocturnal adventurers.

PHOTOGRAPHY BY GEOF KERN PRODUCED BY ANNE COOL/KONO

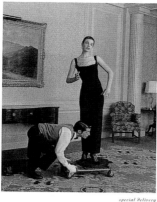

special delivery

goodnight, sweet princess

walking on air

belle of the ball

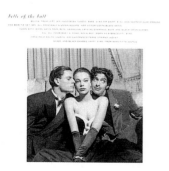

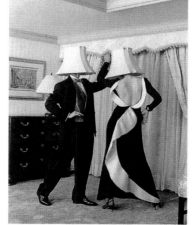

live wires

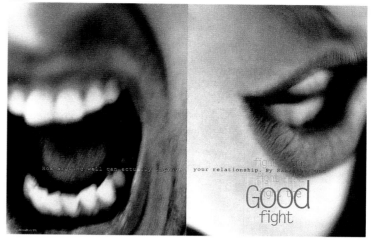

How arguing well can actually improve your relationship. By Samantha Dunn

Good fight

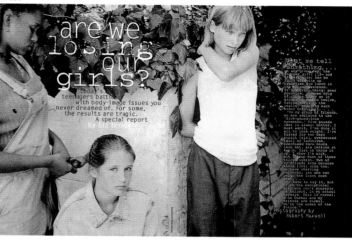

are we losing our girls?

Today's teenagers battle with body-image issues you never dreamed of. For some, the results are tragic. A special report By Liz Brody

Photography by Robert Maxwell

■ 558
Publication San Francisco Focus
Art Director David Armario
Designer David Armario
Photographer Geof Kern
Photo Editor Maureen Sphuler
Publisher KQED, Inc.
Issue May 1995
Category Story/Fashion & Beauty

■ 559
Publication Shape
Creative Director Kathy Nenneker
Art Director Yvonne Duran
Photographer Ken Schles
Publisher Weider Publications
Issue July 1995
Category Spread/Reportage & Travel

■ 560
Publication Shape
Creative Director Kathy Nenneker
Art Director Stephanie Birdsong
Photographer Robert Maxwell
Publisher Weider Publications
Issue November 1995
Category Story/Reportage & Travel

PHOTOGRAPHY MERIT ■

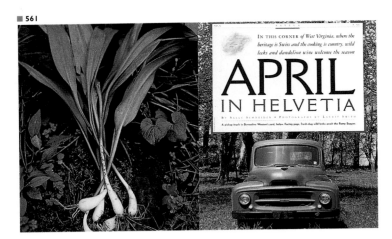

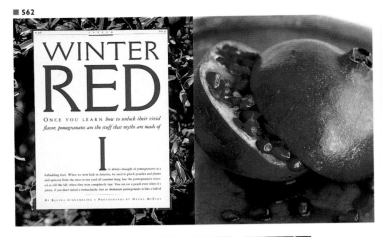

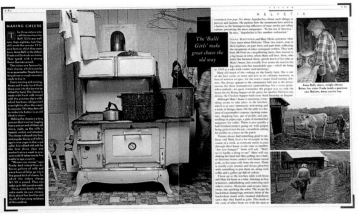

■ 561
Publication Saveur
Creative Director Michael Grossman
Art Director Jill Armus
Designer Marilu Lopez
Photo Editor Susan Goldberger
Photographer Laurie Smith
Publisher Meigher Communications
Issue March/April 1995
Category Story/Still Life & Interiors

■ 562
Publication Saveur
Creative Director Michael Grossman
Art Director Jill Armus
Designer Carla Frank
Photo Editor Susan Goldberger
Photographer Maura McEvoy
Publisher Meigher Communications
Issue November/December 1995
Category Story/Still Life & Interiors

By Jay Stuller

There never was a harder place than 'the Rock'

Used for 29 years to house the nation's most criminals, the penitentiary on Alcatraz earned its reputation as 'Uncle Sam's Devil's Island'

Surrounded by a thick fog, the U.S. Penitentiary at Alcatraz looms above the waters of San Francisco Bay.

Photographs by Regis Lefebure

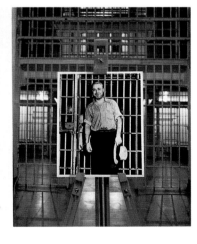

DUMB AND DUMBER

In between influencing a presidential election and dominating a music industry, MTV finds time to promote some good old-fashioned mindless degradation. Elizabeth Gilbert sojourns to Lake Havasu, Arizona, for MTV's *Spring Break '95.*

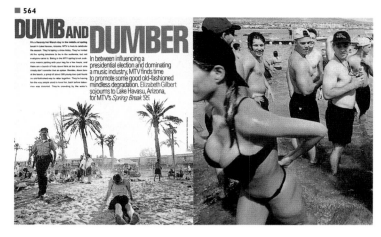

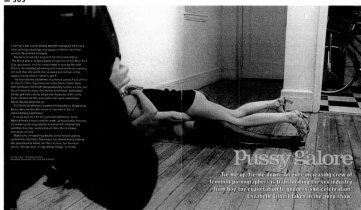

Pussy galore

Tie me up, tie me down: An ever-increasing crew of feminist pornographers is transforming the sex industry — from boy-toy exploitation to goddess-slut celebration. Elizabeth Gilbert takes in the peep show.

<div style="writing-mode: vertical">PHOTOGRAPHY MERIT</div>

■ 563
Publication Smithsonian
Art Director Edgar Rich
Photo Editor Edgar Rich
Photographer Regis Lefebure
Publisher Smithsonian Magazine
Issue September 1995
Category Story/Reportage & Travel

■ 564
Publication Spin
Art Director Bruce Ramsay
Designer Bruce Ramsay
Photo Editor Shana Sobel
Photographer Geoffroy de Boismenu
Publisher Camouflage Association
Issue July 1995
Category Spread/Reportage & Travel

■ 565
Publication Spin
Art Director Bruce Ramsay
Designer Bruce Ramsay
Photo Editor Shana Sobel
Photographer Bill Miller
Publisher Camouflage Association
Issue April 1995
Category Spread/Reportage & Travel

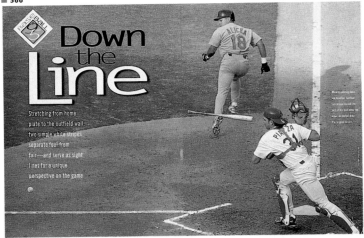

Down the Line

Stretching from home plate to the outfield wall, two simple white stripes separate foul from fair—and serve as sight lines for a unique perspective on the game

A private look at the Baltimore Orioles' Cal Ripken Jr. and his family reveals a tender side to baseball's toughest player
by Tim Kurkjian

MAN OF IRON

PHOTOGRAPHS BY WALTER IOOSS JR.

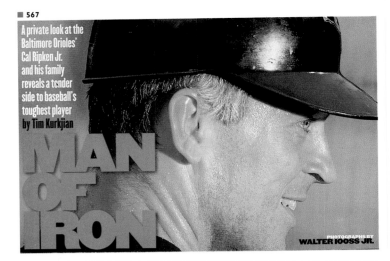

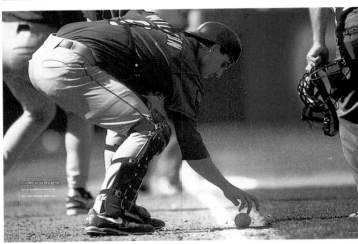

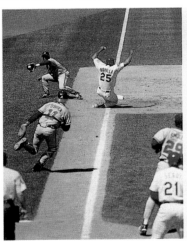

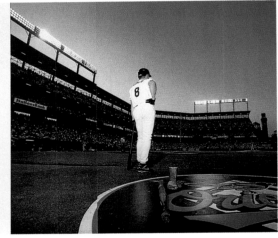

■ 566
Publication Sports Illustrated
Design Director Steven Hoffman
Designer Ed Truscio
Photo Editors Steve Fine, Maureen Grise
Photographers Peter Read Miller, Jim Gund, Brad Mangin, Chuck Solomon, John Biever, William R. Sallaz, Al Tielemans
Publisher Time Inc.
Issue May 1, 1995
Category Story/Reportage & Travel

■ 567
Publication Sports Illustrated
Design Director Steven Hoffman
Art Director Craig Gartner
Photographer Walter Iooss Jr.
Publisher Time Inc.
Issue August 8, 1995
Category Story/Reportage & Travel

Mickey Mantle

The legacy of the last great player on the last great team
by Richard Hoffer

If, they say, this kid, with all his great talent, would devote himself to baseball, he could become the greatest player who ever lived.

"Billy, Whitey, Hank Bauer, Moose Skowron —with those guys I shared life. We were as close as brothers."

Once Upon a Time...

...Prairie View had a dominant football program. Now, after 46 straight losses, the pitiful Panthers are on the verge of smashing the alltime record for consecutive defeats

BY JOHN ED BRADLEY
Photographs by Jeff Lowe

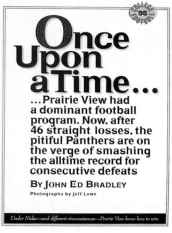

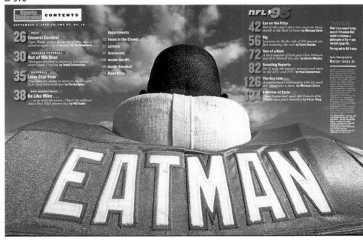

EATMAN

Broken Promise

Three devastating injuries in three NFL seasons have kept Miami's Steve Emtman from fulfilling his huge potential—so far

by John Ed Bradley

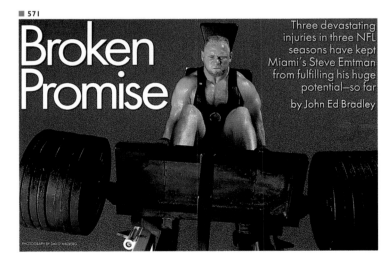

PHOTOGRAPHY MERIT ■

■ 568
Publication Sports Illustrated
Design Director Steven Hoffman
Designer Ed Truscio
Photo Editors Steve Fine, Maureen Grise
Photographers Grey Villet, Hy Peskin, Michael O'Neill, Art Rickerby, Ozzie Sweet
Publisher Time Inc.
Issue August 21, 1995
Category Story/Reportage & Travel

■ 569
Publication Sports Illustrated
Design Director Steven Hoffman
Designer Reyes Melendez
Photographers Jeff Lowe, Steve Fine
Publisher Time Inc.
Issue August 28, 1995
Category Portrait

■ 570
Publication Sports Illustrated
Design Director Steven Hoffman
Designer Ed Truscio
Photographers Bill Frakes, Heinz Kluetmeier
Publisher Time Inc.
Issue September 4, 1995
Category Portrait

■ 571
Publication Sports Illustrated
Design Director Steven Hoffman
Art Director Craig Gartner
Photographer David Walberg
Publisher Time Inc.
Issue September 25, 1995
Category Portrait

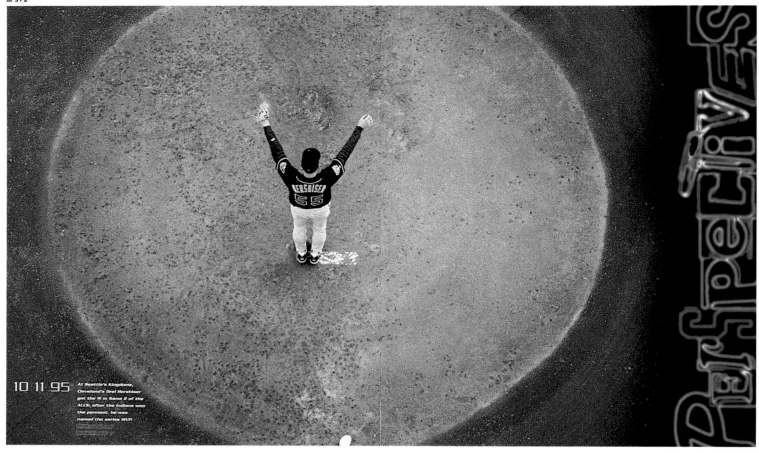

10 11 95 At Seattle's Kingdome, Cleveland's Orel Hershiser got the W in Game 2 of the ALCS, after the Indians won the pennant, he was named the series MVP.

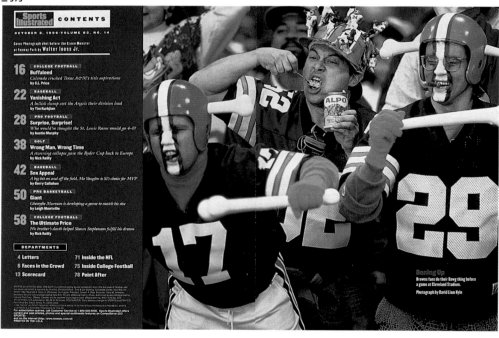

Sports Illustrated CONTENTS
OCTOBER 2, 1995·VOLUME 83, NO. 14
Cover Photograph shot before the Green Monster at Fenway Park by **Walter Iooss Jr.**

16 COLLEGE FOOTBALL
Buffaloed
Colorado crushed Texas A&M's title aspirations
by S.L. Price

22 BASEBALL
Vanishing Act
A hellish slump cost the Angels their division lead
by Tim Kurkjian

28 PRO FOOTBALL
Surprise, Surprise!
Who would've thought the St. Louis Rams would go 4-0?
by Austin Murphy

38 GOLF
Wrong Man, Wrong Time
A stunning collapse gave the Ryder Cup back to Europe
by Rick Reilly

42 BASEBALL
Sox Appeal
A big bat on and off the field, Mo Vaughn is SI's choice for MVP
by Gerry Callahan

50 PRO BASKETBALL
Giant
Gheorghe Muresan is developing a game to match his size
by Leigh Montville

58 COLLEGE FOOTBALL
The Ultimate Price
His brother's death helped Sheuan Stephenson fulfill his dream
by Rick Reilly

DEPARTMENTS

4 Letters 71 Inside the NFL
8 Faces in the Crowd 75 Inside College Football
13 Scorecard 78 Point After

Boning Up
Browns fans do their Bawg thing before a game at Cleveland Stadium.
Photograph by David Liam Kyle

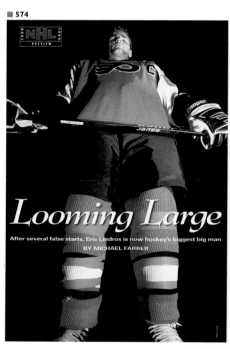

Looming Large
After several false starts, Eric Lindros is now hockey's biggest big man
BY MICHAEL FARBER

Publication Sports Illustrated Presents
Art Director F. Darrin Perry
Designer Michael D. Schinnerer
Photo Editor Jeffrey Weig
Photographer Robert Beck
Publisher Time Inc.
Issue Fall 1995
Category Spread/Reportage & Travel

Publication Sports Illustrated
Design Director Steven Hoffman
Designer Dolly Holmes
Photographers David Liam Kyle, Heinz Kluetmeier
Publisher Time Inc.
Issue October 2, 1995
Category Spread/Reportage & Travel

Publication Sports Illustrated
Design Director Steven Hoffman
Designer Anne Russinof
Photographers Burke Uzzle, Heinz Kluetmeier
Publisher Time Inc.
Issue October 9, 1995
Category Portrait

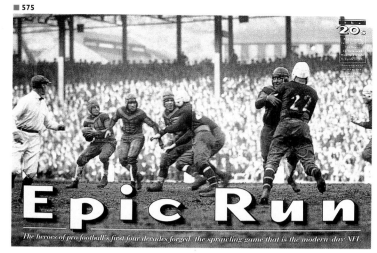

Epic Run

The heroes of pro football's first four decades forged the sprawling game that is the modern-day NFL

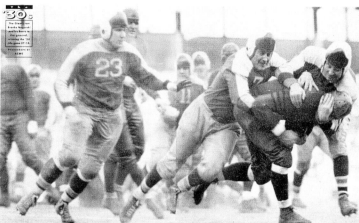

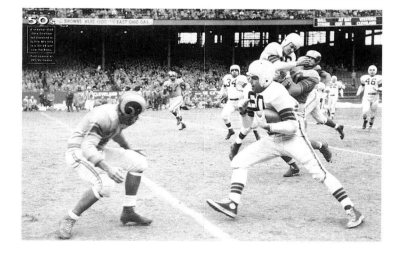

Architectural
salvage
The ultimate recycle

columns and cornices, fanlights and newel posts: Craftsmen's details are grace notes of style. Look carefully and you'll find pieces of the past, from leaded-glass windows to claw-footed tubs, being sold by salvage yards across the country.

BY PETER LEMOS

Warehouse of Recycled Goods

PHOTOGRAPHY MERIT ■

Publication Sports Illustrated Classic
Design Director Steven Hoffman
Art Director Craig Gartner
Designer Craig Gartner
Publisher Time Inc.
Issue Fall 1995
Category Story/Reportage & Travel

Publication This Old House
Design Director Mathew Drace
Art Director Timothy Jones
Photographers Aldo Rossi, Mark Weiss
Publisher Time Inc.
Issue September/October 1995
Category Story/Reportage & Travel

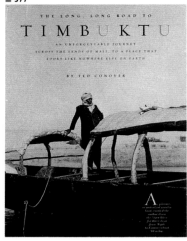
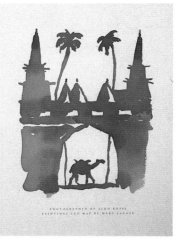

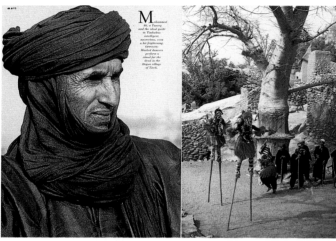

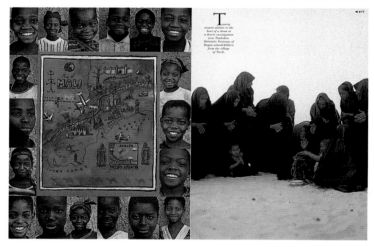

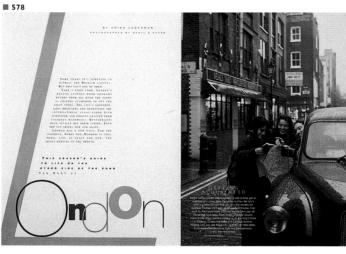

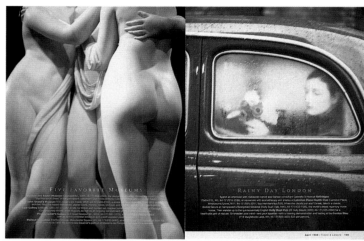

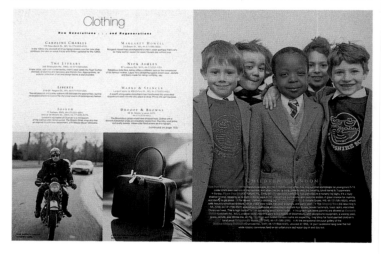

■ 577
Publication Travel & Leisure
Art Director Giovanni Russo
Designers Gaemer Gutierrez, Giovanni Russo
Illustrator Marc Lacaze
Photo Editor James Franco
Photographer Aldo Rossi
Publisher American Express Publishing
Issue February 1995
Category Story/Reportage & Travel

■ 578
Publication Travel & Leisure
Art Director Giovanni Russo
Designers Gaemer Gutierrez, Giovanni Russo
Photo Editor James Franco
Photographer Gentl & Hyers
Publisher American Express Publishing
Issue April 1995
Category Story/Reportage & Travel

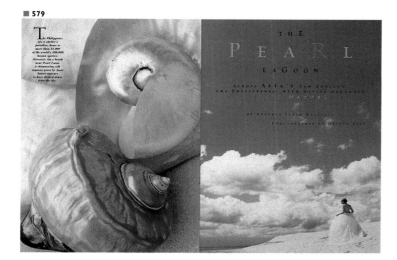

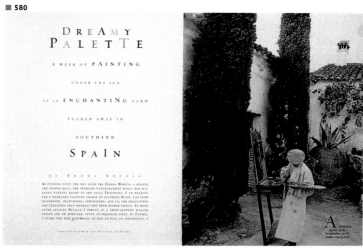

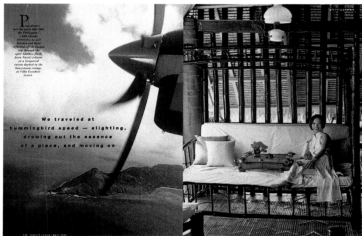

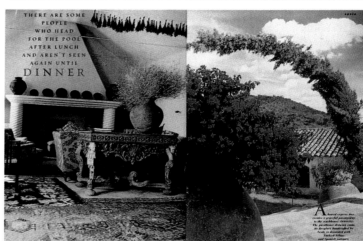

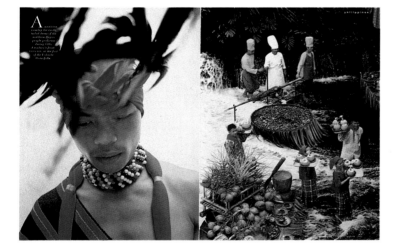

PHOTOGRAPHY MERIT ■

■ 579
Publication Travel & Leisure
Art Director Giovanni Russo
Designer Giovanni Russo
Photo Editor James Franco
Photographer Oberto Gilli
Publisher American Express Publishing
Issue April 1995
Category Story/Reportage & Travel

■ 580
Publication Travel & Leisure
Art Director Giovanni Russo
Designer Giovanni Russo
Photo Editor James Franco
Photographer Steven Sebring
Publisher American Express Publishing
Issue June 1995
Category Story/Reportage & Travel

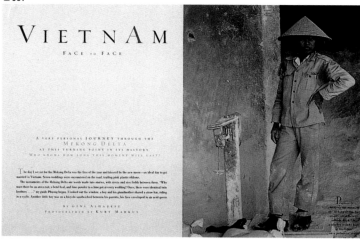

VIETNAM
FACE to FACE

A VERY PERSONAL JOURNEY THROUGH THE
MEKONG DELTA
AT THIS TURNING POINT IN ITS HISTORY.
WHO KNOWS HOW LONG THIS MOMENT WILL LAST?

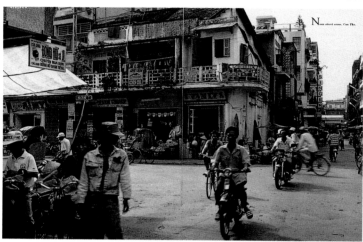

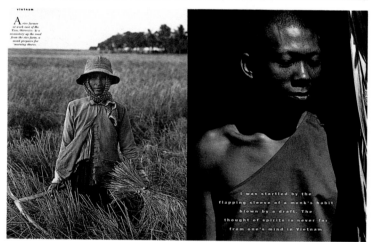

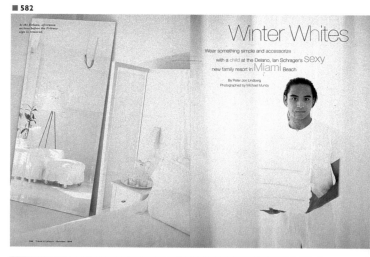

Winter Whites

Wear something simple and accessorize
with a child at the Delano, Ian Schrager's sexy
new family resort in Miami Beach

By Peter Jon Lindberg
Photographed by Michael Mundy

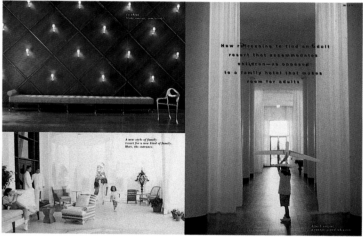

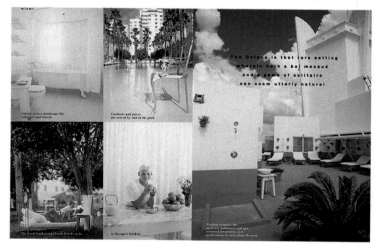

■ 581
Publication Travel & Leisure
Art Director Giovanni Russo
Designer Giovanni Russo
Photo Editor James Franco
Photographer Kurt Markus
Publisher American Express Publishing
Issue October 1995
Category Story/Reportage & Travel

■ 582
Publication Travel & Leisure
Art Director Giovanni Russo
Designer Giovanni Russo
Photo Editor James Franco
Photographer Michael Mundy
Publisher American Express Publishing
Issue October 1995
Category Story/Reportage & Travel

November / December

Resources

An **exclusive guide** to **unique** and **hard-to-find** home and **garden** products

113

When summer thaws the north, Finland's solemnity gives way to the sweetest sounds in all of Europe

Finns at Play

BY CHARLES MICHENER

photographed by ROBIN BOWMAN

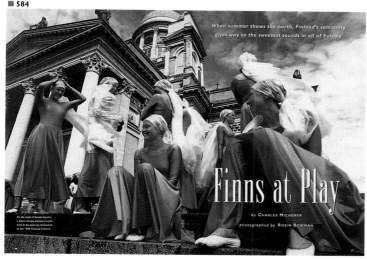

Turkish Blend

IN CAPPADOCIA, THE SACRED AND THE SECULAR FORM AN OTHERWORLDLY LANDSCAPE

BY SALLY SINGER PHOTOGRAPHED BY BASIL PAO

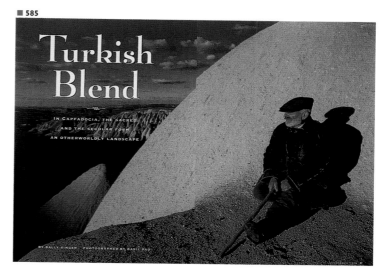

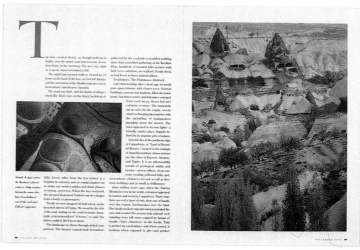

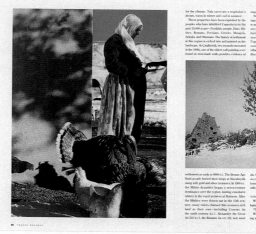

PHOTOGRAPHY MERIT ■

REUNION

I think of Anna Heilman as the sort of person who makes the best of bad things...

by **Peter Hellman** photographed by **Antonin Kratochvil**

HEART of SPAIN

Venerable Seville combines the pace of age with the pulse of youth

photographed by **DENNIS MARSICO**

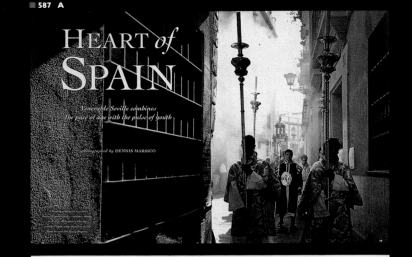

Most ghastly of the displays, mounted within the old barracks, are bins heaped with booty stripped from victims.

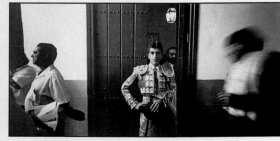

G reat old cities evoke familiar symbols—the Eiffel Tower, say, or Rome's Colosseum...

BOLD DEBUT

Before retreating, the Germans dynamited the four huge killing facilities at Birkenau, including the remains of No. 4.

IMPERIAL MEMORIES

ICON HAVEN

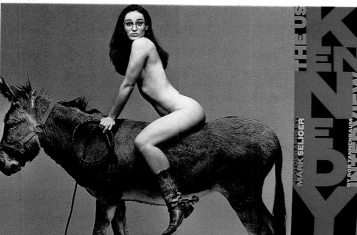

PROFILE Does accidental celebrity mean never having to say you're sorry? An aspiring entertainer realizes some of his blond ambitions while trying to keep his head above water

KATO KAELIN
BY MIM UDOVITCH

PHOTOGRAPHS BY MARY ELLEN MARK

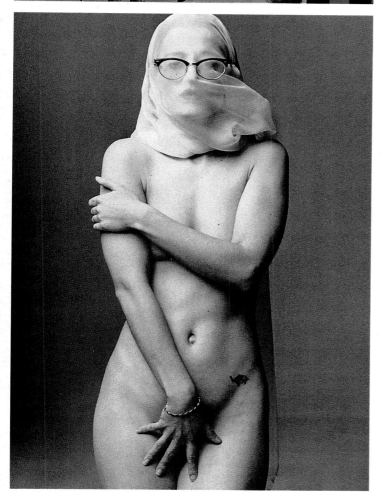

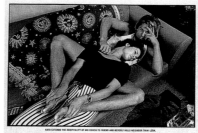

■ 588
Publication US
Art Director Richard Baker
Photo Editors Jennifer Crandall, Rachel Knepfer
Photographer Mark Seliger
Publisher US Magazine Co., L.P.
Issue February 1995
Category Story/Portraits
 ■ A Spread/Portrait

■ 589
Publication US
Art Director Richard Baker
Photo Editors Jennifer Crandall, Rachel Knepfer
Photographer Mary Ellen Mark
Publisher US Magazine Co., L.P.
Issue November 1995
Category Story/Portraits
 ■ Story/Reportage & Travel
 A Spread/Portrait

PHOTOGRAPHY MERIT ■

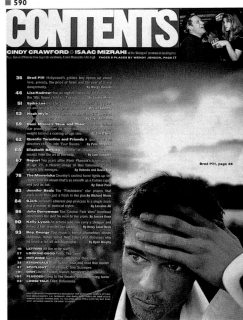

■ 590

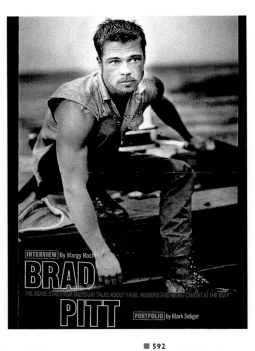

■ 590

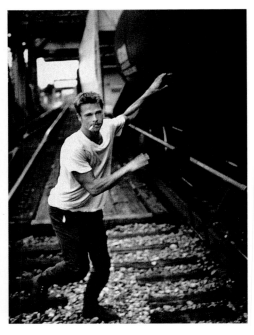

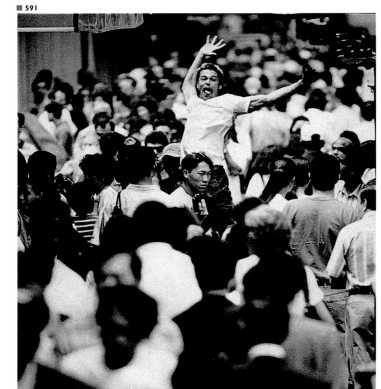

■ 591

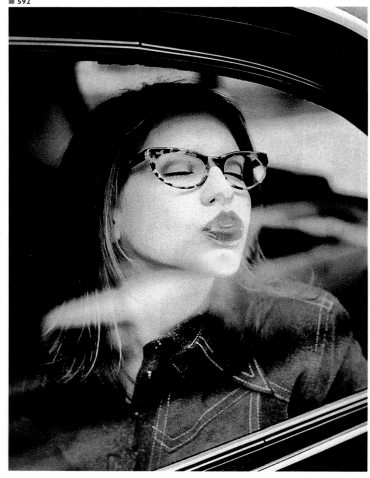

■ 592

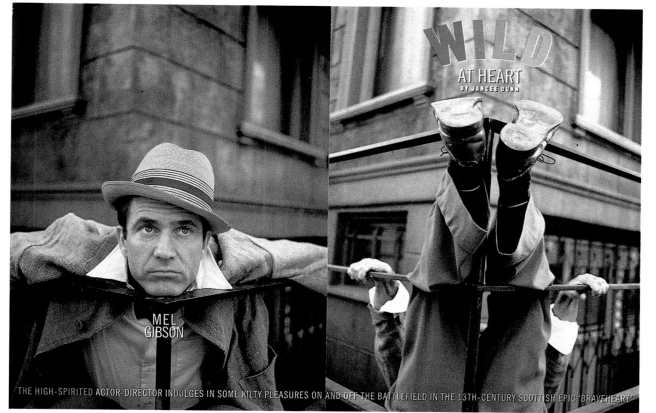

WILD AT HEART
BY JANCEE DUNN

MEL GIBSON

THE HIGH-SPIRITED ACTOR-DIRECTOR INDULGES IN SOME KILTY PLEASURES ON AND OFF THE BATTLEFIELD IN THE 13TH-CENTURY SCOTTISH EPIC 'BRAVEHEART'

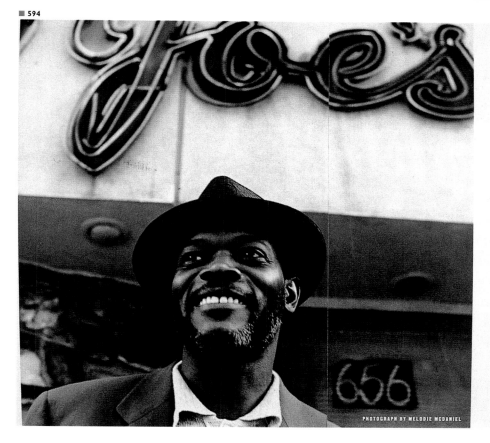

PHOTOGRAPH BY MELODIE McDANIEL

Samuel L. Jackson

He was the kind of actor movie audiences saw a lot of but could never quite get a handle on. Still, directors knew Jackson because his forte was making a bit part stand out by playing it any way they wanted — with humor (*National Lampoon's Loaded Weapon I*), menace (as the thug in *Mo' Better Blues*) or poignancy (the crack-addled brother in *Jungle Fever*). *Pulp Fiction*, however, signaled the beginning of a new era for the 45-year-old Tennessee native. In a film where everyone gave the performance of their career, Jackson stole the show as a Bible-quoting killer named Jules. And the splashy parts keep coming: He's a merciless attorney in *Losing Isaiah*, a misinformed cop in *Kiss of Death* and a good guy in *Die Hard With a Vengeance*. There's even talk of a prequel to *Pulp Fiction*, which would look at the early life of Jules and Vincent (John Travolta's character). After 20 years in the business, he can finally be called an overnight sensation.

"I remember watching the tribute to Sir Laurence Olivier on TV. They went through all those films that he had done, and I sat there saying: 'Oh, I saw that! Oh, man, I remember that!' They were all so satisfying. Something like that would really make me feel like I had done something worthwhile. I'd like this huge body of work that people could look at and go, 'Yeah, I really enjoyed that.' Things that moved people and things that people had a good time watching." — *Laura Morice*

■593
Publication US
Art Director Richard Baker
Photo Editors Jennifer Crandall, Rachel Knepfer
Photographer Melodie McDaniel
Publisher US Magazine Co., L.P.
Issue April 1995
Category Portrait

■594
Publication US
Art Director Richard Baker
Photo Editors Jennifer Crandall, Rachel Knepfer
Photographer Peggy Sirota
Publisher US Magazine Co., L.P.
Issue June 1995
Category Portrait

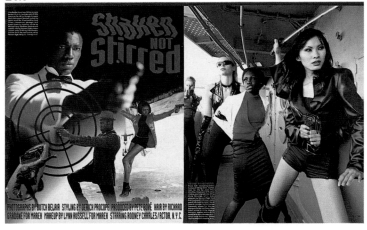

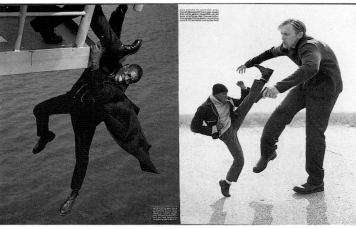

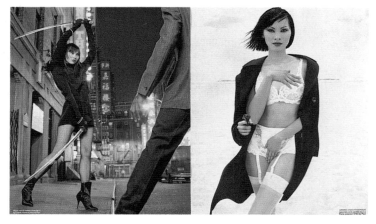

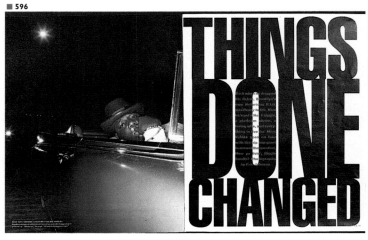

THINGS DONE CHANGED

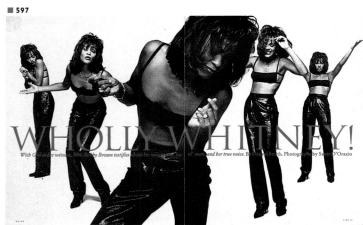

WHOLLY WHITNEY!

With God as her witness, Mrs. Bobby Brown testifies about her musical rebirth, ol' souls and her true voice. By Danyel Smith. Photography by Sante D'Orazio

■595
Publication Vibe
Art Director Diddo Ramm
Designer Diddo Ramm
Photo Editor George Pitts
Photographer Butch Belair
Publisher Time Inc.
Issue September 1995
Category Story/Fashion & Beauty

■596
Publication Vibe
Art Director Diddo Ramm
Designer Diddo Ramm
Photo Editor George Pitts
Photographer Barron Claiborne
Publisher Time Inc.
Issue October 1995
Category Portrait

■597
Publication Vibe
Art Director Diddo Ramm
Designer Diddo Ramm
Photo Editor George Pitts
Photographer Sante D'Orazio
Publisher Time Inc.
Issue December 1995
Category Portrait

VIBEfashion

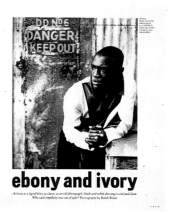

ebony and ivory

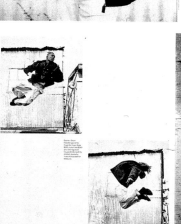

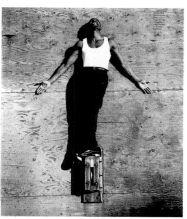

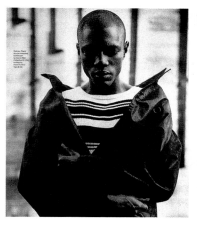

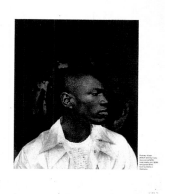

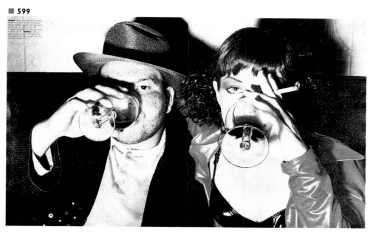

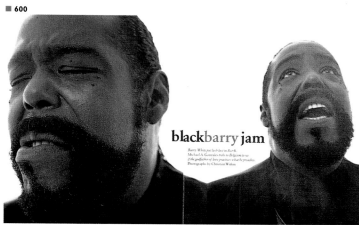

blackbarry jam

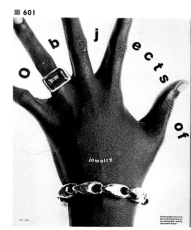

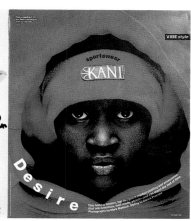

VIBEstyle

sportswear
KANI

PHOTOGRAPHY MERIT ■

■ 598
Publication Vibe
Art Director Diddo Ramm
Designer Diddo Ramm
Photo Editor George Pitts
Photographer Butch Belair
Publisher Time Inc.
Issue February 1995
Category Story/Fashion & Beauty

■ 599
Publication Vibe
Art Director Diddo Ramm
Designer Diddo Ramm
Photo Editor George Pitts
Photographer Geoffroy de Boismenu
Issue January 1995
Category Spread/Fashion & Beauty

■ 600
Publication Vibe
Art Director Diddo Ramm
Designer Diddo Ramm
Photo Editor George Pitts
Photographer Christian Witkin
Issue February 1995
Category Story/Fashion & Beauty

■ 601
Publication Vibe
Art Director Diddo Ramm
Designer Diddo Ramm
Photo Editor George Pitts
Photographer Mark Mattock
Publisher Time Inc.
Issue December 1995
Category Spread/Fashion & Beauty

■ 602

GARY SCHNEIDER'S PHOTOGRAPHS

THROUGH GLASS, DARKLY

LAUREN SEDOFSKY

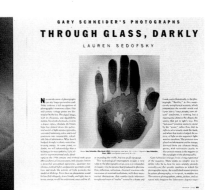

■ 603

The New World Disorder

In the post-cold war era, the fear of nationalism that stresses ethnic ties above all threatens to tear civilization apart

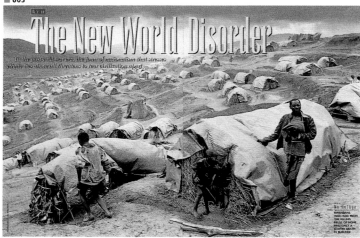

■ 604

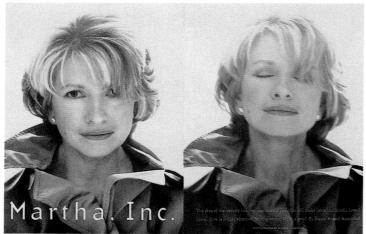

Martha. Inc.

■ 605

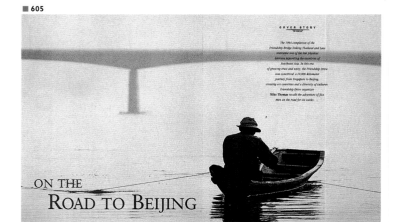

ON THE
ROAD TO BEIJING

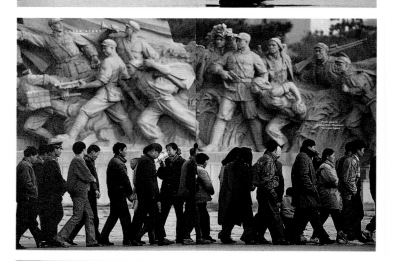

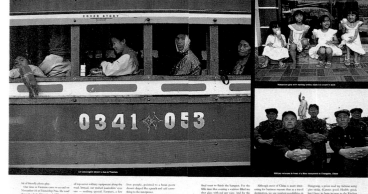

■ 602
Publication ARTFORUM
Design Director Kristin Johnson
Photographer Gary Schneider
Publisher ARTFORUM
Issue March 1995
Category Spread /Still Life & Interiors

■ 603
Publication Dateline
Design Director Jay Petrow
Photo Editor Michael Hirsch
Photographer Yan Morvan
Publisher Overseas Press Club
Issue 1995
Category Spread Page/Reportage & Travel

■ 604
Publication Working Woman
Art Director Gina Davis
Designers Gina Davis, Jamie Lipps
Photo Editor María Millán
Photographer Ruven Afanador
Publisher Lang Communications
Issue June 6, 1995
Category Portrait

■ 605
Publication Expression
Creative Director Colleen McCudden
Art Director Rina Poh
Designer Josephine Yu
Photo Editor Andrew Gun
Photographer Dilip Mehta
Issue February/March 1995
Category Story/Reportage & Travel

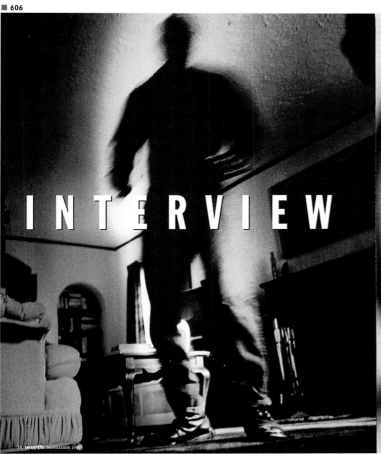

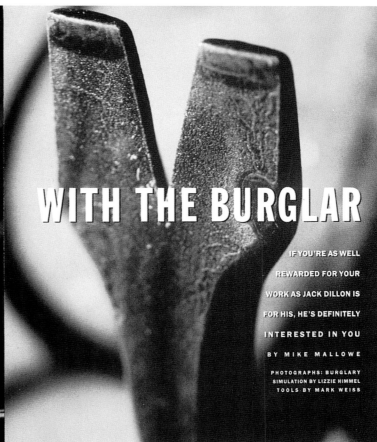

INTERVIEW WITH THE BURGLAR

IF YOU'RE AS WELL REWARDED FOR YOUR WORK AS JACK DILLON IS FOR HIS, HE'S DEFINITELY INTERESTED IN YOU

BY MIKE MALLOWE

PHOTOGRAPHS: BURGLARY SIMULATION BY LIZZIE HIMMEL TOOLS BY MARK WEISS

PHOTOGRAPHY MERIT ■

"IT ALL STARTS HERE."

HE SAYS, "IF YOU GET THE RIGHT FEELING ABOUT PEOPLE, YOU FOLLOW THEM HOME."

"THERE'S NO TRICK TO IT."

I DON'T ENJOY TALKING WITH JACK DILLON.

DILLON IS THOUGHTFUL. "I'M BEGINNING TO SEE WHY THEY BROKE INTO YOUR PLACE,"

HE SAYS, "IT'S ALMOST INDEFENSIBLE."

■ 606
Publication Worth
Art Director Philip Bratter
Designer Philip Bratter
Photo Editor Jennifer Graylock
Photographers Lizzie Himmel, Mark Weiss
Publisher Capital Publishing
Issue November 1995
Category Story/Still Life & Interiors

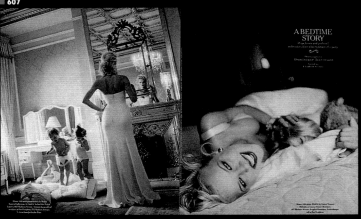

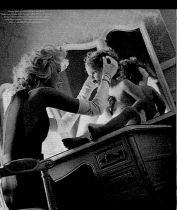

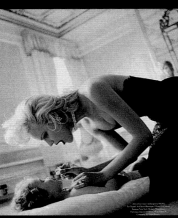

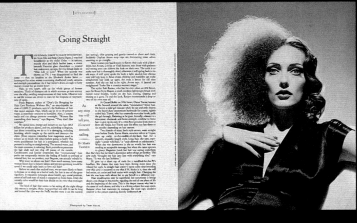

Going Straight

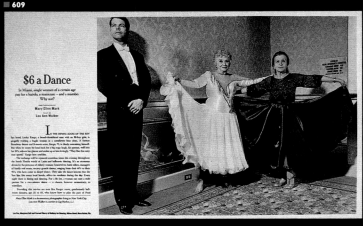

$6 a Dance

In Miami, single women of a certain age pay for a hairdo, a manicure — and a mambo. Why not?

By Mary Ellen Walker

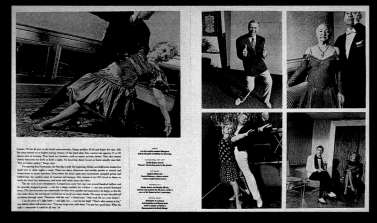

607
Publication The New York Times Magazine
Art Director Janet Froelich
Designer Joel Cuyler
Photographers Dominique Issermann, Elizabeth Stewart
Publisher The New York Times
Issue June 25, 1995
Category Story/Fashion & Beauty

608
Publication The New York Times Magazine
Art Director Janet Froelich
Designer Nancy Harris
Photographer Troy House
Publisher The New York Times
Issue October 1, 1995
Category Spread/Fashion & Beauty

609
Publication The New York Times Magazine
Art Director Janet Froelich
Designer Lisa Naftolin
Photo Editor Kathy Ryan
Photographer Mary Ellen Mark
Publisher The New York Times
Issue April 23, 1995
Category Story/Portraits

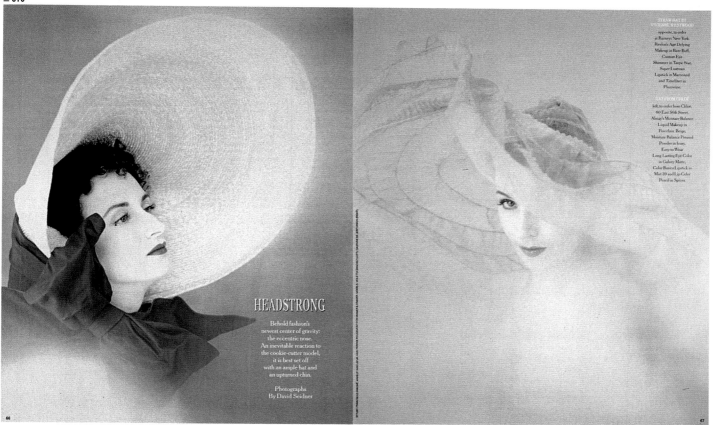

HEADSTRONG

Behold fashion's
newest center of gravity:
the eccentric nose.
An inevitable reaction to
the cookie-cutter model,
it is best set off
with an ample hat and
an upturned chin.

Photographs
By David Seidner

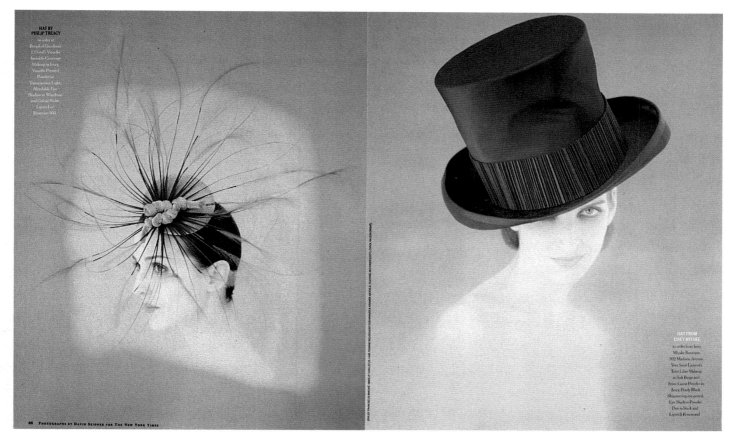

■ 610
Publication The New York Times Magazine
Art Director Janet Froelich
Photographers David Seidner, Franciscus Ankoné
Publisher The New York Times
Issue April 9, 1995
Category Story/Fashion & Beauty

PHOTOGRAPHY MERIT ■

WAR WITHOUT END

Twenty years
after the fall of
Saigon, thousands
of Vietnamese
are still trying to
find a home.

A PHOTO ESSAY BY
SEBASTIÃO SALGADO

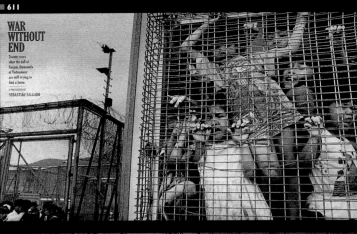

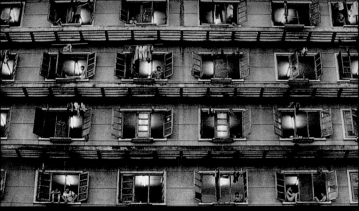

Grozny's Morning After

Russian bombs and rockets no
longer pound the Chechen capital.
There is so little left to pound.

PHOTOGRAPHS BY
ANTHONY SUAU

TEXT BY
MICHAEL SPECTER

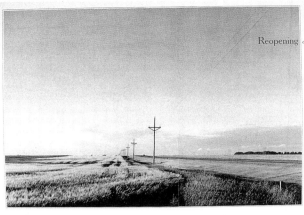

The Reopening of the Frontier

THE GREAT PLAINS are emptying out. What remains is a region populated increasingly by lonely old women and sustained by farm programs, Social Security and Medicare. Which leads to the question: Is the state of North Dakota really necessary?

By JON MARGOLIS

Photographs by CHARLES HARBUTT

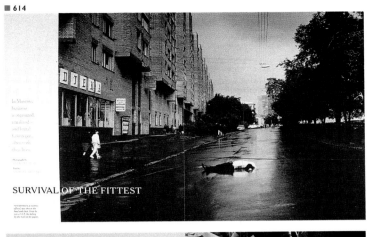

SURVIVAL OF THE FITTEST

Maybe Frank and Deborah Popper had a point when they wrote that depopulation should be encouraged, to transform the area into a national eco-park, 'a buffalo commons.' No one has yet suggested giving the Plains back to the Indians. But it's a thought.

 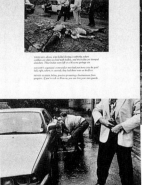

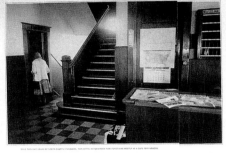

There is nothing unusual in Hamberg about abandoned buildings. That's most of what Hamberg is. More than half of the 30 or so houses stand empty, most for so long that they are uninhabitable.

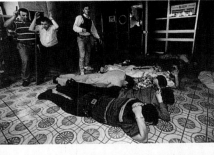

■ 613
Publication The New York Times Magazine
Art Director Janet Froelich
Designer Joel Cuyler
Photo Editor Kathy Ryan
Photographer Charles Harbutt
Publisher The New York Times
Issue October 15, 1995
Category Story/Reportage & Travel

■ 614
Publication The New York Times Magazine
Art Director Janet Froelich
Designer Janet Froelich
Photo Editor Kathy Ryan
Photographer Anthony Suau
Publisher The New York Times
Issue December 17, 1995
Category Story/Reportage & Travel

PHOTOGRAPHY MERIT ■

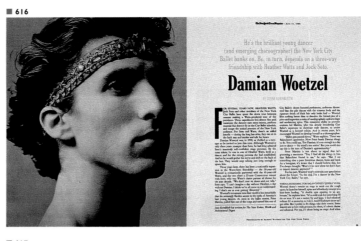

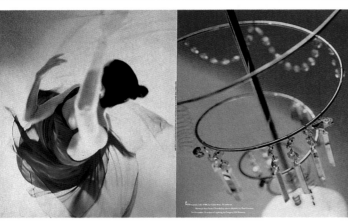

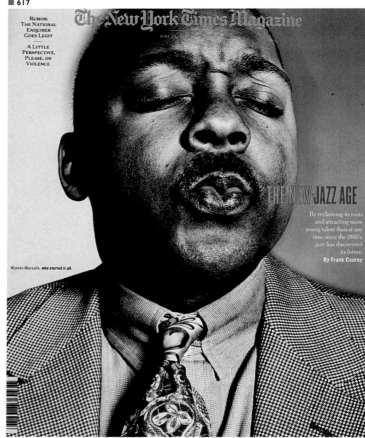

Publication The New York Times Magazine
Art Director Janet Froelich
Designer Catherine Gilmore-Barnes
Photographers Javier Vallhonrat, Fanciscus Ankoné
Publisher The New York Times
Issue June 4, 1995
Category Story/Fashion & Beauty

Publication The New York Times Magazine
Art Director Janet Froelich
Photo Editor Kathy Ryan
Photographer Albert Watson
Publisher The New York Times
Issue June 11, 1995
Category Portrait

Publication The New York Times Magazine
Art Director Janet Froelich
Designer Lisa Naftolin
Photo Editor Kathy Ryan
Photographer Richard Burbridge
Publisher The New York Times
Issue June 25, 1995
Category Portrait

With their miraculous mapping of our genetic
inscape, biology's pioneers are reconfiguring our futures
and influencing our big life decisions. They
are forcing us to ask ourselves what we are really made of,
and what we want to know.

The DNA We've Been Dealt
By Charles Siebert

Photographs by Exum · Digital Collage by Ignacio Rodriguez

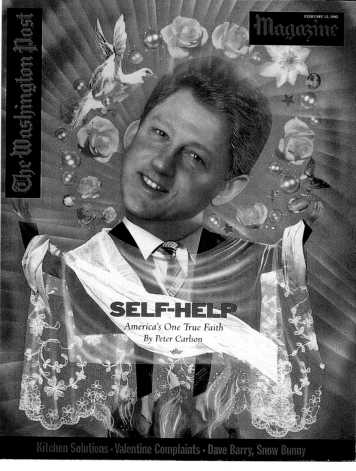

SELF-HELP
America's One True Faith
By Peter Carlson

Kitchen Solutions · Valentine Complaints · Dave Barry, Snow Bunny

I Hear
Seven good reasons why
America
public opinion polling
Yakking
should be banned

By Bob Garfield
Photo Illustration by Janet Woolley

■ 618
Publication The New York Times Magazine
Art Directors Janet Froelich,
Catherine Gilmore-Barnes
Designers Joel Cuyler, Lisa Naftolin
Photo Editor Kathy Ryan
Photographer EXUM
Publisher The New York Times
Issue September 17, 1995
Category Photo Illustration/Story

■ 619
Publication The Washington Post Magazine
Art Director Kelly Doe
Designer Kelly Doe
Illustrator Janet Woolley
Publisher The Washington Post Co.
Issue February 12, 1995
Category Photo Illustration/Single Page

■ 620
Publication The Washington Post Magazine
Art Director Kelly Doe
Designer Kelly Doe
Illustrator Janet Woolley
Publisher The Washington Post Co.
Issue November 5, 1995
Category Photo Illustration/Spread

■ 621

10 symptoms that may not mean what you think By Shari Roan

before you panic... read this

As Freud said, sometimes a cigar is just a cigar. The physical symptoms that keep you sleepless with worry may be just normal changes. A woman's body transforms itself throughout life, but at certain times—adolescence, pregnancy and especially menopause—the changes can be unnerving. If a symptom concerns you, don't let fear take over, as anxiety can worsen any condition. Do check with a professional, though. Sometimes a cigar is *more* than just a cigar.

86 / 87

■ 622

WHO ARE WE?

WHO ARE WE NOT? A LOOK AT USC'S DIVERSE STUDENT BODY

■ 623

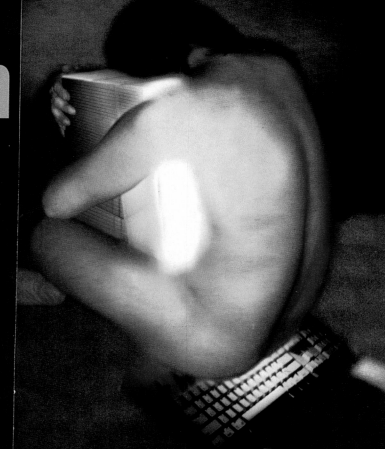

■ COVER STORY

On a Screen Near You:
Cyberporn

It's popular, pervasive and surprisingly perverse, according to the first survey of online erotica. And there's no easy way to stamp it out

By PHILIP ELMER-DEWITT

SEX IS EVERYWHERE THESE DAYS— in books, magazines, films, television, music videos and bus-stop perfume ads. It is printed on dial-a-porn business cards and slipped under windshield wipers. It is acted out by balloon-breasted models and actors with unflagging erections, then rented for $4 a night at the corner video store. Most Americans have become so inured to the open display of eroticism—and the arguments for why it enjoys special status under the First Amendment—that they hardly notice it's there.

Something about the combination of sex and computers, however, seems to make otherwise worldly-wise adults a little crazy. How else to explain the uproar surrounding the discovery by a U.S. Senator—Nebraska Democrat James Exon—that pornographic pictures can be downloaded from the Internet and displayed on a home computer? This, as any computer-savvy undergrad can testify, is old news. Yet suddenly the press is on alert, parents and teachers are up in arms, and lawmakers in Washington are rushing to ban the smut from cyberspace with new legislation—sometimes with little regard to either its effectiveness or its constitutionality.

If you think things are crazy now, though, wait until the politicians get hold of a report coming out this week. A research team at Carnegie Mellon University in Pittsburgh, Pennsylvania, has conducted an exhaustive study of online porn—what's available, who is downloading it, what turns them on—and the findings (to be published in the *Georgetown Law Journal*) are sure to pour fuel on an already explosive debate.

The study, titled *Marketing Pornography on the Information Superhighway*, is significant not only for what it tells us about what's happening on the computer networks but also for what it tells us about ourselves. Pornography's appeal is surprisingly elusive. It plays as much on fear, anxiety, curiosity and taboo as on genuine eroticism. The Carnegie Mellon study, drawing on elaborate computer records of online activity, was able to measure for the first time what people actually download, rather than what they say they want to see. "We now know what the consumers of computer pornography really look at in the privacy of their own homes," says Marty Rimm, the study's principal investigator. "And we're finding a fundamental shift in the kinds of images they demand."

What the Carnegie Mellon researchers discovered was:

There's an awful lot of porn online. In an 18-month study, the team surveyed 917,410 sexually explicit pictures, descriptions, short stories and film clips. On those Usenet newsgroups where digitized images are stored, 83.5% of the pictures were pornographic.

It is immensely popular. Trading in sexually explicit imagery, according to the report, is now "one of the largest (if not the largest)

38 Digital Illustrations for TIME by Matt Mahurin

■ 621
Publication Living Fit
Creative Director Kathy Nenneker
Art Director John Miller
Designer John Miller
Illustrator Amy Guip
Photo Editor Beth Katz
Publisher Weider Publications
Issue Fall 1995
Category Photo Illustration/Spread

■ 622
Publication USC Viewbook 2000
Creative Director Kit Hinrichs
Designer Anne Culbertson
Photographer Steven Heller
Studio Pentagram Design, Inc.
Issue August 1995
Category Photo Illustration/Spread

■ 623
Publication TIME
Art Director Arthur Hochstein
Designer Thomas M. Miller
Illustrator Matt Mahurin
Photo Editor Michele Stephenson
Publisher Time Inc.
Issue July 3, 1995
Category Photo Illustration/Spread

252

STUDENT COMPETITION

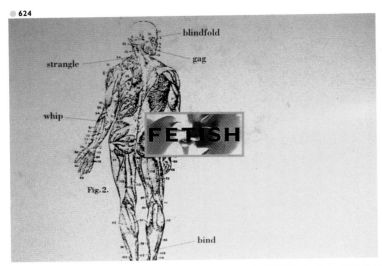

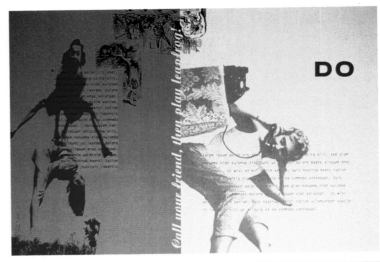

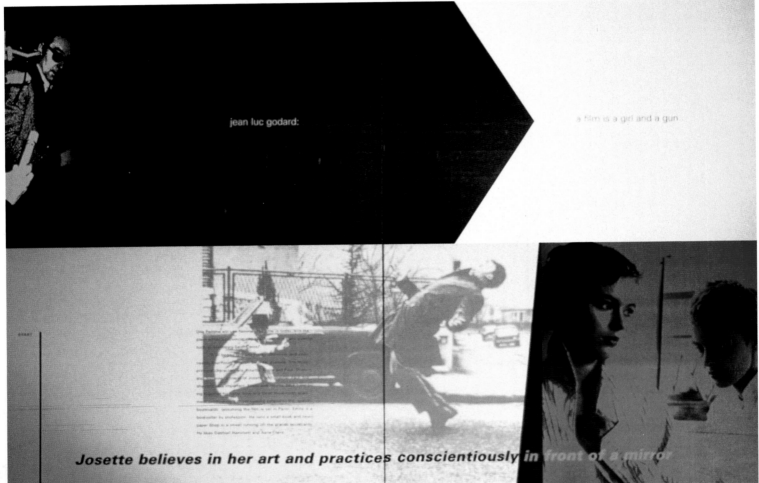

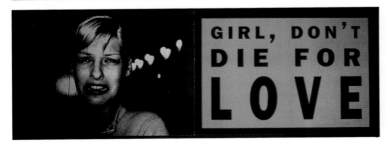

624

B. W. Honeycutt Award Winner
Title Fetish
Designer Gabriel Kuo
School School of Visual Arts, New York City
Instructor Chris Austopchuk
Category New Magazine Design

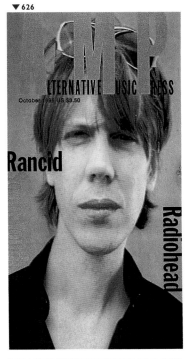

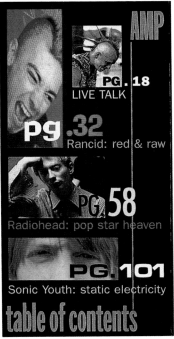

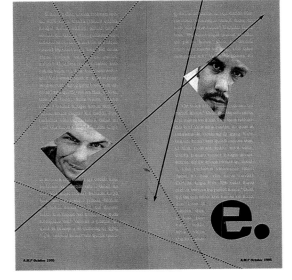

Title Skydiver
Designer Michael Tompert
School Academy of Art College,
San Francisco
Instructor Linda Hinrichs
Category New Magazine Design

Title Alternative Music Press
Designer Chris Klimasz
School School of Visual Arts,
New York City
Instructor Gail Anderson
Category New Magazine Design

STUDENT COMPETITION EXCELLENCE ▼

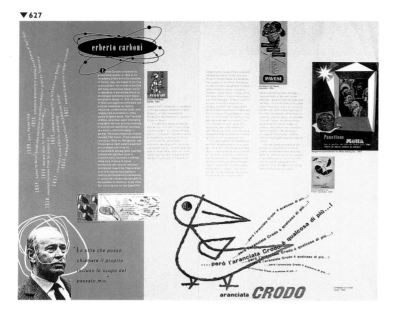

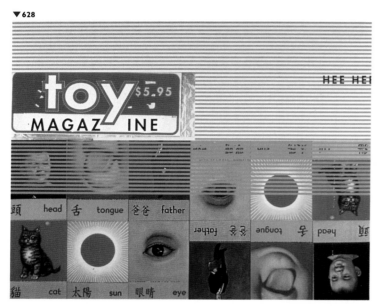

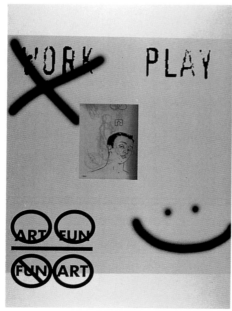

Title Erberto Carboni
Designer Lara Philliposian
School University of Washington, Seattle
Instructor Chris Ozubko
Category Design/Story

Title Toy
Designer Gillian Wong
School School of Visual Arts, New York City
Instructor Chris Austopchuk
Category Design/Story

Title CCAC News
Designers Eric Heiman, Nadine Stellavato
School California College of Arts & Crafts, San Franciso
Instructor Bob Aufuldish
Category Publication Redesign

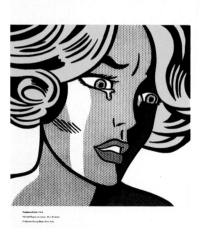

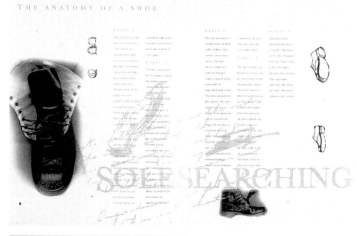

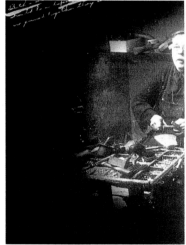

■ 630
Title Roy Lichenstein Brochure
Designer Ida Lee
School Academy of Art College, San Francisco
Instructor Leif Ameson
Category New Publication Design

■ 631
Title Solesearching
Designer Jamie Calderon
School Academy of Art College, San Francisco
Instructor Katharine Morgan
Category New Magazine Design

STUDENT COMPETITION MERIT

257

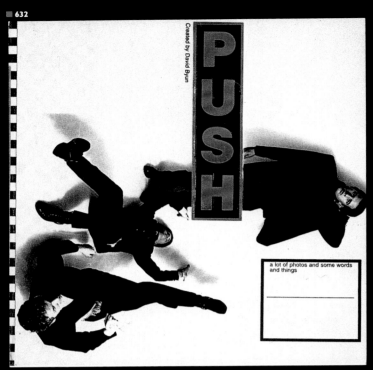

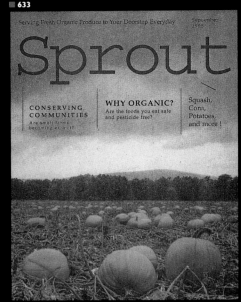

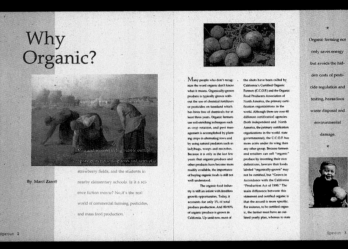

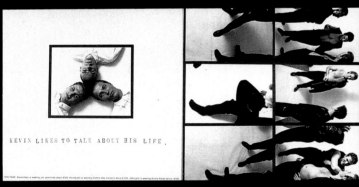

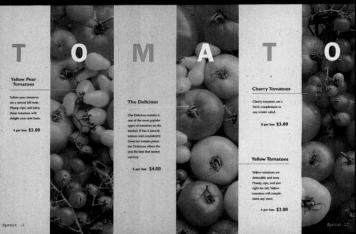

632
Title Push
Designer David Byun
School School of Visual Arts, New York City
Instructor Chip Kidd
Category New Magazine Design

633
Title Sprout
Designer Mei Yee Tse
School Rhode Island School of Design,
Instructor Victoria Cahve Clement
Category New Publication Design

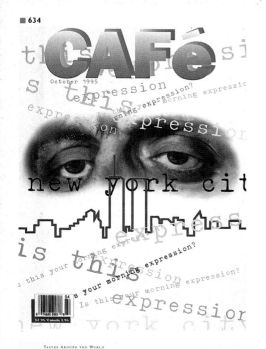

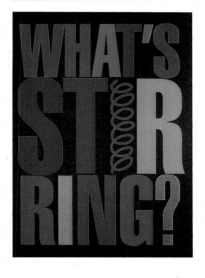

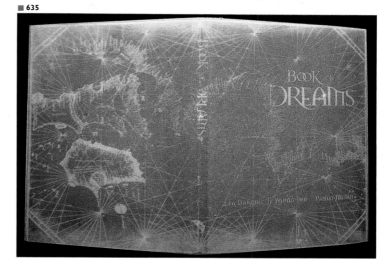

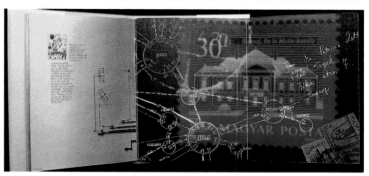

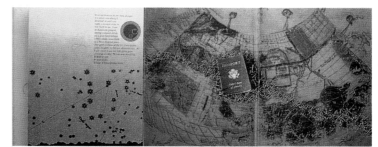

STUDENT COMPETITION MERIT

■ 634
Title Café
Designer Zhao Wen Li
School School of Visual Arts, New York City
Instructor Gail Anderson
Category New Magazine Design

■ 635
Title Book of Dreams
Designers Lea Baran, Pablo Medina, Jamie Ji Young Jun
School Pratt Institute, New York City
Instructor Kevin P. Gatta
Category New Publication Design

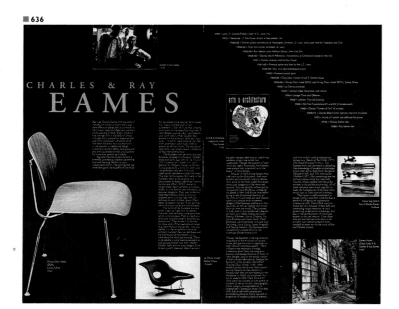

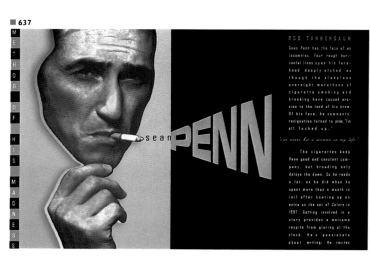

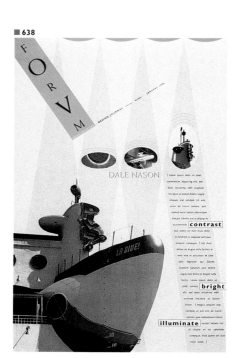

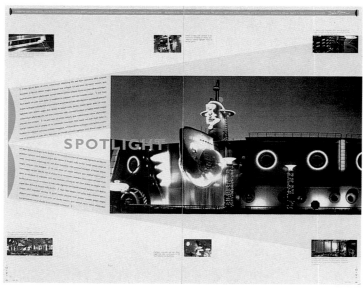

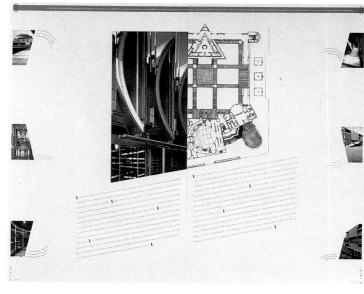

Title Charles & Ray Eames
Designer Ben Graham
School University of Washington, Seattle
Instructor Chris Ozubko
Category Design/Spread

Title Sean Penn
Designer Frank Brian Martino
School School of Visual Arts, New York City
Instructor Chris Austopchuk
Category Design/Spread

Title Forum
Designer Joey Fong Ho-Ching
School Academy of Art College, San Francisco
Instructor Leif Arneson
Category Magazine Redesign

Title Tribe
Designer Surya Sutantio
School Academy of Art College, San Francisco
Instructor Paul Hauge
Category Design/Story

Title Kansas State Collegian
Designer Derek C. Simmons
School Kansas State University, Manhattan
Instructor Ron Johnson
Category Newspaper Redesign

STUDENT COMPETITION MERIT ■

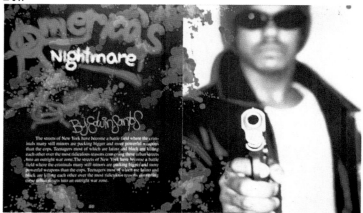

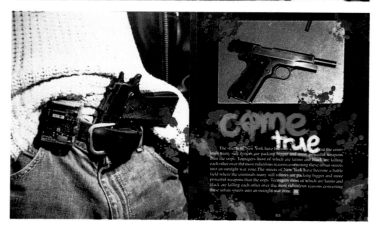

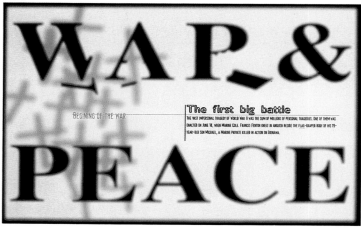

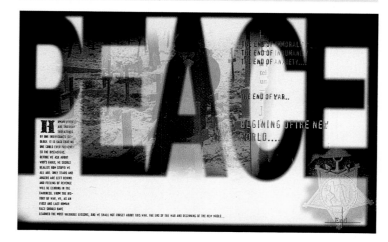

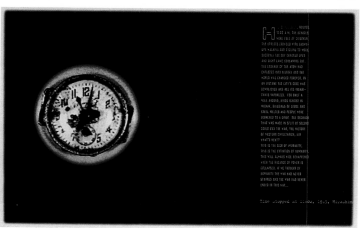

Title America's Nightmare
Designer Edwin Santos
School Fashion Institute of Technology, New York City
Instructor Susan Cotler Block
Category Design/Multi-page Story

Title War and Peace
Designer Dong-Hyun Kim
School School of Visual Arts, New York City
Instructor Gail Anderson
Category Design/Story

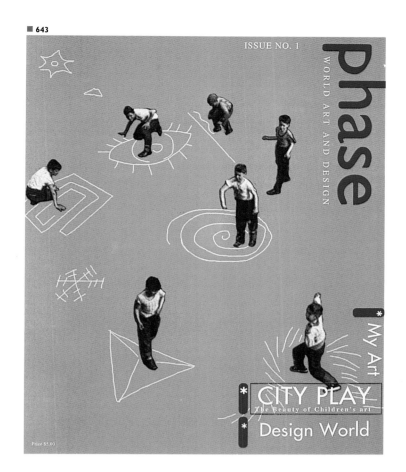

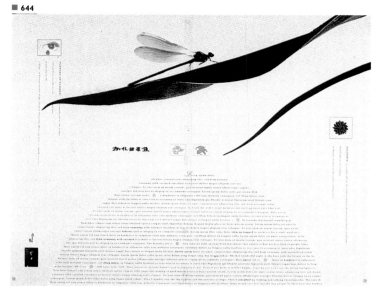

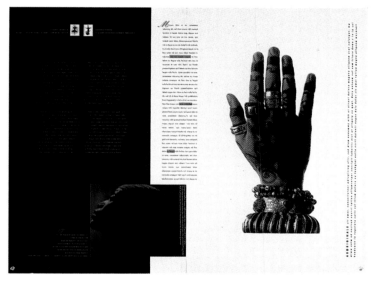

■ 643
Title Phase
Designer Fang Zhou
School School of Visual Arts, New York City
Instructor Gail Anderson
Category Design/Cover

■ 644
Title Forum
Designer Peter Tjahjadi
School Academy of Art College, San Francisco
Instructor Leif Ameson
Category Design/Story

JUNE ISSUE 95 US $5.95

METRO-POLIS

Six

6

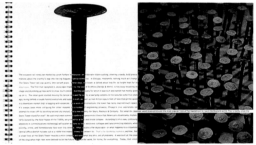

-NAIL IT

SUPERCUTS
annual report 1996

COMMITMENT
CONSISTENCY
& QUALITY

OUR MAJOR
ACCOMPLISHMENTS IN
1996 ARE RELATED TO
OUR AGGRESSIVE
EXPANSION STRATEGY

WHILE MARKET SHARE
GROWTH IS A MAJOR
THRUST, WE ARE ALSO
CONTINUING OUR HIS-
TORY OF LEADERSHIP
AND INNOVATION,WHILE
PROVIDING SUPERIOR
SERVICE.

financial highlights

G R O W T H

■ 645
Title Metro-polis
Designer Mijin Lee
School School of Visual Art, New York City
Instructor E.C, Williams
Category Magazine Redesign

■ 646
Title Supercuts Annual Report 1996
Designer Aya Kotake
School Academy of Art College, San Francisco
Instructor Julia Brown
Category Design/Multi-page Story

PHOTOGRAPHY INDEX

▼ PUBLISHERS

■ CLIENTS

■ STUDIOS & FIRMS